PORTRAIT OF

Camelot

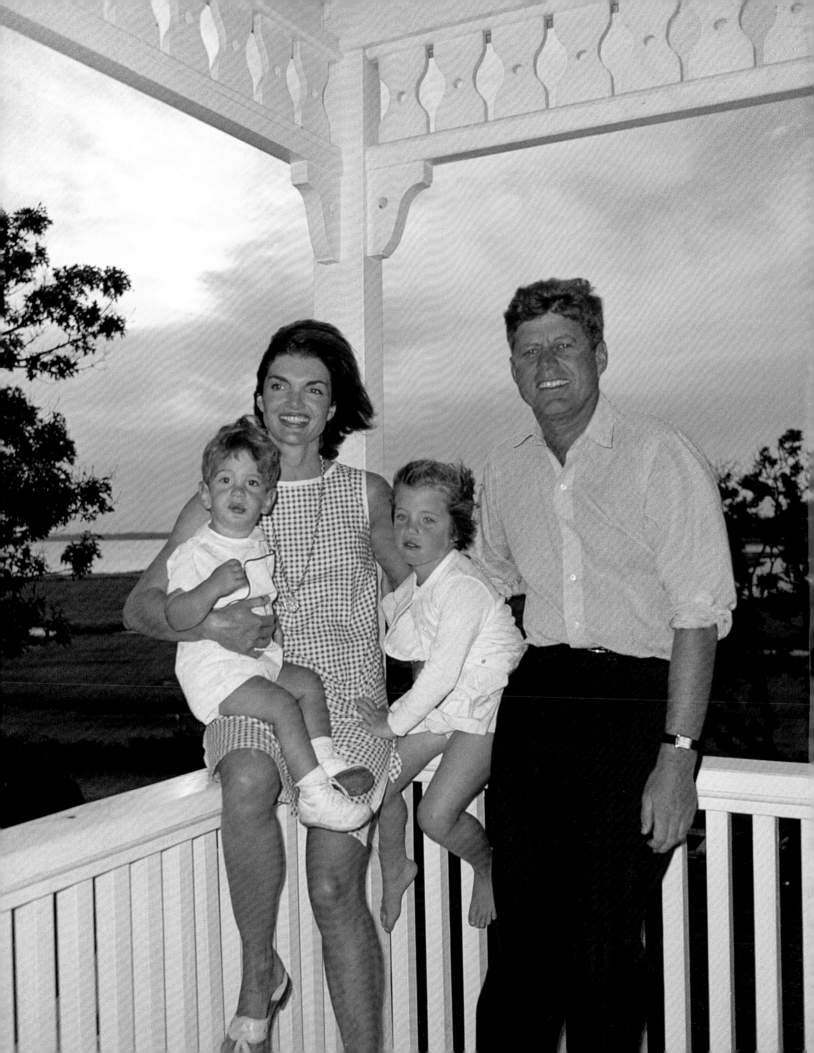

PORTRAIT OF
Camelot

A THOUSAND DAYS IN THE KENNEDY WHITE HOUSE

Richard Reeves

WITH HARVEY SAWLER
PHOTOGRAPHS BY CECIL W. STOUGHTON

Abrams, New York

A Young President

1961

1962

1963

Cecil W. Stoughton, The President's Photographer

HARVEY SAWLER

Notes on the DVD

Index

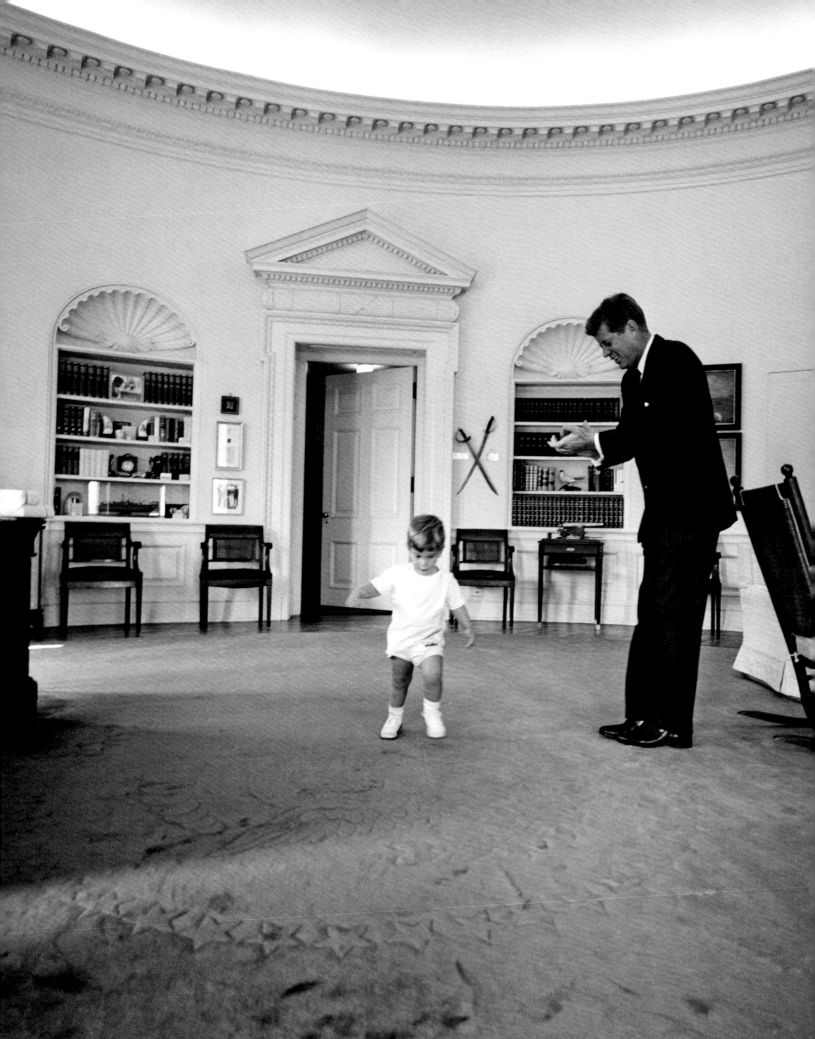

A Young President

On the first Saturday of December 1960, Senator and President-elect John F. Kennedy, the youngest man ever elected president, came to the White House for a meeting with President Dwight D. Eisenhower, the oldest man ever elected to lead the nation. Eisenhower, in an overcoat and hat, waited inside the doors of the North Portico as the president-elect's car arrived. The moment it stopped, Kennedy, hatless and coatless, jumped out of the car and bounded up the six stairs; Eisenhower, glaring at his aides, came though the door, whipping off his hat. That's what the cameras caught: an angry old man and a smiling young one.

It was no accident, of course. That was what Kennedy wanted the world to see.

Kennedy's first campaign poster, the one he used when he ran for the House of Representatives in 1946, was *The New Generation Offers a Leader*. Now the New Generation was taking power. The torch was passed in the most symbolic way, from the seventy-one-year-old commanding general of the Allied armies in World War II to a forty-three-year-old who had served as a navy lieutenant (junior grade) in the same war. The camera had something to do with that fact, too. Kennedy's Republican rival for the presidency, Vice President Richard Nixon, had also served in the navy, as a lieutenant (senior grade). The photographs each man chose for their campaign literature were worth thousands and thousands of words. Nixon stood stiffly in his dress blues. Kennedy was shown bare-chested, wearing sunglasses and a crushed fatigue cap at the wheel of his small patrol boat, *PT-109*. Nixon was almost the same age as Kennedy, but Nixon was an old man's idea of a young one.

Kennedy, exploiting his beautiful, young wife, Jacqueline, and a baby girl named Caroline, was never quite what he seemed: one of us. He was, in fact, a child of privilege and a chronically ill one at that. But Kennedy and his family—his father had been president of RKO Pictures—understood the publicity and public relations that sold entertainment, specifically movies, and they used that savvy in the political world. Witness the film and stills of Kennedy, the young candidate with pants rolled up, walking barefoot on the beaches of Cape Cod. Nixon, who resented and envied the Kennedy grace his whole adult life, at one point tried to echo that apparent ease, walking along the Pacific surf for photographers. He was wearing black wingtip shoes.

o o o

The time of the old men was over. The United States was beginning to burst at its seams in the 1960s, economically,

technologically, and culturally. Jet airliners, interstate highways, direct long-distance telephone dialing, Xerox machines, and Polaroid cameras were speeding up life everywhere. Air-conditioning was making it possible to build new cities in deserts and swamps. New things and new words were appearing almost every day: ZIP codes, WeightWatchers, Valium, transistors, computers, lasers, the Pill, DNA, LSD.

America had become richer and more cosmopolitan since the end of World War II, and its new wealth was shared by many millions now. Middle-class Americans could buy their own homes away from the cities where they worked, could send their children to the best colleges, could fly to vacations in the Caribbean or Europe. A lot of this was new, and people did not know quite what to do with it all. And there were the Kennedys! Young, rich, well educated, well mannered, gaily presiding over the White House, over the world, really.

The young Kennedys transcended politics. It is extraordinary to remember that when John Kennedy was elected president, American men kept their hair short and wore hats and three-button tube suits with skinny ties. Their new leader had long hair (for the time), hated hats, and wore custom-made European two-button suits with rolled lapels. *Esquire* magazine picked that up early in 1963:

Kennedy sets the style, tastes and temper of Washington more surely than Franklin Roosevelt did in twelve years, Dwight Eisenhower in eight, Harry Truman in seven. Cigar sales have soared. (Jack smokes them.) Hat sales have fallen. (Jack does not wear them.) Dark suits, well-shined shoes, avoid button down shirts (Jack says they are out of style), secure their striped ties with PT-boat clasps . . . popular restaurants in Washington are LeBistro and the Jockey Club, which serve the light

continental foods that Jackie features . . . The C&O canal now has hikers' traffic jams. The Royal Canadian Air Force exercise manual is in every office.

Kennedy himself was an attractive amalgam of rich kid and all-American boy—he actually preferred meat and potatoes, milk rather than wine, and Sinatra and Broadway show tunes. More fundamentally, he was in many ways the first self-selected president. If Kennedy had followed the conventions of politics, he probably never would have lived and worked and played in the White House. The most important fact about Kennedy was this: He would not wait his turn—and soon enough more and more young Americans understood that.

John F. Kennedy was forty-three years old when he was elected president. He was a Roman Catholic with limited congressional experience. There was no way he could have gotten the Democratic nomination for president in 1960 if he had played by the old rules, which gave nominating power to the party's senior members: the infamous "bosses," the state and congressional leaders of the party. Instead, Kennedy began running two years early, traveling the country to create his own organization and his own constituency of reporters and correspondents, men his own age. Candidate Kennedy used them all to win a series of primary elections and media coverage as the "people's choice." He had the nomination in hand before the party's 1960 convention even began. As president, Kennedy changed politics some, but he remade the culture of American ambition. Watching the Kennedys was that most American of activities: self-improvement.

During the brief Kennedy administration, all things seemed possible. On one of the best of days, April 19, 1963, *Time* magazine reported:

President Kennedy flung wide the French doors of his office, stepped out into the spring twilight, inhaled deeply. The fresh scent of thick bluegrass and moist earth, the sight of grape hyacinth bordering the flower garden, the hues of cherry blossoms and forsythia across the yard made him smile. Off to his right, Caroline's swings and slides lent a touch of outdoor domesticity. Said the president with an expansive wave, 'Look at that. Isn't that great?' The president's mood seemed to reflect the nation's . . .

And the nation reflected its young leader. Those words were approved, as always, by Henry Luce, the creator of *Time*. Luce did not particularly like Kennedy's politics, but he thought the president was focusing Americans on the things that mattered—active citizenship, the joy of life itself. Kennedy seemed to be bringing out the best in the American people. Perhaps he was just the end of an old America, but he wanted to be seen as the beginning of the new—and photographs were the record of that ambition. So it was not surprising that one of the new president's early actions was to appoint an official personal photographer—a first—a forty-one-year-old army captain named Cecil Stoughton.

Mrs. Kennedy once worked as a photographer herself (for the *Washington Star*) and had definite ideas about how she, her husband, and, especially, their children would be presented to the public. The first lady demanded control over photographers—when, where, and how they would work: "That's enough. Thank you!" There was, in fact, a steady flow of memos from Jackie about what she wanted photographed (and how) and what she did not. Mrs. Kennedy sent Stoughton to events she wanted to know about, but as a politician's wife did not want to be shown attending, including fashion shows in Paris. On a January day in 1963, Mrs. Kennedy sent a memo to her husband saying: "I was passing by

Mrs. Lincoln's office today and I saw a man [it was Representative Wayne Aspinall of Colorado] being photographed in the Rose Garden with an enormous bunch of celery. I think it is most undignified for any picture of this nature to be taken on the steps leading up to the president's office or on the South grounds. If they want their pictures taken they can pose by the West Lobby. This also includes pictures of bathing beauties, etc. . . ." To show events and people as she wanted them seen, the first lady had albums made overnight to present to guests who were there the night before.

But when Jacqueline Kennedy was away, the president would literally call in photographers, including Stoughton, who had a buzzer in his basement office connected to one on Kennedy's desk. The president often had his finger on that buzzer as the car carrying his wife away pulled out on to the streets through the White House gates.

For Kennedy, as president, the stakes were even higher about what would be photographed and what would not. As far as he was concerned, the Kennedy children could be photographed constantly—and he never tired of looking at those pictures. The president also kept as much control as possible of which family photos were made public. There were rules, strictly enforced with help from the Secret Service, friends, and aides: no kissing pictures, no pictures of Kennedy with his crutches or in the water with his back brace showing. The difference with his wife was over quantity, not quality.

More important, Kennedy understood that photographs taken with him smiling were the coin of the realm. Friends, other politicians, contributors—world leaders, too—wanted, *needed*, a picture with Kennedy, preferably signed, on their desks or office walls. So there was also a fairly long list of people the president refused to be seen with when photographers might be present.

At the top of that list for a time was Martin Luther King, Jr. The president took seriously FBI reports that King was a communist. But Kennedy knew a star when he saw one and invited King to the White House—with photographers—after watching, on television, the African-American leader deliver his "I Have a Dream" speech.

Others on that "no pictures" list were Sammy Davis Jr., not because he was black but because he had a white wife; economist Leon Keyserling, who had said "Kennedy is as bad as Eisenhower"; and Dr. Leonard Larson, the president of the American Medical Association, who was opposed to the administration's health care initiatives. As a communist, Marshal Tito, the president of Yugoslavia, was a special problem during a state visit. Kennedy solved that problem by arranging for a photo session with Tito in the Oval Office, but ordered photographers in advance to shoot him only from the back—and those were the photos released to the public.

If ever Kennedy realized there were pictures that could be used against him, he did something about it. The first time Hugh Sidey of Time-Life met Senator John Kennedy was in the Capitol. They were stopped by Senator George Smathers, who had his arms around Miss Florida contestants. Smathers pulled Kennedy into the group and a passing Time-Life photographer got the moment on film. "Go back and get that film," Kennedy said to Sidey. And he did.

Visiting the flight deck of the USS *Kitty Hawk* with California Governor Pat Brown, Kennedy laughed when Brown, putting cream in his coffee, spilled some and leaped up to the sound of shutters clicking. "Pat," said the president, "if I spilled boiling oil on my crotch in front of those guys, I would sit there and just keep smiling."

Kennedy was not a man who wasted time—he had been sick most of his life and always expected to die young—but sometimes he would spend hours looking at photographs, deciding which ones might be used on a poster or released to newspapers. He was a man

who lived life as a race against boredom, but he did not consider pondering details of presentation to be boring. On January 24, 1963, Kennedy's chief economic adviser, Walter Heller, came into the Oval Office to get approval for a twenty-two page document, "The Special Message to Congress on Tax Reduction and Reform." The president flipped through the pages quickly and said, "Okay."

"My God," said Heller. "That's certainly expressing a lot of confidence in me."

"Sure, why not?" the president said as Heller left.

Outside, standing with the president's secretary, Evelyn Lincoln, Heller said he had forgotten to show the president the pale blue cover of the paper. "Well," Heller said, "he won't want to be bothered by this."

"Yes, he will," Mrs. Lincoln said, and brought the cover inside.

Kennedy himself came out, saying, "That's not strong enough. Make it navy blue or royal blue."

o o o

The years from 1961 to 1963 are remembered by many as "Camelot," though that word was never used while Kennedy was alive. A week after his assassination, his widow called a friendly journalist, Theodore H. White, author of *The Making of the President*, to the Kennedy family compound at Hyannis Port on Cape Cod. Mrs. Kennedy wanted White to write an article on the historic legacy of her husband's short presidency.

"For President Kennedy: An Epilogue" appeared in the December 6, 1963 issue of *Life* magazine. White's piece included the first mention of Camelot as a metaphor for the Kennedy years. More than thirty years later, after both White and Jacqueline Kennedy Onassis had died, the Kennedy library in Boston released some of White's papers, including the notes he had taken after interviewing the president's

widow. Mrs. Kennedy had brought up the subject of Camelot, not so much the legend of King Arthur and the knights of the Round Table, but the musical imagining of that story, which had opened on Broadway a month after Kennedy was elected. According to White's notes, this is part of what the former first lady said as she tried to describe what was going on in her mind as she flew back to Washington, sitting by her husband's coffin:

There's one thing I wanted to say . . . one thing kept going through my mind, the line from a musical comedy . . . I want to say this one thing. It's been almost an obsession with me. This line from the musical comedy's been almost an obsession with me. At night before going to bed . . . we had an old Victrola. He'd play a couple of records. I'd get out of bed at night and play it for him when it was so cold getting out of bed. It was a song he loved, he loved 'Camelot.' It was the song he loved most at the end . . . on a Victrola ten years old . . . it's the last record, the last side of 'Camelot,' sad Camelot . . . don't let it be forgot that for one shining moment there was Camelot.

The idea of Camelot was an irresistible image and moment for a nation grieving over a president dying young. And, of course, that was exactly what Mrs. Kennedy wanted. She did not want old and dry historians to define her husband and the New Frontier he proclaimed. There was an astonishing density of events in the Kennedy years: the Bay of Pigs invasion, the Cuban Missile Crisis, a series of Berlin crises, civil rights and riots at home, the first nuclear control treaties, the creeping advance in Vietnam. With all that, the president's wife wanted John F. Kennedy remembered as a man interrupting official discussions of war and peace and justice to walk onto the lawn behind the White House to play with his children for a few minutes. These photographs are the albums of Camelot.

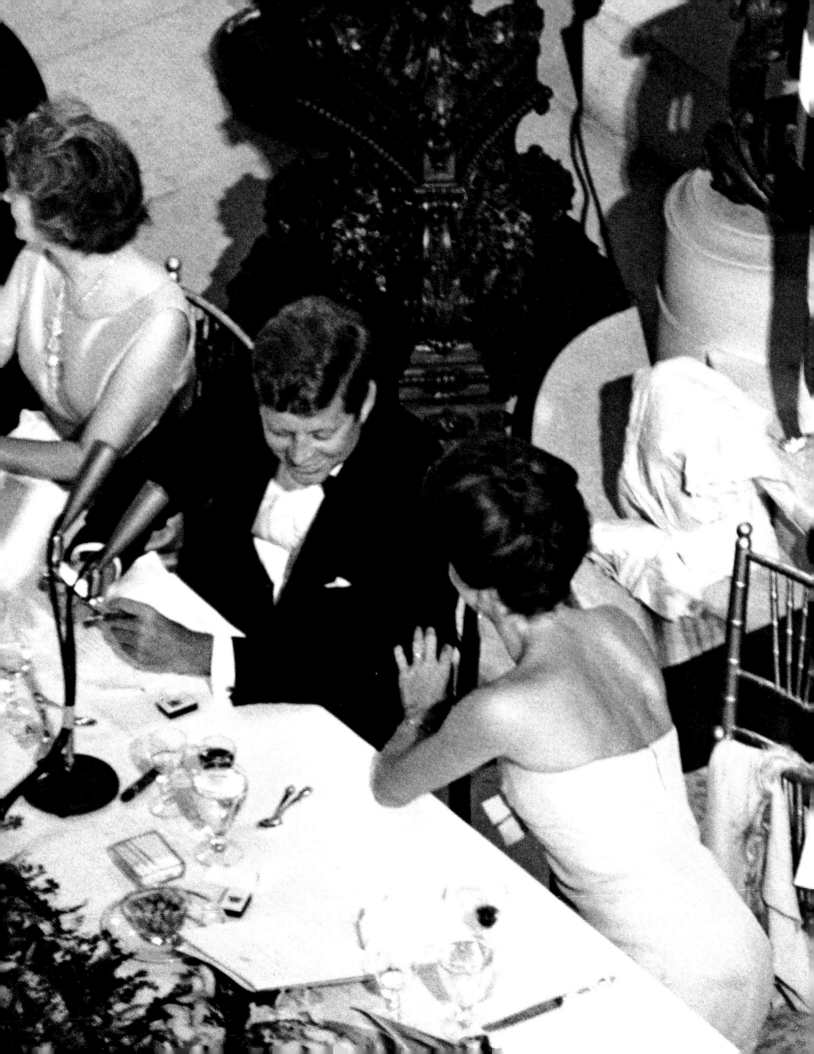

January 20 John F. Kennedy was sworn in as the thirty-fifth president of the United States on a cold (22 degrees) Washington day with bright sunlight reflecting off eight inches of new snow. Chief justice of the Supreme Court Earl Warren administered the oath of office. Standing behind the new president is vice president Lyndon B. Johnson, already sworn in, and his predecessor, former vice president Richard M. Nixon. Sixteen Kennedys stood among the 105 men and women on the platform. Cecil Stoughton was the sole photographer on the dais and the only one shooting from this perspective.

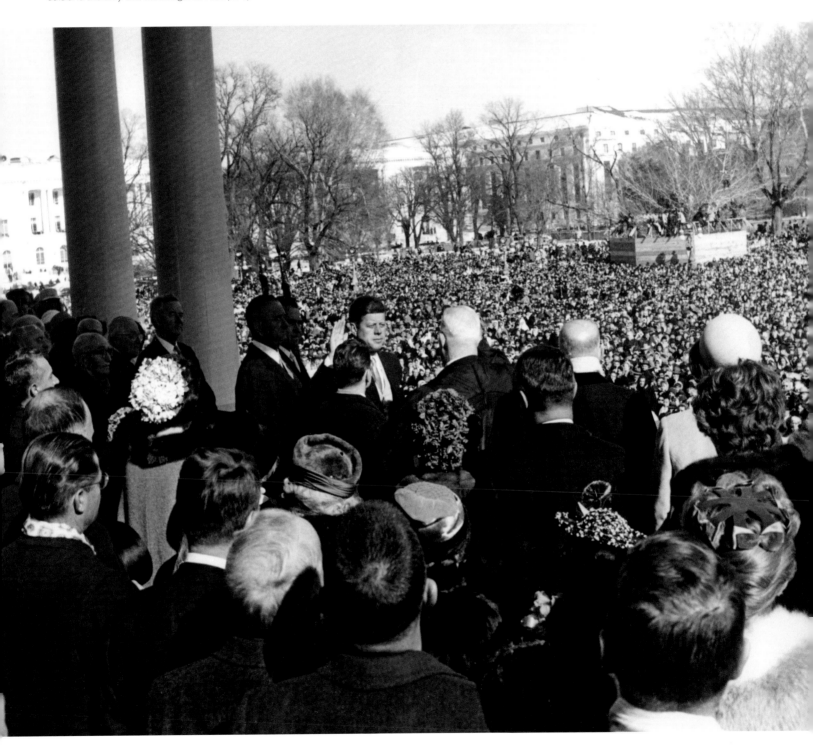

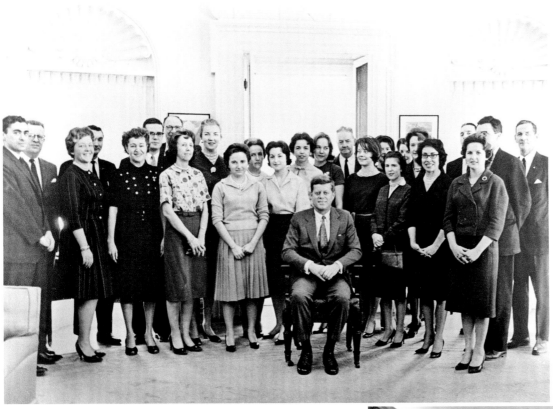

January 22 Kennedy sitting for a formal photograph of his new staff.

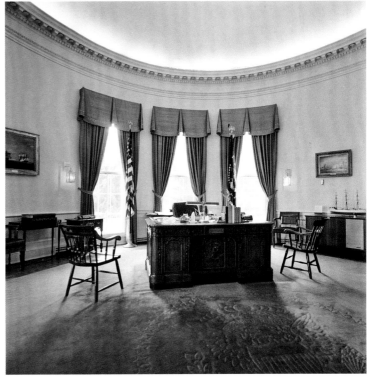

February 25 During the inaugural celebrations, White House employees had stripped the Oval Office and the West Wing of all evidence that Dwight Eisenhower had ever been there. The centerpiece of Kennedy's Oval Office was a desk made from the timbers of a British ship, the HMS *Resolute*, an exploration vessel abandoned in the Arctic in the 1850s and later rescued by American sailors. Found in a government storeroom, the desk was originally a gift from Queen Victoria to president Rutherford B. Hayes.

March 1 On his forty-first day in office, Kennedy held his fifth press conference, this one broadcast live from the auditorium at the Department of State. (President Eisenhower's conferences were filmed, then edited, and broadcast later.) It was a busy day for Kennedy. He signed the executive order creating the Peace Corps. He also sent a secret cable to the United States Embassy in Saigon saying: "White House ranks defense of Vietnam among highest priorities of U.S. foreign policy . . ."

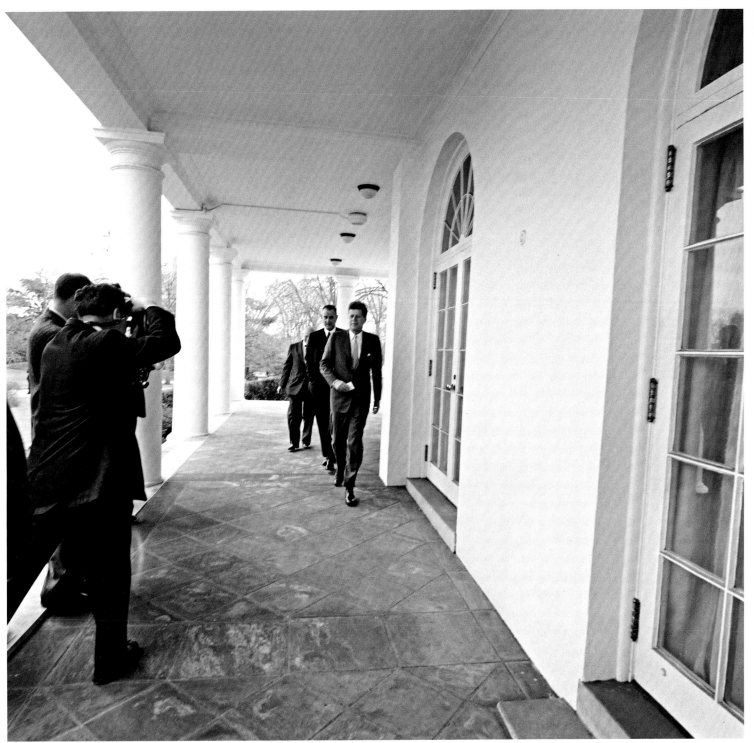

March 6 One of the pleasures of the presidency is walking to work—and deciding whether or not photographers will be around. On the forty-fifth day of Kennedy's administration, they were invited to record a morning meeting with Vice President Johnson.

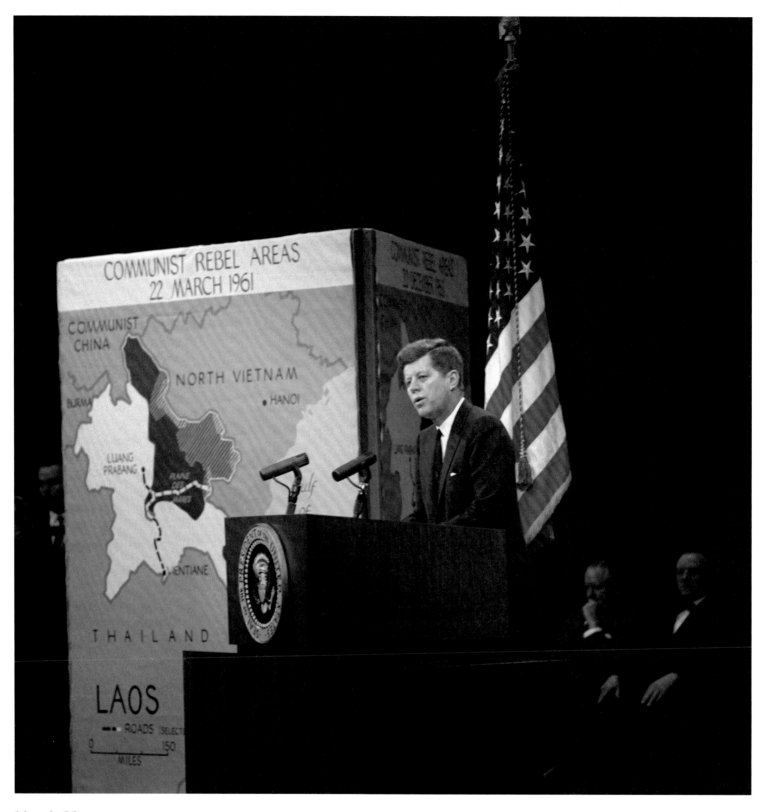

March 23 At 6 PM, Kennedy went on television again, using a pointer to try to explain American policy in the four countries that once were part of French Indochina: North Vietnam, South Vietnam, Laos, and Cambodia. Laos was his focus. The small, easygoing kingdom was being slowly taken over by communists backed by North Vietnam and the Soviet Union. "We strongly and unreservedly support the goal of a neutral and independent Laos," the president said that night. *Neutral* was the key word. Kennedy had already decided Laos was lost to communism. Privately, he was saying that if the United States took a stand in Southeast Asia it would be to defend South Vietnam.

March 24 Press secretary Pierre Salinger stood beside Kennedy after he signed an order restoring former president Eisenhower to his military rank: five-star general.

April 10 The president at Griffith Stadium, before throwing out the first ball on opening day of the Washington Senators' 1961 season. His resident baseball expert, David Powers, is to his left, wearing a hat. Powers had caught the president warming up in the Rose Garden that morning, playing catch with a Secret Service agent.

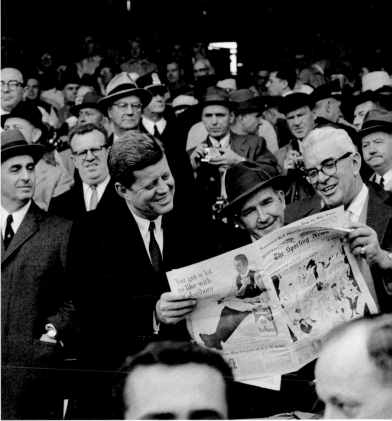

April 10 The president speaking during a conference of staff and officers of the North Atlantic Treaty Organization. Later that day, it took staffers four hours to find British prime minister Harold Macmillan's proposals for the future of the organization. Kennedy had left the papers in his daughter's bedroom.

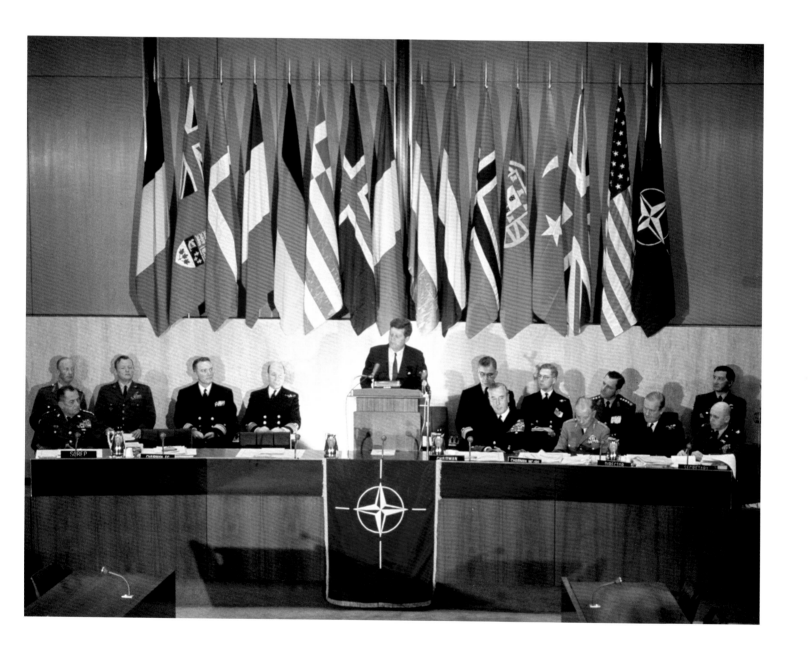

April 19 The president with Roman Catholic nuns from
Holy Rosary Academy in Newton, Massachusetts.

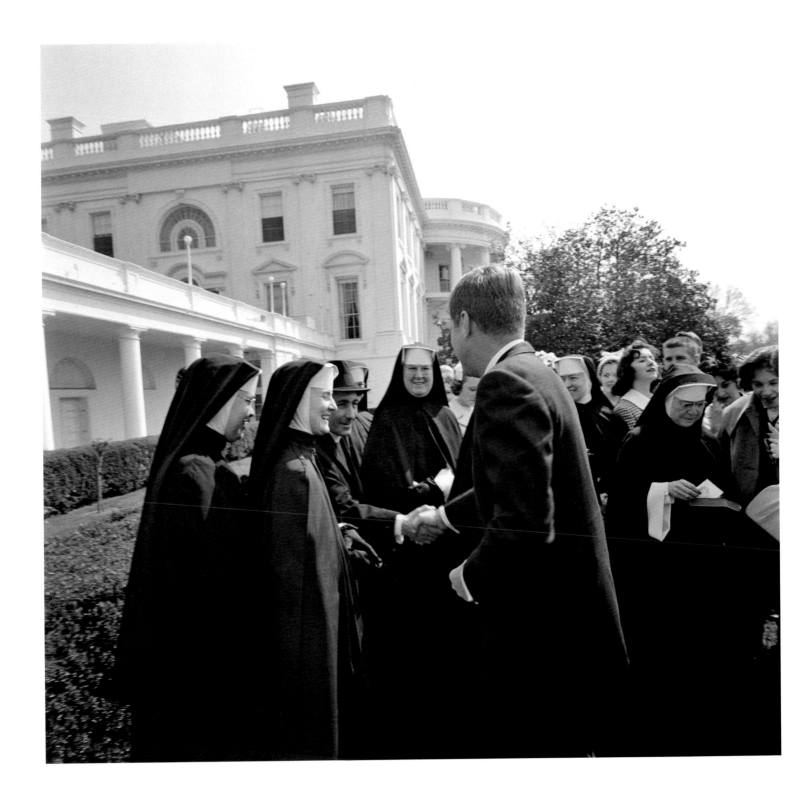

May 3 Jacqueline Kennedy, with Vice President Johnson and secretary of the treasury Douglas Dillon, watching fireworks from a White House balcony in honor of Habib Bourguiba, president of Tunisia, who paid the first state visit of the Kennedy administration. On the balcony, the president asked Bourguiba if he had to choose between another billion dollars in foreign aid or putting an American on the moon, what would he do? Said Borguiba, "I wish I could tell you to put it in foreign aid, but I cannot."

Guests leaving the fireworks display for the official dinner inside the White House.

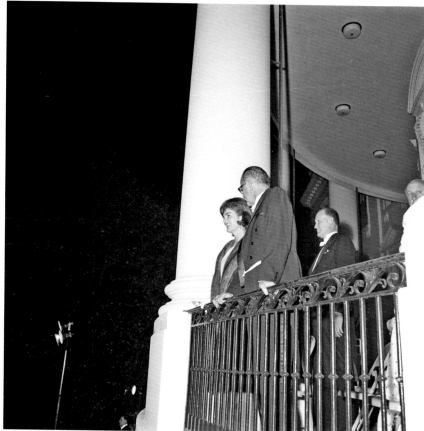

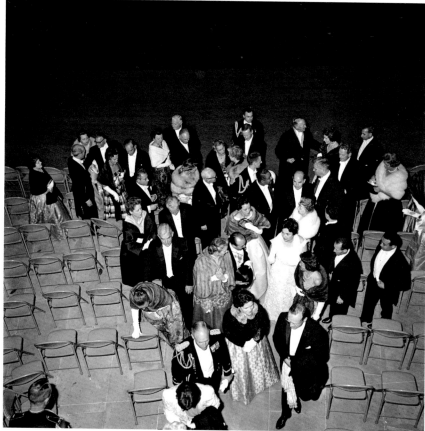

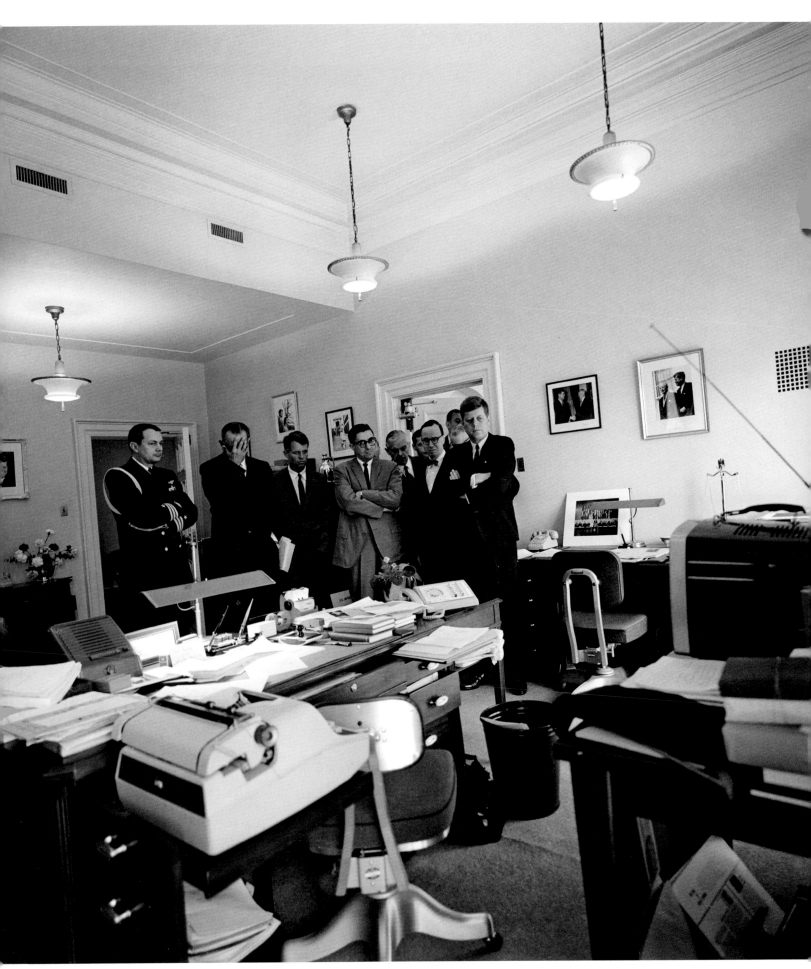

May 5 Kennedy was at a National Security Council meeting about the possibility of a communist takeover of British Guiana in South America when his secretary, Evelyn Lincoln, came in and whispered, "Two minutes." The president walked into Mrs. Lincoln's office to watch the countdown to the liftoff of the rocket carrying the first American into space. (Yuri Gagarin, a Soviet cosmonaut, had already orbited the earth three weeks prior.) Kennedy saw his wife through a doorway and called, "Come in and watch this." He was nervous; confidential White House memos rated the probability of success at 75 percent. Everyone in the room, including Johnson, was just as tense.

Navy captain Alan Shepard, inside a small, cone-shaped capsule called *Freedom 7*, was blasted into space like a cannon shot. *Freedom 7* rode a 115-mile-high arc that was supposed to end with a parachute landing in the Atlantic Ocean. Fifteen minutes later, an assistant press secretary, Andrew Hatcher, ran into the room, bumped into the president, and said, "The astronaut is in the helicopter. The pilot says he appears normal and in good shape."

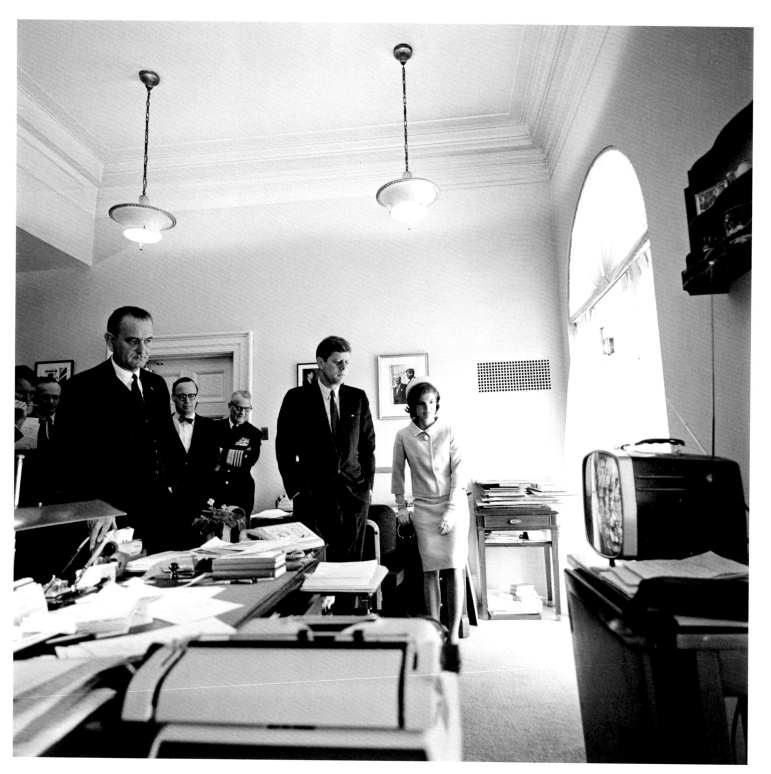

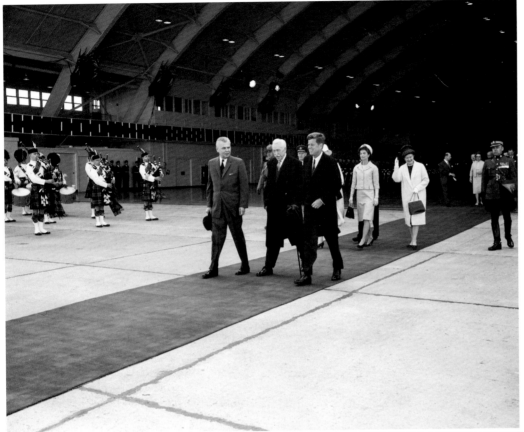

May 17 Kennedy's first foreign trip was close to home: Canada. Kennedy walked the red carpet with Canadian prime minister John Diefenbaker (left) and Canadian governor general Georges Vanier (center); after that everything went wrong. The president's mission was secret: to persuade Diefenbaker, a man he instantly disliked, to accept American missiles facing the Soviet Union in his country. Kennedy failed. Then, after placing a wreath at Ottawa's National War Memorial, he picked up a silver shovel to plant a ceremonial tree and felt the twinge of pain in his back he knew would lead to spasms and excruciating pain. By the time Kennedy was back on *Air Force One*, he could barely walk and the pilot was calling Andrews Air Force Base to make sure the president's crutches were brought from the White House.

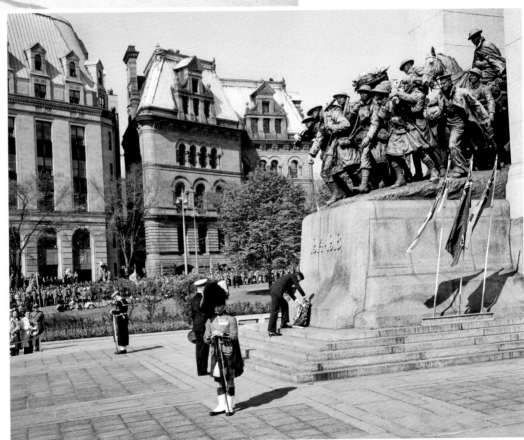

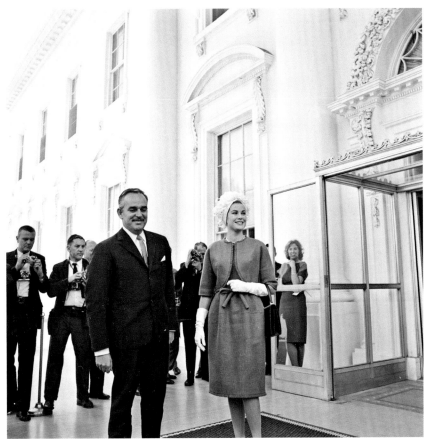

May 24 Prince Rainier III, the ruler of the tiny Principality of Monaco, and his princess, the American actress Grace Kelly, were among the first foreign visitors to Washington during the Kennedy administration.

May 25 "These are extraordinary times," said the president in delivering his Special Message to the Congress on Urgent National Needs. He asked for two billion dollars more in military spending. He brought the senators and representatives to their feet, roaring approval, as he said he intended to meet with Soviet leader Nikita Khrushchev shortly in Vienna. The place went wild when Kennedy also declared, "I believe this nation should commit itself to achieving the goal, before this decade is out, of landing a man on the moon and returning him safely to Earth."

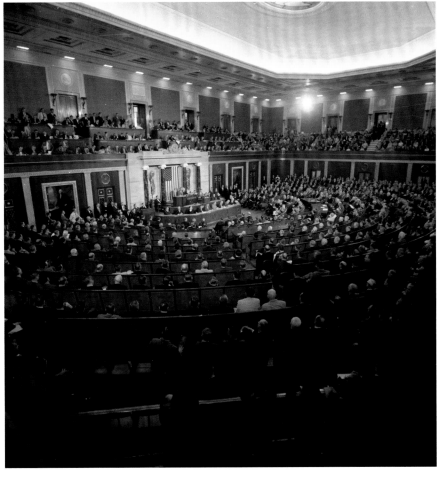

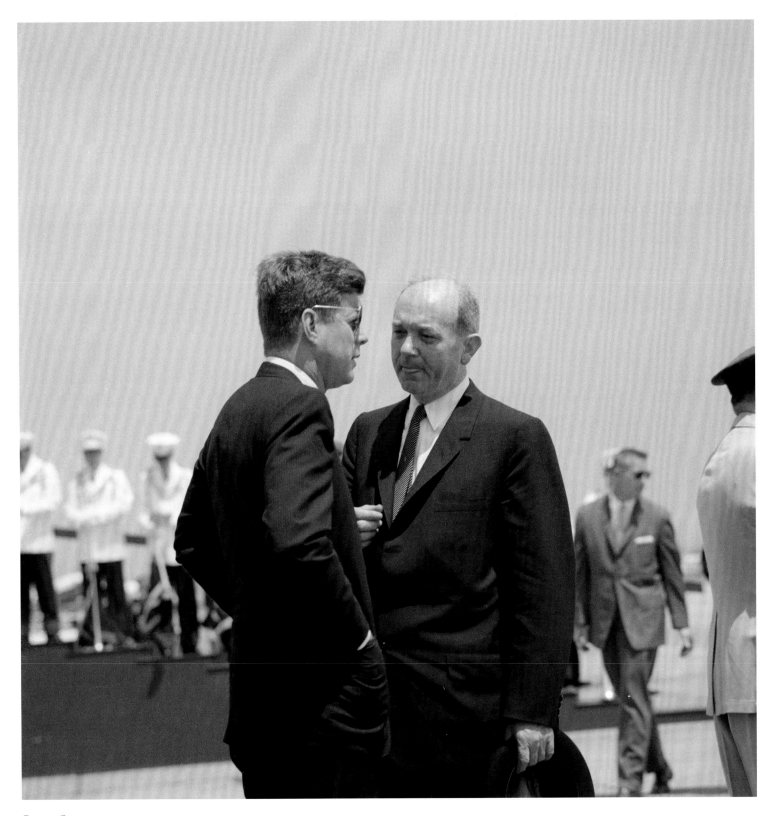

June 8 The president talking with his secretary of state, Dean Rusk, as they waited for the arrival of Fulbert Youlou, president of the Republic of Congo.

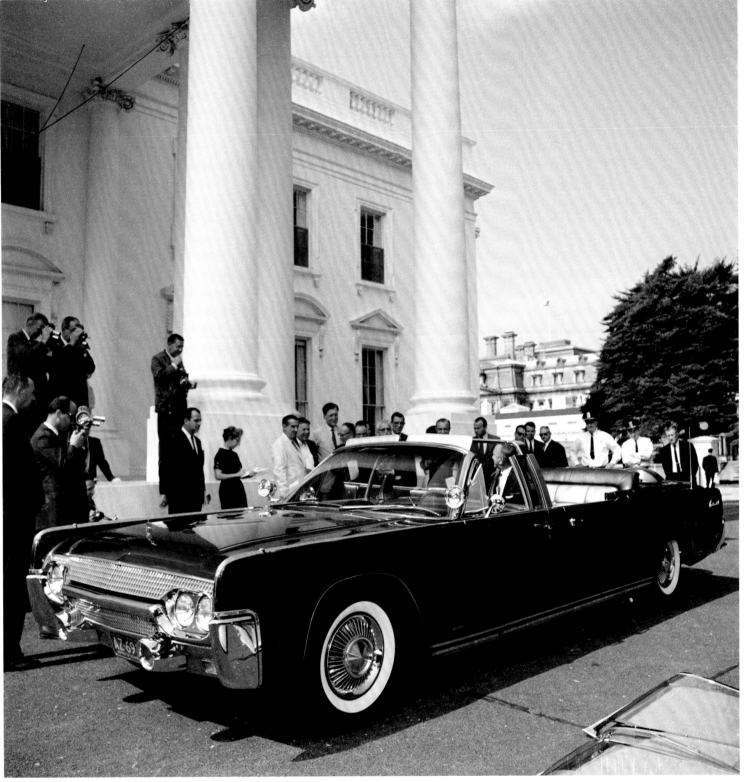

June 14 The president and White House staffers looking over a new presidential limousine, a Lincoln Continental manufactured (and armored) by the Ford Motor Company.

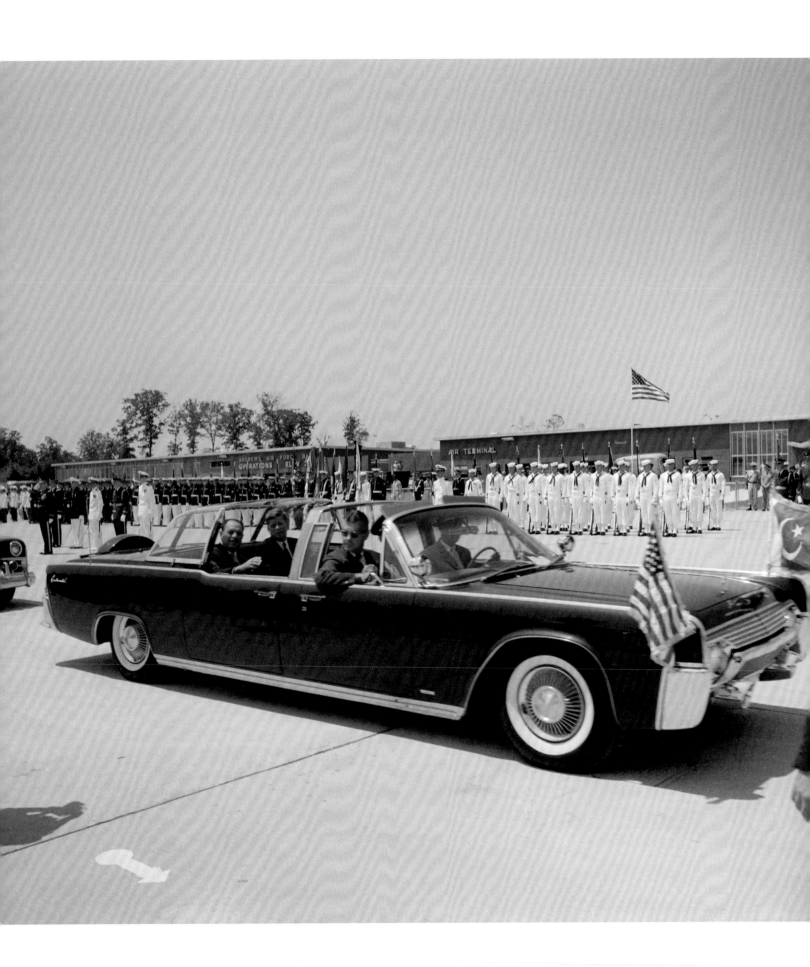

July 11 Arrival ceremonies for Mohammad Ayub Khan,
the president of Pakistan.

 The two presidents at a state dinner held at Mount Vernon.
President Khan shares the table at far left with Mrs. Kennedy.

July 13 The president greeting American Field Service students in the White House Rose Garden before they took up postings abroad.

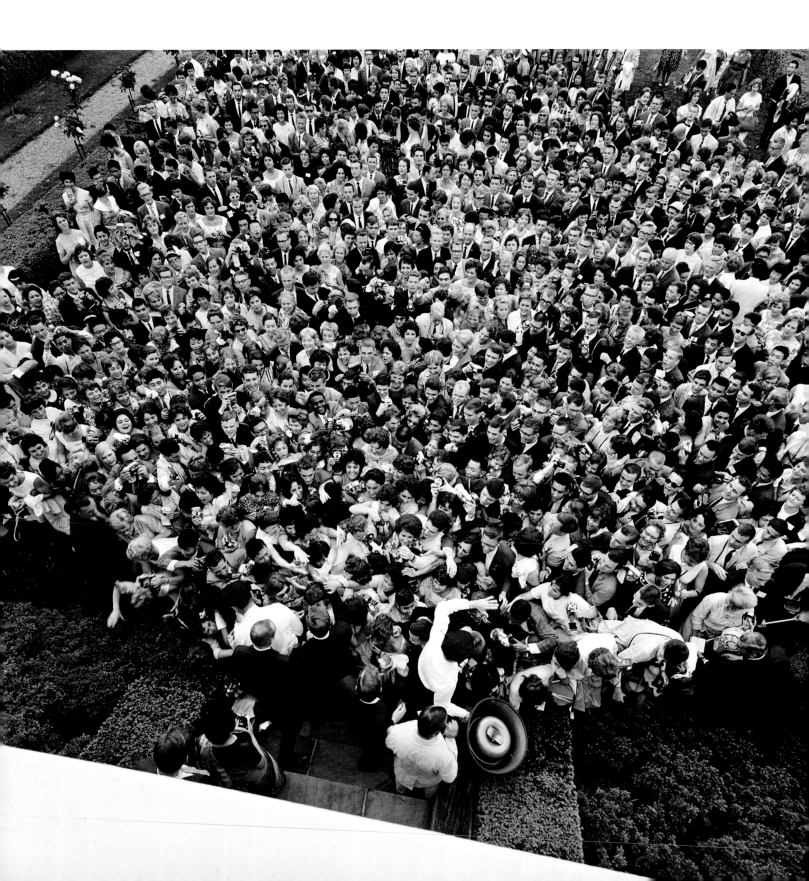

July 20 A White House luncheon for eighty-one-year-old General Douglas MacArthur (seated at Kennedy's right). The president came to greatly admire MacArthur, though not for his politics or for his World War II record. What changed Kennedy's mind about the hero of conservatives was reading the citation for the Distinguished Service Cross MacArthur won as a thirty-eight-year-old brigadier in World War I combat.

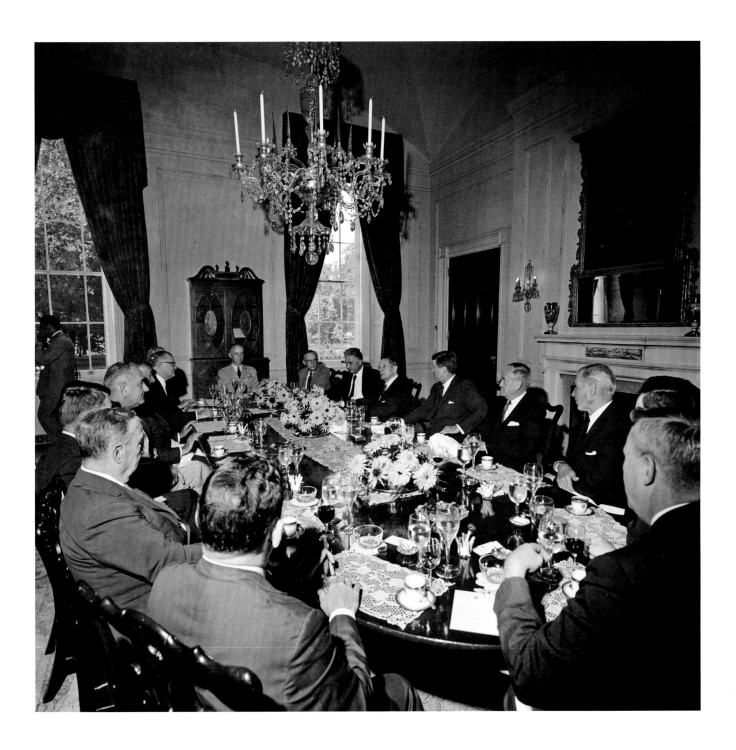

July 25 "Seven weeks ago tonight I returned from Europe to report on my meeting with Premier Khrushchev . . . ," the president began a 10 PM national television broadcast. "In Berlin, as you recall, he intends to bring to an end, through a stroke of the pen, first our legal rights to be in West Berlin. That we cannot permit," the president continued, saying he would seek congressional approval for another $3.25 billion in defense spending and triple draft calls for the army. Then he said, "An attack upon that city will be regarded as an attack on us all. To sum it all up: we seek peace—but we shall not surrender." Watching from behind the cameras in the Oval Office, Robert F. Kennedy estimated that the chance of nuclear war was one in five.

August 9 As Kennedy met with American diplomats and military officers in Washington, Khrushchev was doing the same in Moscow—and repeated that the Soviets intended to use that stroke of the pen to complete a peace treaty with East Germany, a treaty that would grant the East Germans the power to seize West Berlin. As Kennedy prepared to fly to the family home in Hyannis Port, Massachusetts, for the weekend, he learned that the new Soviet commander in Germany, Marshal Ivan Koniev, told American officers, "Gentlemen, you can rest easy . . . your rights will remain untouched and nothing will be directed against West Berlin." He was lying.

August 25 The president arriving at Otis Air Force Base en route to
Hyannis Port and obviously in pain as he comes slowly down the stairs
to the ground.

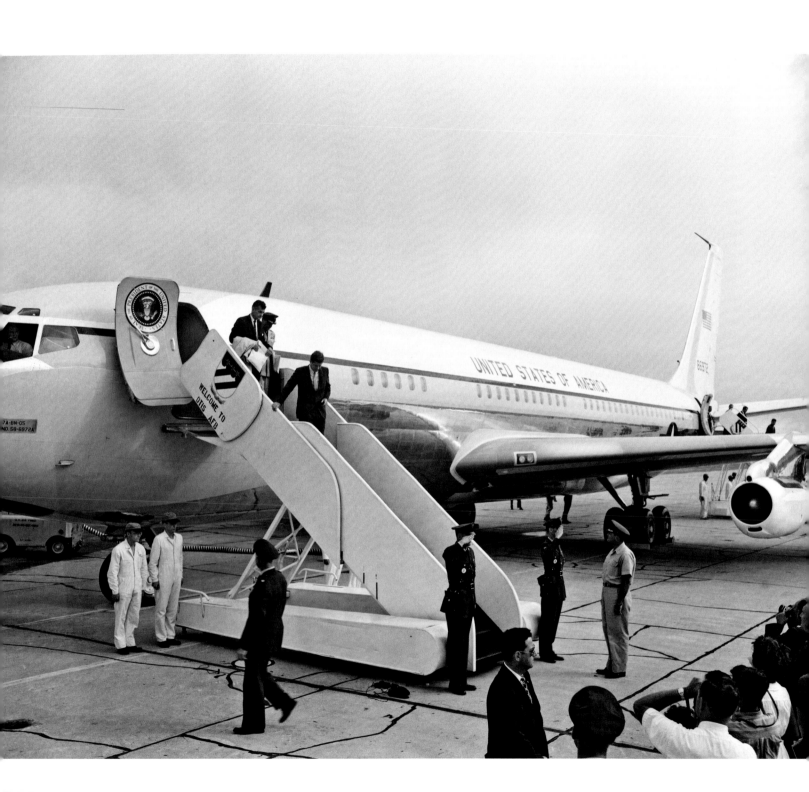

August 25 A gathering of the Kennedy clan at Hyannis Port; head shots of Edward Kennedy (top left) and brothers-in-law Stephen Smith and Peter Lawford (both right), who were not there, were pasted in to create a family photo for patriarch Joseph Kennedy's birthday.

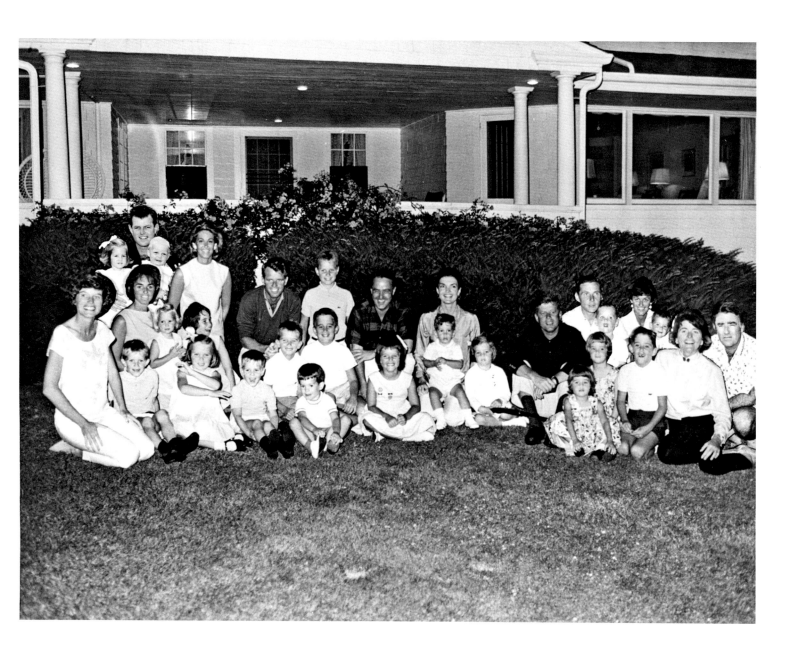

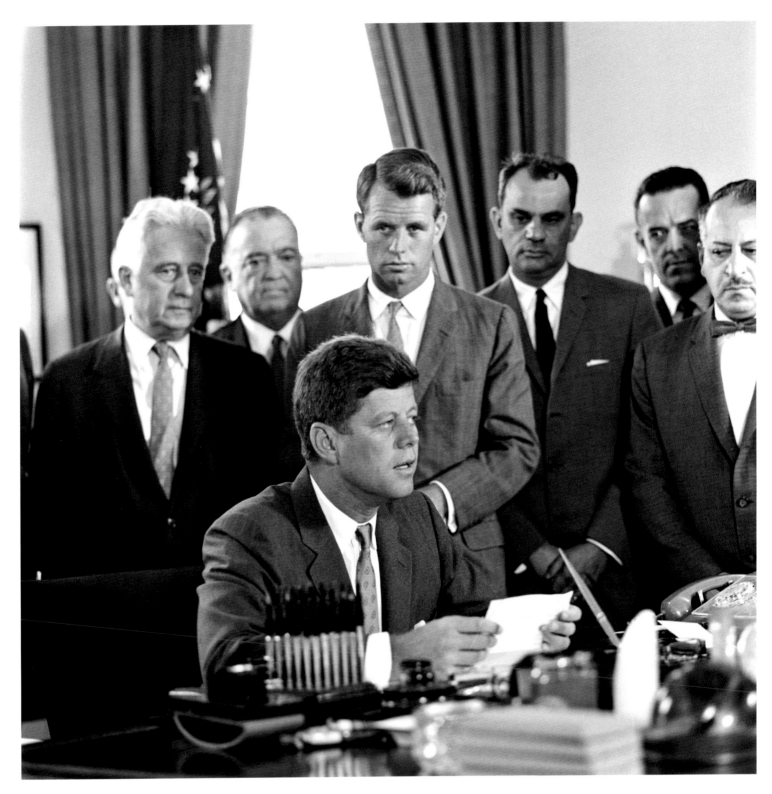

September 13 The president ceremoniously signs S 1656, an interstate anticrime bill. Standing behind him are Senator Kenneth Keating, a New York Republican who was the bill's principal sponsor, FBI director J. Edgar Hoover, and the president's brother, attorney general Robert Kennedy. The attorney general told his brother Hoover "is frightening . . . rather a psycho." Within three years, Robert Kennedy would run against Keating and defeat him for the senatorial seat.

September 19 Mrs. Kennedy, among those waiting behind ropes and lines as her husband greeted the president of Peru, Don Manuel Prado. Mrs. Prado stands at the first lady's left.

September 25 By the time President Kennedy spoke to the United Nations General Assembly for the first time, recurring Berlin crises had climaxed with the building of a wall by the East Germans, backed by Khrushchev, which divided the German city in two. Most Americans were outraged, but Kennedy was not among them. The thirteen-foot-high "Anti-Fascist Protection Wall" solved some real problems for both the Soviet Union and the United States: Khrushchev had to stop the exodus of two thousand people a day from east to west; Kennedy might have been forced to use nuclear weapons to stop the Red Army if it attempted to overrun West Berlin, West Germany, and perhaps all of Western Europe. In New York, secret Soviet emissaries told Kennedy that there would be no more confrontation in Berlin—and that Khrushchev hoped the president would moderate U.S. rhetoric about Berlin. Kennedy did that, emphasizing the need for nuclear disarmament talks. Listening to his speech at the UN were (from left) Secretary of State Rusk and the American ambassador to the UN, Adlai Stevenson. Later in the day, Kennedy and Stevenson met with Prince Norodom Sihanouk of Cambodia in the Kennedy family's apartment at the Carlyle Hotel.

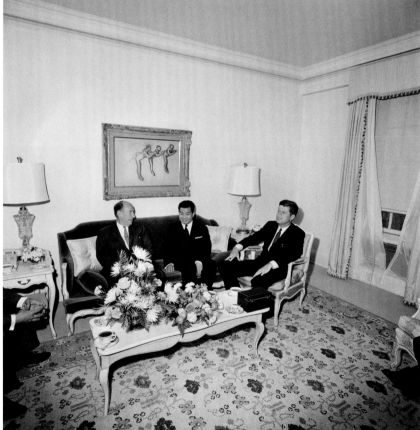

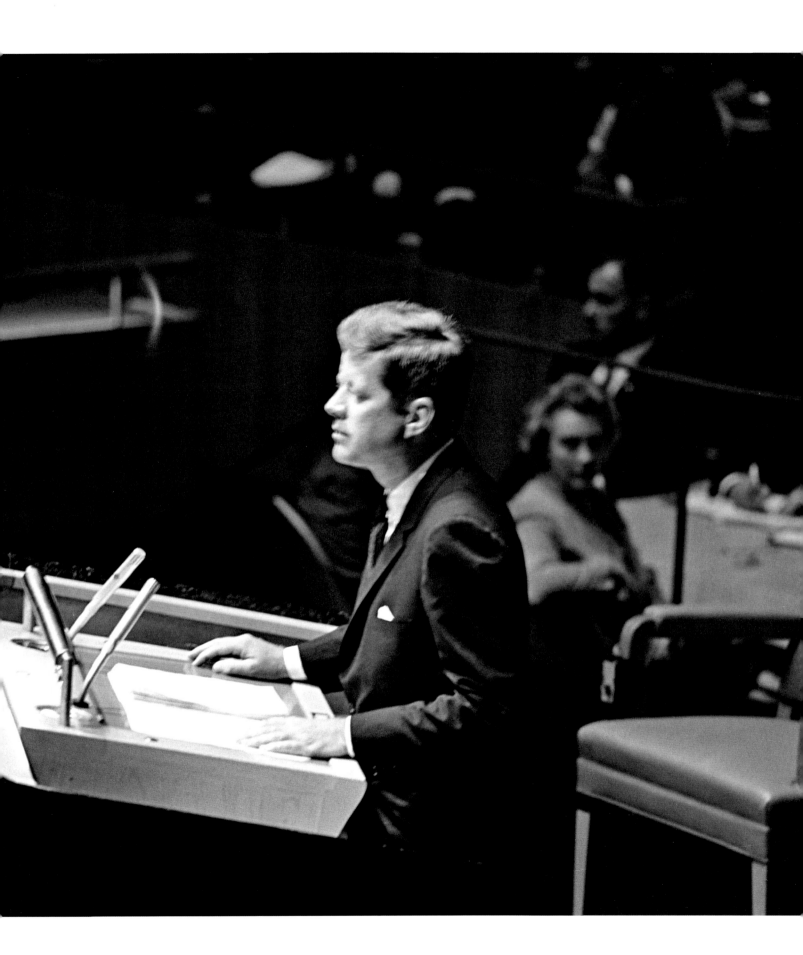

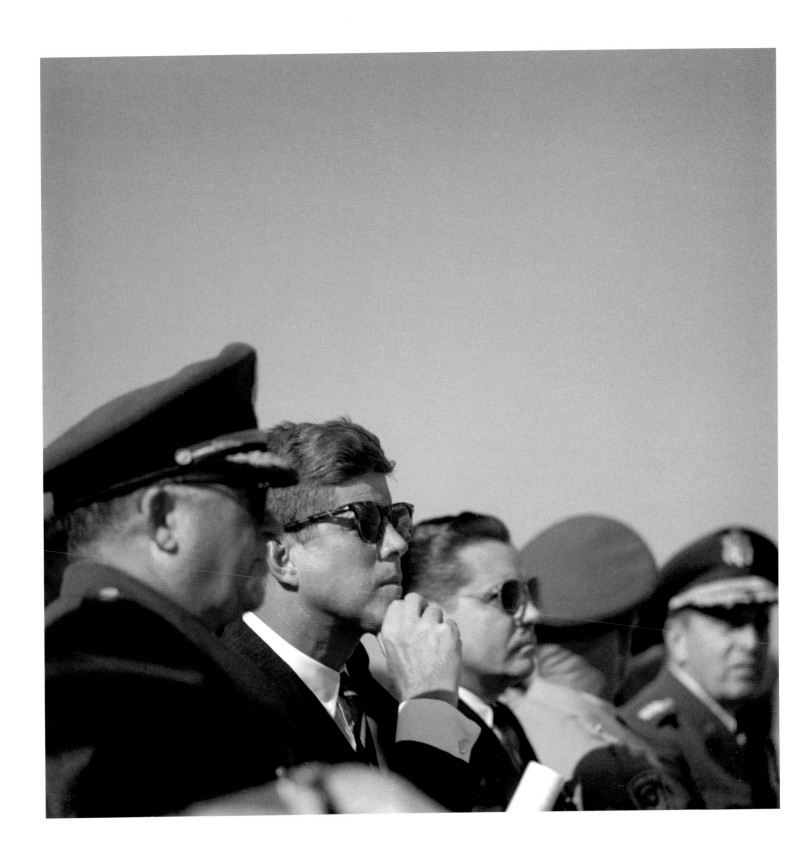

October 12 Kennedy once had casually remarked, "What does an Army Division actually look like?" He found out during a visit to Fort Bragg, North Carolina, when the 82nd Airborne Division—six thousand men and their equipment—was drawn up for a presidential review.

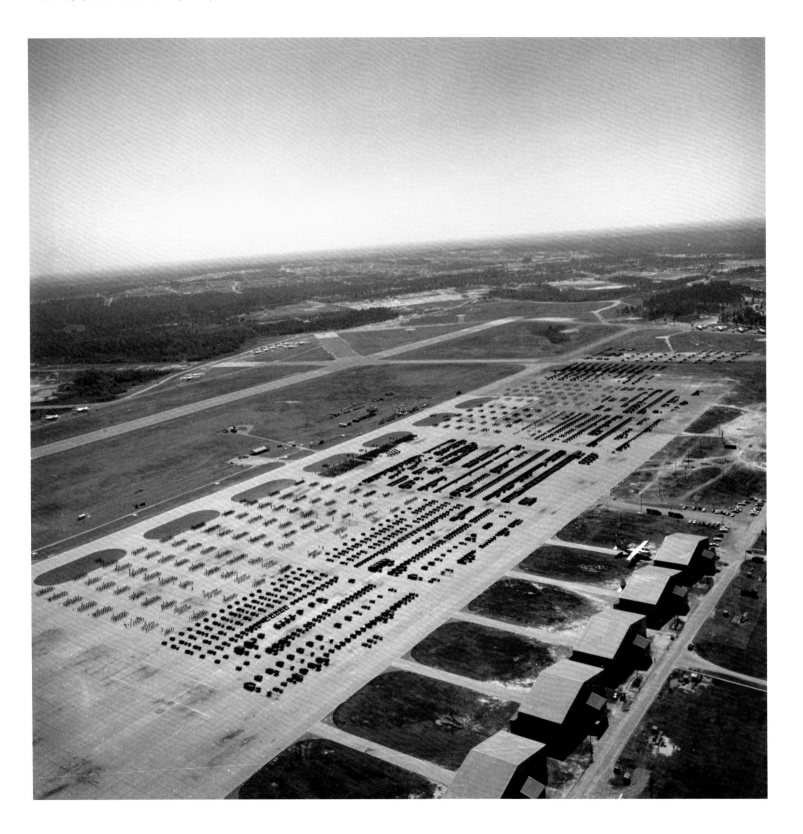

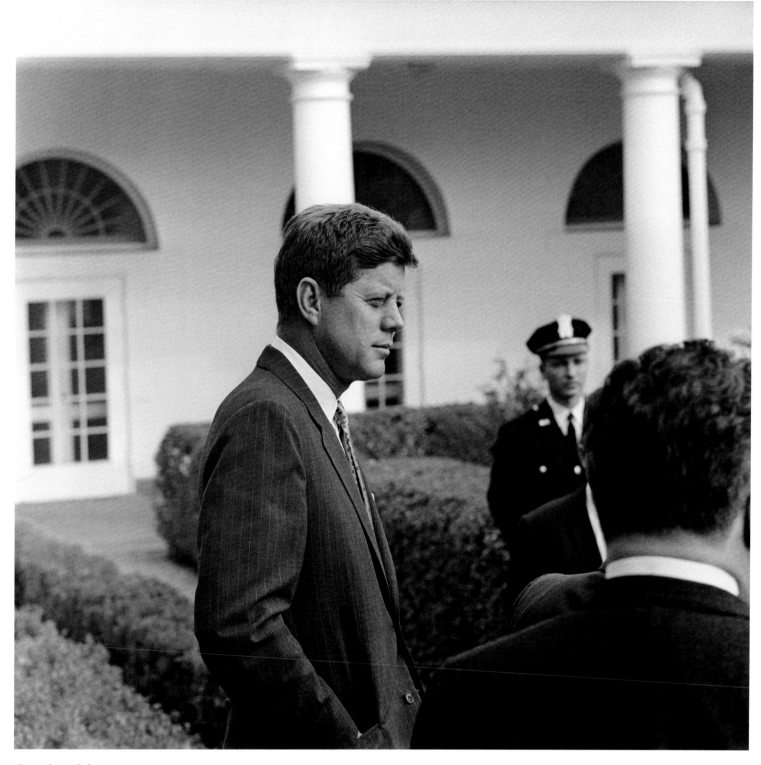

October 24 Tensions flared again in Berlin late in the month, with American and Soviet tanks facing off against each other at a checkpoint between the divided sectors of the German city. "Are you nervous?" the president asked his special representative in the city, retired general Lucius Clay, the hero of the Berlin Airlift in 1948–49. The general replied that he thought people in Washington were more nervous. "Well," said Kennedy, "there may well be a lot of nervous people around here, but I'm not one of them." And he certainly didn't look nervous as he stepped outside the White House after a meeting of the National Security Council. One reason Kennedy was calm was that he had, through a secret emissary, a Russian intelligence operative named Georgi Bolshakov, made a deal with Khrushchev for both sides to move their tanks slowly back from Checkpoint Charlie.

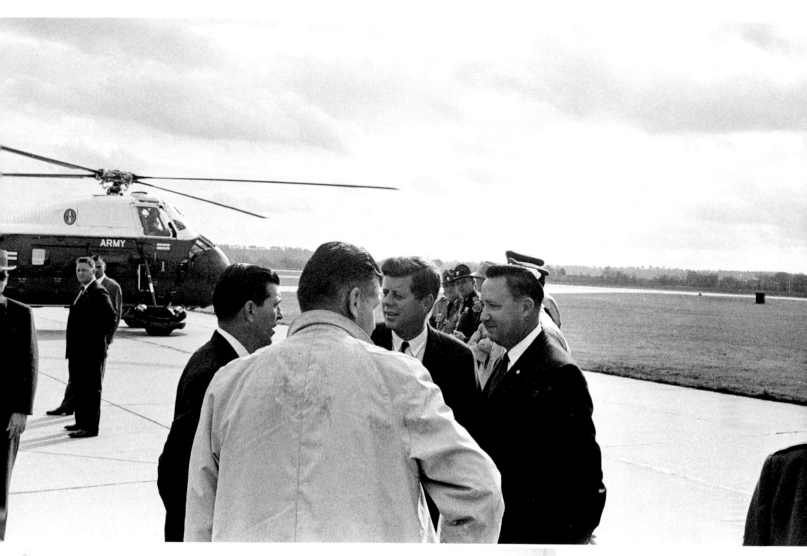

October 29 The president made a quick western swing, landing at Fort Smith, Arkansas, and ending the day at Big Cedar, Oklahoma, for the opening of the Ouachita National Forest Road, a pet project of an influential senator, Robert S. Kerr, who holds the scissors for the ribbon cutting.

November 1 Former president Harry S. Truman and his wife, Bess, were guests of the Kennedys at a formal White House dinner. The couple standing behind the presidents is the Trumans' daughter, Margaret, and to her right, her husband, Clifton Daniel, the managing editor of the *New York Times*. After dinner, guests were treated to Truman playing his signature tune, "The Missouri Waltz."

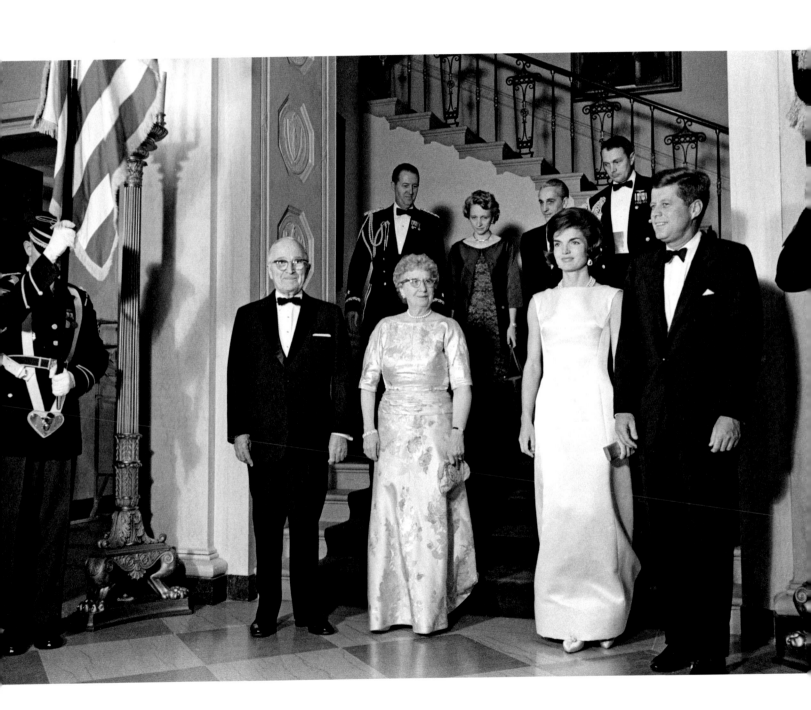

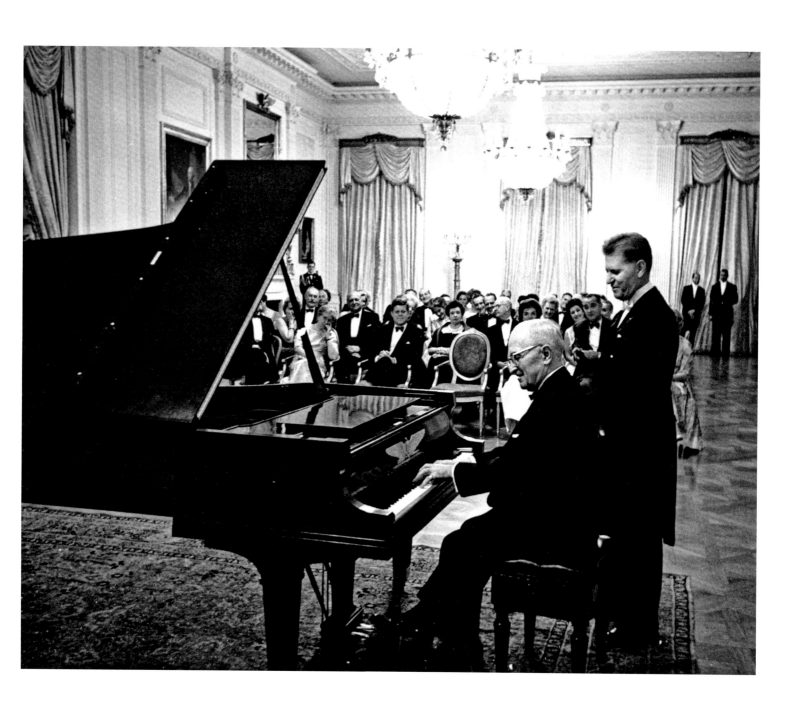

November 7 One of the world leaders Kennedy did not get along
with was India's prime minister Jawaharlal Nehru, shown here at a
White House dinner with his daughter Indira, a future prime minister.
"What do you think of the idea of our Peace Corps?" Kennedy asked.
"A good plan," Nehru answered. "Privileged young Americans would
learn a great deal from the poor village people of India."

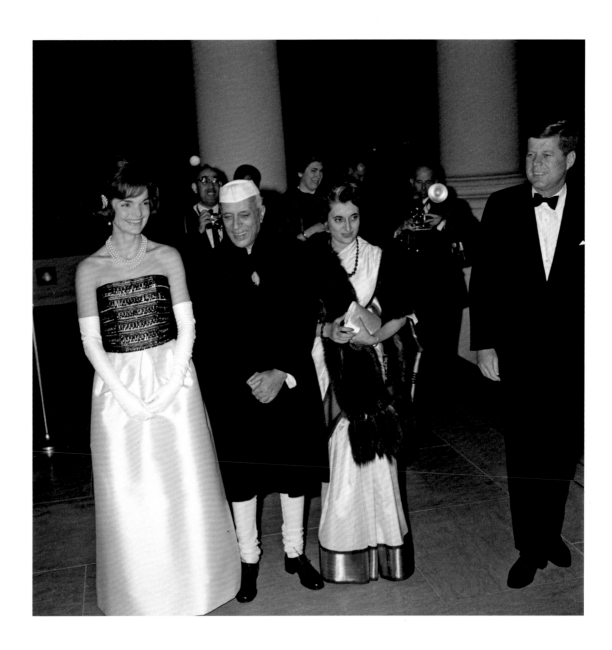

November 11 The president with his Joint Chiefs of Staff
on Veterans Day at Arlington National Cemetery.

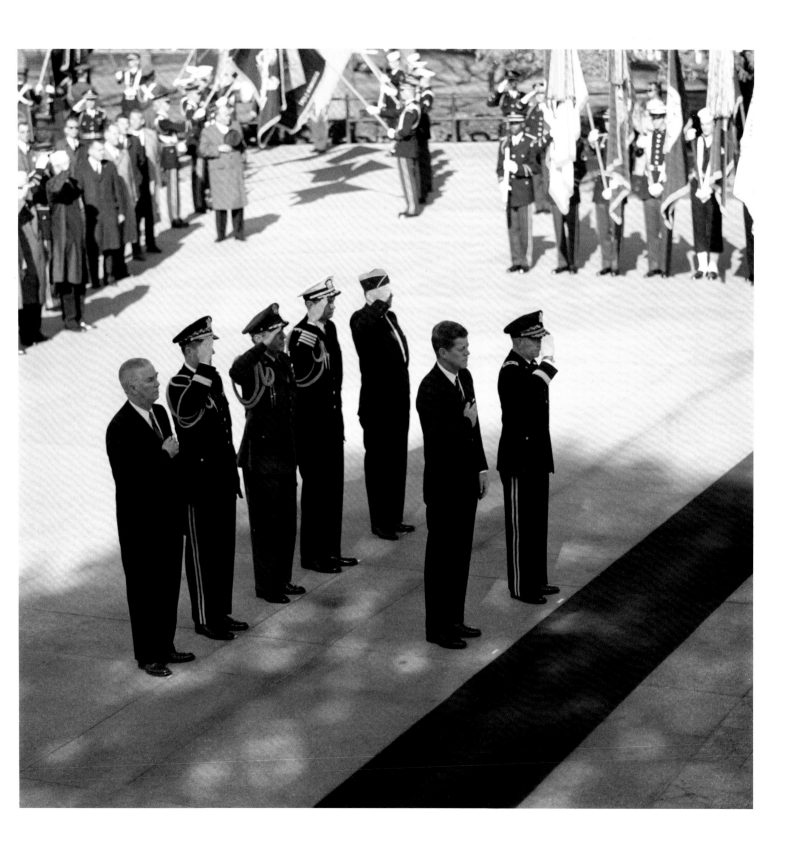

November 13 The Jacqueline Kennedy influence. Whatever the public thought, the young president was pretty much a meat and potatoes, Frank Sinatra, and *Guys and Dolls* kind of American. It was Mrs. Kennedy who opened the door to the high culture of cellist Pablo Casals and others. Once, when she told Pierre Salinger to tell the president she had no intention of meeting with a delegation of Girl Scout leaders, Kennedy said he would go upstairs himself and ask her. "It cost me," Kennedy said as his wife stepped into the crowd. "A new dress?" Salinger asked. "No," said Kennedy. "Worse than that: two symphonies."

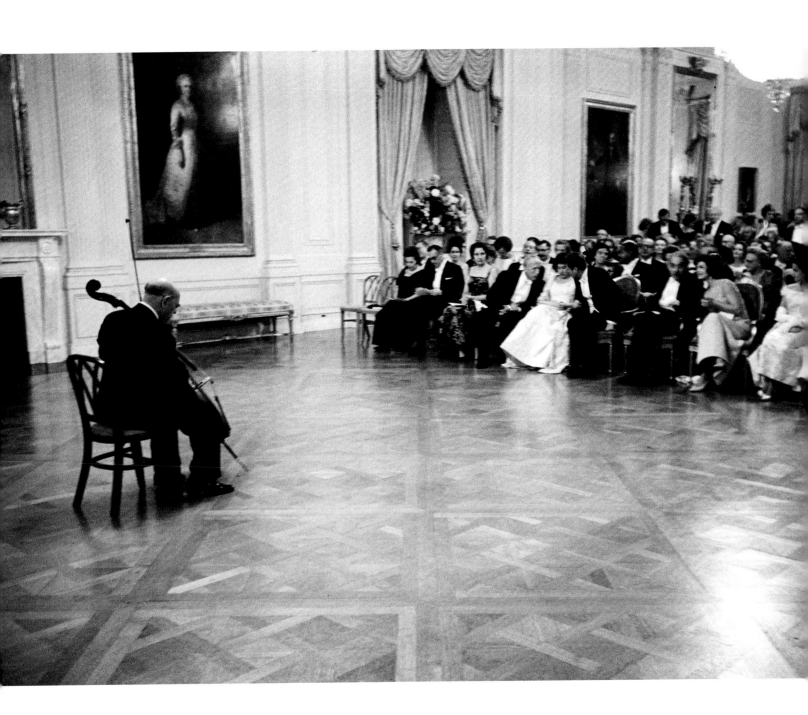

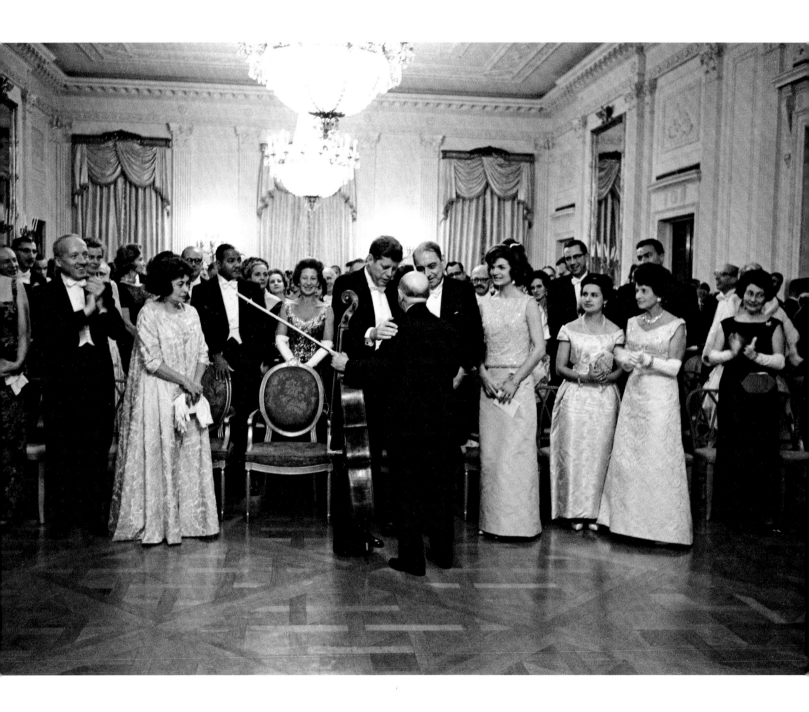

November 18 The president in Bonham, Texas, at the funeral of Speaker of the House Sam Rayburn, the Texan who served in the House of Representatives for forty-eight years and helped push through the new administration's first legislative victories in 1961.

Later that same day, the president made it to Los Angeles for a dinner in his honor held by producers and movie stars. Kennedy had been a regular in Hollywood since he was a young man because his father, Joseph, was president of the RKO Pictures studio, and the son of power would flip through casting books hunting for starlets he might date.

November 24 A meeting on the Defense Department budget in the living room of the president's house in Hyannis Port. Secretary of defense Robert McNamara is seated on Kennedy's right. The painting over the mantel is of the USS *Joseph P. Kennedy Jr.*, named for the president's brother, who was killed in World War II.

The next day, Kennedy did an interview with Alexei Adzhubei, the editor of the Soviet newspaper *Izvestia* and, perhaps more important, the son-in-law of Khrushchev.

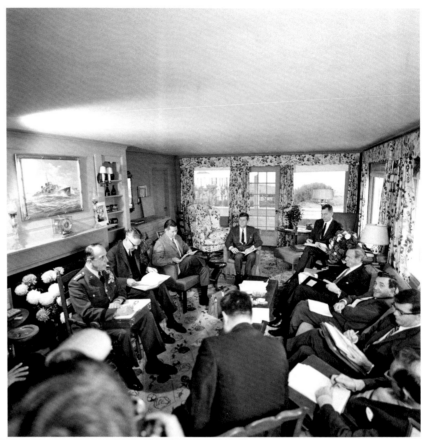

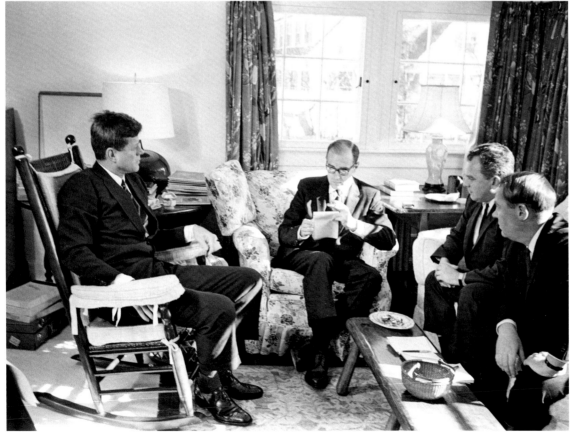

November 28 The president helicoptered to the Central Intelligence Agency headquarters in Langley, Virginia, for the presentation of a medal to Allen Dulles (walking behind Kennedy). Dulles was retiring as head of the CIA. He had known he was leaving since the disastrous Bay of Pigs invasion in April, when the CIA's plans to eliminate Cuban leader Fidel Castro had ended in the death or imprisonment of most of the Cuban exile force trained by the agency. "In a parliamentary system I would resign," said Kennedy. "In our system the president can't and doesn't. So Allen must go."

December 2 One of the obligations—and pleasures—of the presidency: the annual Army-Navy football game at Municipal Stadium in Philadelphia. Kennedy, a navy man, sat on West Point's side of the field for one half and on the Naval Academy side for the other. Three days later, in New York, he presided over the College Football Hall of Fame dinner and the presentation of the Heisman Trophy to the player of the year, Ernest Davis of Syracuse University. Davis was the first African American awarded the Heisman.

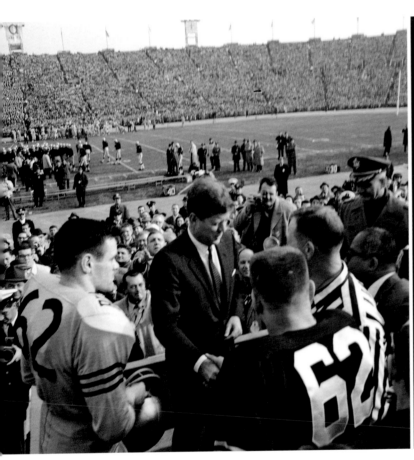

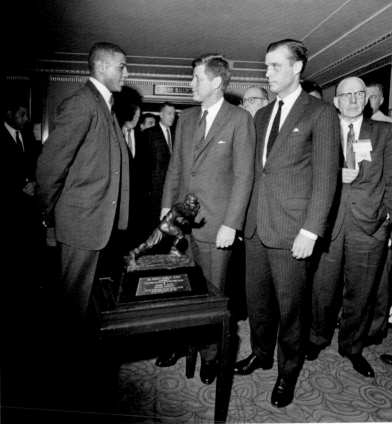

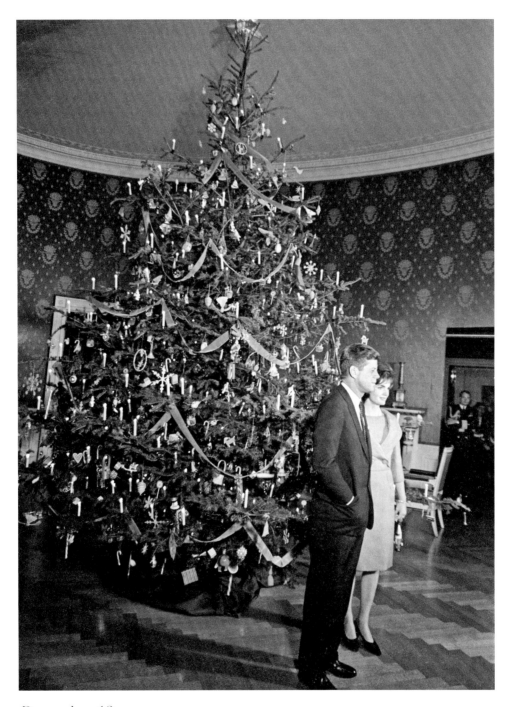

December 13 The Kennedys posing in front of the White House Christmas tree in the Blue Room. The first lady started the tradition of decorating the tree with a theme; the ornaments here were inspired by *The Nutcracker Suite*.

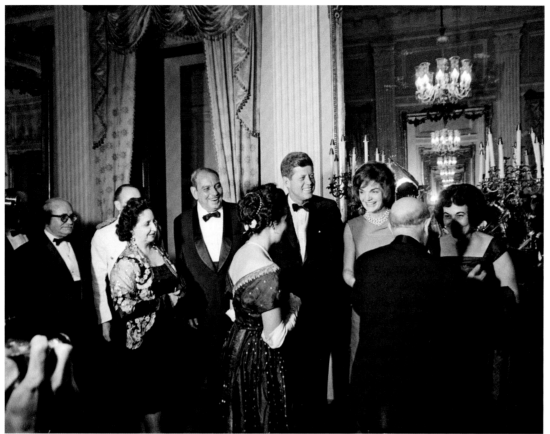

December 16 The president and Mrs. Kennedy kicked off a tour of Latin America in San Juan, Puerto Rico, and then continued to Caracas and La Morita, Venezuela, and Bogotá, Colombia. The president began the trip in a testy mood, blaming his air force attaché, General Godfrey McHugh, for packing suits too heavy for the 80-degree temperatures, then telling Richard Goodwin, who planned the trip, "Well, Dick, if this doesn't work out, you might as well keep going south." The tour worked out sensationally. American diplomats told Kennedy there had never been presidential welcomes like this, because there had never been a Catholic president with a dark and beautiful wife who spoke Spanish to the crowds. "Do you know why these workers and *campesinos* are cheering you like that?" asked Alberto Lleras Camargo, president of Colombia. "It's because they believe you are on their side."

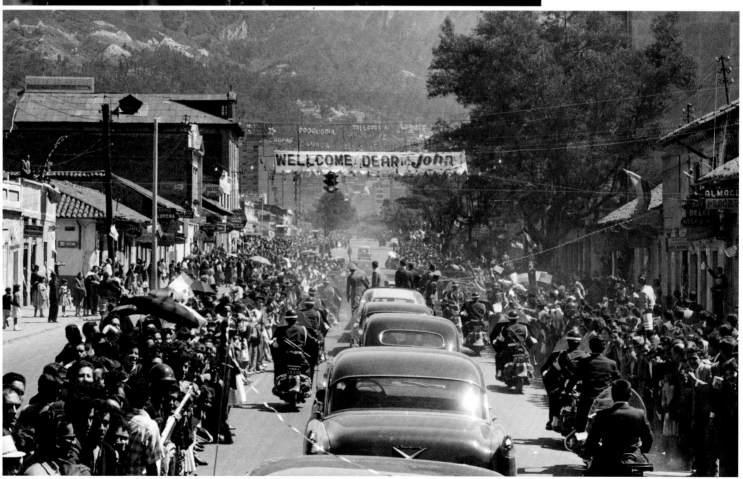

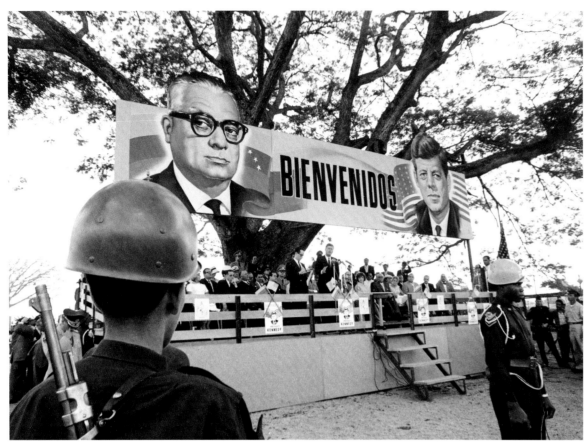

December 22 Kennedy in Bermuda for a meeting with British prime minister Harold Macmillan, standing to the president's right. Kennedy tried and failed to persuade Macmillan to allow American nuclear testing on Christmas Island, a British possession. But the two Anglo-Saxons, as French president Charles de Gaulle called them, became close despite their twenty-three-year age difference. Macmillan, in his diary, said of Kennedy: *"He is courteous, amusing, and likes jokes or a neat turn of phrase. There is a marked contrast between president Kennedy 'in action' on a specific issue (i.e., Congo, West Irian, Ghana) and his attitude on larger issues (the nuclear war, the struggle between East and West, Capitalism and Communism, etc.). In the first, he is an extraordinarily quick and effective operator—a born 'politician' (not in a pejorative sense). On wider issues, he seems rather lost . . . In health, I thought the president was not in good shape. His back is hurting. He cannot sit long without pain."*

January 11 "Strengthening the Economy" was the title of the first section of Kennedy's second State of the Union message. With Vice President Johnson and the new Speaker of the House, John McCormack of Massachusetts, applauding behind him, the president said, "Let us not forget that we have suffered three recessions in the last seven years. We need standby authority, subject to Congressional approval, to adjust personal income taxes downward . . . to slow down an economic decline before it drags us all down."

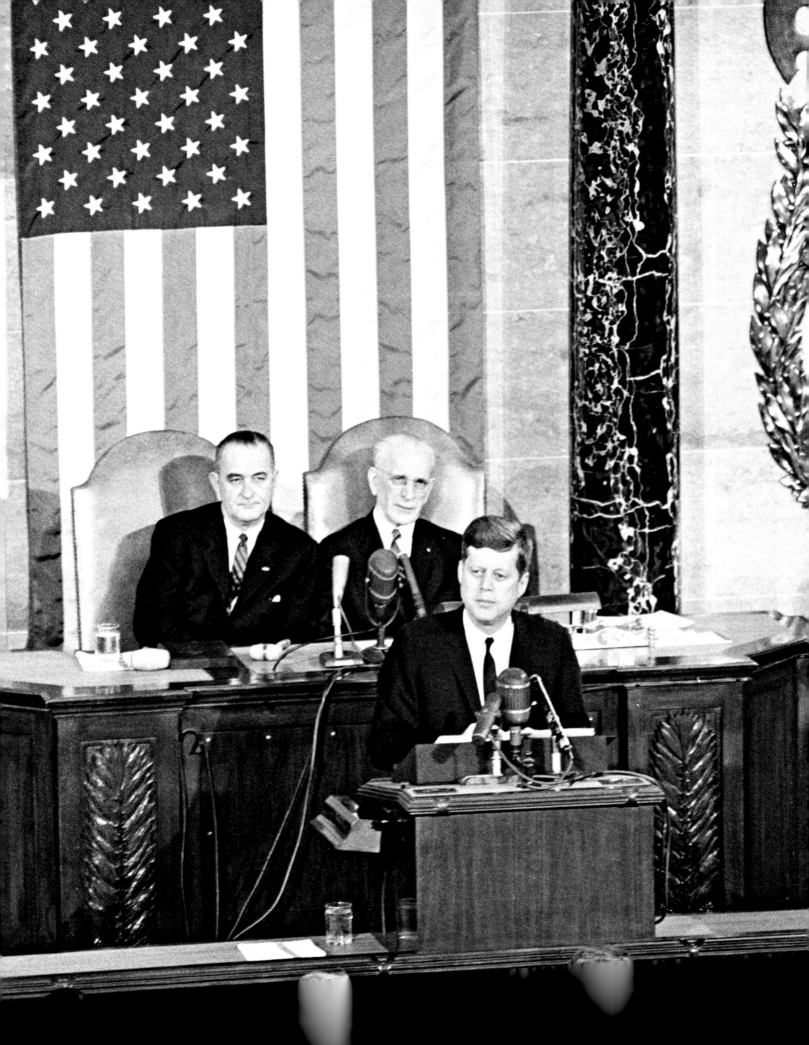

January The president at his desk in the Oval Office. The white objects around the lamp are scrimshaw—carvings by whalers on whale teeth and bones—that Kennedy collected.

January 15 The camera setup in the State Department auditorium for the twentieth presidential press conference.

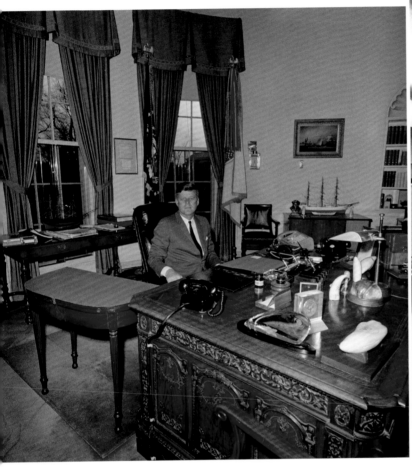

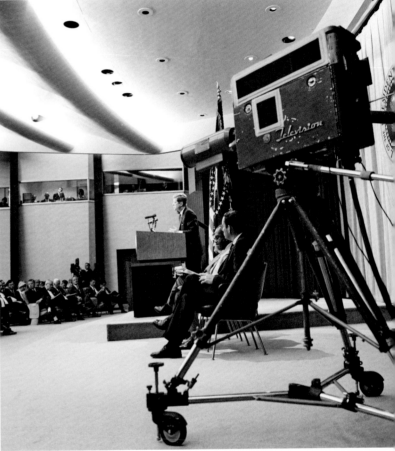

January 19 Kennedy in New York, meeting with U Thant, the secretary-general of the United Nations, and Adlai Stevenson, the U.S. ambassador to the international organization and Kennedy's old rival.

January 24 The president had held nineteen press conferences in 1961—the White House called them "news conferences"—but his style had already changed the Washington press corps. For one thing, reporters were dressing better, and there were many more of them when they realized they might be on television. They also realized that all important news, especially good news, would be coming from the White House rather than the Cabinet departments. The old days were over and first-rank reporters such as Peter Lisagor of the *Chicago Daily News* and Sander Vanocur of NBC News were spending all their time at the White House rather than popping from one government agency to another.

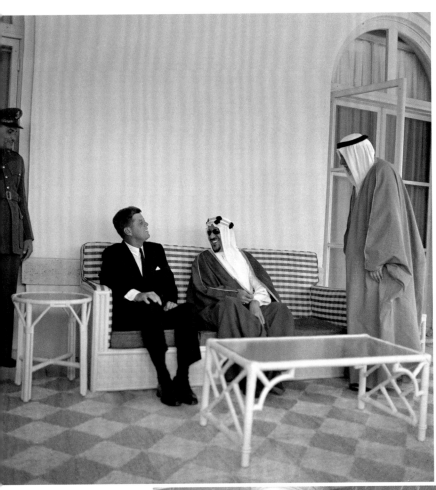

January 27 The president meeting Saud ibn Abd al-Aziz Saud (seated), king of Saudi Arabia in Palm Beach. The Saudi leader sparked a domestic crisis in the Kennedy household when he gave a valuable Arabian stallion to Mrs. Kennedy and the president wanted her to return it. She had also received gift horses from Ireland and Pakistan. Kennedy sent his chief of protocol, Angier Biddle Duke, to explain the rules governing White House gifts: "Tell her it's hurting me politically. The Arabs give her those horses and then the Israelis come along with an old Bible worth about $12." Mrs. Kennedy said she understood the limits on public officials accepting such things, but she was not a public official—"I am a wife and a mother"—and she intended to keep the horse.

February 1 Kennedy greeting Secretary of State Rusk (front, left) and a U.S. delegation returning from a conference with Latin American officials in Punte Punta del Este, Uruguay.

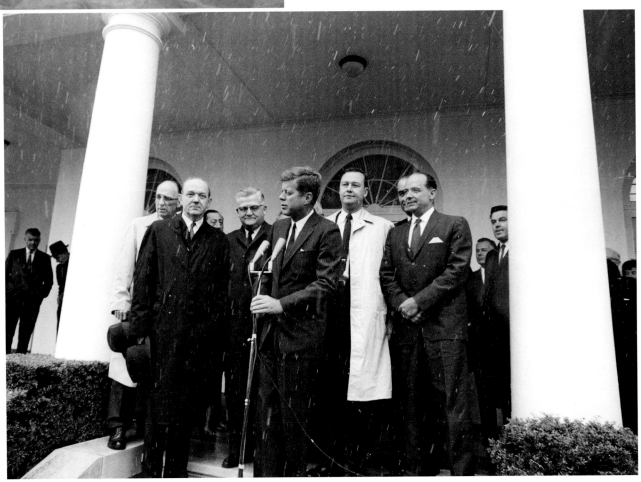

February 5 Astronaut John Glenn visited the White House two weeks before he became the first American to orbit the earth, ten tense months after Yuri Gagarin of the Soviet Union had accomplished that feat. Vice President Johnson, who was supervising the space program, had earlier told Kennedy what an all-American boy Glenn was, a marine major and Korean War ace. The vice president added, "If only he were a Negro." It was the president's favorite Johnson story, one he told to anyone who would listen—and people always listen to a president.

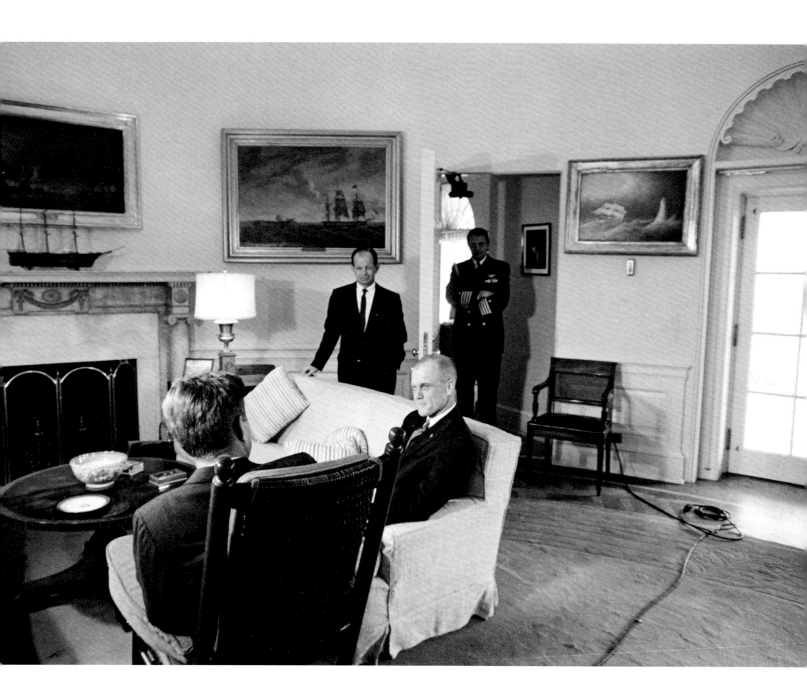

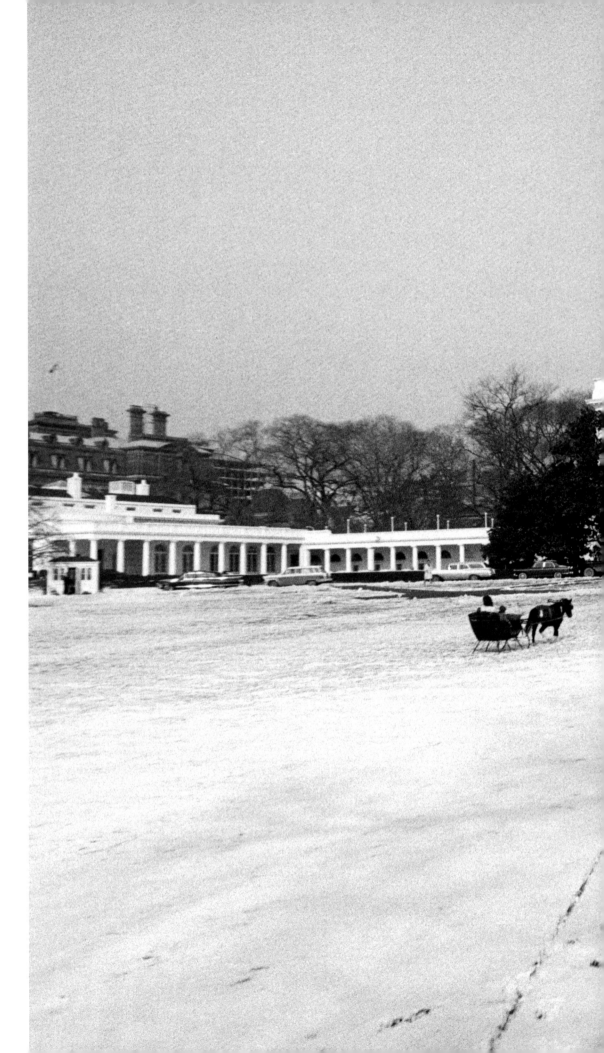

February 13 Jacqueline Kennedy and children Caroline and John Jr. in a real one-horse open sleigh, drawn by Caroline's pony Macaroni. This photo was used on the Kennedy White House Christmas card that year.

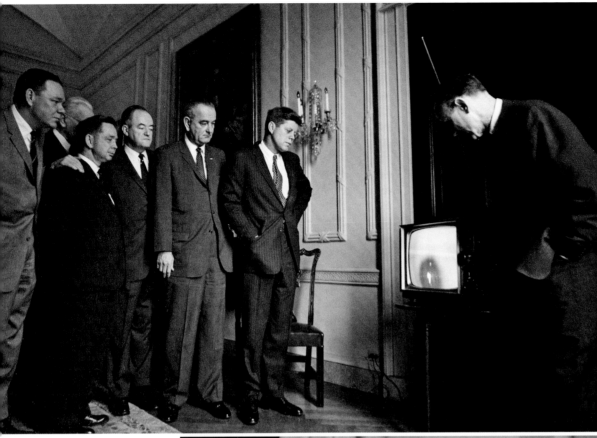

February 20 The president, vice president, Senator Hubert Humphrey from Minnesota, Representative Carl Albert from Oklahoma, and other officials nervously watching as John Glenn's capsule, *Friendship 7,* on top of an Atlas rocket, lifted off from Cape Canaveral in Florida. An obviously delighted president talking to the astronaut after Glenn splashed down in the Atlantic and was taken aboard the aircraft carrier destroyer USS *Noa.*

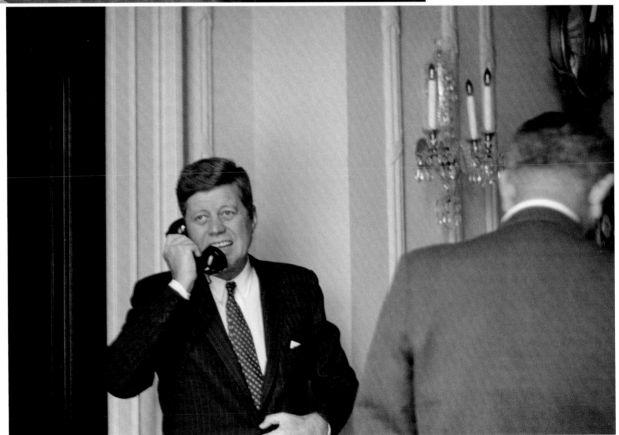

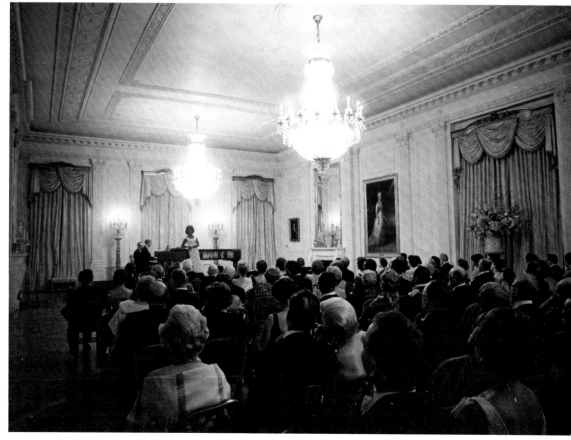

February 20 The president and Mrs. Kennedy greeting mezzo-soprano Grace Bumbry during a White House reception honoring Vice President Johnson, Speaker John McCormack, and Chief Justice Warren. The opera sensation performed at a concert afterward.

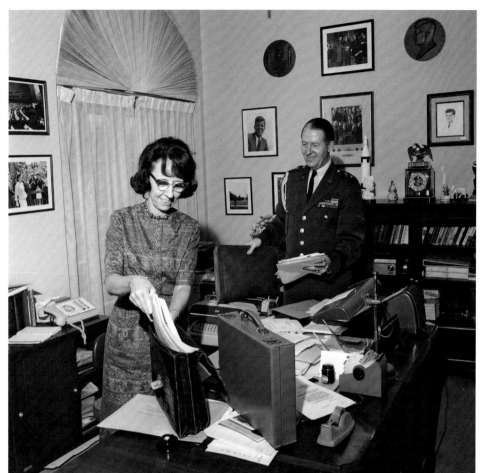

February 23 The president's secretary, Mrs. Evelyn Lincoln, and a military aide, General Chester Clifton, packing the president's reading material before he flew to Cape Canaveral to meet with John Glenn and inspect *Friendship 7*.

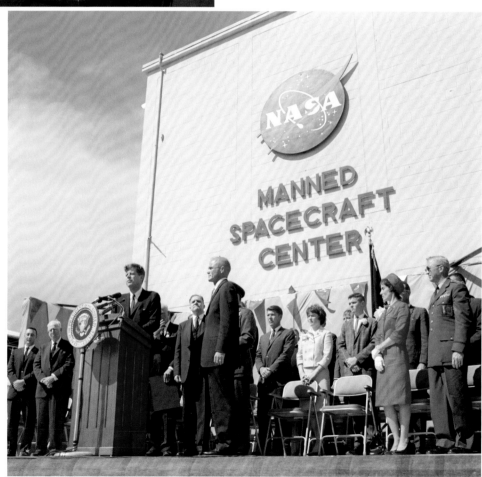

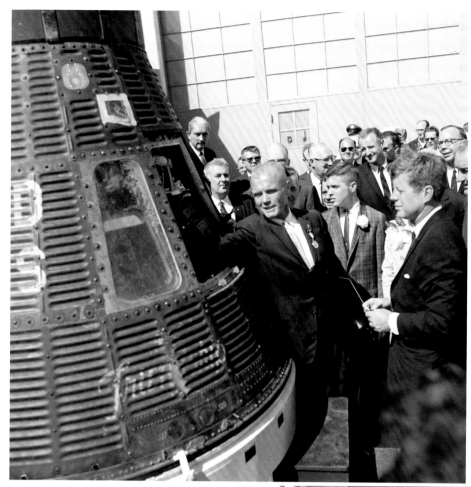

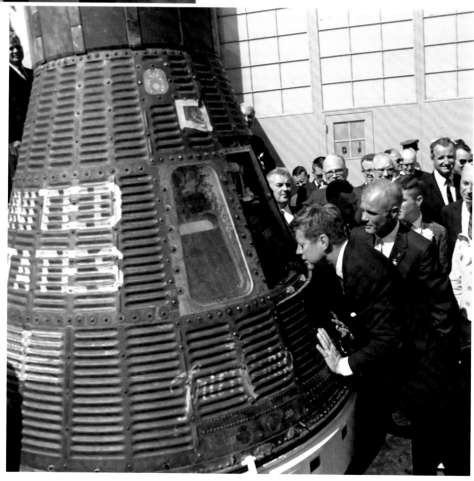

February 23 Vice President Johnson rode with Colonel and Mrs. Glenn in a parade for National Aeronautics and Space Agency employees and contractors at the cape.

Air Force One, a specially fitted Boeing 707, and the flying White House. "Anyone who thinks the presidency is an unbearable burden," said Kennedy, "has never traveled on *Air Force One*."

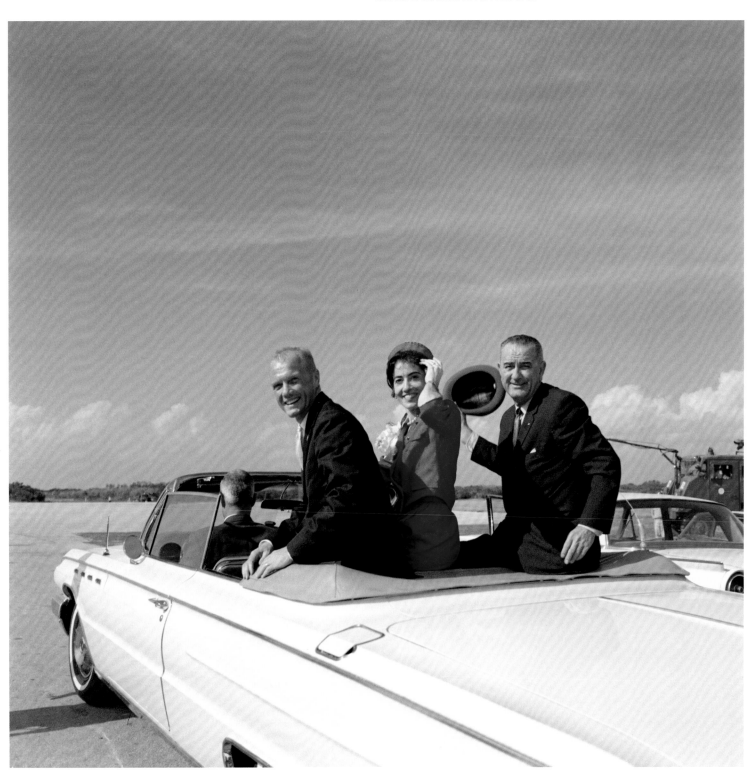

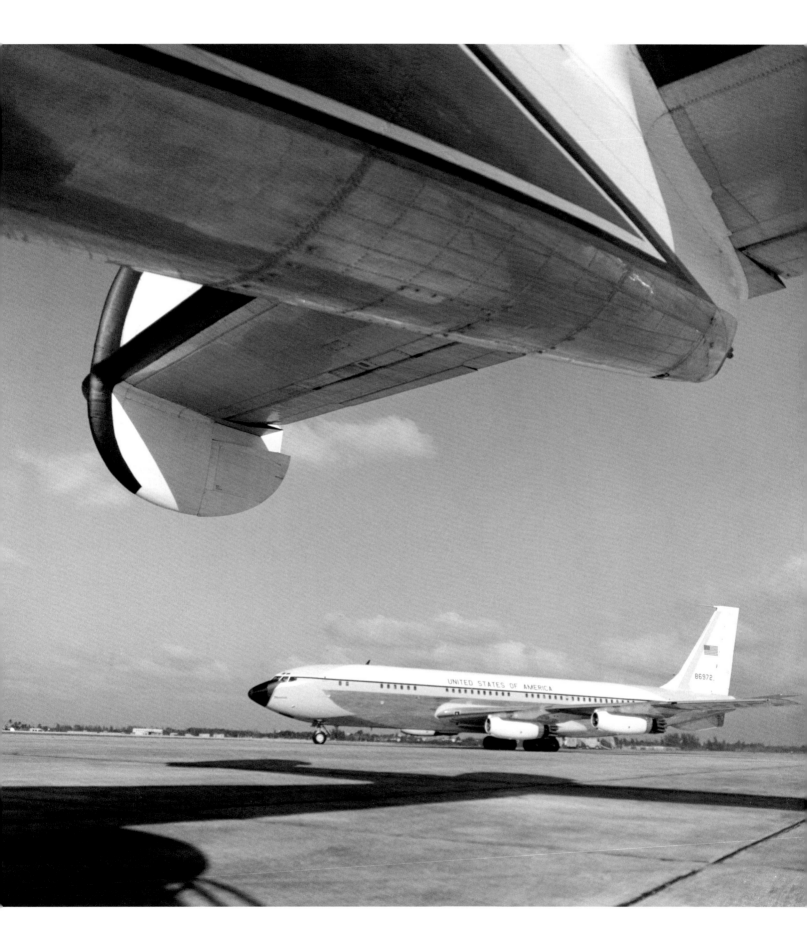

March 11 A regal Mrs. Kennedy during a trip to the Vatican to meet Pope John XXIII; Monsignor Martin J. O'Connor accompanies her through the Pontifical North American College.

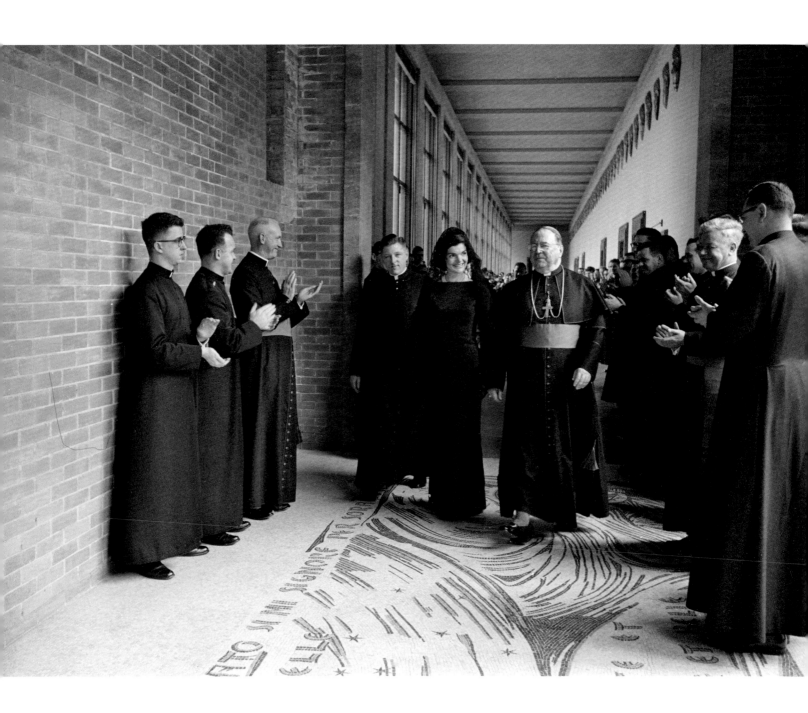

March 12–26 Mrs. Kennedy touring in India with economist John Kenneth Galbraith, a Kennedy friend and the U.S. ambassador to India. The first lady's itinerary included state dinners, the Taj Mahal, and a boat trip on Lake Pichola with her sister Princess Lee Radziwill.

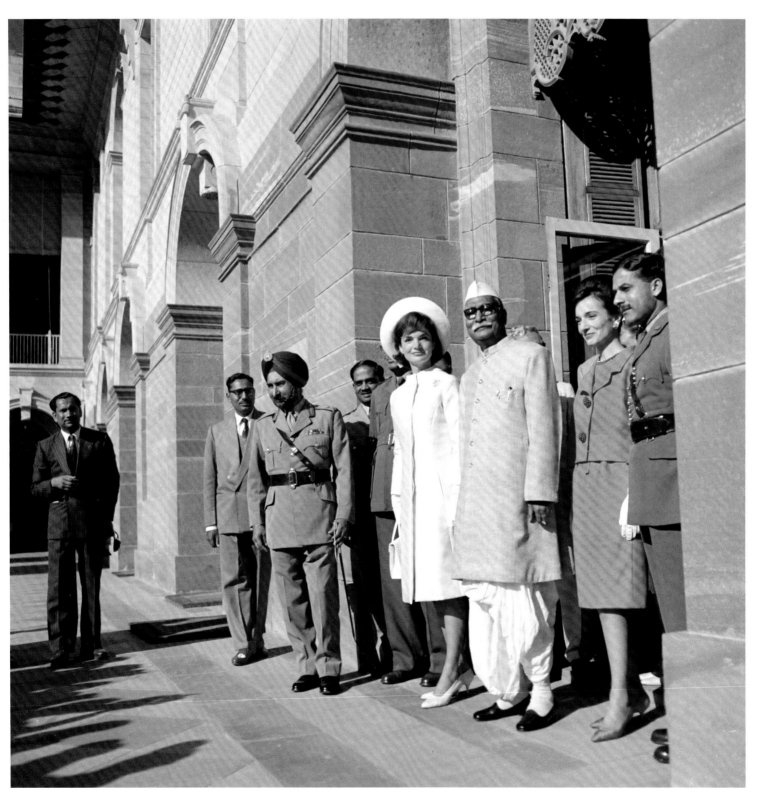

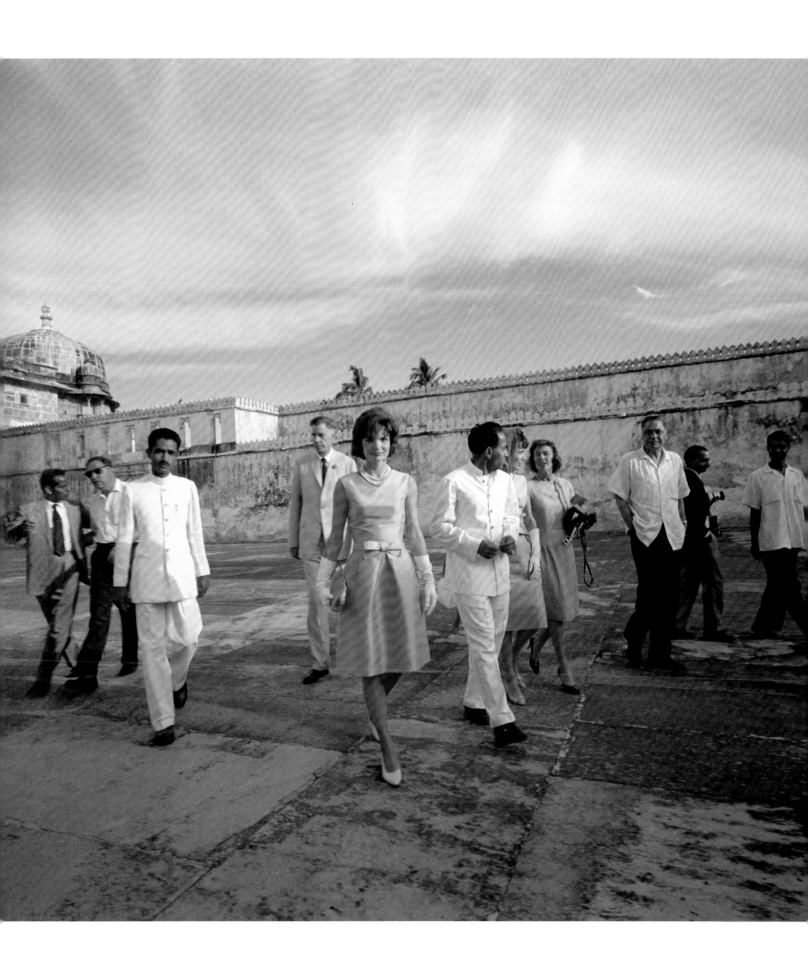

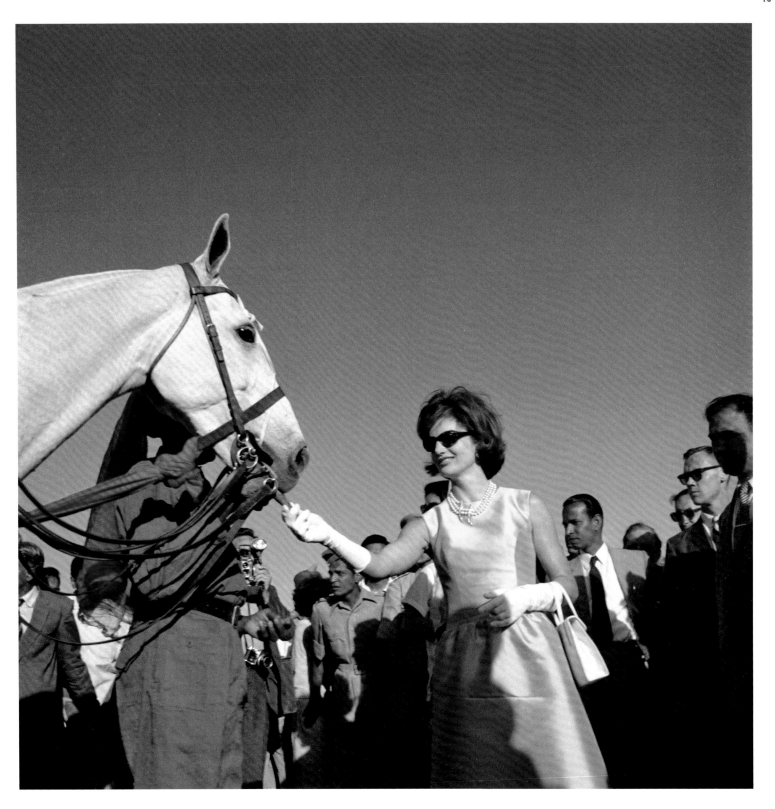

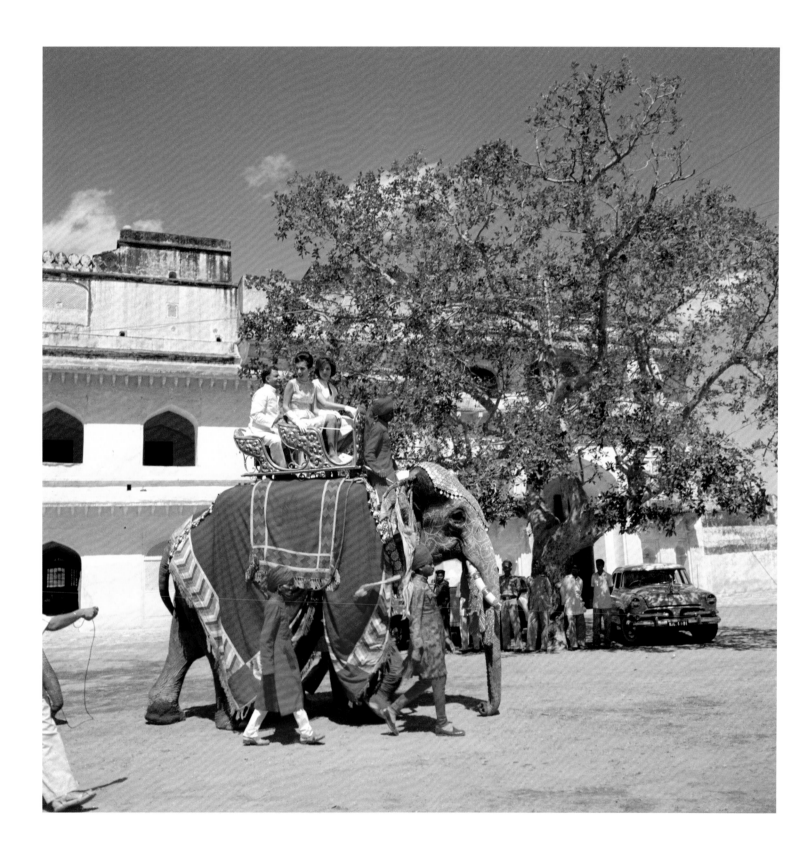

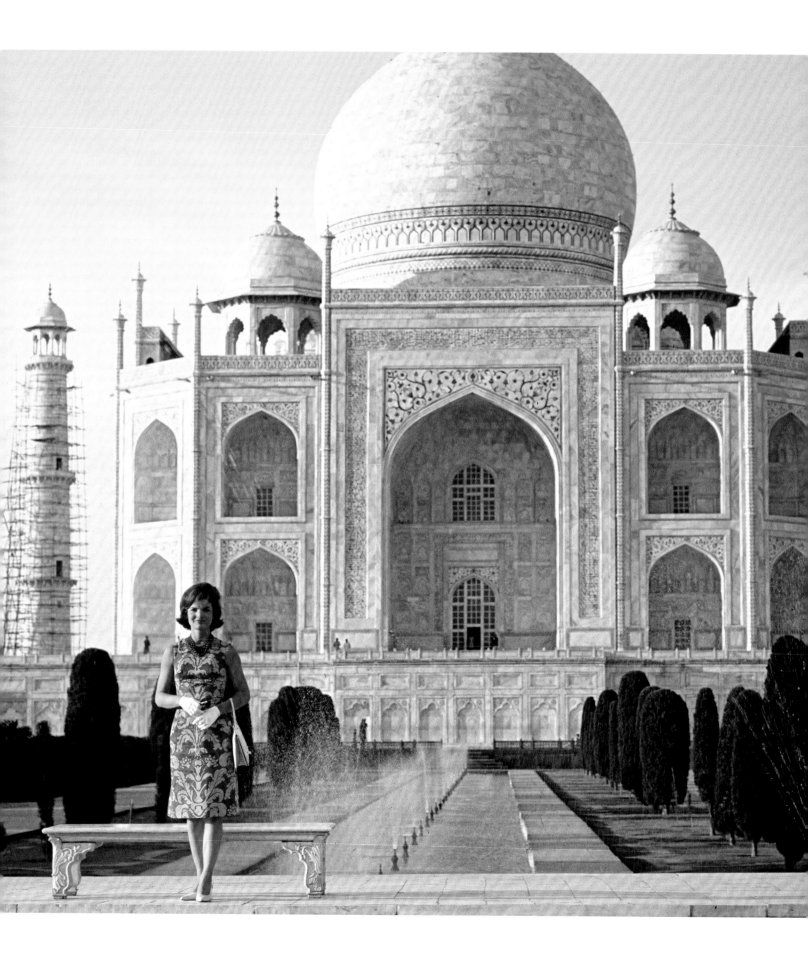

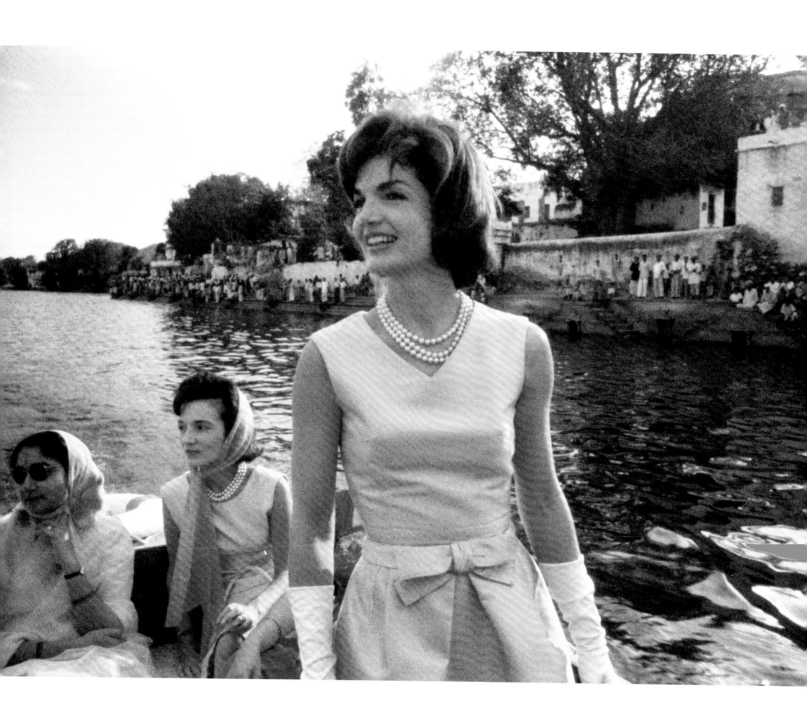

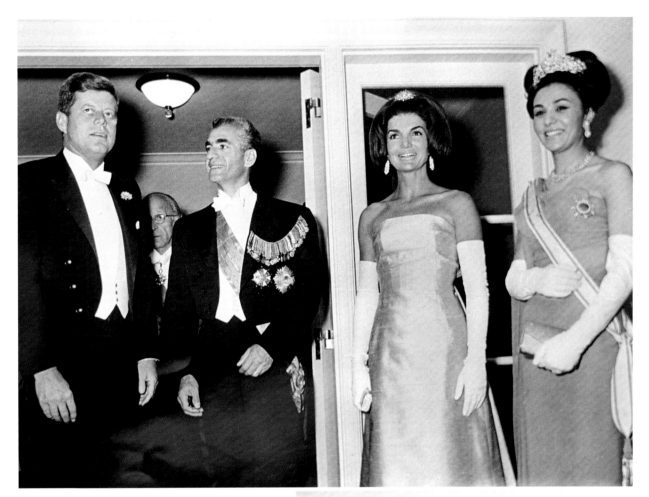

April 11 The Kennedys welcome the shah of Iran, Mohammad Reza Shah Pahlavi, and his empress, Farah Diba, to the White House. The empress and Mrs. Kennedy outside the White House with John Jr. Within a year, the shah would be in hiding as ten thousand barefoot Muslims, led by Ayatollah Khomeini, roared through the streets of Tehran—demonstrations that ended only after Khomeini was exiled ultimately to France.

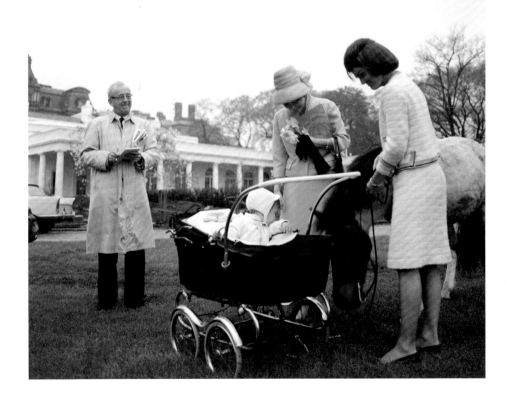

The president with the Greater Boston Youth Symphony Orchestra and the Breckenridge Texas Boys Choir, who were performing under the south portico of the White House.

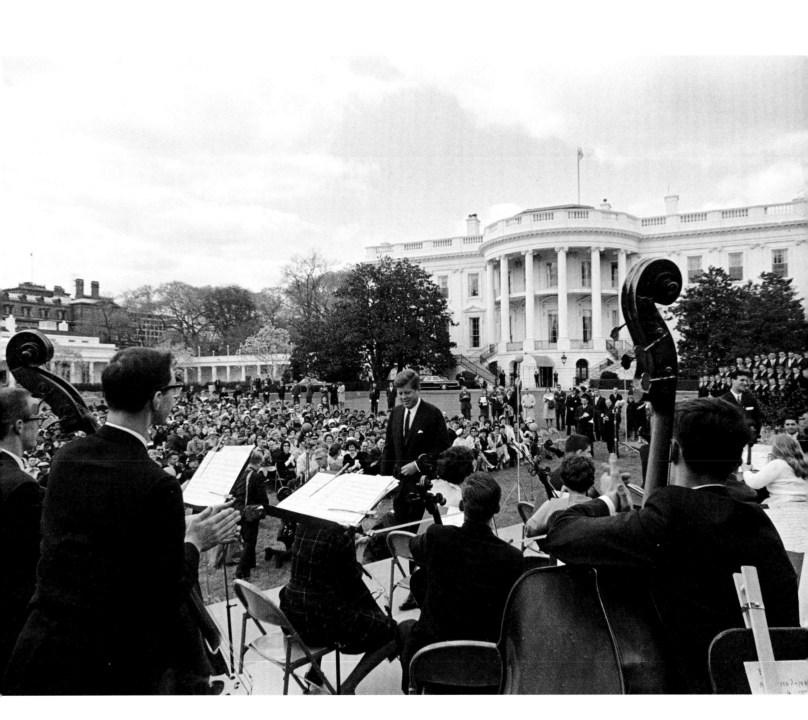

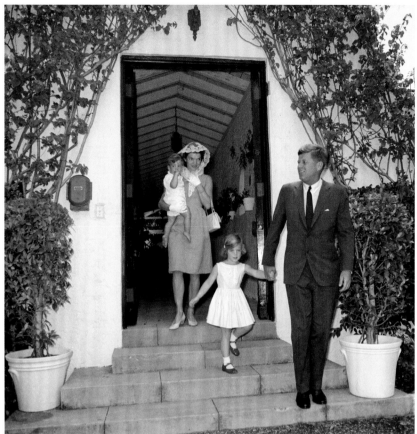

April 23 The Kennedy family leaving their Palm Beach home for Mass on Good Friday.

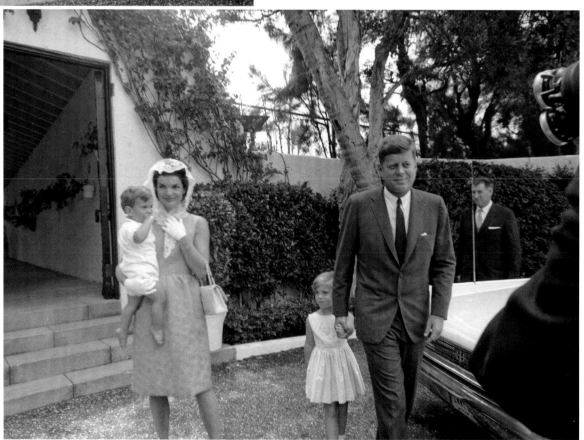

April 27 British prime minister Harold Macmillan (speaking)
arrives at Andrews Air Force Base for another session with Kennedy.
The two men, a generation apart, were fast and good friends. Kennedy
was comfortable enough with the sixty-eight-year-old Englishman
to flabbergast Macmillan by saying, "I wonder how it is for you, Harold,
but if I don't have a woman for three days, I get terrible headaches."

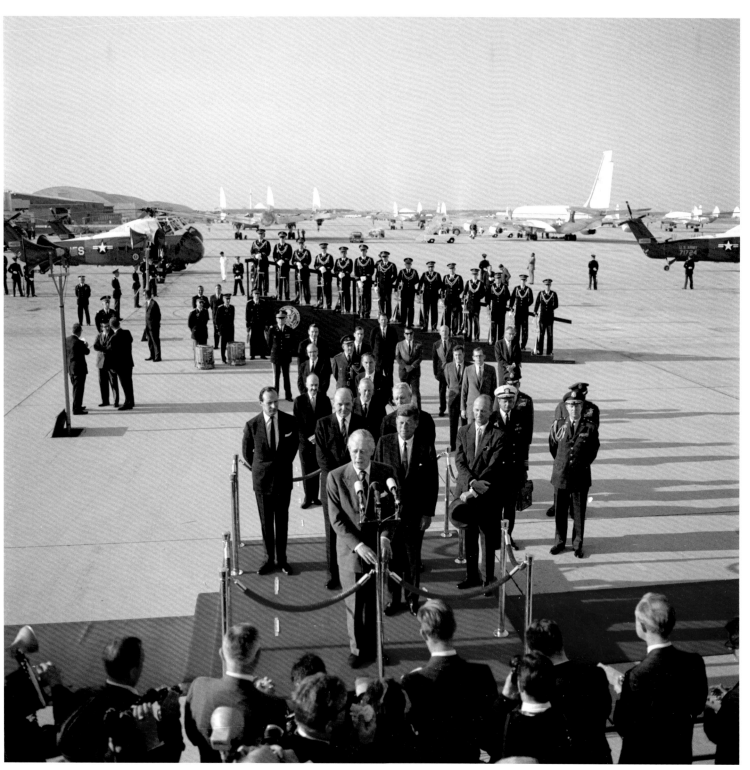

April 29 The great White House dinner and concert honoring winners of the Nobel Prize from the Western Hemisphere. In his remarks, Kennedy said, "I think this is the most extraordinary collection of talent, of human knowledge, that has ever been gathered together at the White House, with the possible exception of when Thomas Jefferson dined alone."

The president talks with writer Pearl Buck on his right, while Mrs. Kennedy speaks with poet Robert Frost.

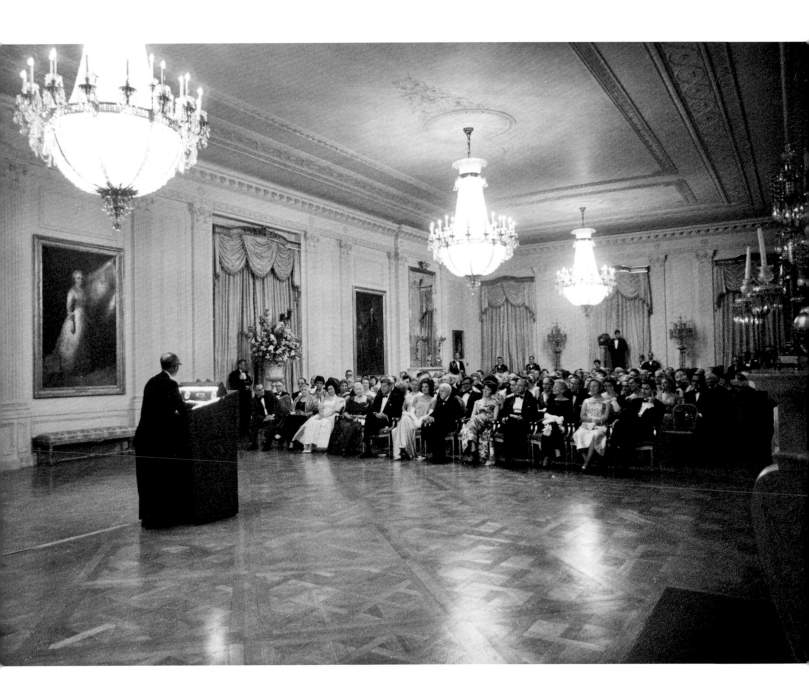

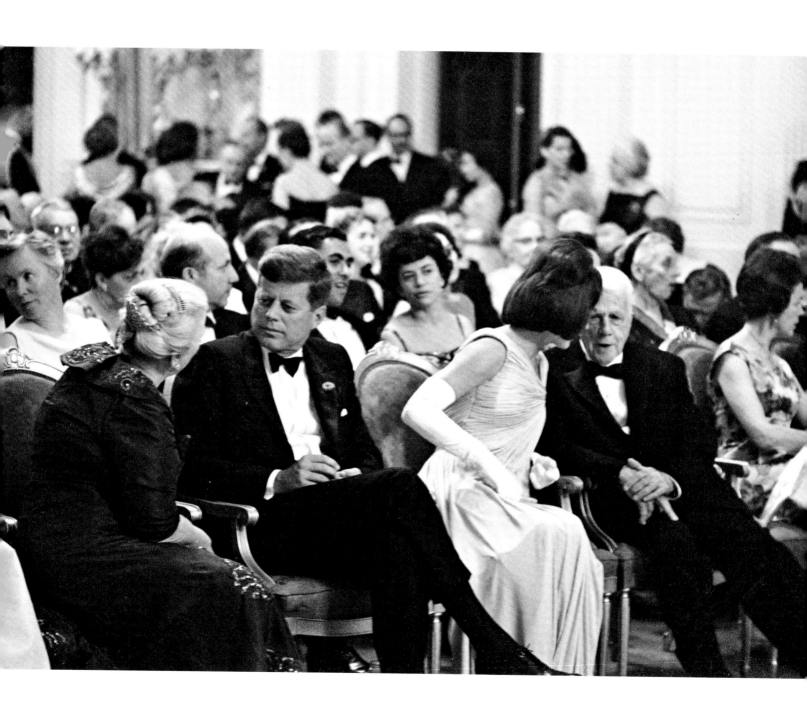

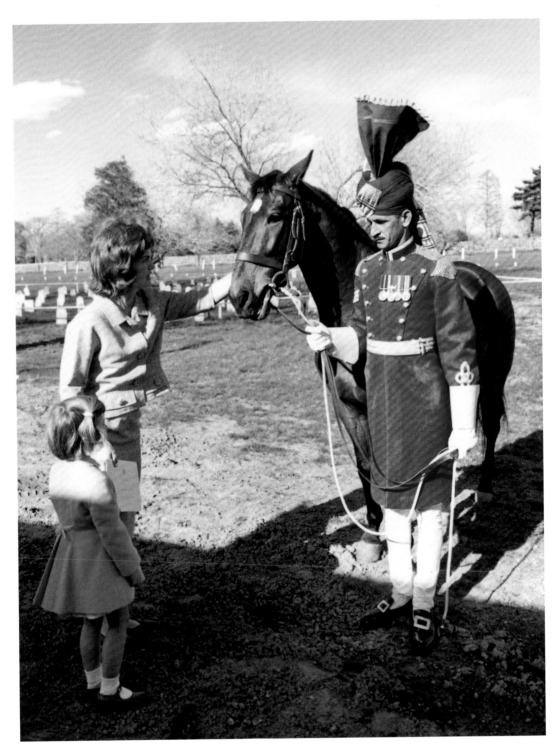

April Mrs. Kennedy and her daughter, Caroline, with Sardar, a gift from Mohammad Ayub Khan, president of Pakistan. In addition to horses from Saudi Arabia and Pakistan, the first lady was also given a thoroughbred from the president of Ireland.

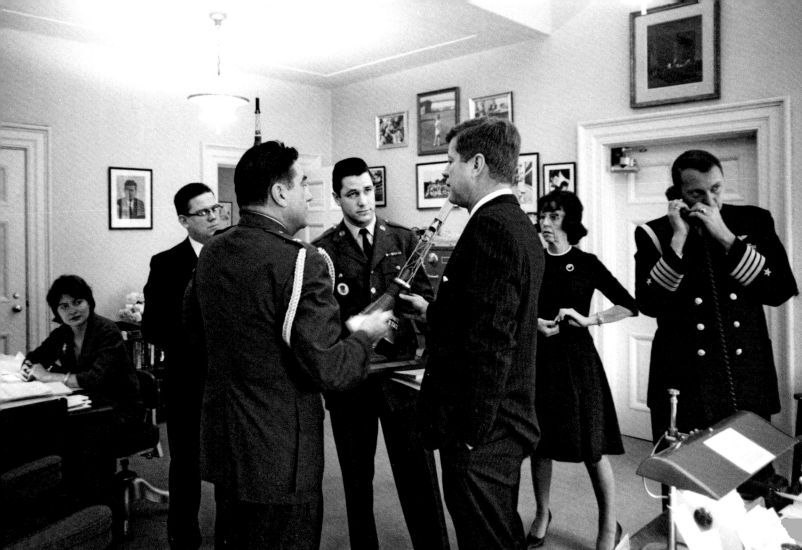

May The president holding a model of the Mercury *Friendship 7* Atlas booster rocket presented to him by General Godfrey McHugh, his air force attaché.

May 1 President Kennedy, backed by congressional supporters of the Educational Television Facilities Act, which marked the first federal assistance to public broadcasting and provided for the construction of educational television stations.

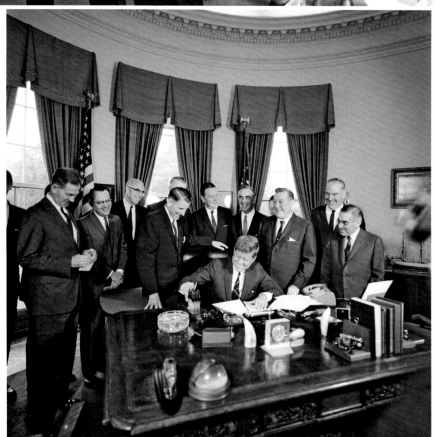

May 3 Mrs. Kennedy, a graduate of Miss Porter's School in Farmington, Connecticut, invited her classmates, teachers, and others to a reception and dinner at the White House.

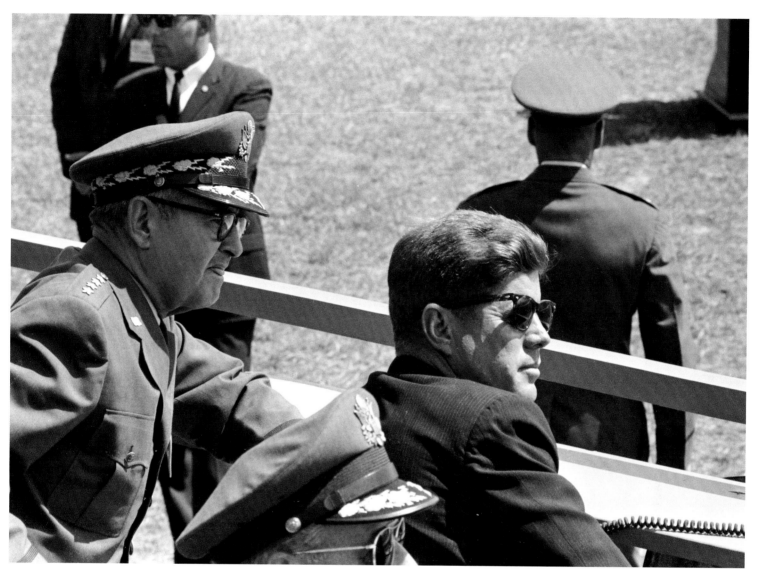

May 4 The president sitting next to General Curtis LeMay as jet fighters dropped napalm in a demonstration at Eglin Air Force Base in Florida. LeMay was a tough-talking bomber pilot who was a hero, a legend, really, of World War II. Kennedy despised the general but had to put up with him because the president was afraid LeMay would tour the country attacking Kennedy's defense policy. "Don't let that man near me again," the president told aides after one meeting with LeMay. Still, Kennedy appointed him chief of staff of the Air Force and privately repeated a quote from another general: "LeMay's like Babe Ruth: Personally he's a bum, but he's got talent and people love him."

May 8 Kennedy walking to a helicopter for a quick trip to speak at a United Auto Workers convention in Atlantic City, New Jersey. The man standing behind the car is John "Muggsy" O'Leary, a former Boston policeman and Kennedy family retainer, who was the president's driver.

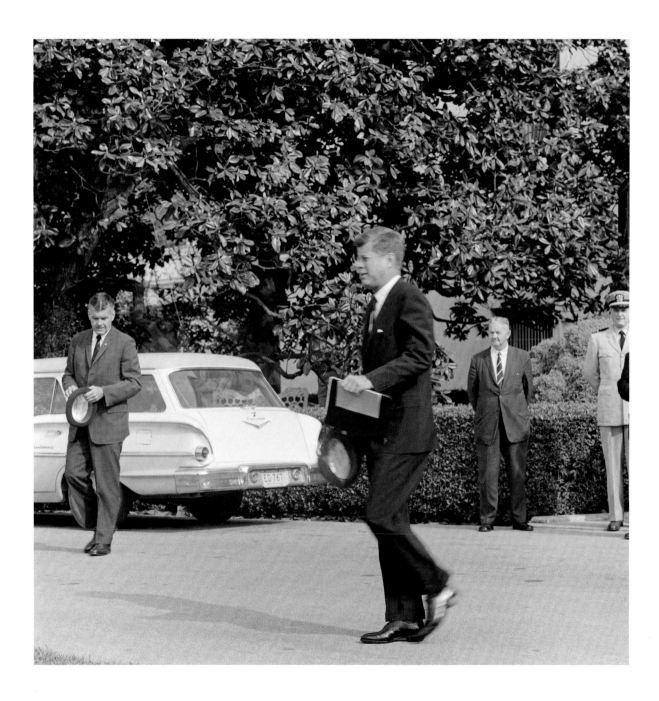

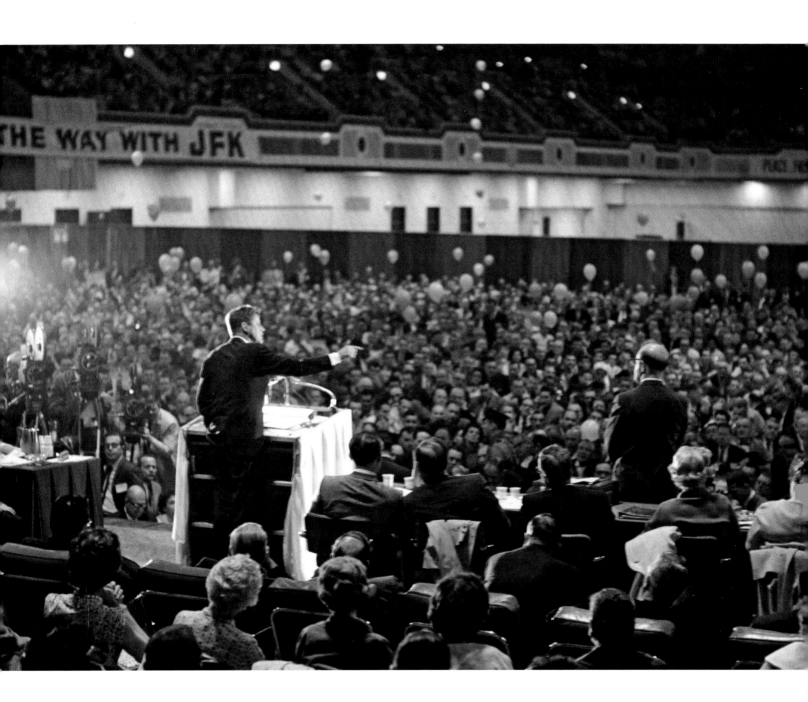

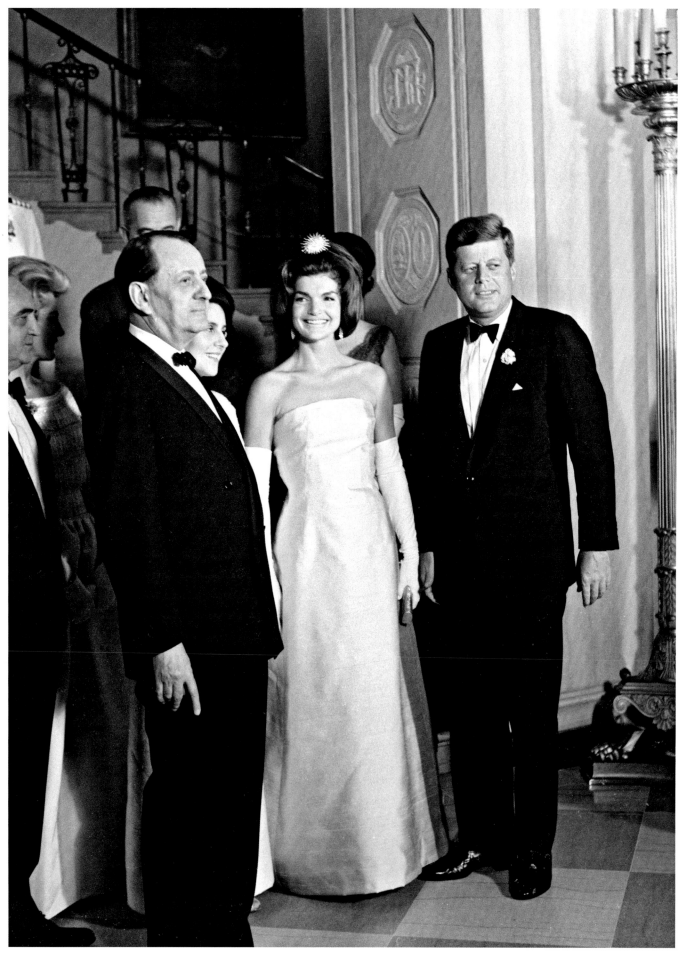

May 11 The Kennedys standing with André Malraux, the French minister for cultural affairs. The president called the brilliant writer and Resistance hero "my wife's intellectual crush." The affection and admiration went both ways. It was Malraux who approved Mrs. Kennedy's plan to bring the *Mona Lisa* to the United States for exhibition in Washington and New York.

At the same dinner, the Kennedys stood on either side of violin virtuoso Isaac Stern.

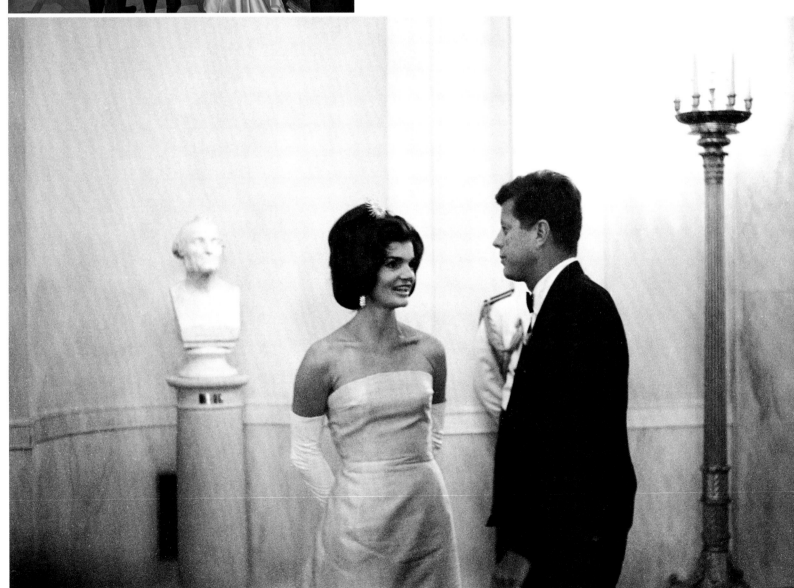

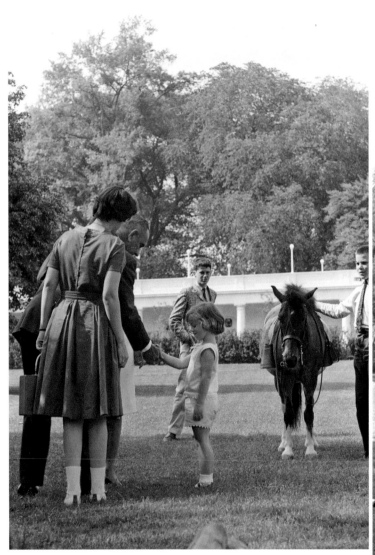

May 19 The president celebrated his forty-fifth birthday in public ten days before the actual date. The all-star gala in Madison Square Garden drew fifteen thousand people willing to pay from $3 to $100 to benefit the Democratic National Committee. A burst of stars onstage entertained the crowd and the guest of honor: Jack Benny, Harry Belafonte, Peggy Lee, Henry Fonda, Shirley MacLaine and Jimmy Durante, and Ella Fitzgerald (shown performing), Mike Nichols and Elaine May, and Maria Callas (shown at the after-party with the president and Adlai Stevenson).

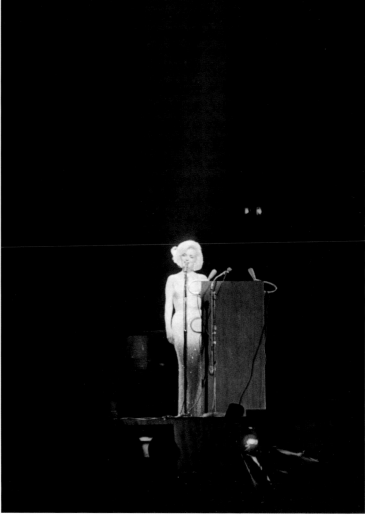

But it was Marilyn Monroe (shown singing and at the after-party) who made the evening memorable. Wearing a flesh-colored, five-thousand-dollar gown with nothing under it except the world's most famous body, she sang "Happy Birthday, Mr. President" in a whispery voice, both seductive and childlike. The performance was enhanced by the fact that Monroe had been telling friends she was having an affair with the president. Kennedy responded by saying, "Thank you. I can now retire from politics after having had 'Happy Birthday' sung to me in such a sweet wholesome way." Mrs. Kennedy responded by staying at the home they rented in Virginia's horse country, watching Caroline win a third-place ribbon at a local children's horse show. The next day the president dispatched William Haddad, the inspector-general of the Peace Corps and a former New York reporter, to the city's newspaper offices to deny there was a Kennedy-Monroe relationship. Within ten weeks, Monroe was dead, a suicide.

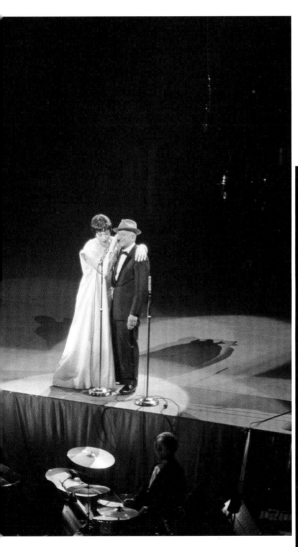

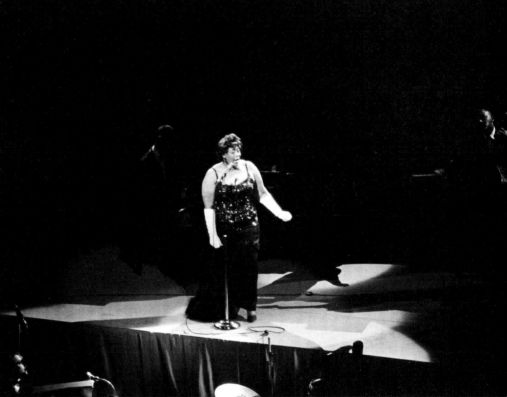

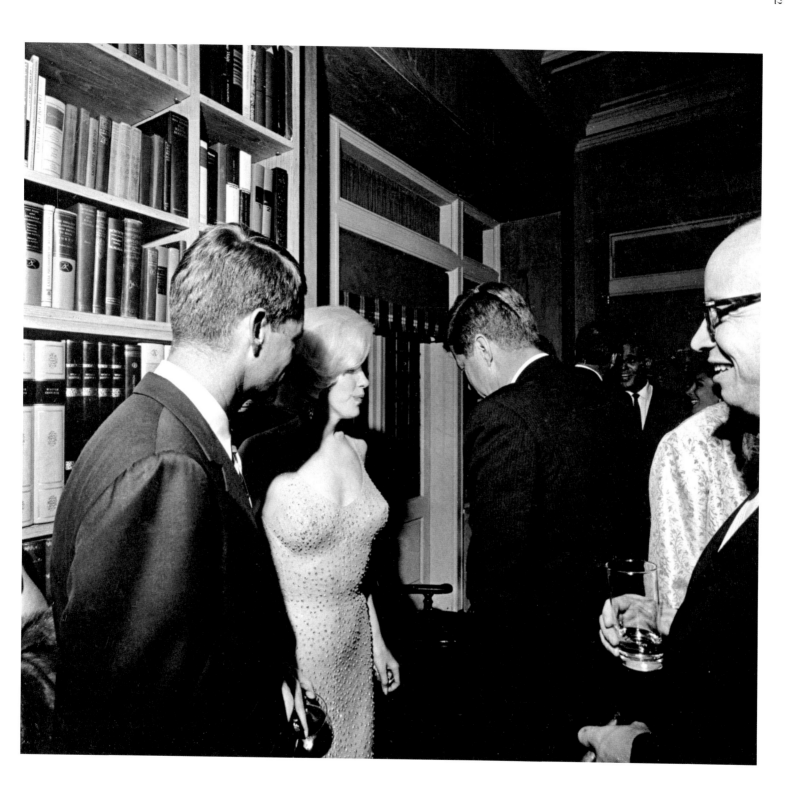

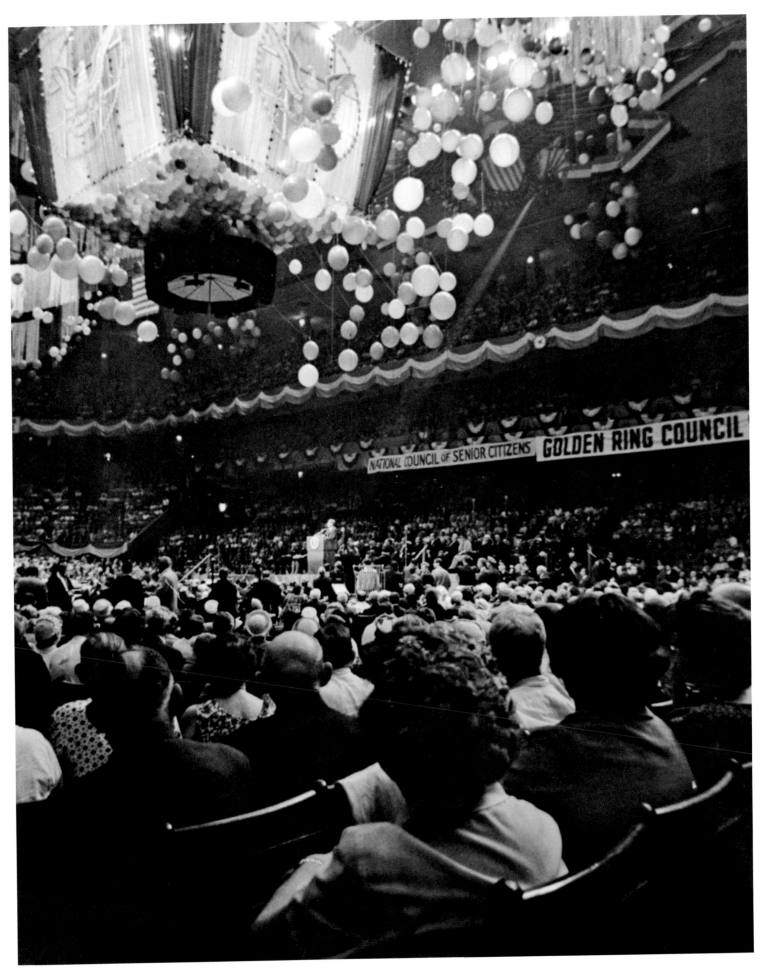

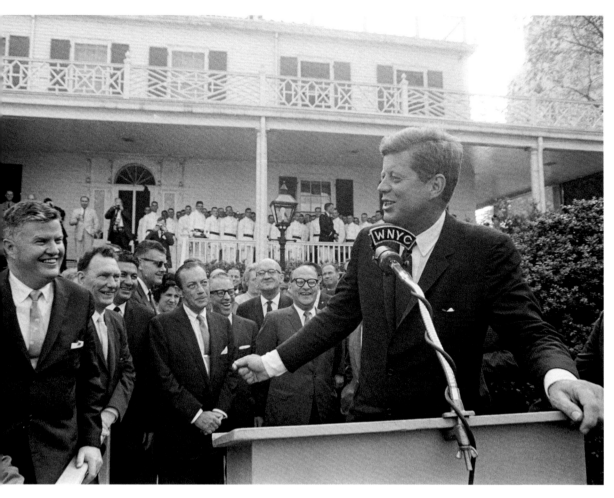

May 20 The president was back at Madison Square Garden to address a senior citizens' rally promoting health care for the elderly. Then he was on to Gracie Mansion, the home of New York's mayors, for some political talk with mayor Robert F. Wagner (standing with his hands folded). This time Mrs. Kennedy was there.

May 22 The president and first lady walk a receiving line outside the White House of participants in the Campaign Conference for Democratic Women.

May 28 The president posing with women newspaper editors in the Oval Office.

May 29 Kennedy met with Secretary of Defense McNamara (left) and his staff at the Pentagon. The subject, not for the first time, was nuclear disarmament.

Military guards watch as the president leaves the Pentagon.

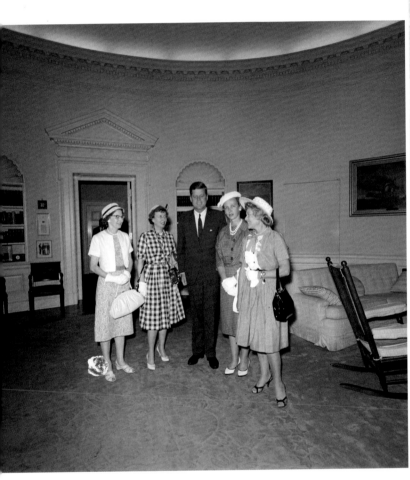

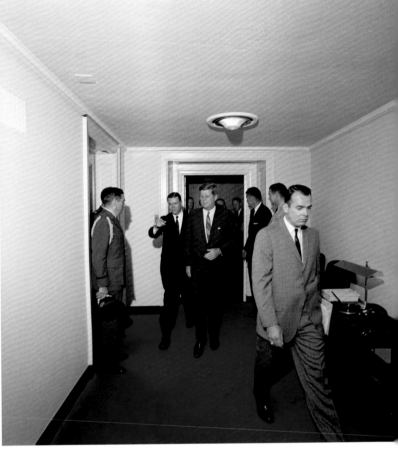

June 5 Project Mercury astronaut Scott Carpenter and his family came to the White House for a get-acquainted session with the president. Twelve days prior, Carpenter had become the second American to orbit the earth.

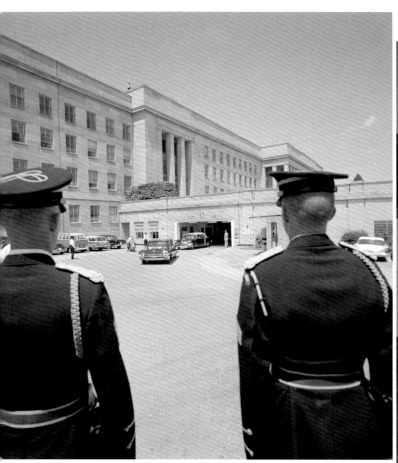

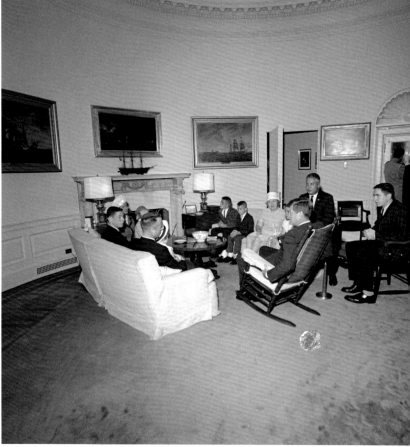

June 6 The 1961 commencement address at the United States Military Academy at West Point was given by a distinguished alumnus, General Douglas MacArthur, who said, "Your mission remains fixed, determined, inviolable—it is to win our wars. Everything else in your professional career is but corollary to this vital dedication." President Kennedy, shown riding with West Point Commandant General William Westmoreland and his own aide, Kenneth O'Donnell, had a different message to the class of 1962: "Whether it is Vietnam or Laos or in Thailand, whether it is a military group in Iran, whether it is a military attaché in some Latin American country during a difficult and challenging period . . . whatever your position, you will need to know and understand not only the foreign policy of the U.S. but the foreign policy of all countries scattered around the world . . . You will be involved in economic judgments, which most economists would hesitate to make. You will need to understand the importance of military power and also the limits of military power . . ."

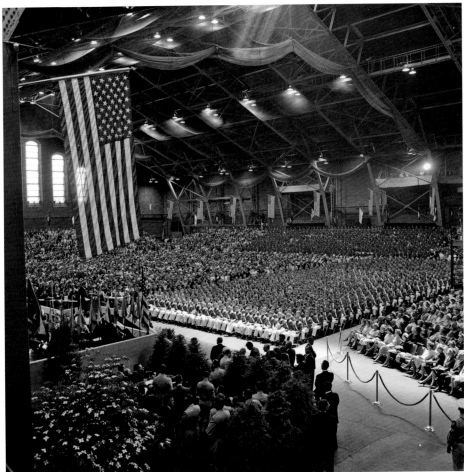

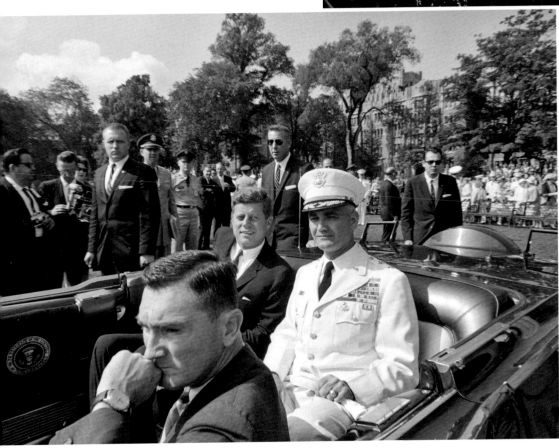

June 11 The president, walking here with Yale president A. Whitney Griswold, charmed the graduates and parents of the class of 1962 by saying, "I have the best of both worlds, a Harvard education and a Yale degree." The speech itself, however, was a serious one about the relationship between big government and big business. Three days later, a reporter at a news conference asked whether a stock market slump had put business on the offensive and had Kennedy trapped right where financiers wanted him. "I can't believe I'm where business—big business—wants me," answered the president of the United States.

June 29–30 The Kennedys took Mexico by storm: in motorcades
and at lunches and dinners with the country's leaders, beginning with
President Adolfo López Mateos, shown toasting the American president.

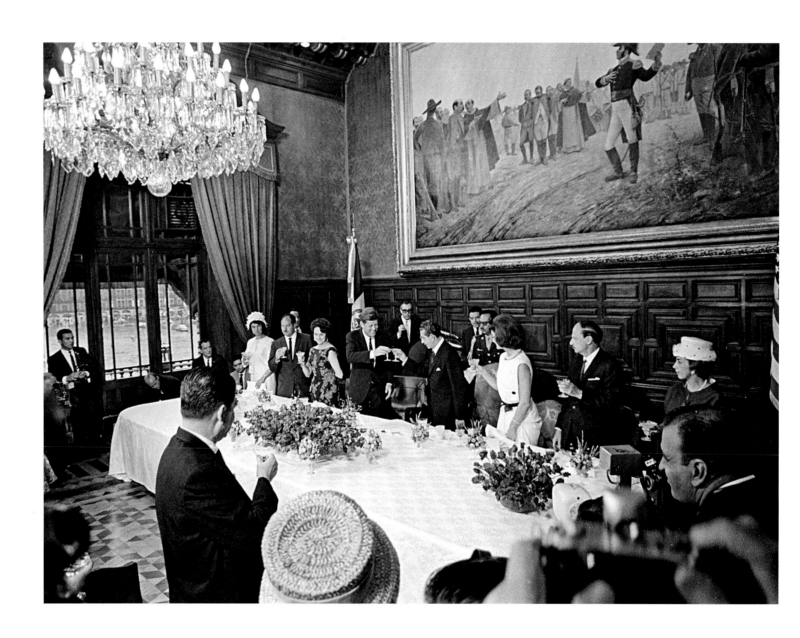

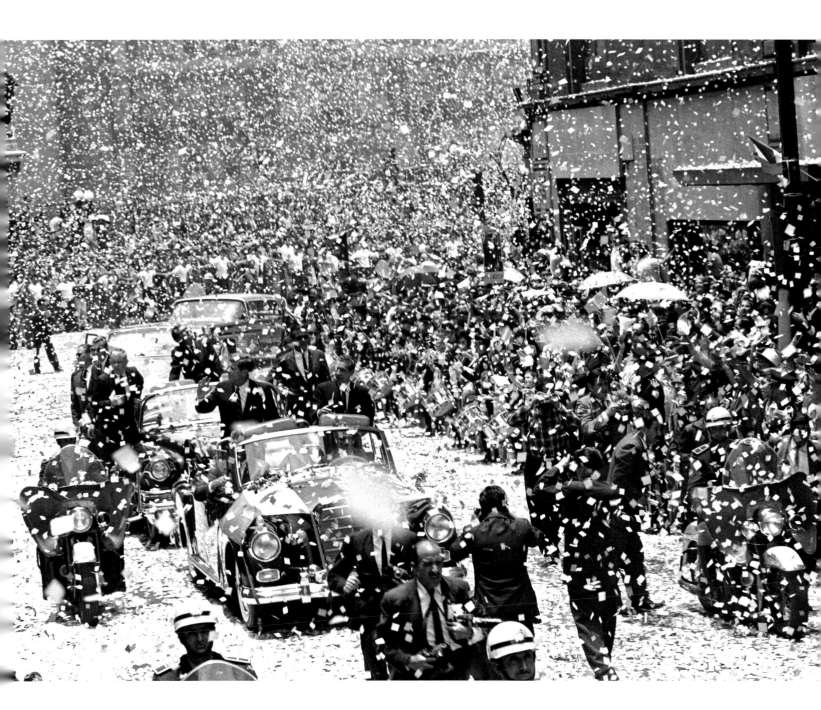

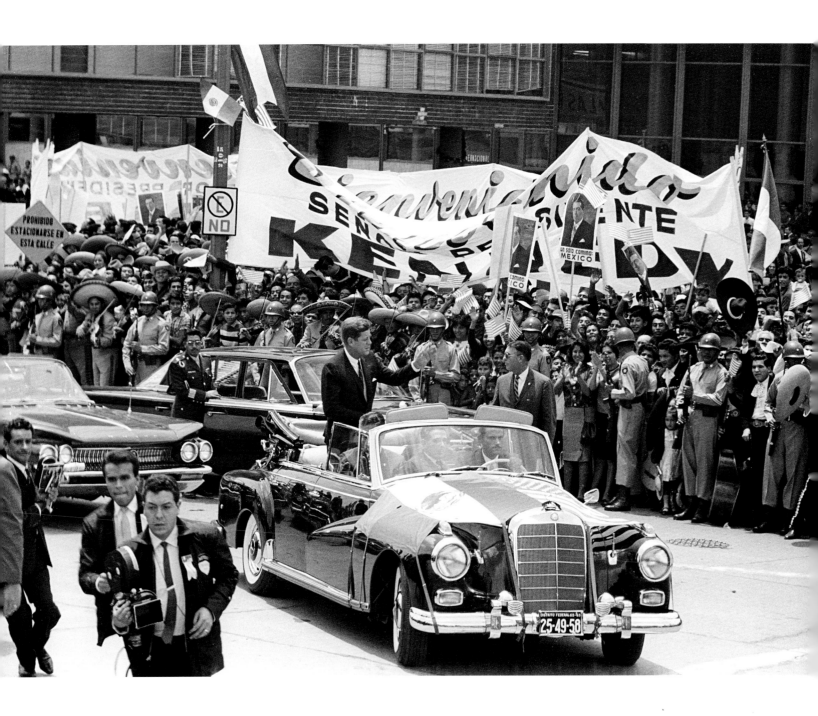

July 4 A presidential address at Independence Hall in Philadelphia.

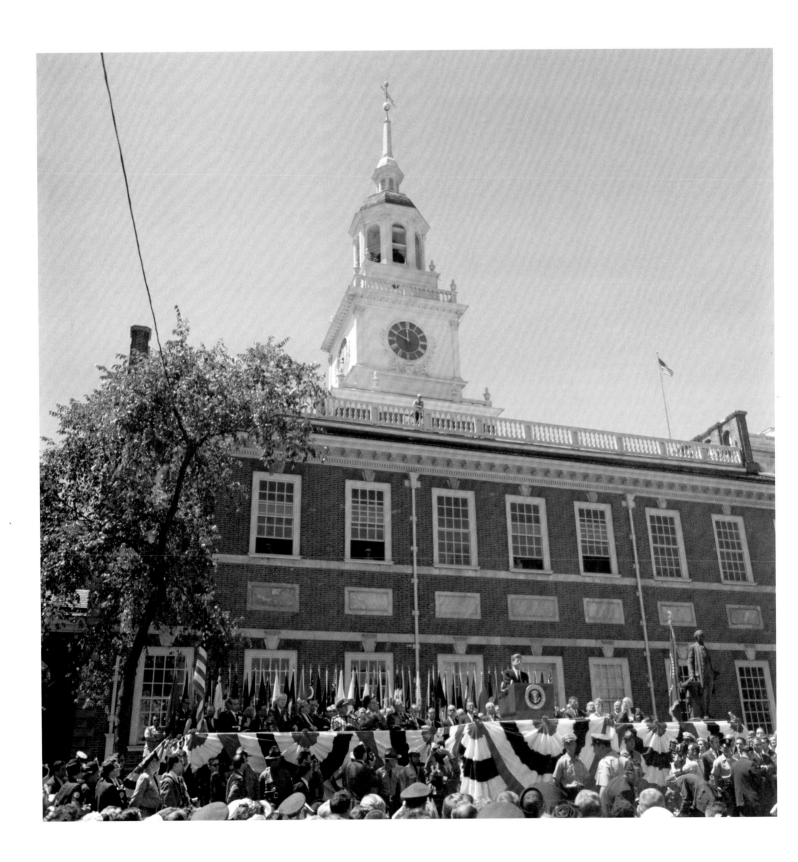

July 10 The president
at the Major League
All-Star Game at D.C.
Stadium. Kennedy talked
with Stan Musial of the
St. Louis Cardinals and
then threw out the first
ball as play began.

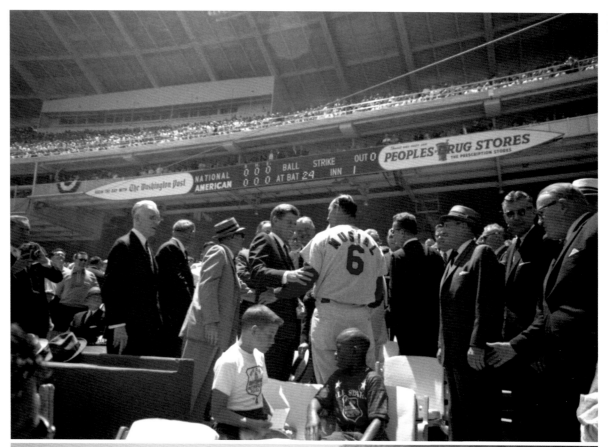

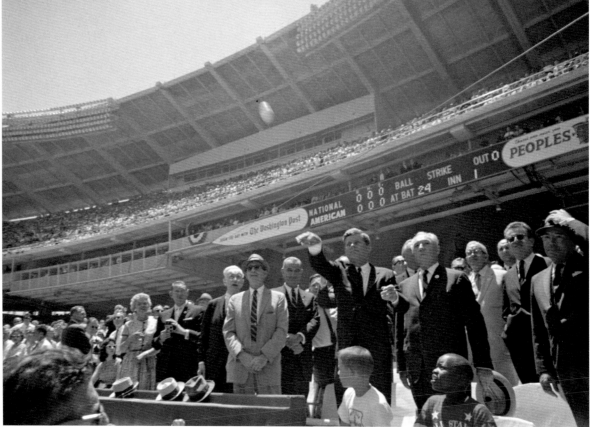

July 17 The president posing with the outgoing secretary of the Department of Health, Education, and Welfare, Abraham Ribicoff (right), and his successor, Anthony Celebrezze.

July 26 Kennedy greeting the one millionth visitor to the White House, Mr. and Mrs. William Nealy and their daughter Eleanor. Actually no one knew who was the millionth visitor. The Nealys were picked by staffers for their average American looks.

July 26 The president with his resident intellectual and sometime speechwriter, Arthur Schlesinger, Jr. Part of Schlesinger's charge was to write the first book after Kennedy left office, which he did. After the failure of the Bay of Pigs, Kennedy ruefully told Schlesinger he had a title for him: *Kennedy: The Only Years.*

July 28–August 4 The president's arrival by helicopter at Hyannis Port. Kennedy and kids on his beloved sailboat, *Victura*, a present from his parents on Kennedy's fifteenth birthday. Robert Kennedy with several of his children: Robert Jr., David, Kerry, Michael, and Courtney. The president and Mrs. Kennedy on the porch with their children, Caroline and John Jr.

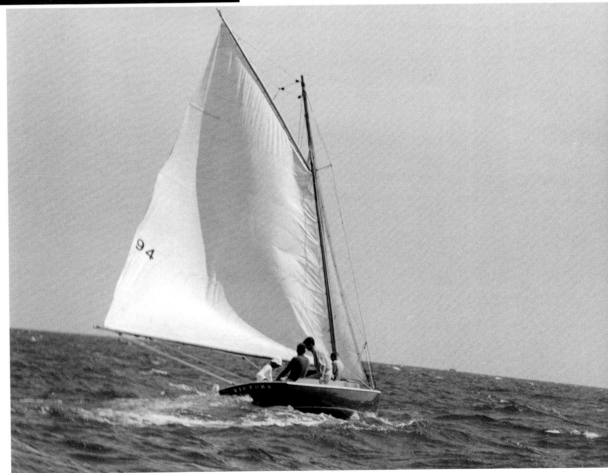

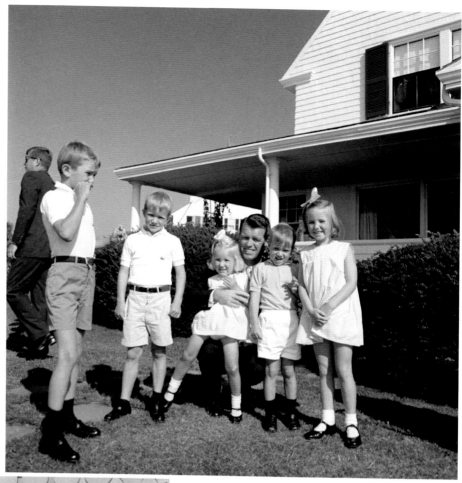

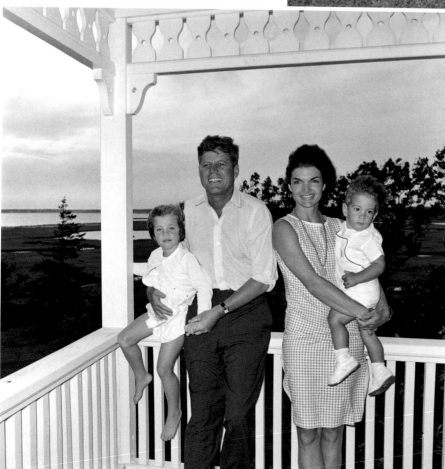

August 2 The president greeting members of the National Association of Colored Women's Clubs, who presented him with a copperplate engraving of President Abraham Lincoln.

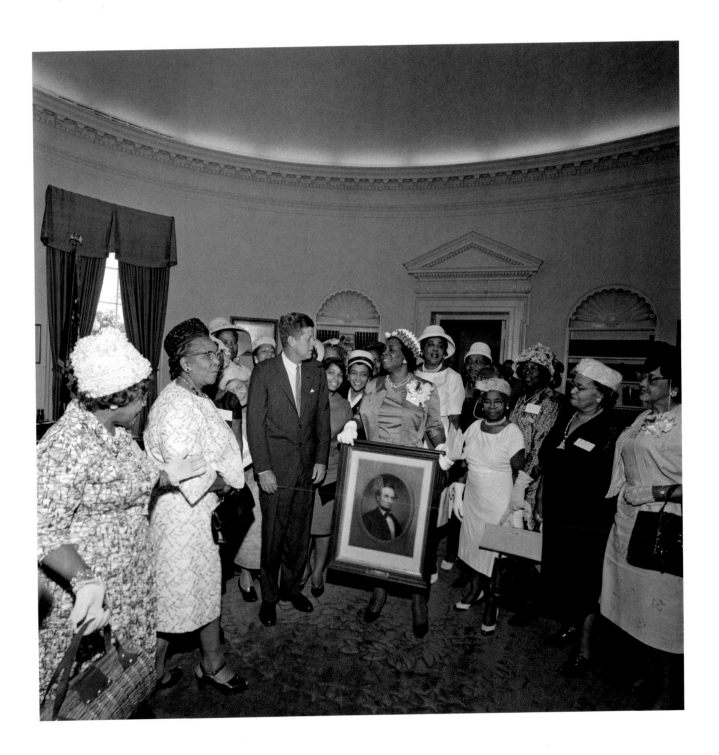

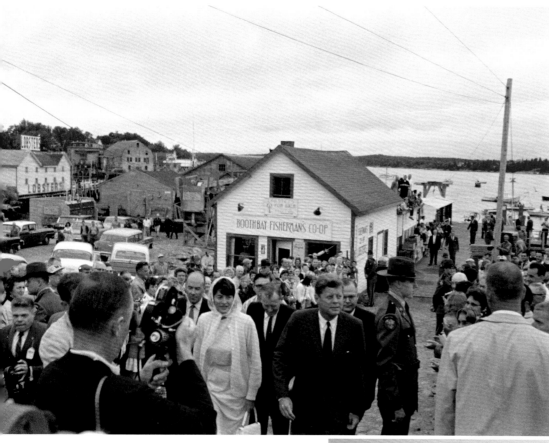

August 12 The president and his sister, Patricia Lawford, going to Mass at Boothbay Harbor, Maine.

August 15 The president greeting a delegation of officials and chiefs from the American Indian Chicago Conference on the White House South Lawn.

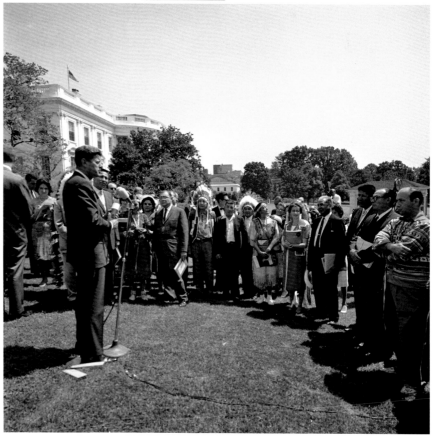

August 16 A meeting with General Douglas MacArthur in the Oval Office.

August 17 Kennedy's western state conservation tour began in Pierre, South Dakota, where he dedicated the Oahe Dam on the Missouri River.

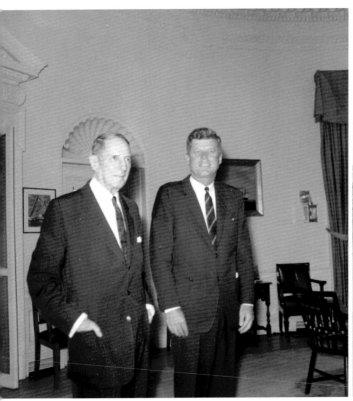

September 5 The president signing a bill placing Frederick Douglass's home in Washington, D.C., in the National Park System.

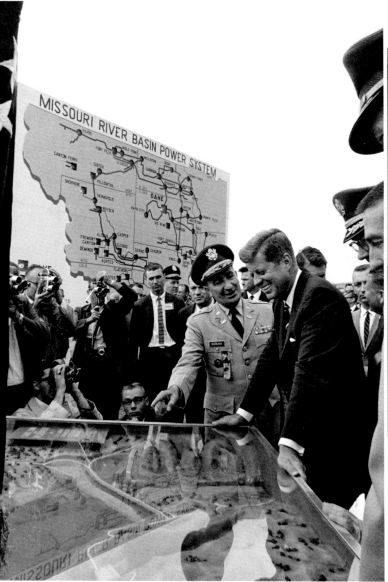

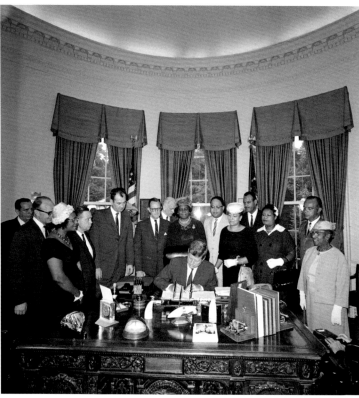

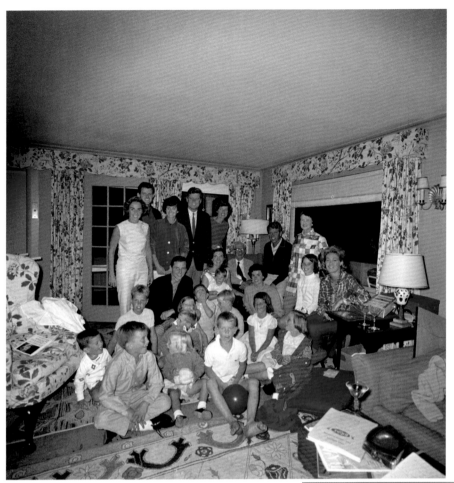

September 8 The Kennedy clan gathers to celebrate two days after the birthday of Joseph P. Kennedy. The adults, left to right, are: Ethel Kennedy; Edward Kennedy; Jean Smith; Steve Smith (kneeling); the president; Eunice Shriver; the first lady; Joseph Kennedy, Sr. (in chair); Ann Gargan (kneeling); Robert Kennedy; Rose Kennedy; and Joan Kennedy.

President Kennedy joins in a birthday sing-along with Joan Kennedy; Ann Gargan (behind); Eunice Shriver; Jacqueline Kennedy (behind); Ethel Kennedy; Jean Smith; Edward Kennedy (behind); Robert Kennedy; and Steve Smith.

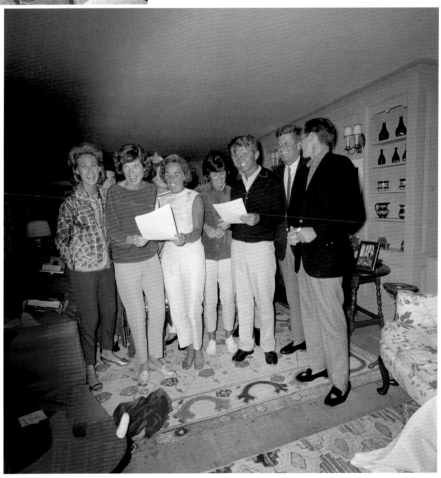

September 10 Two presidents, the thirty-fifth and thirty-fourth, together in the Oval Office.

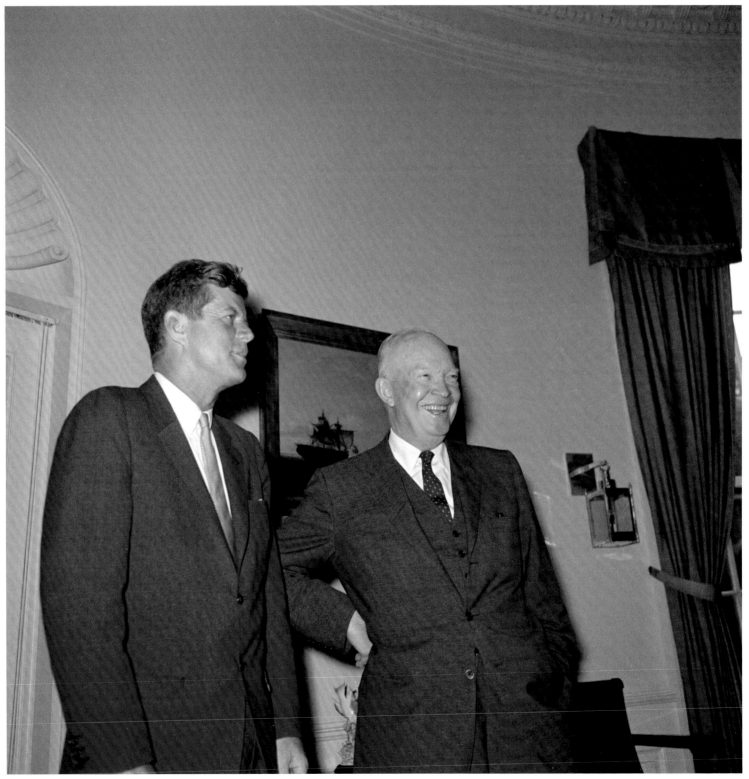

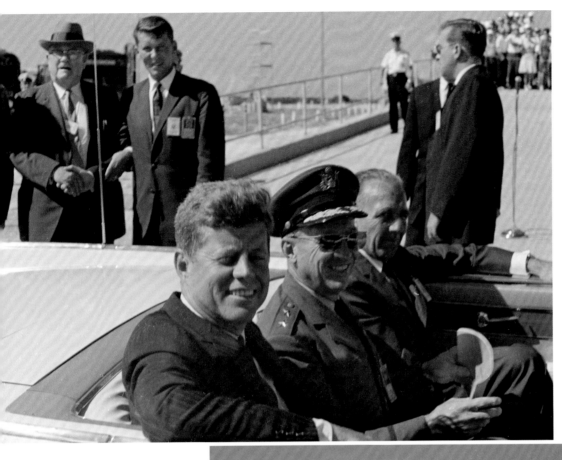

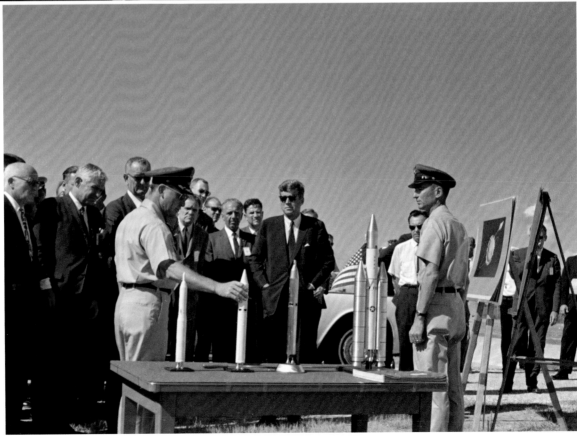

September 11 Kennedy visits NASA facilities at Cape Canaveral,
Florida, and Huntsville, Alabama.

In Huntsville, the president and vice president talk with scientist
Dr. Wernher von Braun in front of a Saturn rocket.

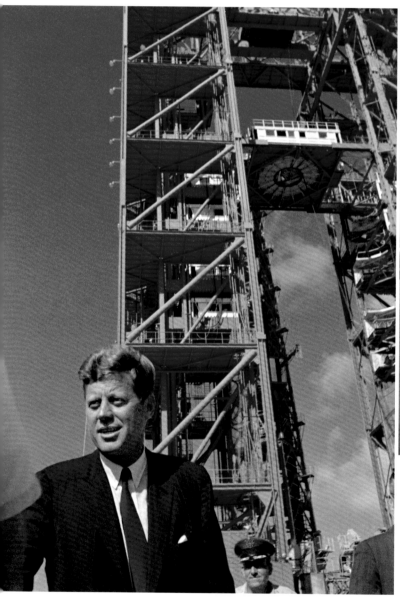

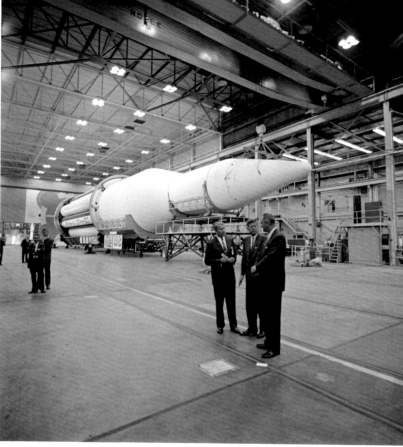

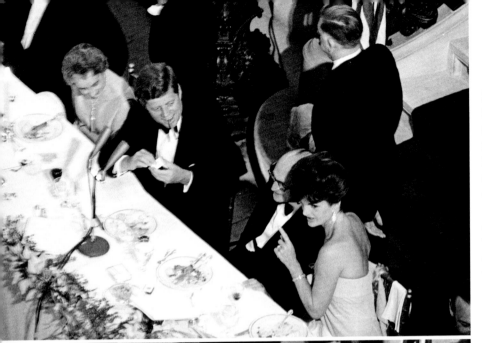

September 14 Jacqueline Kennedy preferred gracious Newport, Rhode Island, where she had summered as a girl, to the rough-and-ready ocean life of the Kennedys of Hyannis Port, Massachusetts. She had no trouble, however, getting her husband, the enthusiastic sailor, to Newport in 1962 for the eighteenth America's Cup final between the American sailboat, *Weatherly*, and Australia's first contender, the *Gretel*. Both Kennedys were in their element at the glamorous dinner at The Breakers before the race began. Said the president that night, "I really don't know why it is that all of us are so committed to the sea, except I think it is because in addition to the fact that the sea changes and the light changes, and ships change, it is because we all came from the sea. We have salt in our blood, in our sweat, in our tears. We are tied to the ocean. And when we go back to the sea, whether it is to sail or to watch it, we are going back from whence we came."

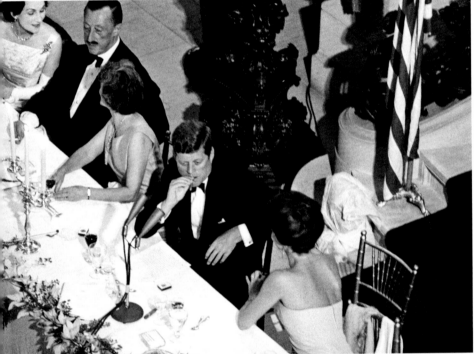

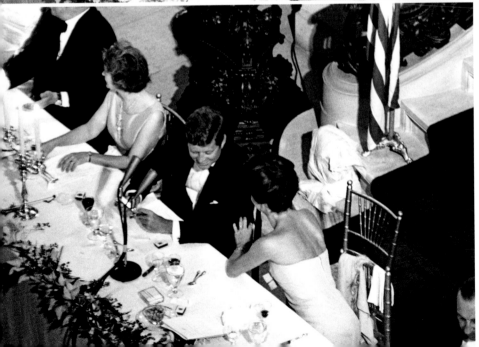

September 15 At the races. Kennedy and a bundled-up Pierre
Salinger aboard the USS *Joseph P. Kennedy Jr.*, watching the America's Cup
maneuvering off Newport.

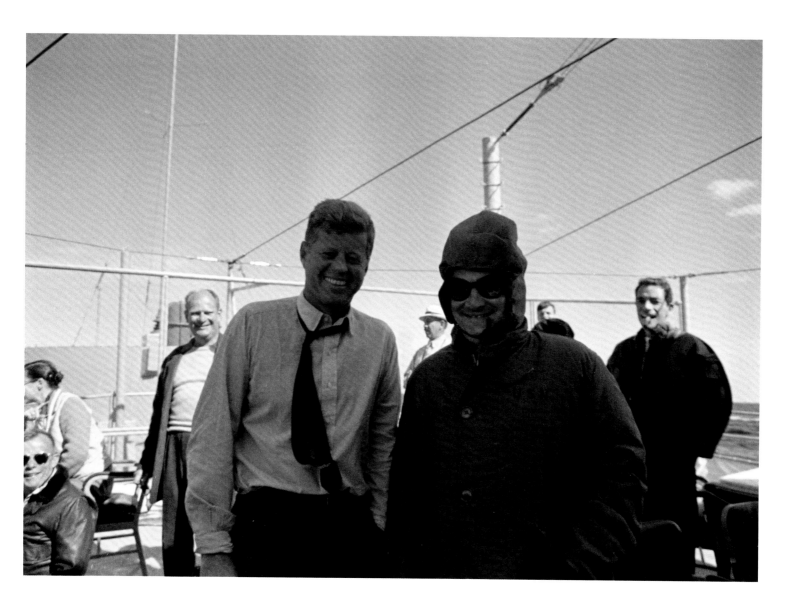

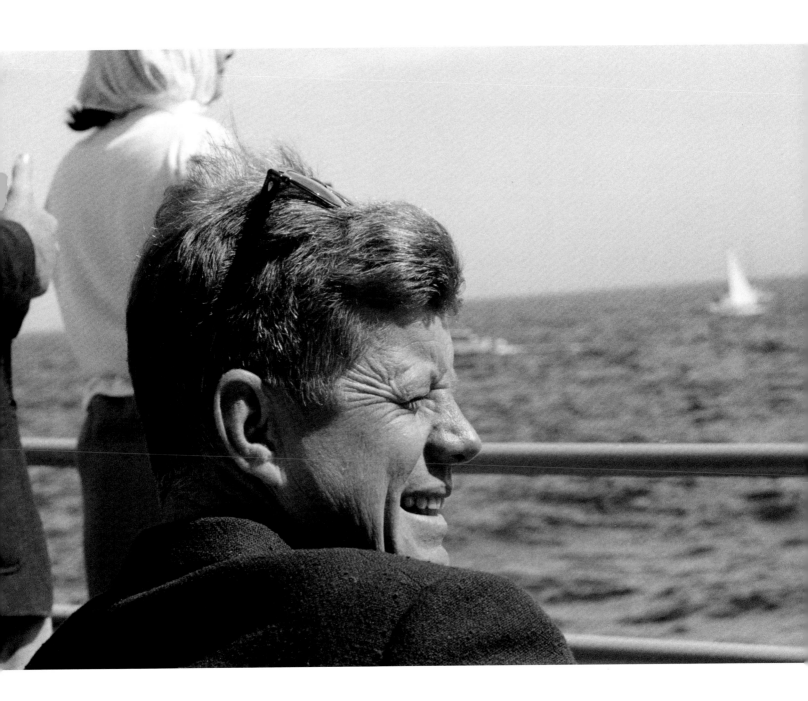

September 15 The president intent on the America's Cup, is later
joined in watching the race by the first lady.

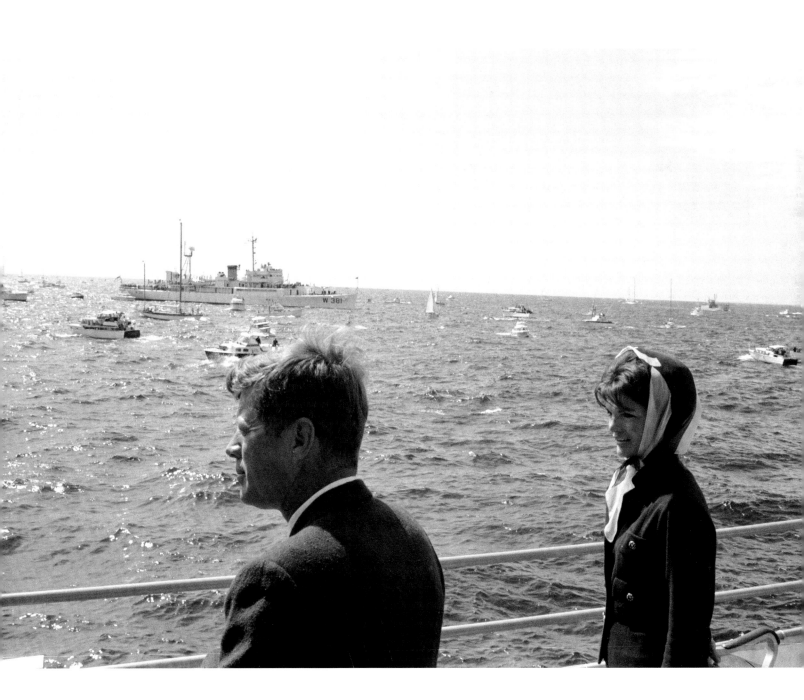

September 20, 27 and
October 5, 6 With the 1962
congressional elections coming up, the
president hit the road as often as he
could. He is shown here campaigning for
Democrats in Harrisburg, Pennsylvania,
on September 20; Wheeling, West
Virginia, on September 27; Cincinnati,
Ohio, on October 5; and stopping to
congratulate a bride and groom in
Detroit, Michigan, on October 6. Later
that day Kennedy greeted Democrats
in Muskegon, Michigan, and then spoke in
St. Paul, Minnesota; state attorney general
Walter Mondale is in the foreground.

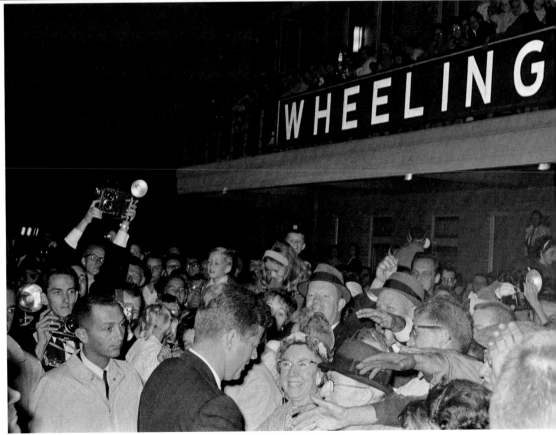

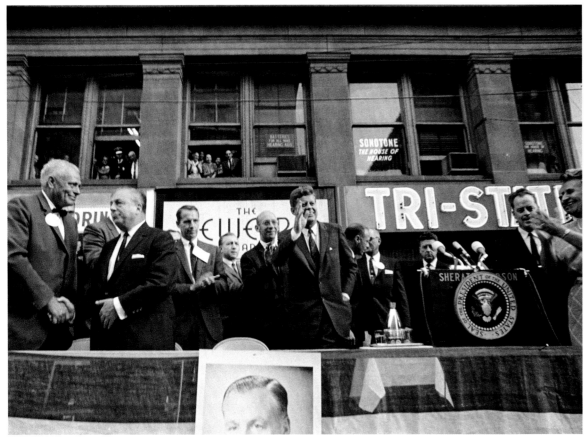

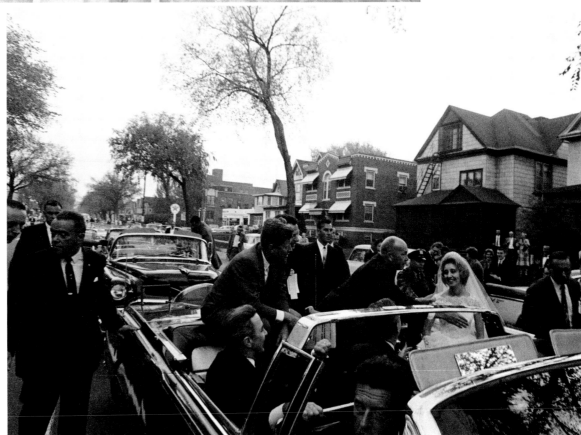

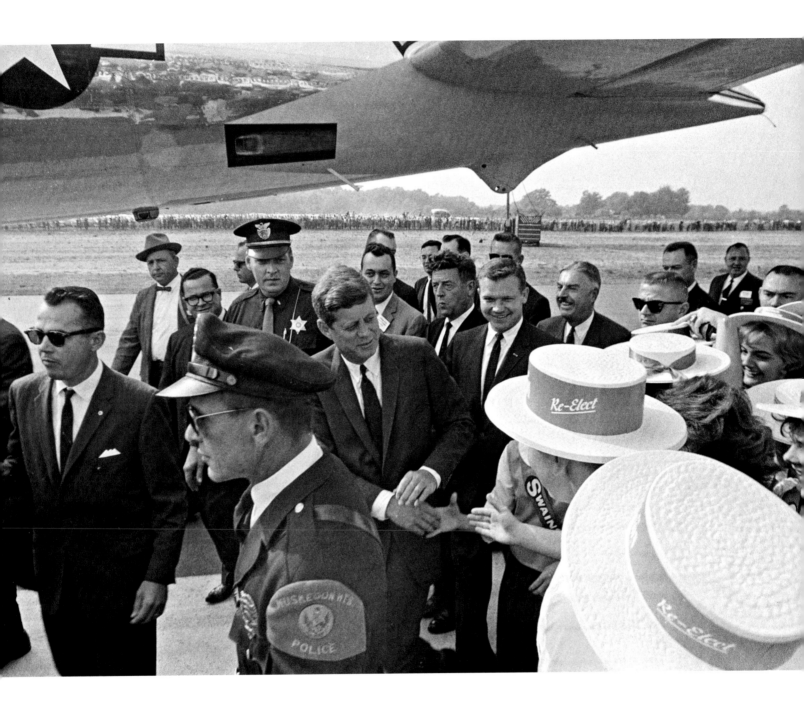

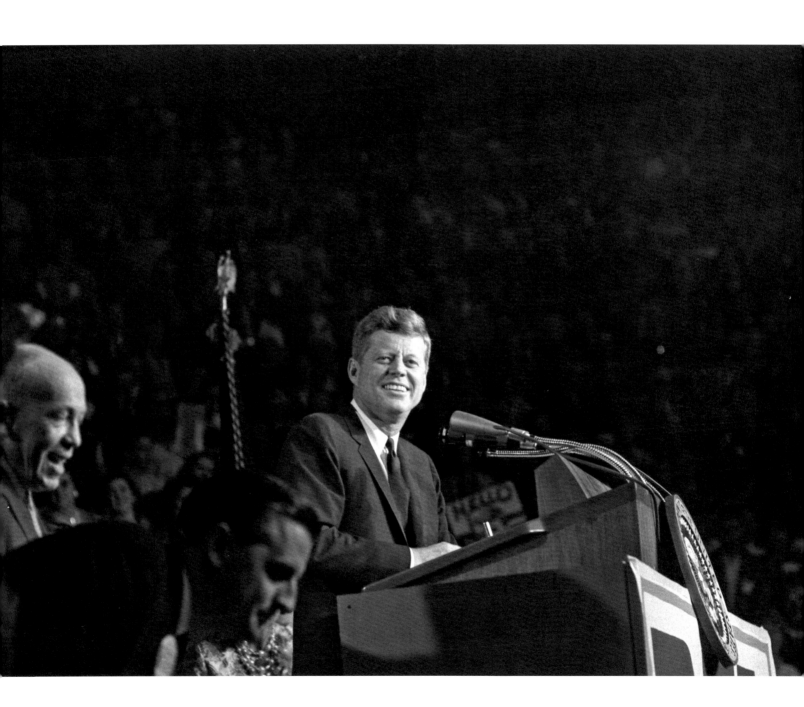

October 1 Kennedy watches as his brother swears in army general Maxwell Taylor, the president's principal military adviser, as chairman of the Joint Chiefs of Staff. The air force chief of staff, General Curtis LeMay, is standing in the back on left. LeMay later talked with Kennedy, whose body language seemed to reveal his feelings about the air force general. But both men knew that behind the routine business of swearings in, the White House had, for almost a month, been receiving hourly reports of a buildup of Soviet troops and equipment, including missile components, in Fidel Castro's Cuba. Republicans in Congress, particularly Senator Kenneth Keating from New York and Senator Homer Capehart from Indiana, who had access to some of the same information, were publicly calling on the president to act. Said Capehart: "It is high time the American people demand that President Kennedy quit 'examining the situation' and start protecting the interests of the United States."

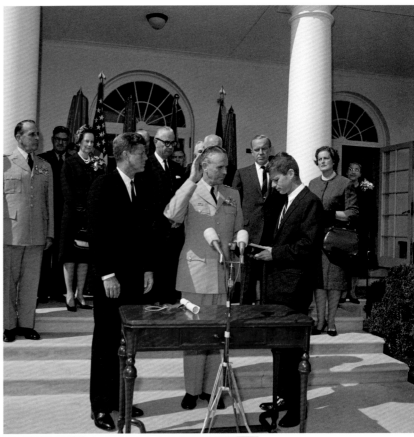

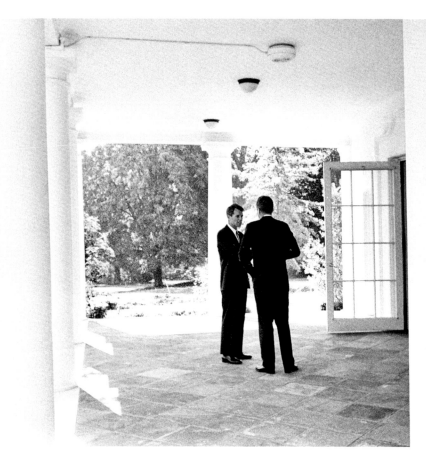

October 3 The brothers Kennedy conferring alone outside the president's office. The subject was Cuba. Ten Soviet ships had arrived there in the past six weeks, compared with a normal schedule of one every six weeks. Robert Kennedy and General Taylor met with the National Security Council's special group on counterinsurgency on October 9. Again, the subject was Cuba—even as the president was stating he had no evidence of increased Soviet activity on the island ninety miles off the coast of Florida.

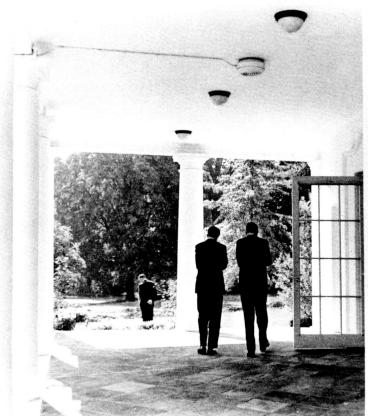

October 10 The president and his children playing in the Oval Office. Often, as soon as Mrs. Kennedy—ever the protective mother—left on a trip, Kennedy would call in photographers to shoot photos like these. Many would be published in mass-circulation magazines such as *Life* and *Look*.

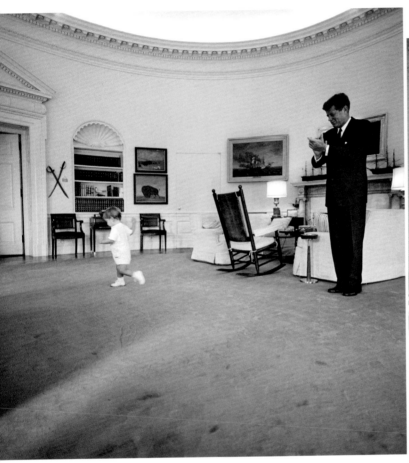

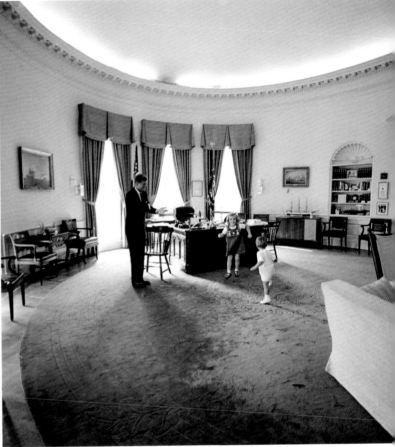

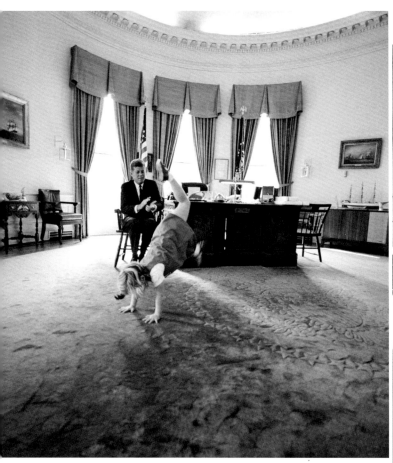

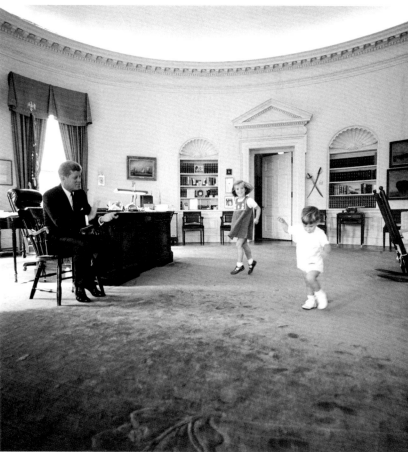

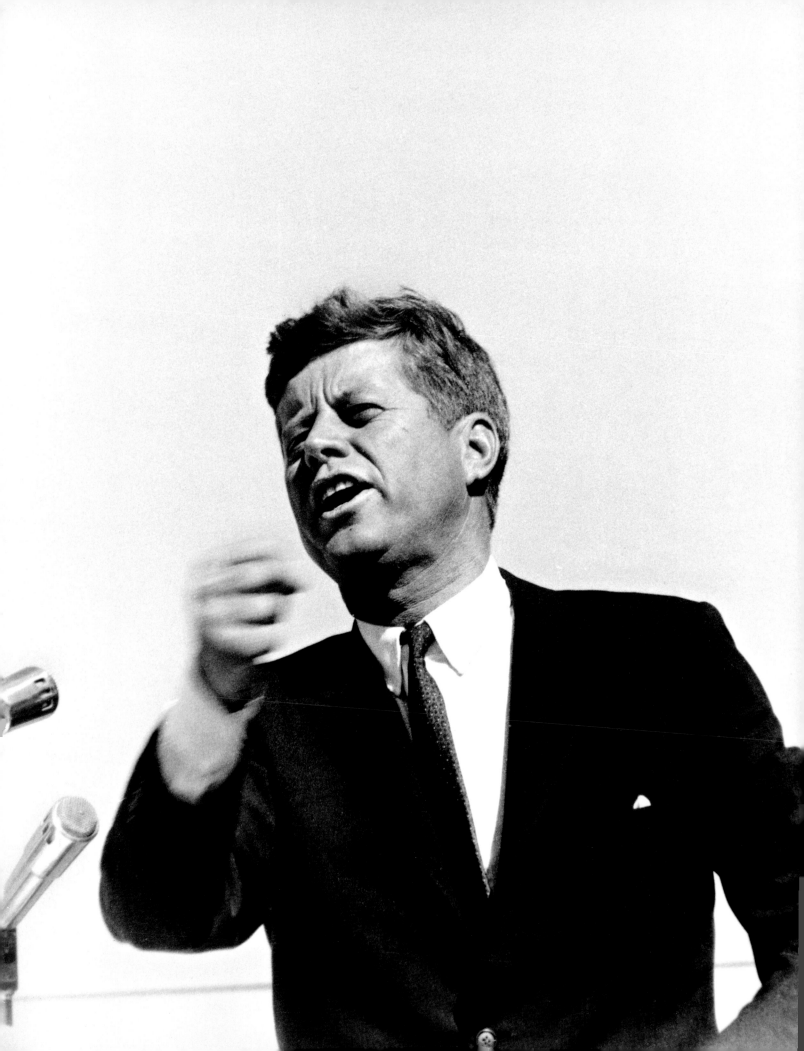

October 13, 14, 17 While secret meetings on the Cuban situation were being held around the clock in the White House, the president was determined to act as if all was calm and normal. Midterm elections were a little more than two weeks away when Kennedy left Washington to campaign for Democratic congressional candidates in Monessen, Pennsylvania; Buffalo, New York; and Bridgeport, Connecticut. "We want to look as if nothing unusual is going on around here," the president warned staff and Cabinet members.

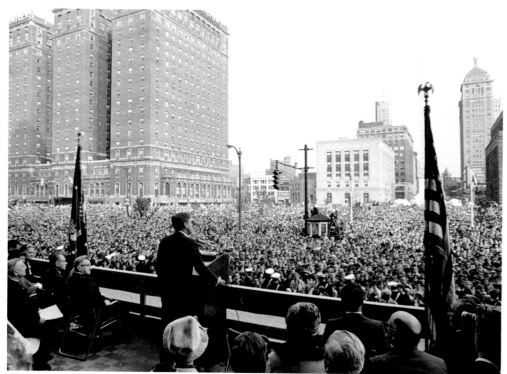

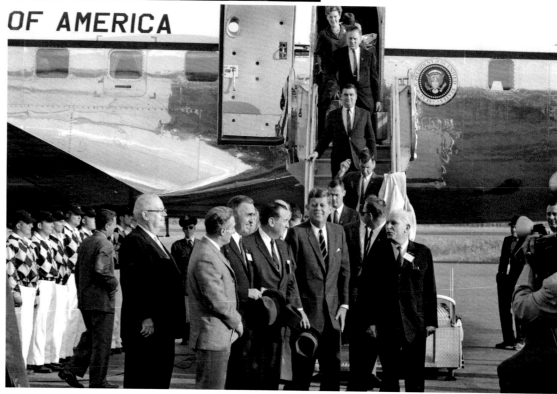

October 18 Soviet foreign minister Andrei Gromyko (right) came to the White House with ambassador Anatoly Dobrynin (center) and deputy foreign minister Vladimir Semenor (left). Gromyko read from a prepared statement: "I have been instructed to make it clear that the purpose of any arms in Cuba is by no means offensive." Kennedy, who had aerial maps of the Soviet's Cuban installations in his desk, slowly read a statement he had first made on September 4, saying that "the gravest issues will arise" if offensive missiles were discovered in Cuba. After the tense meeting ended, the president told one adviser, Robert Lovett, "Gromyko in this very room not over ten minutes ago told more bare-faced lies than I have ever heard in so short a time."

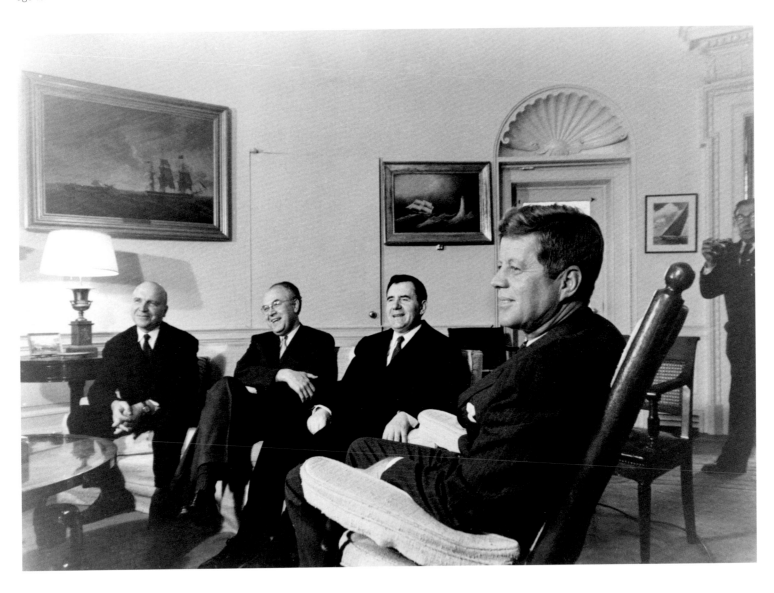

October 19 Continuing to project "business-as-usual," the president went back on the campaign trail, stopping first in Cleveland, Ohio, and then Chicago, Illinois. But that morning he had been told that the Joint Chiefs of Staff and several members of his Cabinet had informally voted to recommend launching air strikes on the Soviet missile installations in Cuba before the Soviets' new weapons were ready for firing. The following morning, October 20, Kennedy told the traveling press he was ill, canceled campaign stops in Wisconsin, and returned to Washington. By now, an official "Executive Committee" of high officials, civilian and military, were meeting for hours every day in the White House, secretly debating two principal American options: bombing or blockading Cuba.

October 22 At 7 PM, the president went on national television to make the most dramatic statement of his life, addressing the possibility of history's first nuclear war: ". . . Within the past week, unmistakable evidence has established the fact that a series of offensive missile sites is now in preparation on that imprisoned island [Cuba]. The purpose of these bases can be none other than to provide a nuclear strike capability against the Western Hemisphere." Kennedy then announced a "quarantine" on all shipments of war-making material to Cuba by sea. He concluded, "It shall be the policy of this nation to regard any nuclear missile launched from Cuba against any nation in the Western Hemisphere as an attack by the Soviet Union on the United States, requiring a full retaliatory strike upon the Soviet Union."

October 23 The next morning the president signed an official order authorizing American ships to stop and board Soviet vessels in the Atlantic Ocean and the Caribbean Sea.

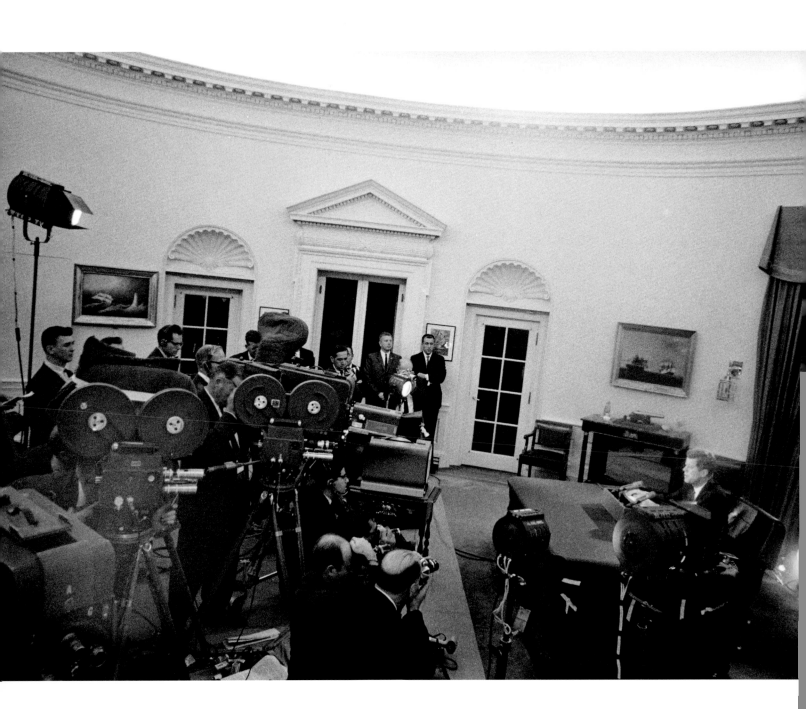

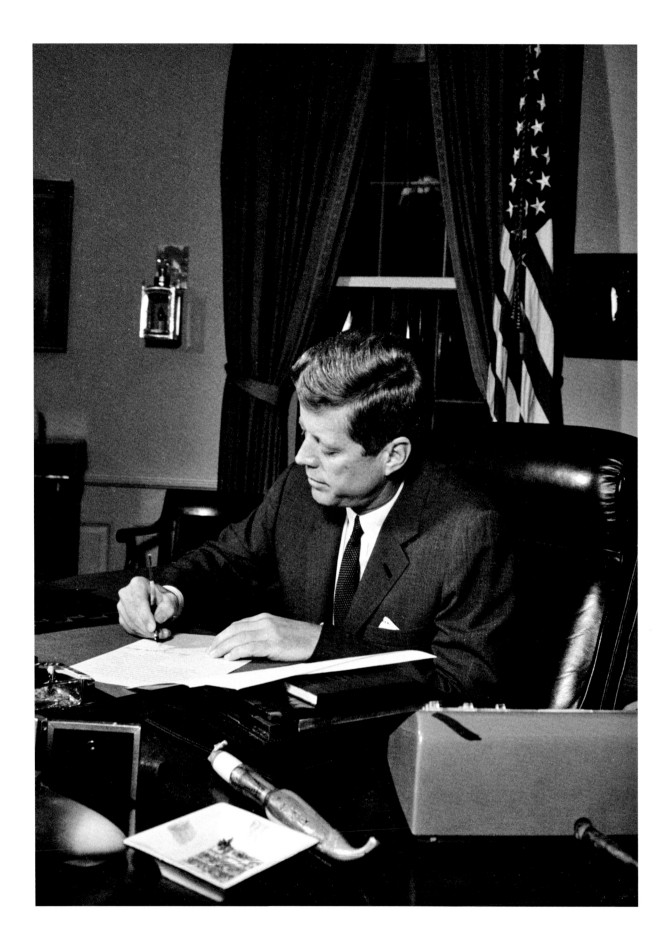

October 29 EXCOMM, officially the Executive Committee of the National Security Council, met almost around the clock for thirteen days in October. At this session, the president is presiding, sitting between Secretary of State Rusk and Secretary of Defense McNamara. Among the others in the room were Robert Kennedy, national security adviser McGeorge Bundy, special counsel and adviser Ted Sorensen, and undersecretary of state George W. Ball. During this session, Kennedy and McNamara stepped outside to talk alone under the colonnade of the West Wing. It was the day the crisis, the closest the world had come to nuclear war, came to an end. Soviet Premier Khrushchev, after an exchange of confusing letters with Kennedy, accepted an American pledge not to invade Cuba and to eventually remove U.S. Jupiter missiles from Turkey after the Soviets removed theirs from Cuba.

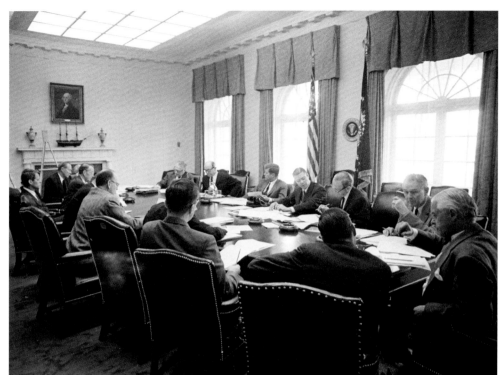

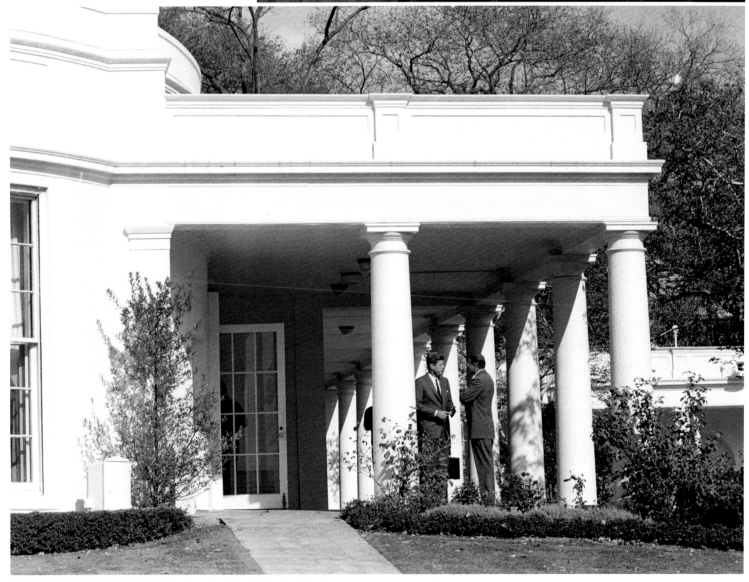

November 1 White House life returned to something like normal as the president prepared to televise an appeal to voters to exercise their privilege the next day.

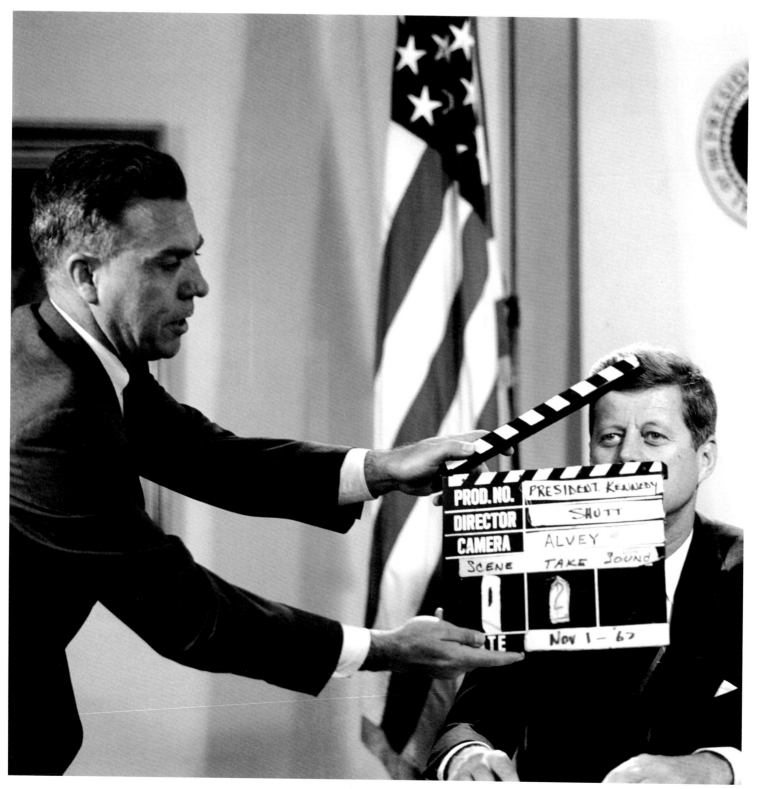

November 10 The president and Mrs. Kennedy and former presidents Harry S. Truman and Dwight D. Eisenhower at the funeral of Eleanor Roosevelt in Hyde Park, New York. Kennedy's fabled charm never impressed the former president's widow, a power in the Democratic Party who favored Adlai Stevenson for the presidential nomination in 1960. Her last communication with Kennedy was a note advising him to hire a voice coach to get more warmth into his speeches.

November 14 Two-year-old John F. Kennedy, Jr., looking a bit dubious about the grandfatherly embrace of West Germany's chancellor, Konrad Adenauer, at the White House.

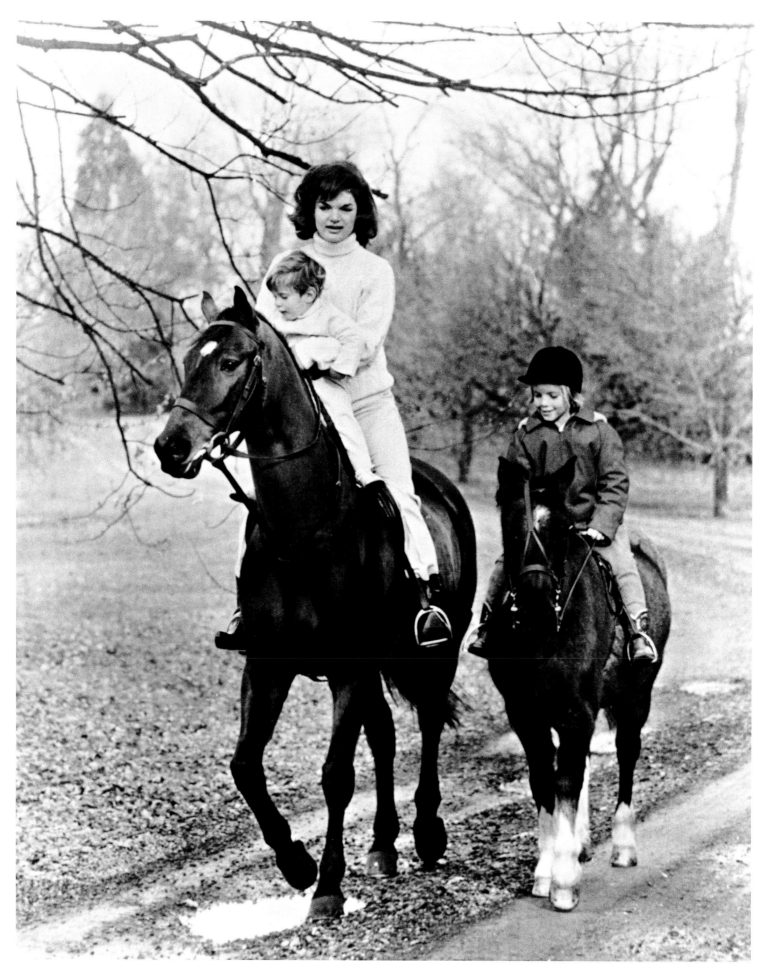

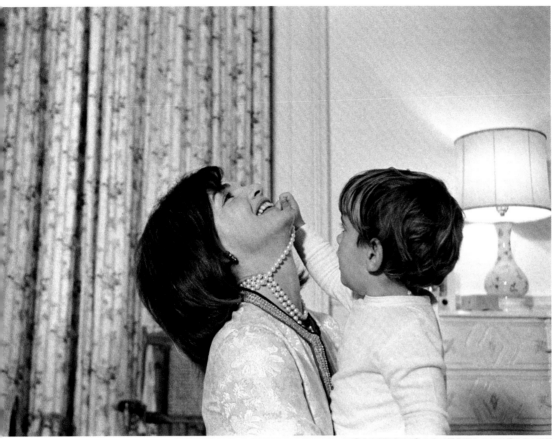

November 19, 27

Jacqueline Kennedy on her Arabian horse, Sardar, holds John Jr. while Caroline rides along on her pony Macaroni. In the White House nursery on Caroline's fifth birthday, which was also celebrated with a party later that day.

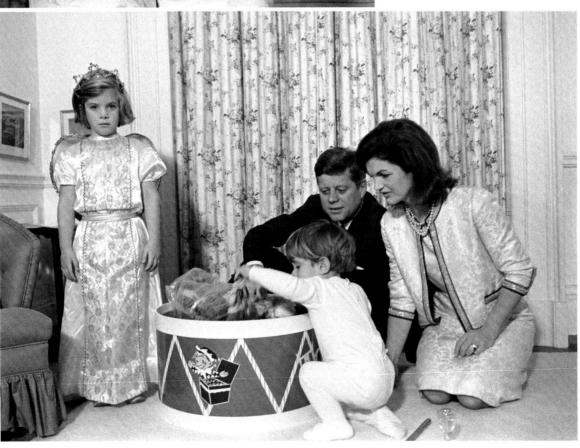

November 26 The president reviewing navy jet squadrons at Boca Chica Naval Air Station in Boca Raton, Florida. Later, *Air Force One* stopped at Fort Stewart, Georgia, where Kennedy, accompanied by the chairman of the Joint Chiefs of Staff, General Maxwell Taylor (right), inspected mobile missile launchers and their weapons. Taylor was one of Kennedy's most important military advisers.

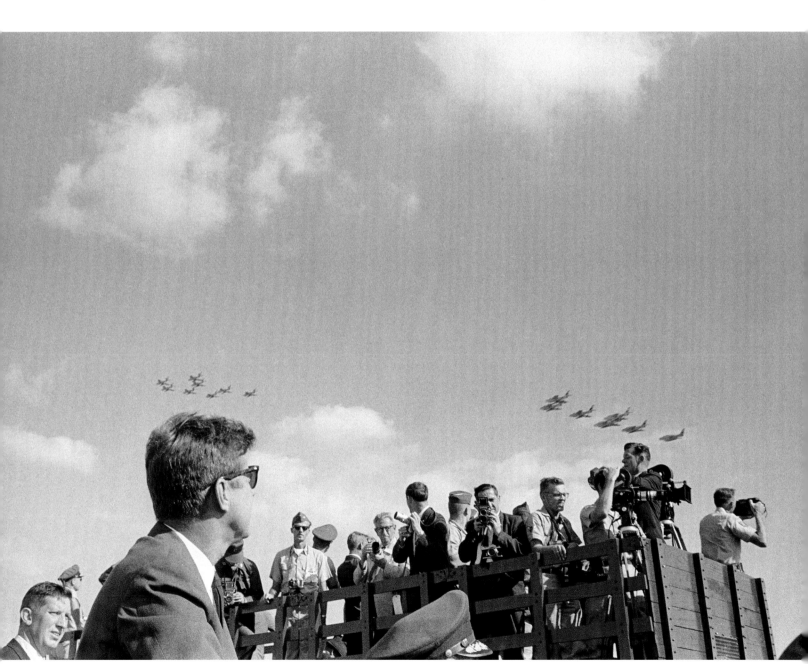

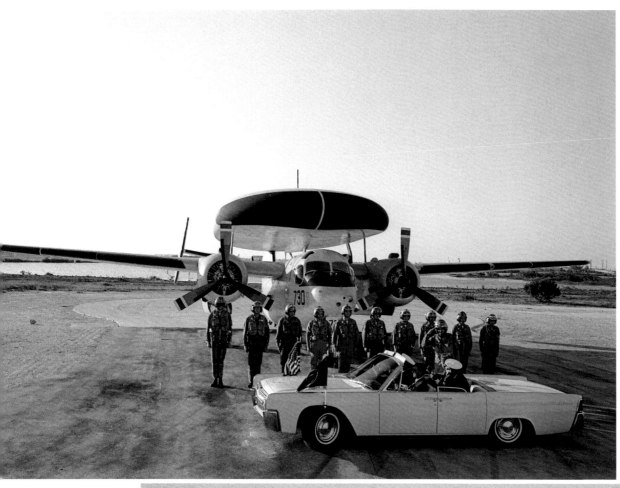

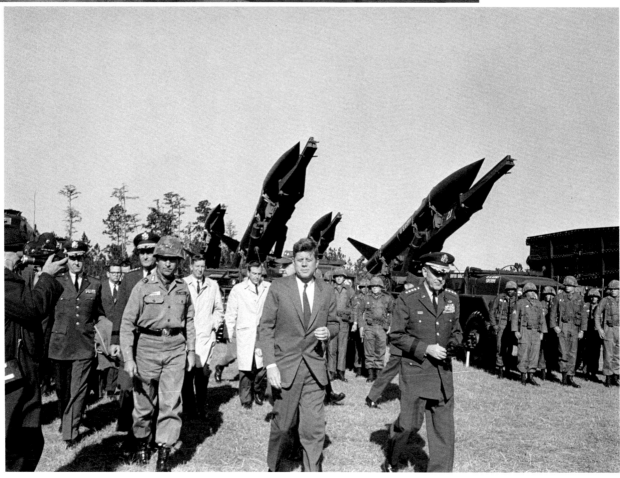

The president and Dave Powers (far right) welcoming entertainers Judy Garland and Danny Kaye in the Oval Office.

November 30 Mrs. Kennedy, holding John Jr., as she leaves the
White House to watch her husband board a helicopter for the short flight
to Andrews Air Force Base, where Kennedy will greet the president of
Honduras, Ramón Villeda Morales.

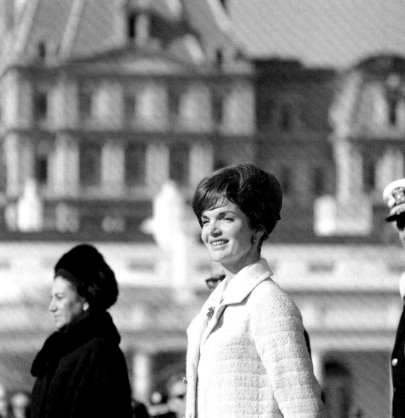

December 1 The president, along with Vice President Johnson and
Secretary of Defense McNamara, meeting with the Joint Chiefs of Staff in
Palm Beach, Florida.

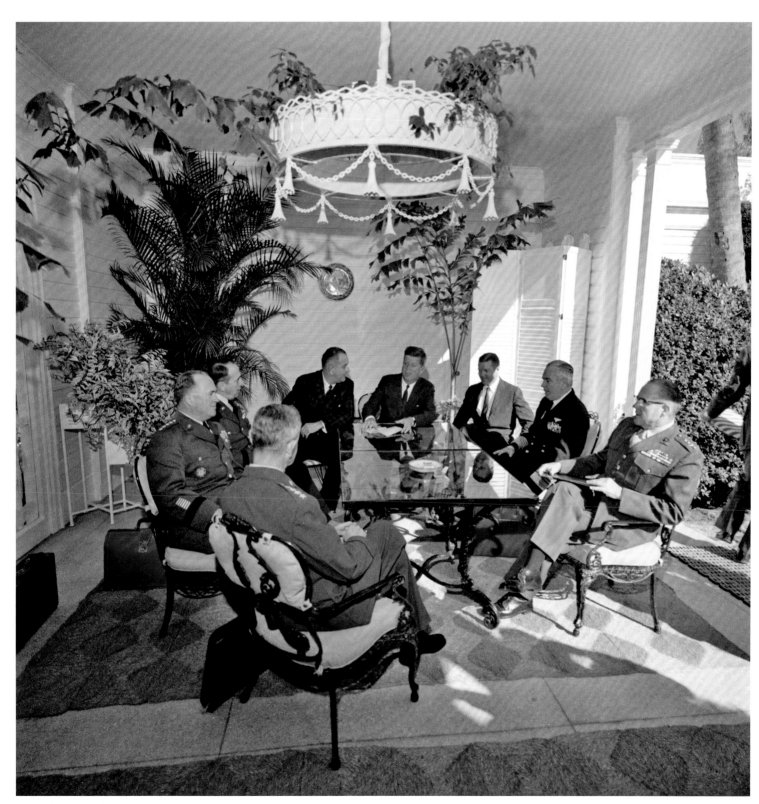

December 1 Kennedy crossing from the navy side of the field to
the army side during halftime of the 1962 Army–Navy football game in
Philadelphia's Municipal Stadium.

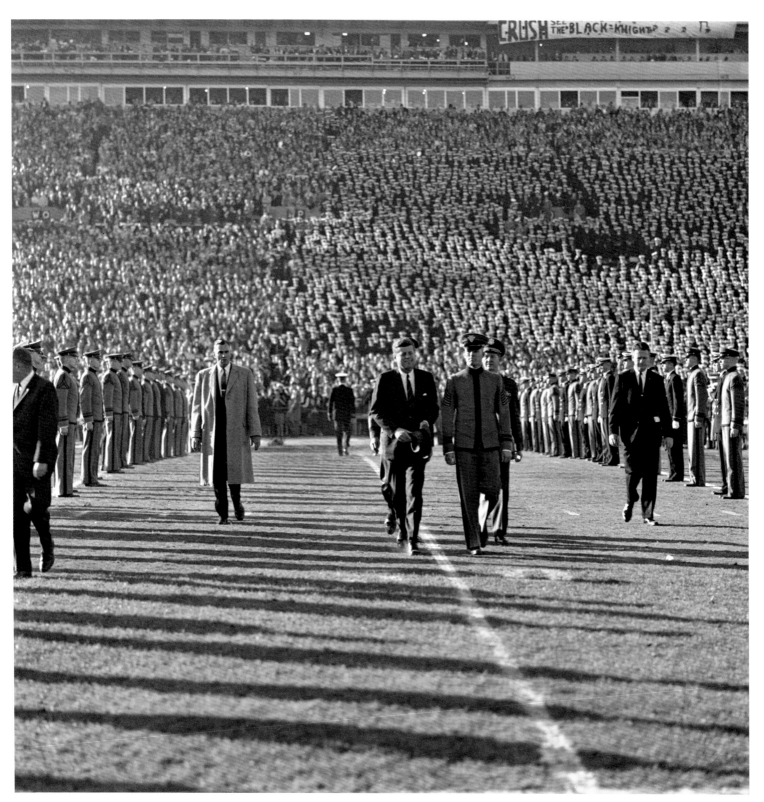

December 4 The president greeting a delegation of radio station representatives, who received certificates of appreciation for their help during the Cuban Missile Crisis. Standing behind the president, holding papers, is the director of the United States Information Agency, the former CBS broadcaster, Edward R. Murrow.

December 6 The president with his mother, Mrs. Rose Kennedy, at the International Awards Dinner of the Joseph P. Kennedy, Jr. Foundation.

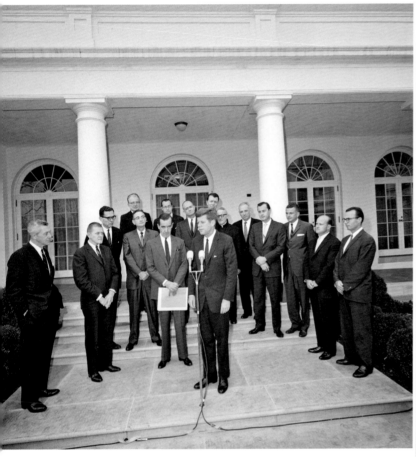

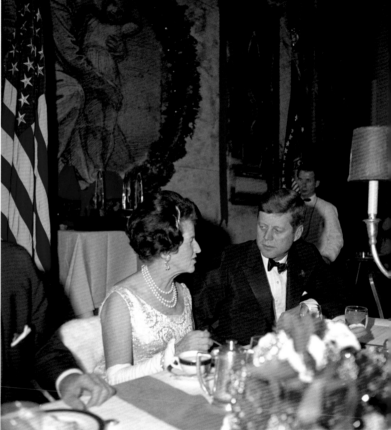

December 10 Kennedy, Secretary of State Rusk, and Secretary of Defense McNamara enjoy a laugh at what appears to be an unusually relaxed meeting in the Oval Office.

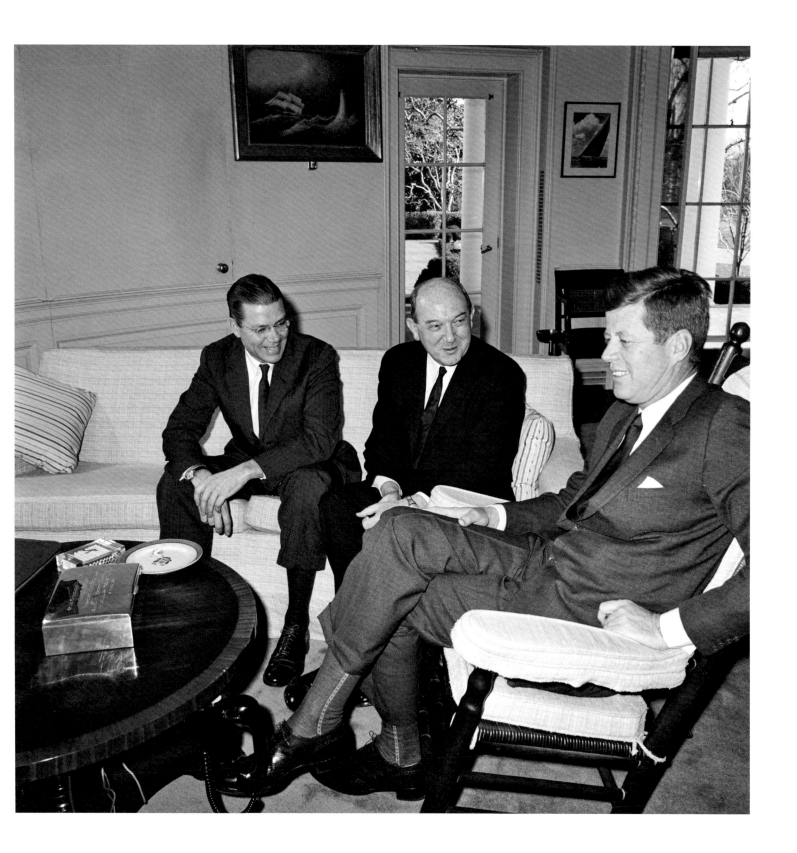

December The first lady, John Jr., and their German shepherd, Clipper, on another White House sledding day; they're later met by the president outside the Oval Office.

Pushinka, a dog given to Caroline Kennedy by Soviet premier Nikita Khrushchev, tries out the slide on the White House lawn.

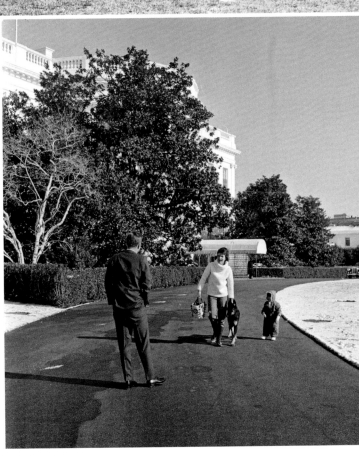

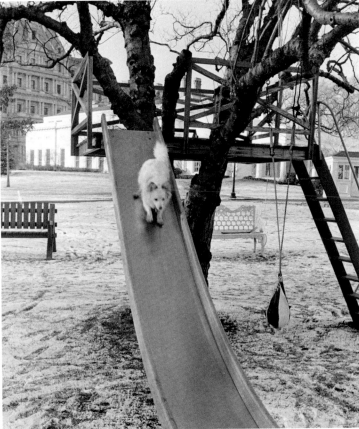

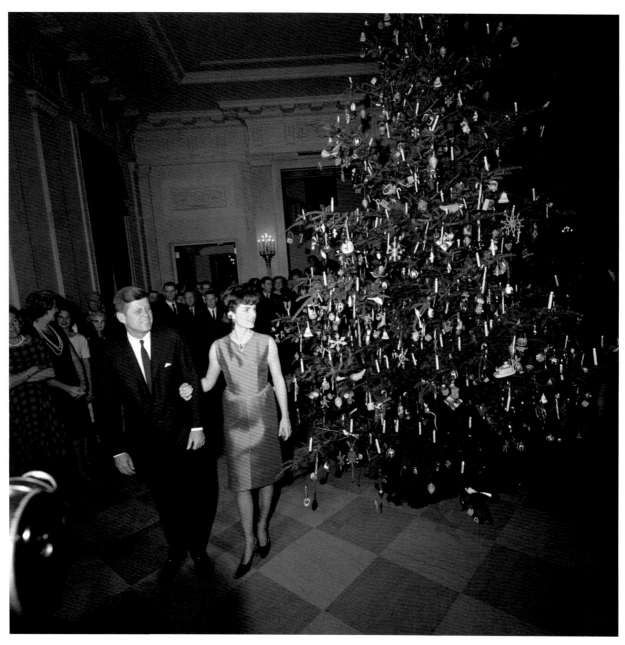

December 12 The Kennedys at the White House Christmas Party.

December 16 The president sat for a two-hour interview that was broadcast as *After Two Years—A Conversation with the President* by all three television networks (ABC, NBC, and CBS) on December 17. Correspondents from the three networks (from the right): George Herman of CBS, Sander Vanocur of NBC, and William Lawrence of ABC. Lawrence asked Kennedy about the role of advisers and the president replied, "Unfortunately your advisers are often divided. If you take the wrong course, and on occasion I have, the president bears the burden of responsibility, quite rightly. The advisers may move on to new advice." When Kennedy's friend Benjamin Bradlee, at the time the Washington bureau chief for *Newsweek*, called to congratulate him on his performance, the president said, "Well, I always said that when we don't have to go through you bastards, we can really get our story over to the American people." Unhappily, Bradlee said, "I'm afraid you're right."

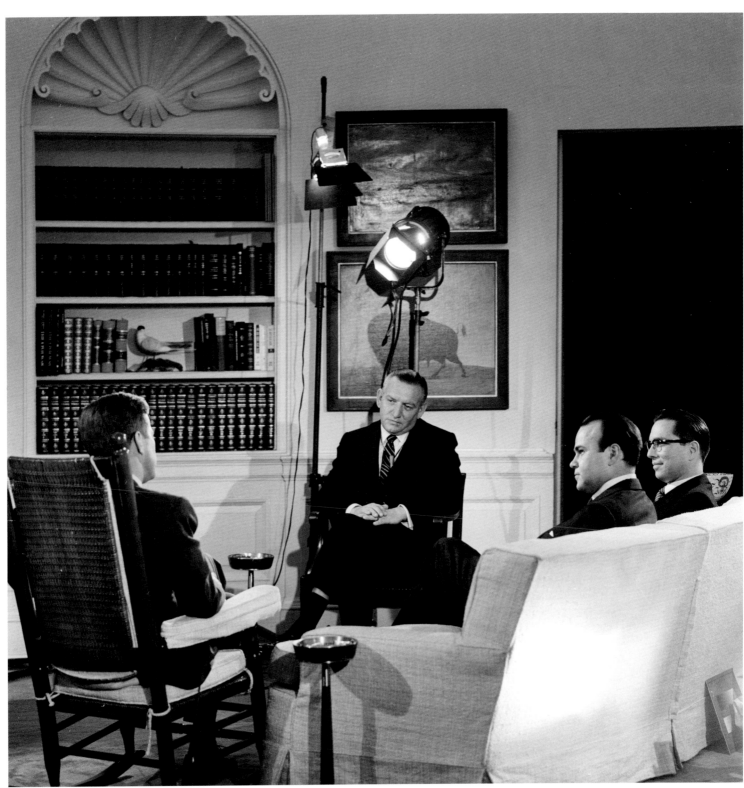

December 19 The president and British prime minister Harold Macmillan at a two-day meeting in Nassau, the Bahamas. The "summit" was set up to bolster Macmillan's political standing at home. The British leader had been embarrassed by an American decision to drop Skybolt, a nuclear missile program, after four unsuccessful tests. That decision angered British leaders because the program had been specifically designed to give Great Britain a more modern nuclear capability than atomic bombs carried by airplanes. To make up for the Skybolt decision, Kennedy told Macmillan the United States would provide Polaris nuclear missiles for British submarines. While in Nassau, Kennedy received a letter he had been hoping to see for two years. Soviet premier Khrushchev wrote, saying, "The period of maximum crisis and tension in the Caribbean is behind us. We are now free to consider other international matters, in particular a subject that has long been ripe for action—the cessation of nuclear tests . . ."

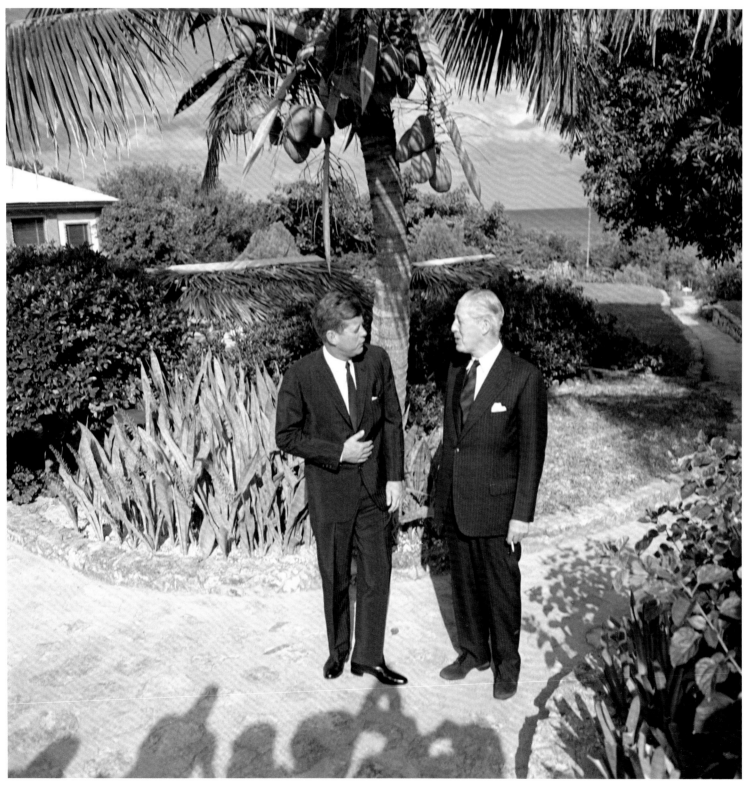

December 24 Christmas Eve for the Kennedys, included Jackie's sister Lee and her husband, Prince Stanislaw "Stash" Radziwill at the family home in Palm Beach, Florida.

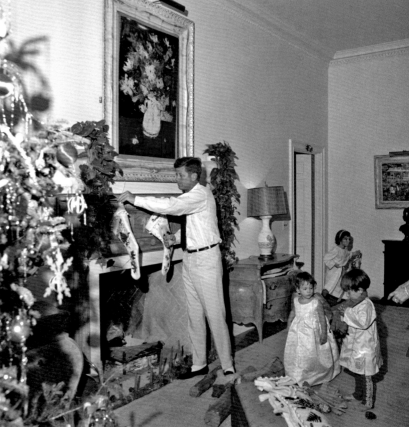

December 27 Among the holiday season visitors to Palm Beach was Golda Meir, once a schoolteacher in Milwaukee and now the foreign minister of Israel.

December 29 The Kennedys board *Marine One*, the presidential helicopter, at Palm Beach for the short run to Miami.

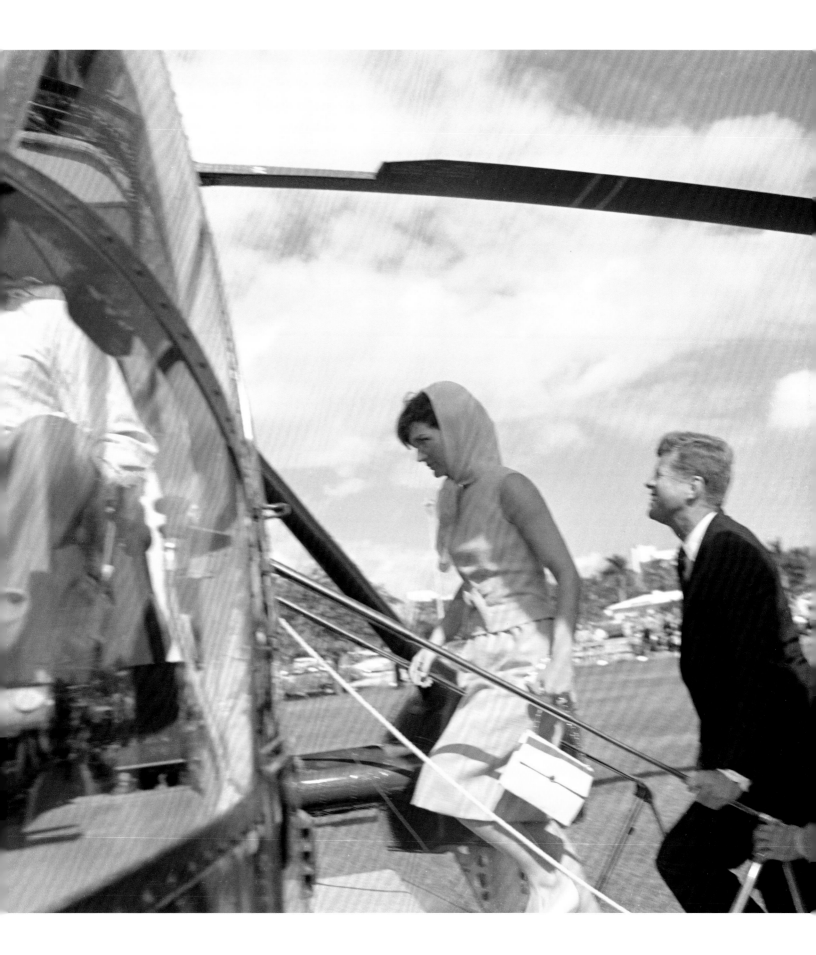

December 29 Waiting for the Kennedys at the Orange Bowl were the survivors of Brigade 2506—the Cubans who had escaped the failed Bay of Pigs invasion, their family members, and other exiled Cubans. The president had been prepared to read a rather cool and diplomatic speech. But as the crowd of forty thousand cheered, a brigade member handed Kennedy a flag the survivor had hidden in a Cuban prison for twenty months. The president got carried away and said, "I want to express my great appreciation to the brigade for making the United States the custodian of this flag. I can assure you that this flag will be returned to this brigade in a free Havana." Mrs. Kennedy translated her husband's words into perfect Spanish, a touch that brought cheer after cheer from the Cubans.

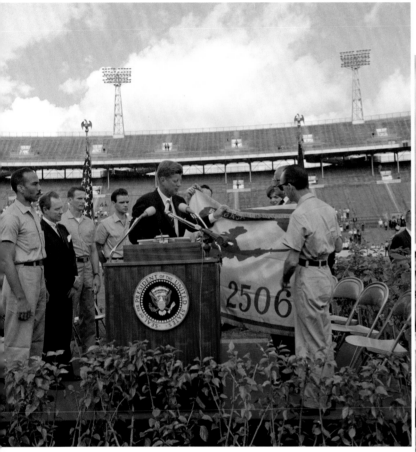

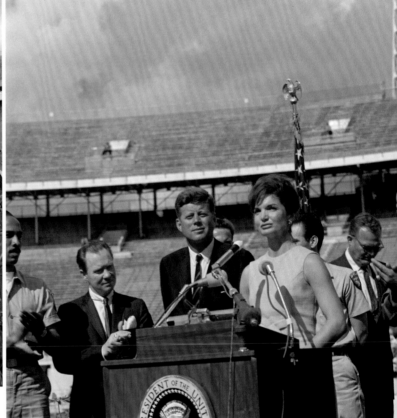

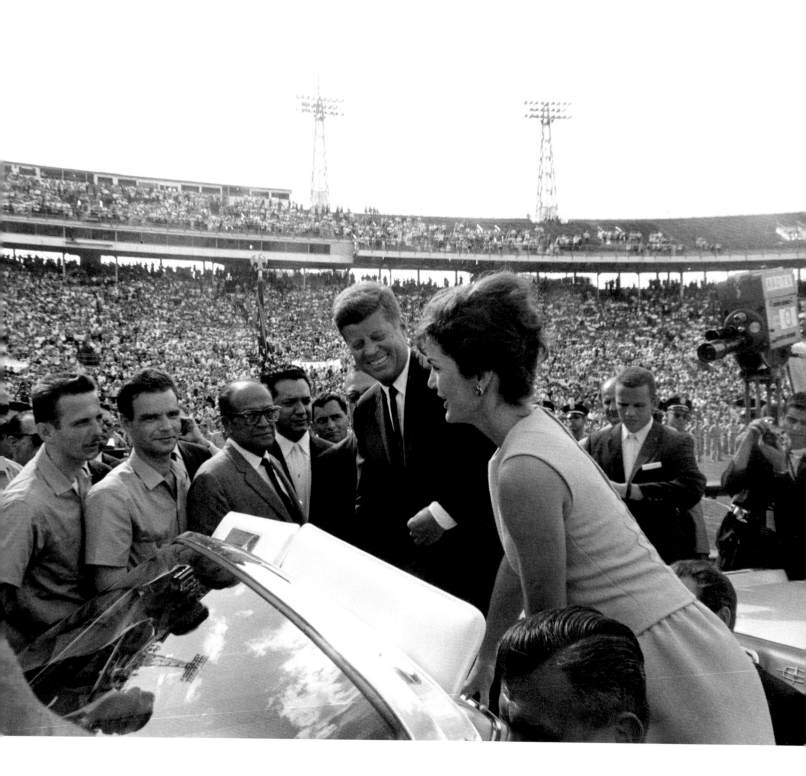

January 1 The Kennedys on their way back from Mass in Palm Beach on New Year's Day.

Later that day the president helicoptered to Miami for the Orange Bowl, where he tossed the coin for field position in the game between the universities of Alabama and Oklahoma.

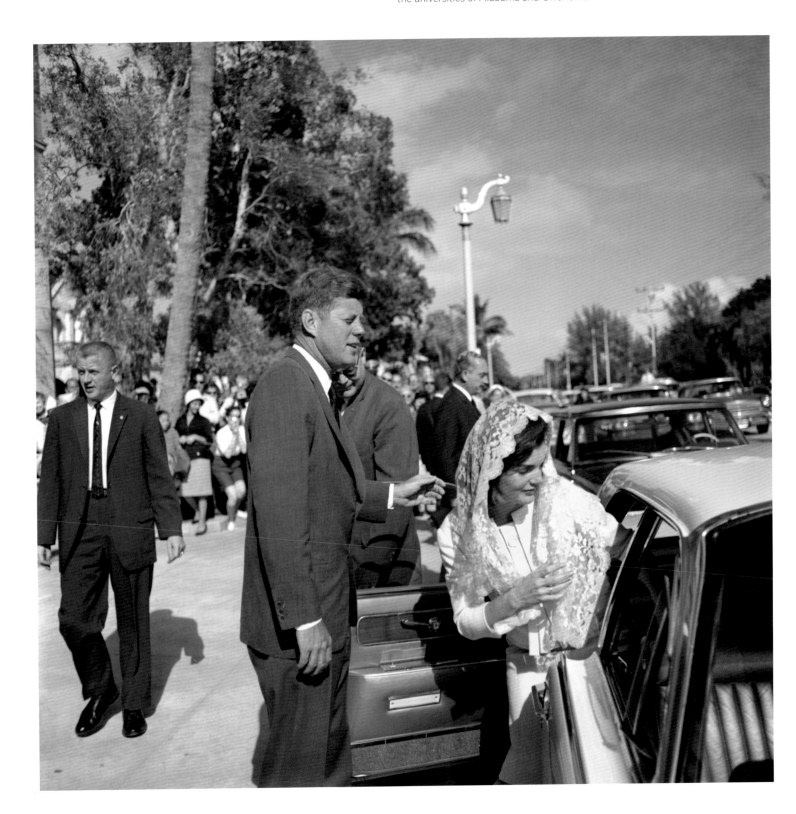

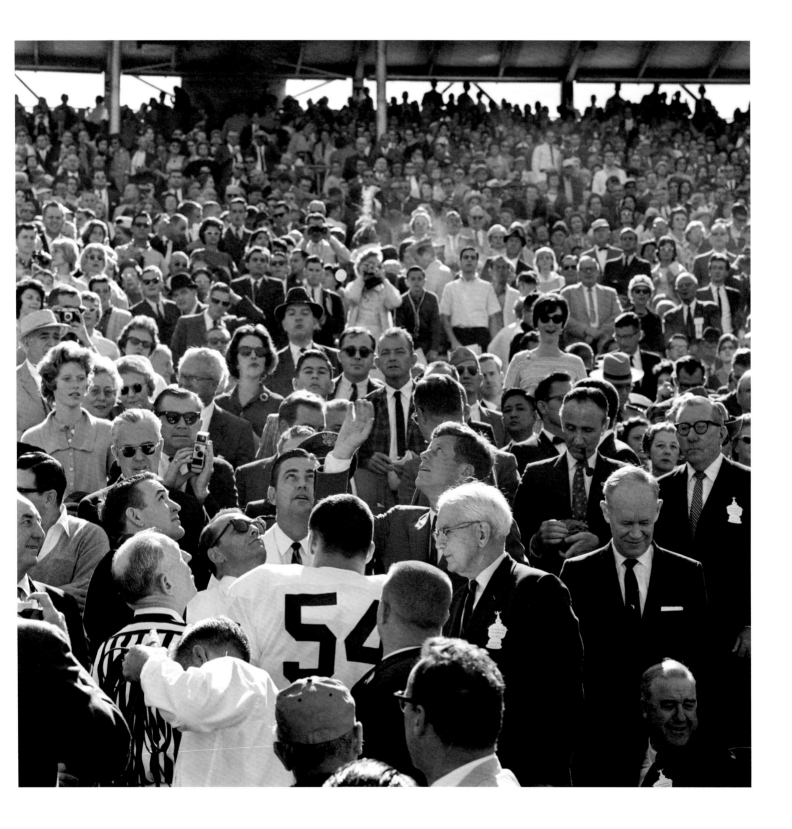

The president at the wheel, a practice discouraged by the Secret Service, with Mrs. Kennedy; Caroline and Mrs. Kennedy's sister, Princess Lee Radziwill; and her husband, Prince Radziwill. The Polish prince's title dated back to the early sixteenth century, though it was now only a courtesy title.

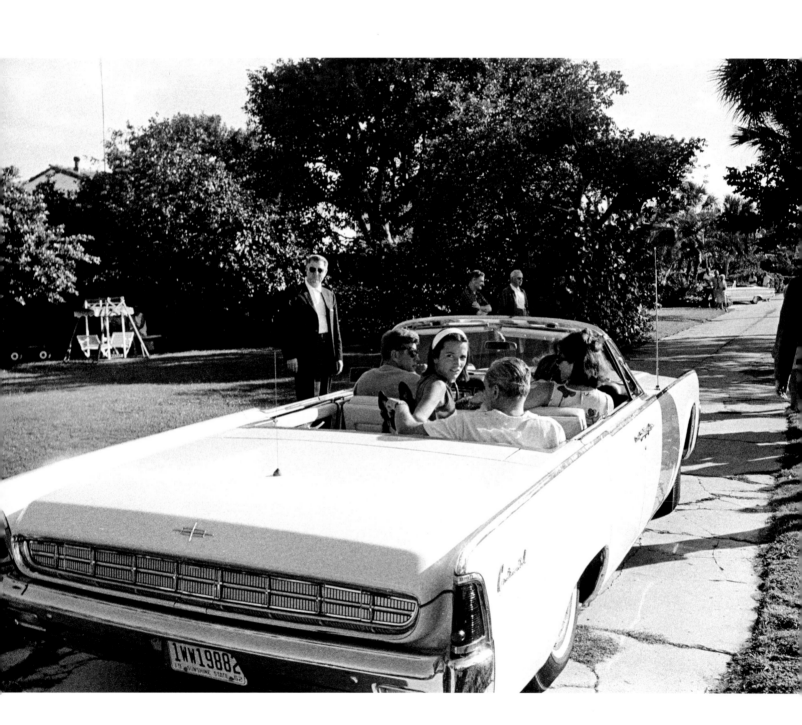

January 7 A relaxed-looking president before returning from Palm Beach to Washington. Kennedy had spent most of the day cruising aboard the *Honey Fitz* with Vice President Johnson as his guest.

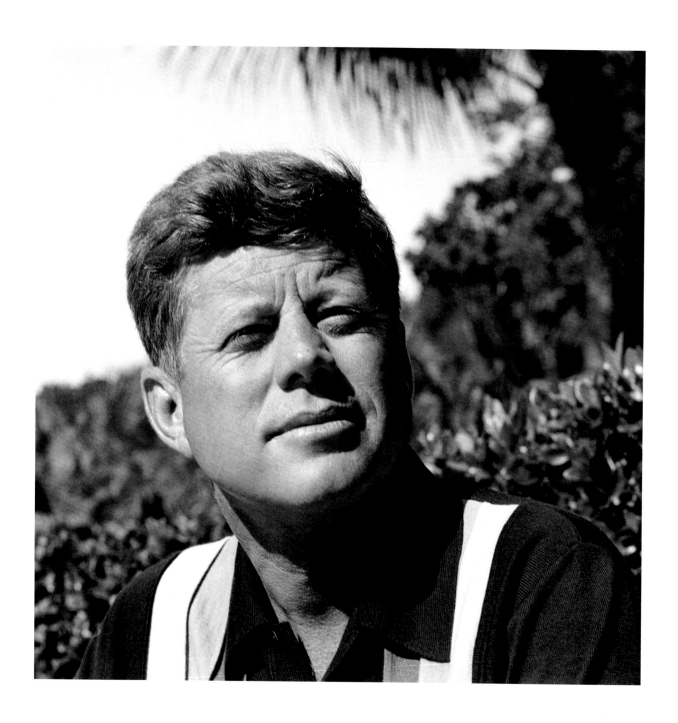

January 8 Jacqueline Kennedy, French minister of cultural affairs André Malraux, and the *Mona Lisa* at the National Gallery in Washington. Kennedy's beauty and perfect French had captivated Malraux when the Kennedys visited Paris in 1961. Their correspondence after that—much of it about exhibiting French art treasures in the United States—led Malraux to accept an invitation to the glittering White House dinner held on May 11, 1962. On the day before the dinner, Mrs. Kennedy brought up the idea of exhibiting the *Mona Lisa* in Washington and New York. As he was preparing to leave, Malraux whispered to his hostess, *"Je vais vous envoyer La Joconde."* Protected in a bulletproof, climate-controlled crate in a separate stateroom aboard the SS *France*, the 460-year-old painting arrived in the United States in December 1962. More than two million Americans waited in lines for hours to view the masterpiece at the National Gallery and at the Metropolitan Museum of Art in New York.

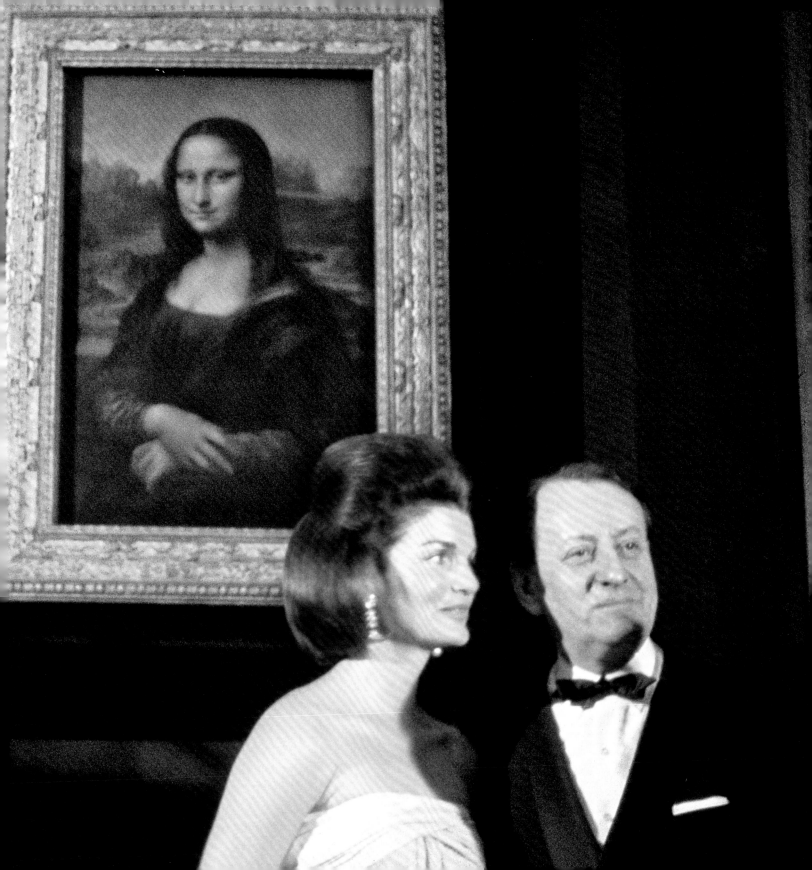

January 14 The president's 1963 State of the Union message concentrated on domestic affairs, particularly the economy, which had improved significantly during his first two years. Gross national product per capita had climbed almost four percent, compared with a one percent average gain during Eisenhower's second term. Inflation was at 1.1 percent. Unemployment, however, was at 5.8 percent, and Kennedy said he hoped to see that drop to 4 percent by November 1964—which happened to be when he would be running for reelection. To cheers from both parties, the president said the country could reach that goal if personal income taxes were reduced from a range of 20–91 percent to 14–65 percent. Vice President Johnson and Speaker McCormack are seated behind the podium.

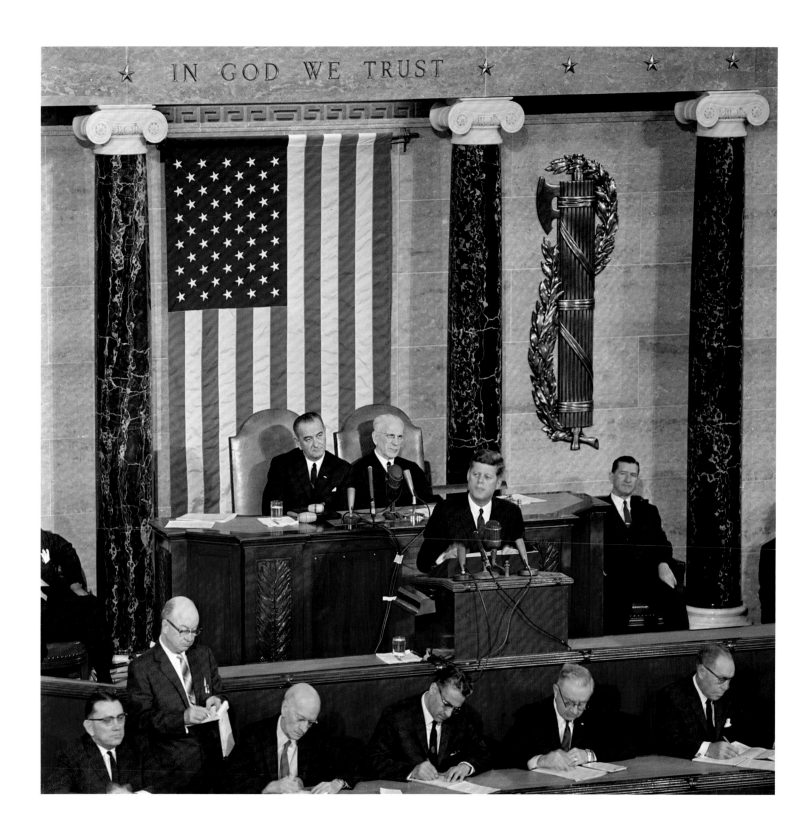

IN GOD WE TRUST

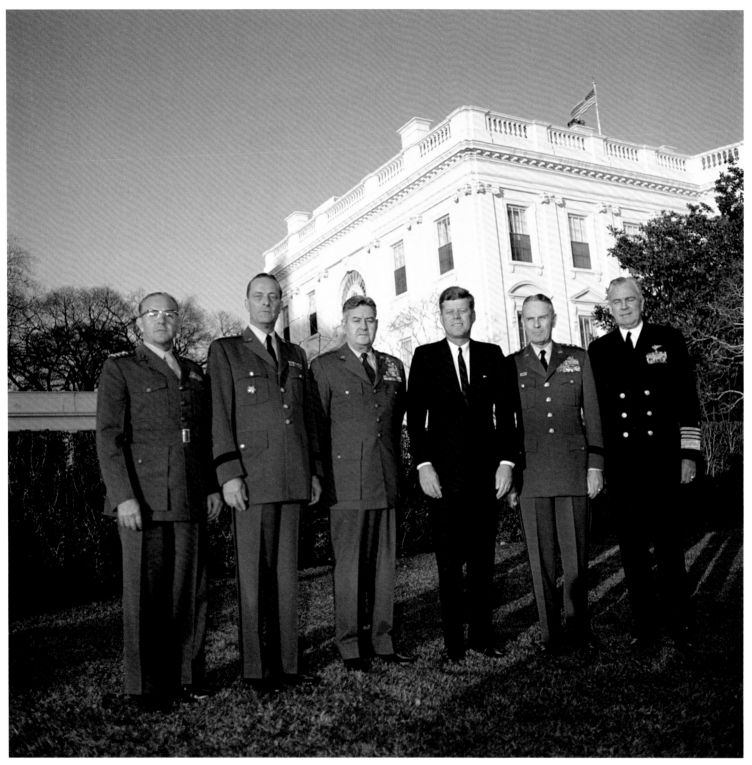

January 15 Kennedy with his Joint Chiefs of Staff, from the left: General David Shoup of the marine corps; General Earle Wheeler of the army; General Curtis LeMay of the air force; the joint chiefs chairman, General Maxwell Taylor; and Admiral George Anderson of the navy. The chiefs had just returned from an inspection tour of South Vietnam, where 11,500 American troops were stationed to help the American-backed government there quell a communist insurgency supplied and largely directed from North Vietnam. WE WADE DEEPER INTO JUNGLE WAR, was the headline above a *Life* magazine story on the newsstands that day. "Americans are in Vietnam because we have determined that this country must not fall under Communist domination," Kennedy wrote in a personal letter to the sister of one of the forty-five Americans killed in Vietnam so far. "As a soldier, [your brother] knew full scale war in Vietnam is at the moment unthinkable . . . I believe if you can see this as he must have seen it, you will believe as he must have believed: that he did not die in vain."

January 16 The president greeting prime minister of Italy Amintore Fanfani during a White House visit. They were later joined by Mrs. Kennedy, and the prime minister presented her with a pair of bas-relief sculptures. Outside, the Kennedy children joined the entourage on the South Lawn.

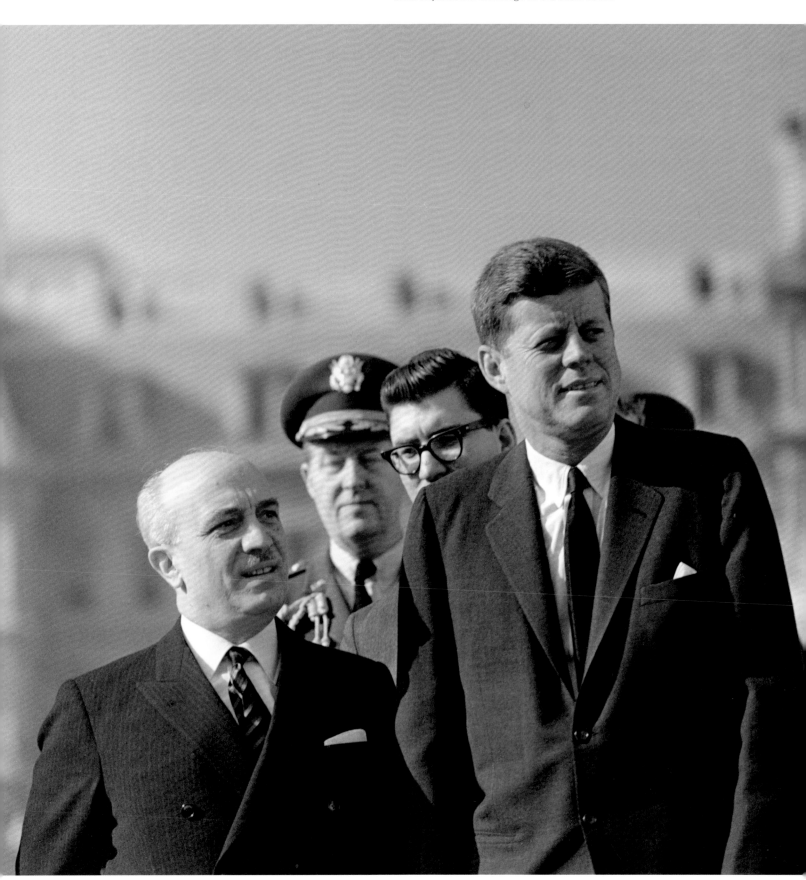

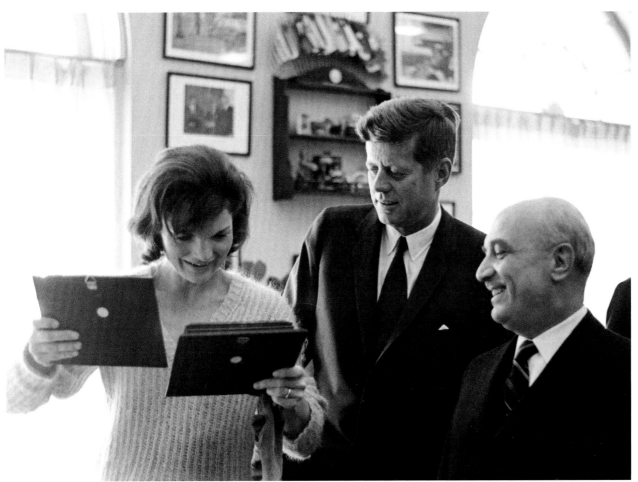

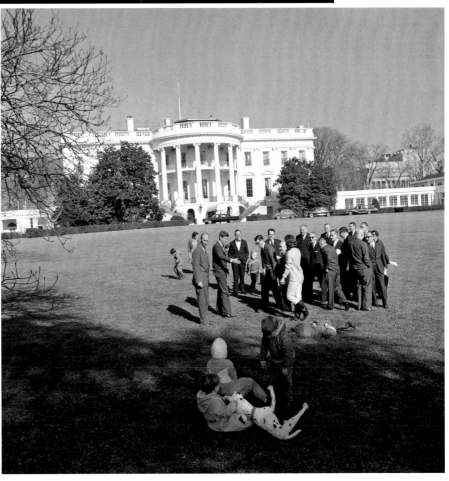

January 18 Kennedy laughing as his longtime driver, John "Muggsy" O'Leary, holds a model airplane. It was at moments like this that the president would push a button under his desk that summoned White House photographers, including Cecil Stoughton.

January 18 The president with a group of Democratic senators, from left to right: Kennedy's brother Edward, the newly elected senator of Massachusetts; Frank Church of Idaho; John Pastore of Rhode Island; Edmund Muskie of Maine; Herman Talmadge of Georgia; and Gale McGee of Wyoming.

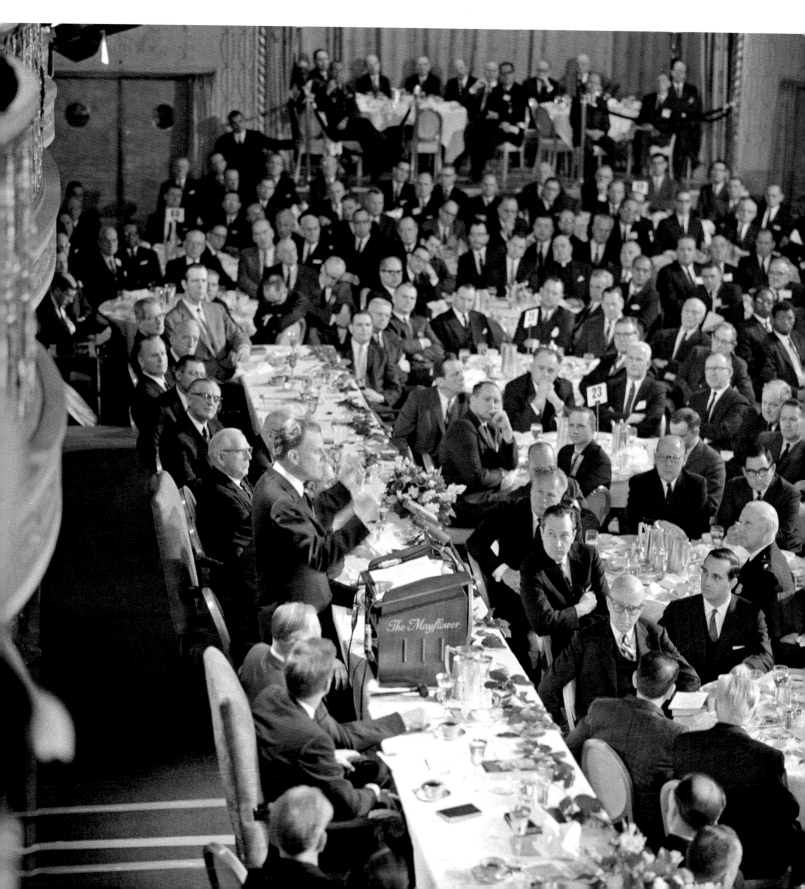

February 7 Kennedy (second from speaker's right) listens to the Reverend Billy Graham address the annual prayer breakfast of the International Christian Leadership at the Mayflower Hotel, a few blocks from the White House.

The Mayflower

February 9 The president with Foy Kohler, the United States ambassador to the Soviet Union. Part of their conversation was about the president's response to Premier Khrushchev's December 19 letter regarding nuclear disarmament. Kennedy answered, "There appear to be no differences between your views and mine regarding the need for eliminating war in this nuclear age . . . I am encouraged that you are prepared to accept the principle of on-site inspections."

February 12 The Kennedys and the Johnsons with a group of African-American leaders at a Lincoln's Birthday reception. The meeting was set up by Kennedy's one African-American adviser, Louis Martin, a former Chicago newspaper publisher, after Martin told the president in a January 29 memo: "American Negroes through sit-ins, kneel-ins, wade-ins etc., will continue to create situations which will involve the police powers of local, state, and federal government." More than eight hundred people were invited to the affair and one was disinvited: Sammy Davis, Jr. The entertainer had a white wife, the Swedish actress May Britt, and Kennedy did not want them photographed in the White House. Privately, Martin told friends, "The truth is the president cares more about Germany than he does about Negroes, he thinks it's more important."

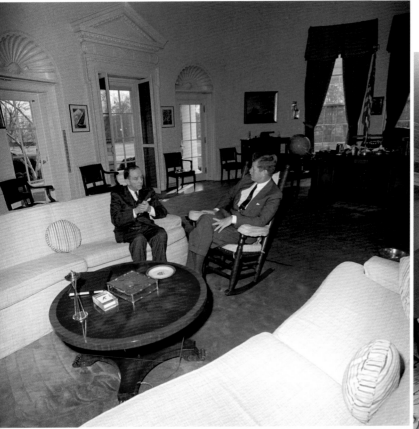

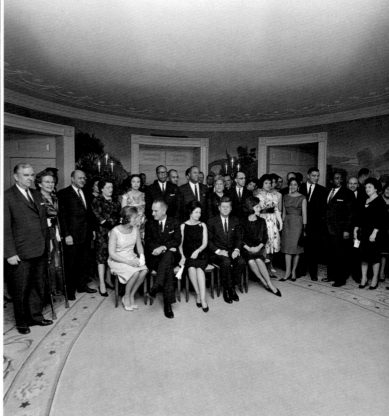

February 15, 23 Press secretary Pierre Salinger accepting an "award" for *not* hiking fifty miles. The pudgy press secretary said he was not ready to risk his life as a hiking craze swept the country. The craze started when someone found a 1908 White House memo in which Theodore Roosevelt said he expected all U.S. Marines to be fit enough to hike fifty miles in twenty hours. Kennedy promoted the hikes, though he did his in a Lincoln Continental.

He presented a "medal of honor" (actually a teabag) to Prince Radziwill and to other staff and friends who made the trek. One of them, the man in dark blue shirt and glasses, was Dr. Max Jacobson, a New York physician who secretly supplied restricted amphetamines to the president and to Mrs. Kennedy, when she showed symptoms of post-partum depression after giving birth to John Jr.

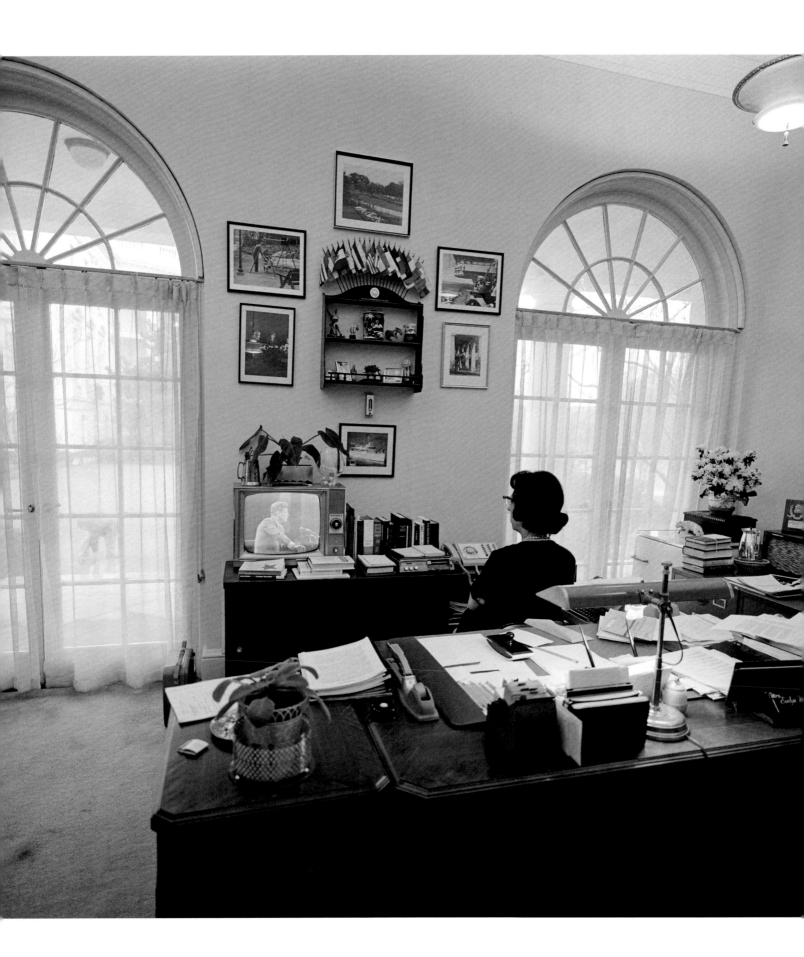

March 6 Mrs. Evelyn Lincoln, personal secretary to the president, in her office just outside the Oval Office watches Kennedy's televised news conference in which he said the United States would not agree to a nuclear test ban without "every assurance that we could detect a series of underground tests" in the Soviet Union.

March 18 A quarter of a million citizens turn out in San José, Costa Rica, to cheer Kennedy as he rides in a motorcade with the country's president, Francisco Orlich Bolmarcich, host of a meeting involving the United States and the heads of state of Guatemala, El Salvador, Honduras, Panama, and Nicaragua.

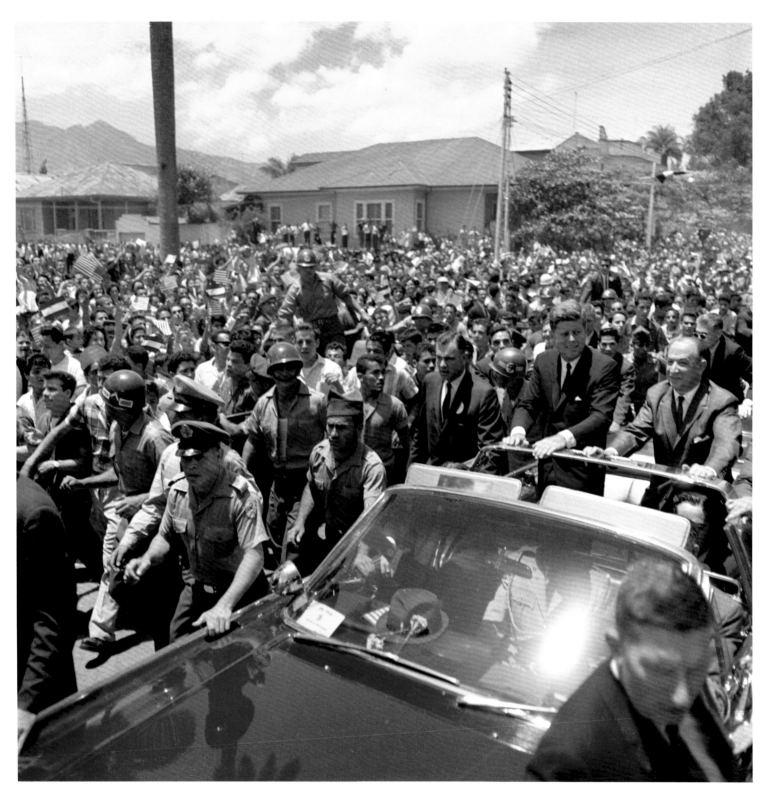

March 28 The president and his children outside the Oval Office.
Among John Jr.'s pet names for his father was "Pooh-Pooh Head."

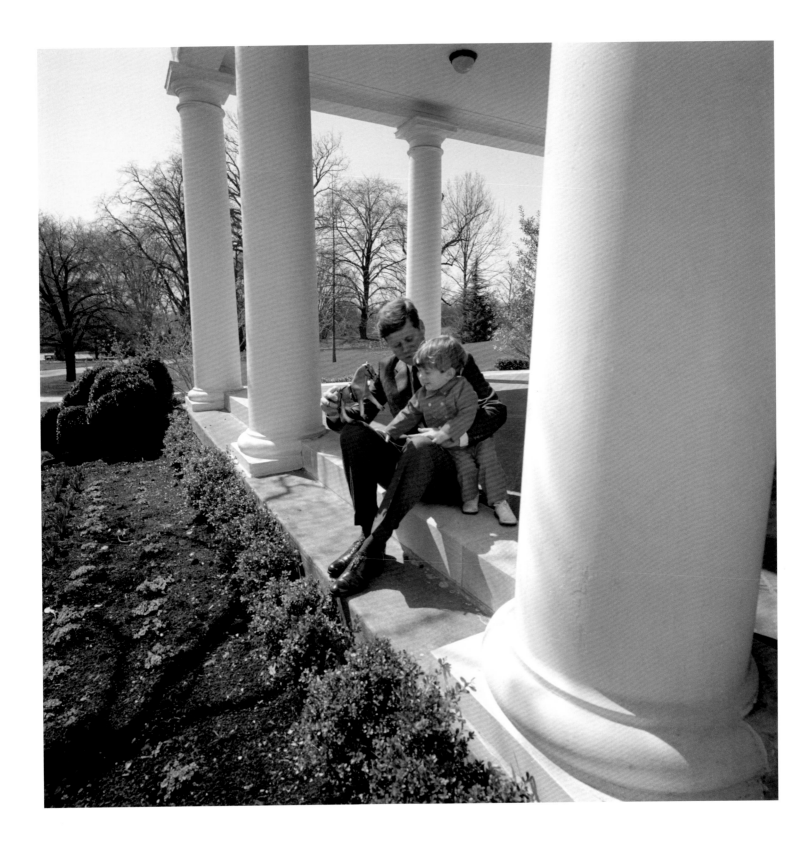

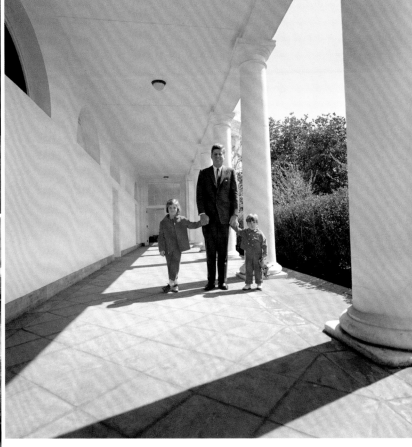

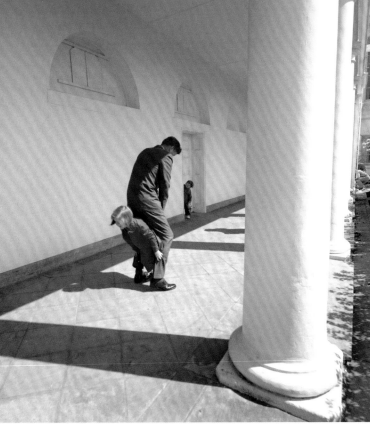

March 28 The first couple before a White House reception with King Hassan II of Morocco.

April 1 The president walking behind the White House on an early spring day.

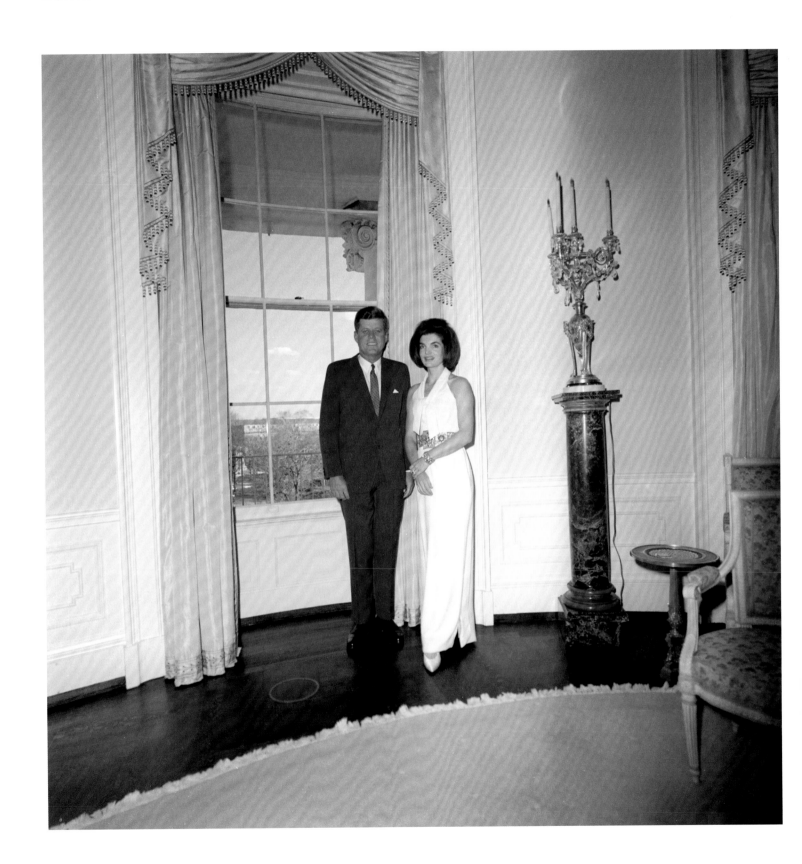

April 1 Caroline and John Jr. picnicking in back of the White House; the president checking out Caroline's little playground with a young friend and the Kennedy's nanny, Maud Shaw.

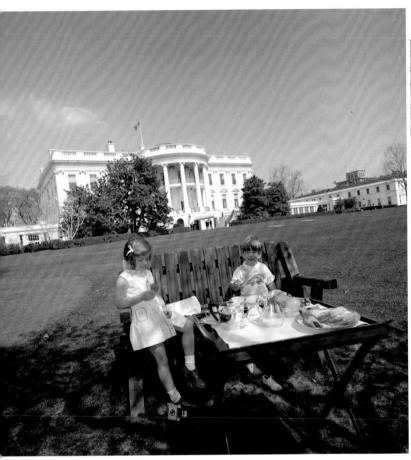

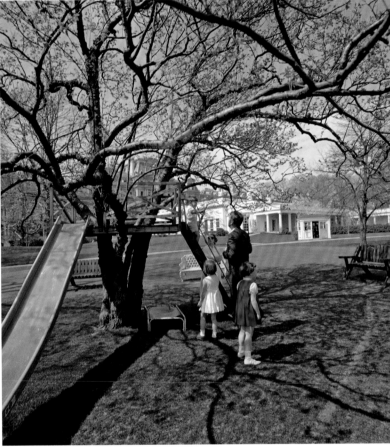

April 4 The first lady lifts John Jr. out of the fountain on the South Lawn of the White House.

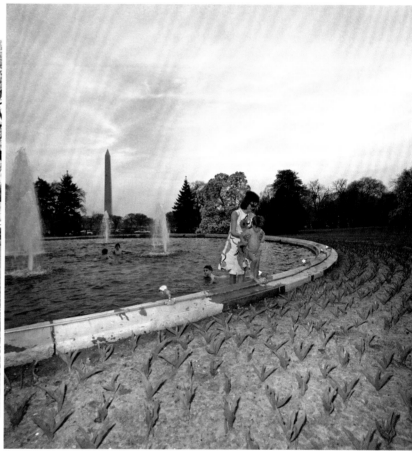

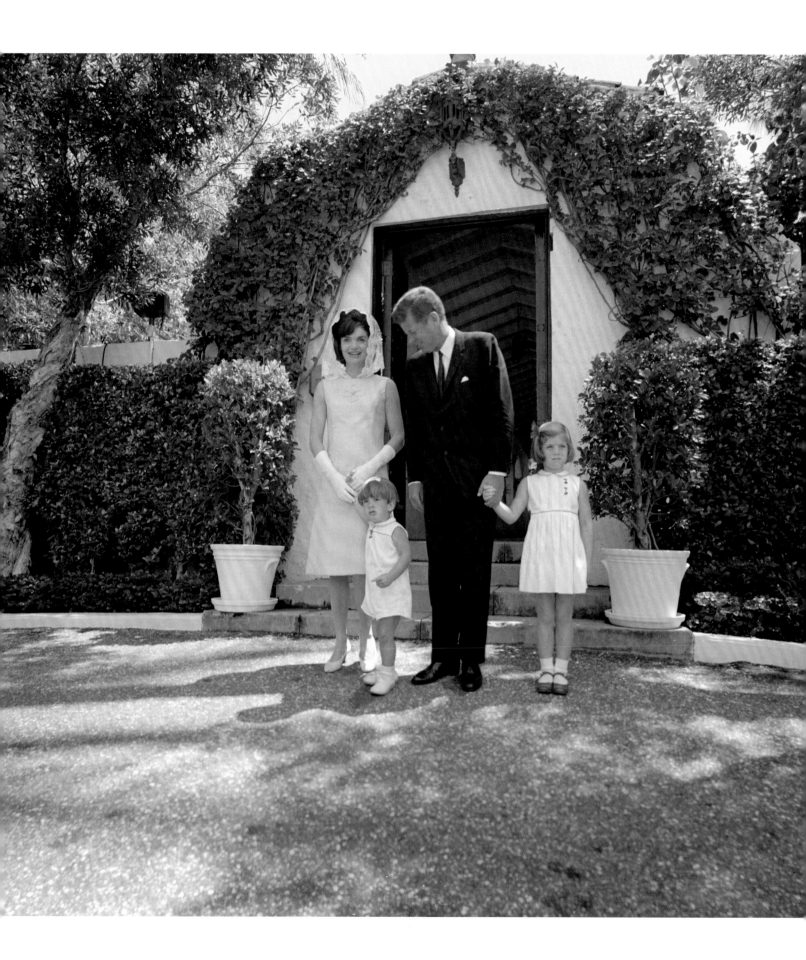

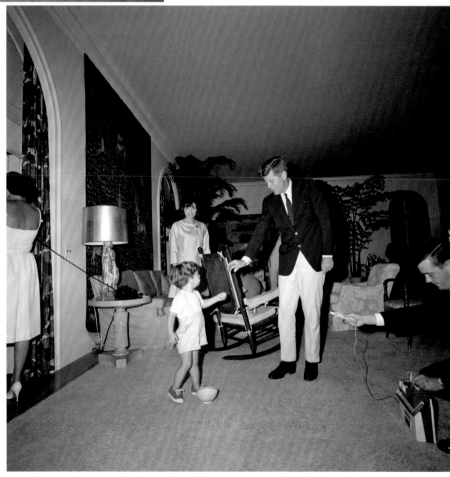

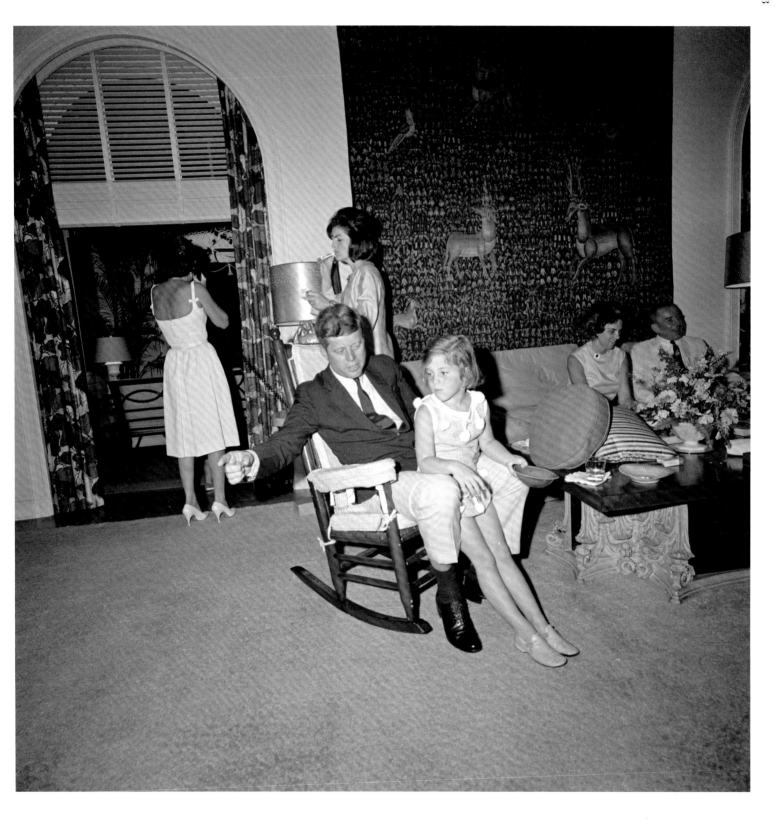

April 19 The president at a reception at the Statler Hilton Hotel in
Washington D.C., hosted by the American Society of Newspaper Editors.

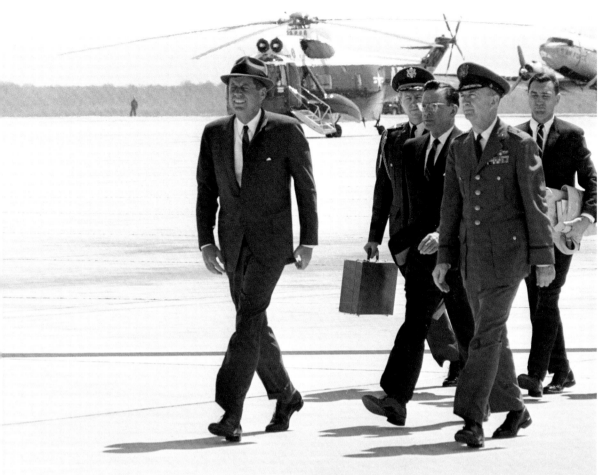

April 20 A rare photograph of the president with
a hat on; Kennedy is arriving in Boston to speak at the
Centennial Celebration of Boston College.

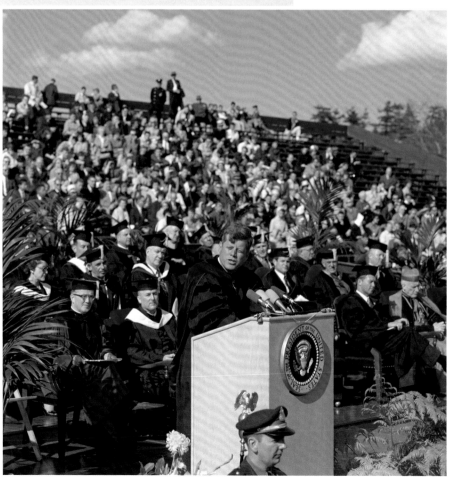

April 25 Kennedy laughing at the toasts and skits at a White House
birthday party for White House aide Dave Powers.

The Kennedys greet Prince Jean of Luxembourg. Standing to the left of the president is ambassador Angier Biddle Duke, the State Department's chief of protocol and an old friend of Mrs. Kennedy.

At the White House dinner for Prince Jean and Grand Duchess Charlotte.

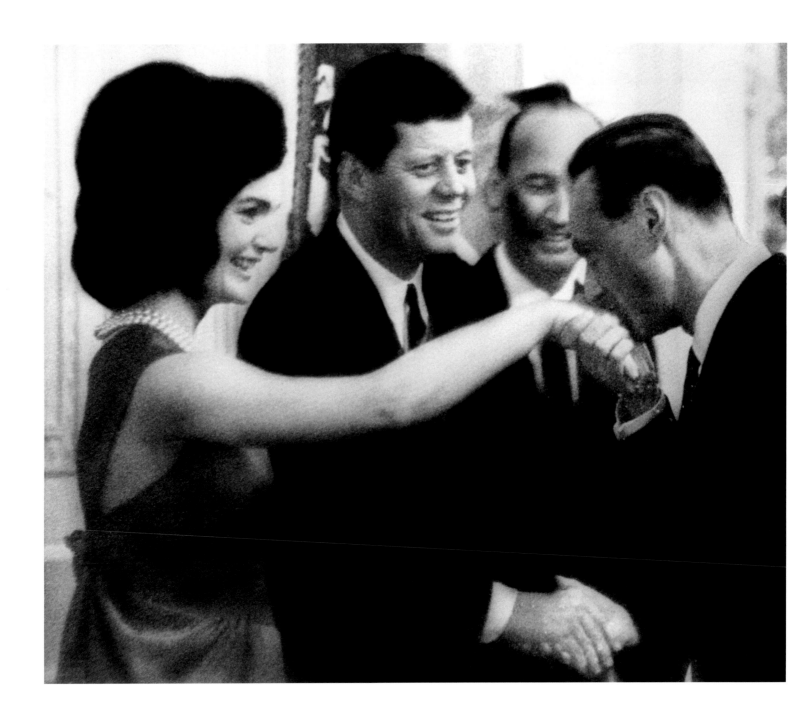

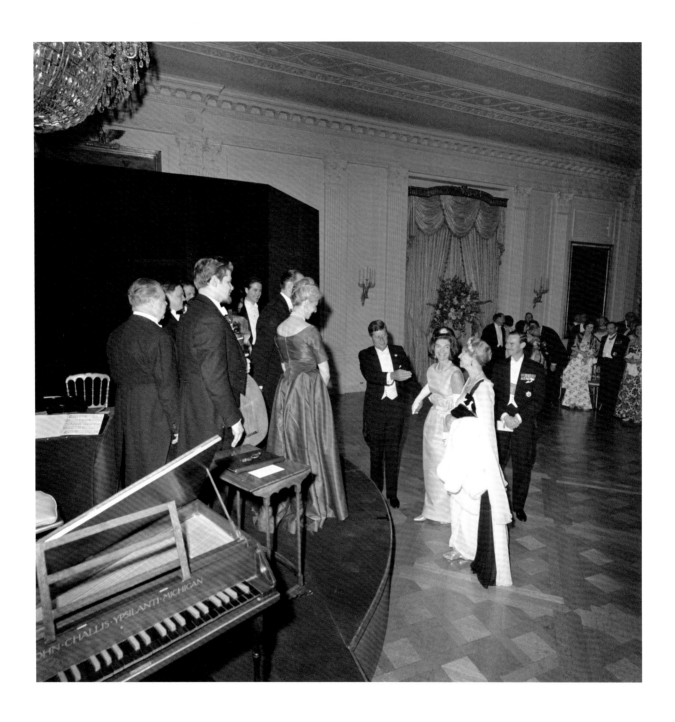

May 2 The president meets with Thomas J. Kiernan, Ireland's ambassador
to the United States (left), and James J. O'Keefe, lord mayor of Dublin.

May 5 Caroline at Camp David with a Secret Service agent, Robert Foster. Her code name was "Lyric."

May 7 The Kennedy brothers and J. Edgar Hoover together at the White House as reports and photographs of racial violence in Birmingham, Alabama, and other southern states began to dominate the news. The African-American leader, Reverend Martin Luther King, Jr., was in and out of jails that spring—as Hoover tried to convince the president that King was a communist bent on overthrowing the government. Kennedy had hoped to avoid dealing with the issues of legal segregation and state and local Jim Crow laws. A desperate King began to use masses of schoolchildren in demonstrations to try to get the attention of the news media, the nation, and especially the president. King got that attention and more when Birmingham police used fire hoses and attack dogs to try to drive the schoolchildren off the streets. "It makes me sick," Kennedy said privately when he saw the photos and film footage. But he still wanted to avoid using federal authority and troops; instead he sent assistant attorney general Burke Marshall to Alabama to try to negotiate some sort of truce. But it was too late for all that.

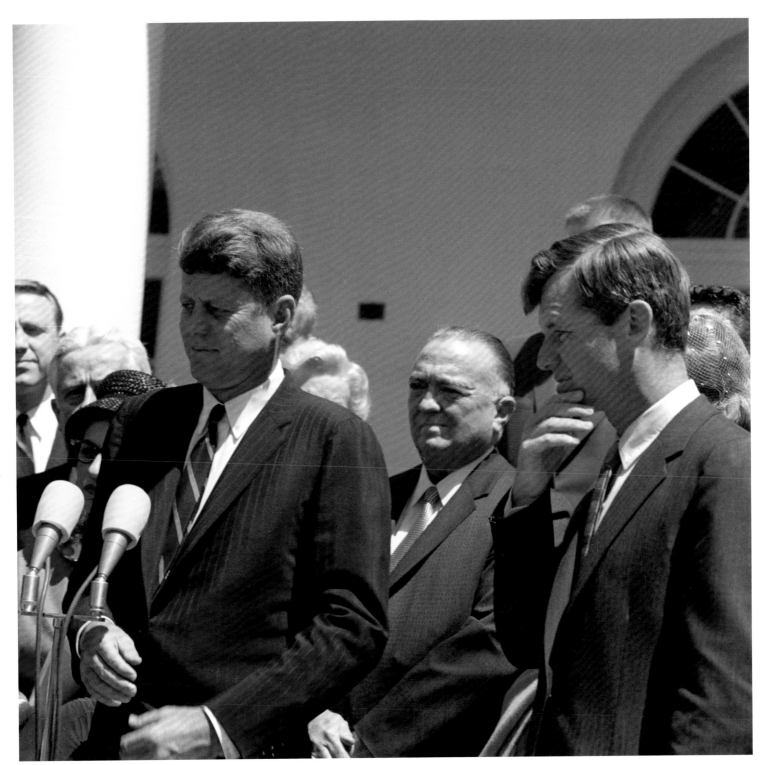

May 8 The president making a birthday call to one of his predecessors, Harry S. Truman, who was turning seventy-nine.

May 10 A characteristic Kennedy pose—leaning over to read a newspaper—this time at Hyannis Port.

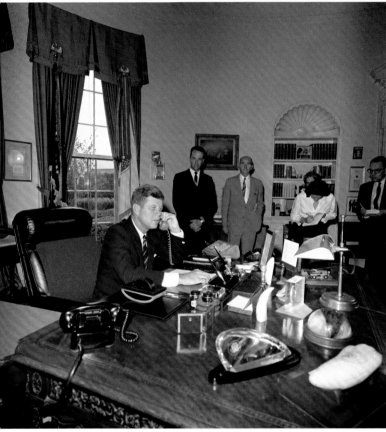

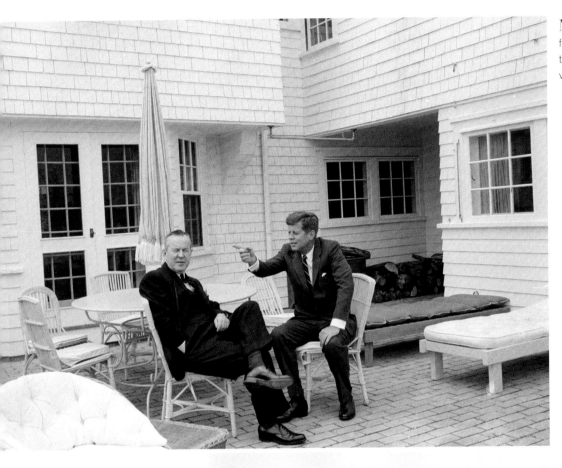

May 10 Kennedy spends time with a
foreign visitor to Hyannis Port, Lester Pearson,
the prime minister of Canada. Pearson greeting
various Kennedys and household staff.

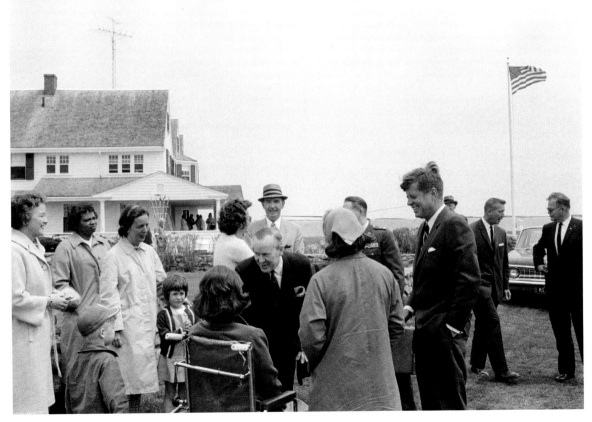

204

May 11 The president with one of the thin cigars he favored.

1963

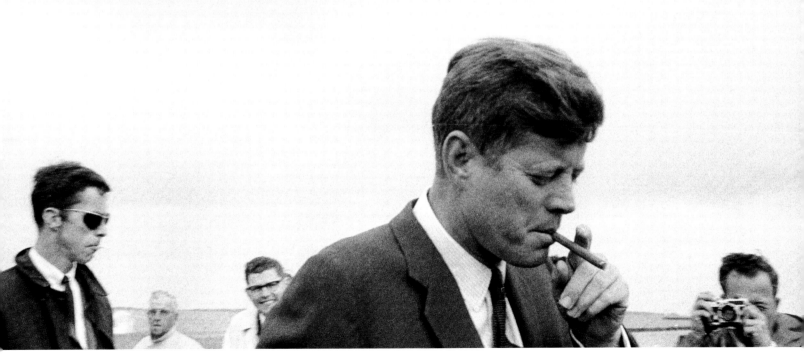

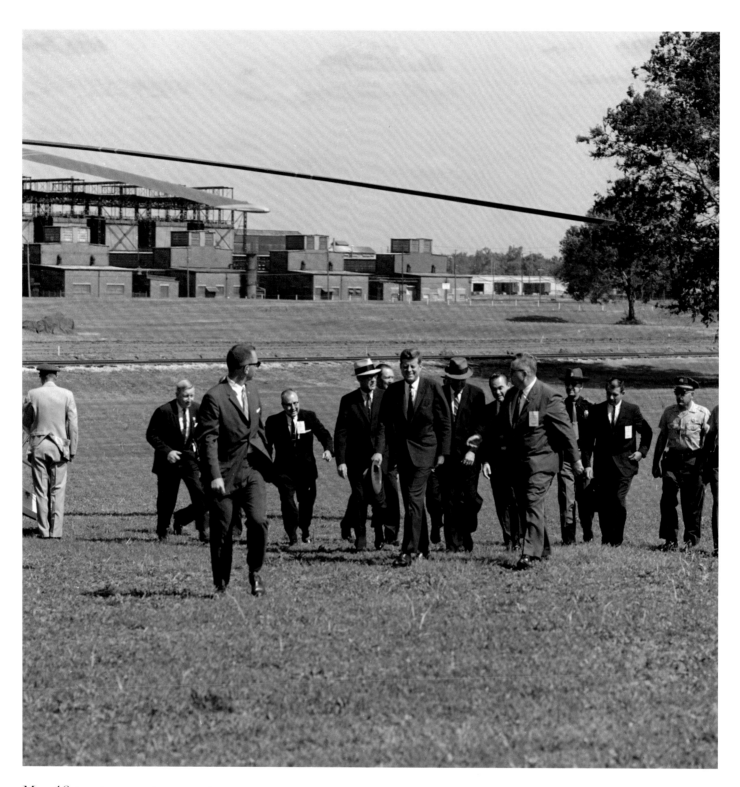

May 18 President Kennedy's 1964 reelection campaign began in mid-1963. He could still draw huge crowds and did so in May when he visited Muscle Shoals, Alabama—hardly Kennedy country—to commemorate the thirtieth anniversary of the Tennessee Valley Authority. Kennedy's purpose was to connect the New Deal and the New Frontier, FDR and JFK. "The work of TVA will never be done," the president declared. "There will always be new frontiers to conquer." Almost lost in the entourage chasing after Kennedy is Alabama's governor, George Wallace.

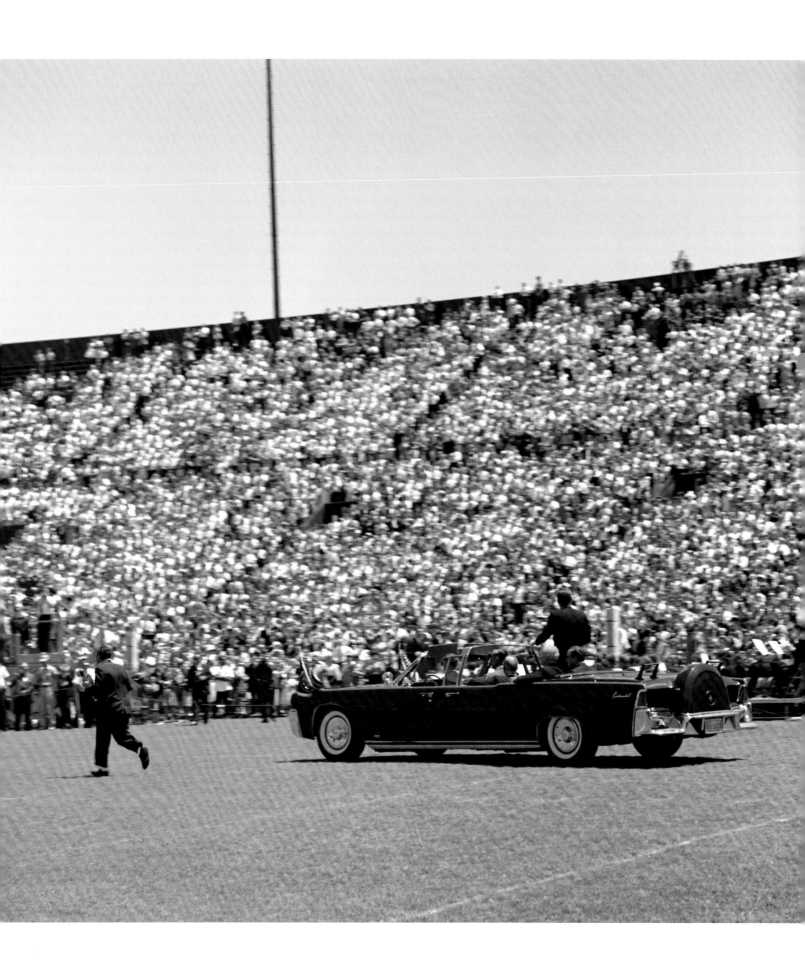

May 21 At the White House, the president presented NASA's Distinguished Service Medal to astronaut L. Gordon Cooper (to his right), who landed safely after twenty-two orbits of the earth. John Jr. seemed more interested in his mother's pearls than in astronaut Cooper.

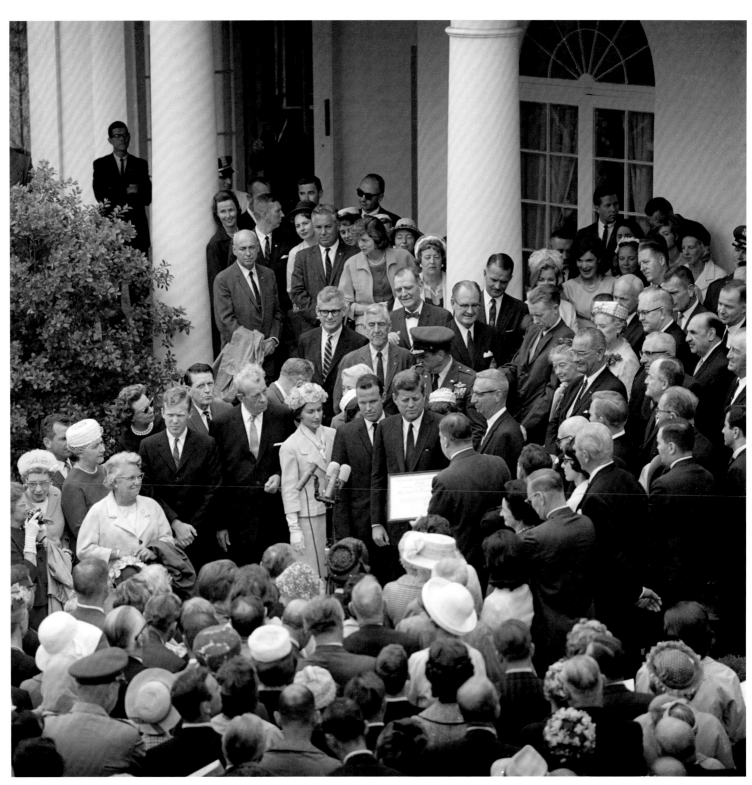

May 29 Kennedy receives the George Washington medal for "Father of the Year" from the National Father's Day Committee. It was also Kennedy's forty-sixth birthday and the White House baker came up the back stairs with the cake for a surprise party thrown by the president's staff. Press Secretary Salinger handled the gift-giving. Later, in the Kennedys' living quarters, friends Ben and Tony Bradlee joined them for a private party.

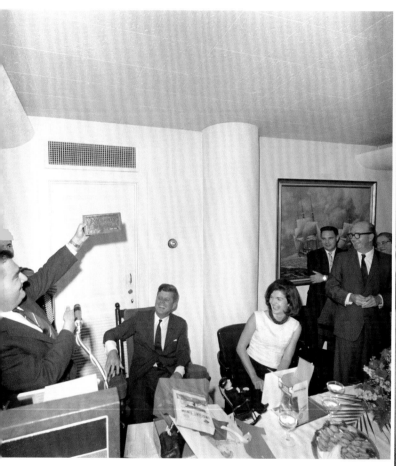

May 30 The president at Memorial Day services at
Arlington National Cemetery.

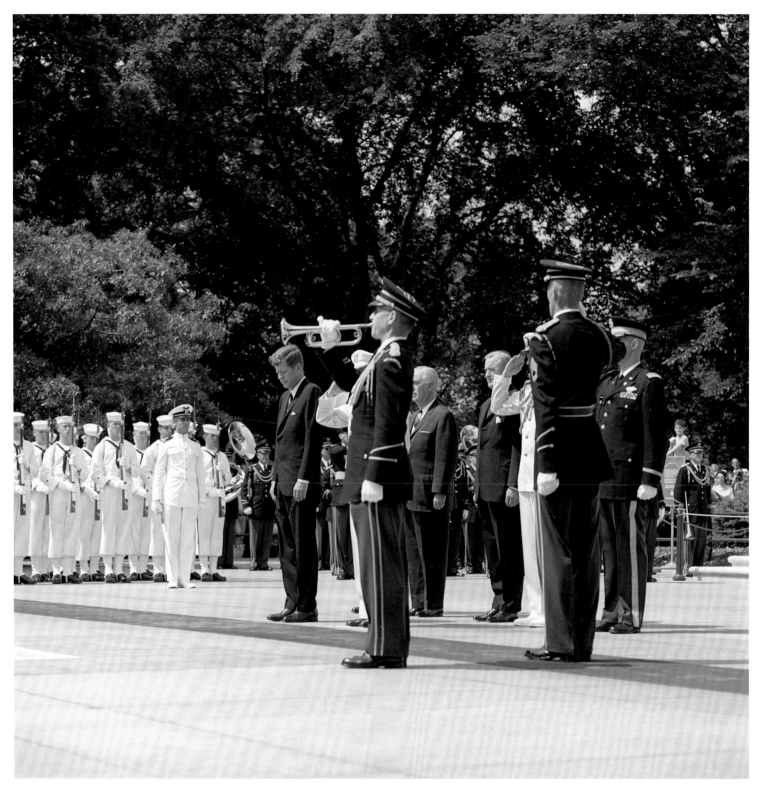

June 3 The president and Mrs. Kennedy welcome Sarvepalli Radhakrishnan, president of India, to an official state dinner given in his honor at the White House.

June 4 President Radhakrishnan and Kennedy in the back seat of the presidential limousine, en route to the first World Food Congress.

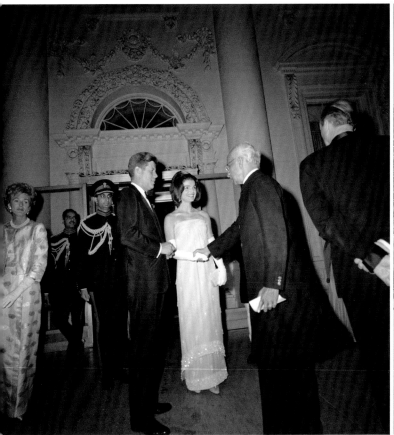

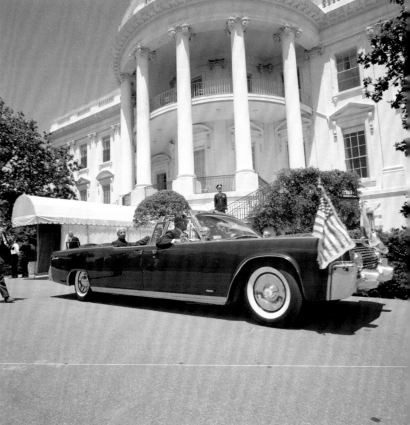

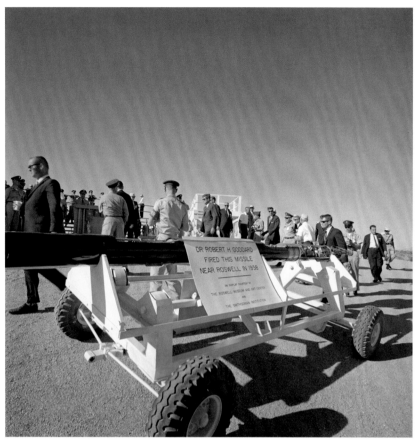

June 5–6 Starting at the U.S. Air Force Academy in Colorado Springs, President Kennedy began a five-day western tour. Next was Texas for a political meeting with Vice President Johnson and the state's Democratic governor, a Johnson protégé named John Connally. Kennedy, who was unpopular in Texas, was convinced that Connally had been stalling on making plans for a fundraising swing through the state. Pressured by both Kennedy and Johnson, Connally agreed to a November trip to Houston, San Antonio, Fort Worth, and Dallas.

The president visits the missile range at White Sands, New Mexico; in the foreground is one of the first missiles ever fired in the United States (1938), which was designed by rocket pioneer Robert H. Goddard.

Kennedy watches a fighting drill at Marine Corps Recruitment Depot in San Diego, California, and naval maneuvers aboard the USS *Kitty Hawk* aircraft carrier, along with governor Edmund G. (Pat) Brown.

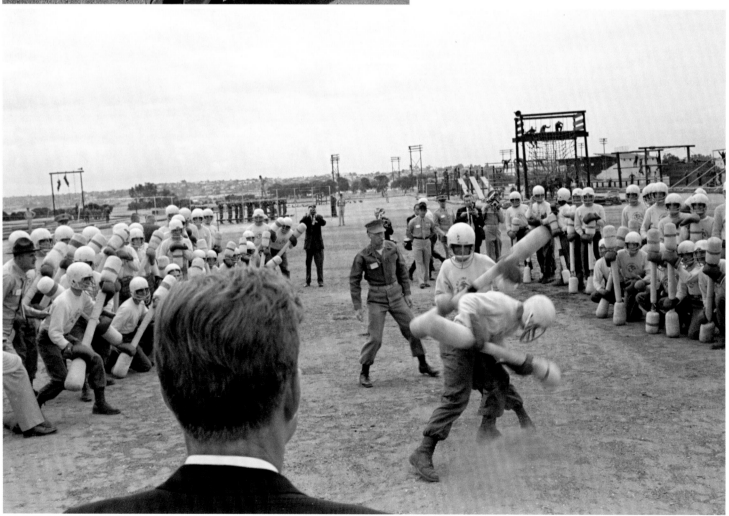

NO SMOKING

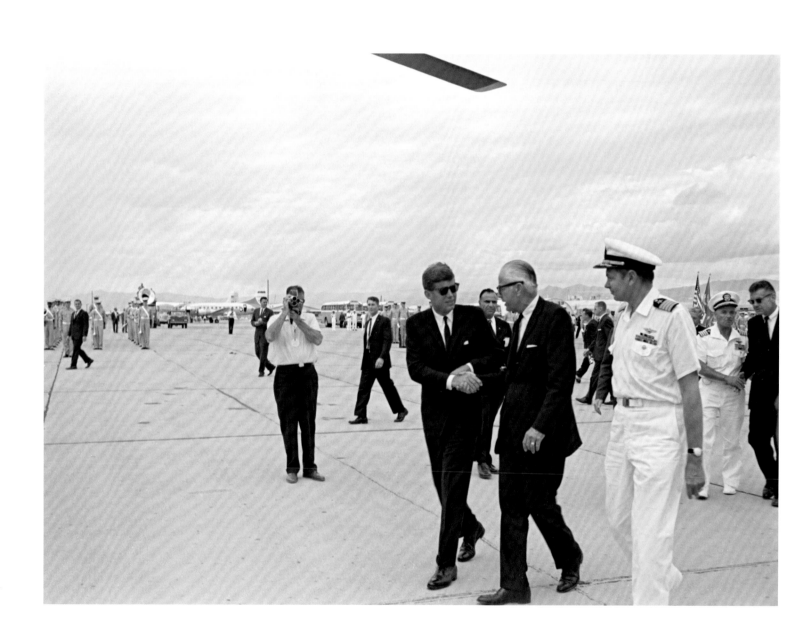

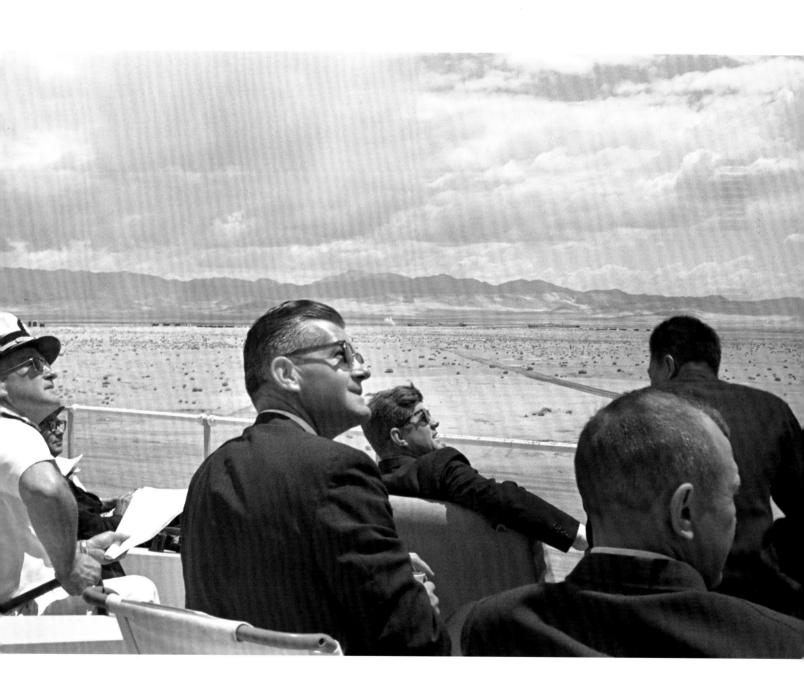

June 8–10 At the end of the western tour, the president arrived in Hawaii for a motorcade through Honolulu and then a speech to the United States Conference of Mayors. Flying home, *Air Force One* stopped in San Francisco, where the president's speechwriter, Theodore Sorensen, came on board with a final draft of a speech called "The Peace Speech," which he had been working on for weeks. The two men edited and revised the draft all the way home. Kennedy arrived back in Washington on the morning of June 10.

He took a steaming hot bath and then was driven to American University, where he gave one of the most important speeches of his life. "Let us reexamine our attitude toward the Soviet Union," Kennedy said, announcing that he planned to meet with Soviet premier Khrushchev to begin negotiations for nuclear test ban treaties. The speech was reprinted in full in *Pravda*, the first time anything like that had happened. "One of the great state papers in American history," said England's *Manchester Guardian* of the speech.

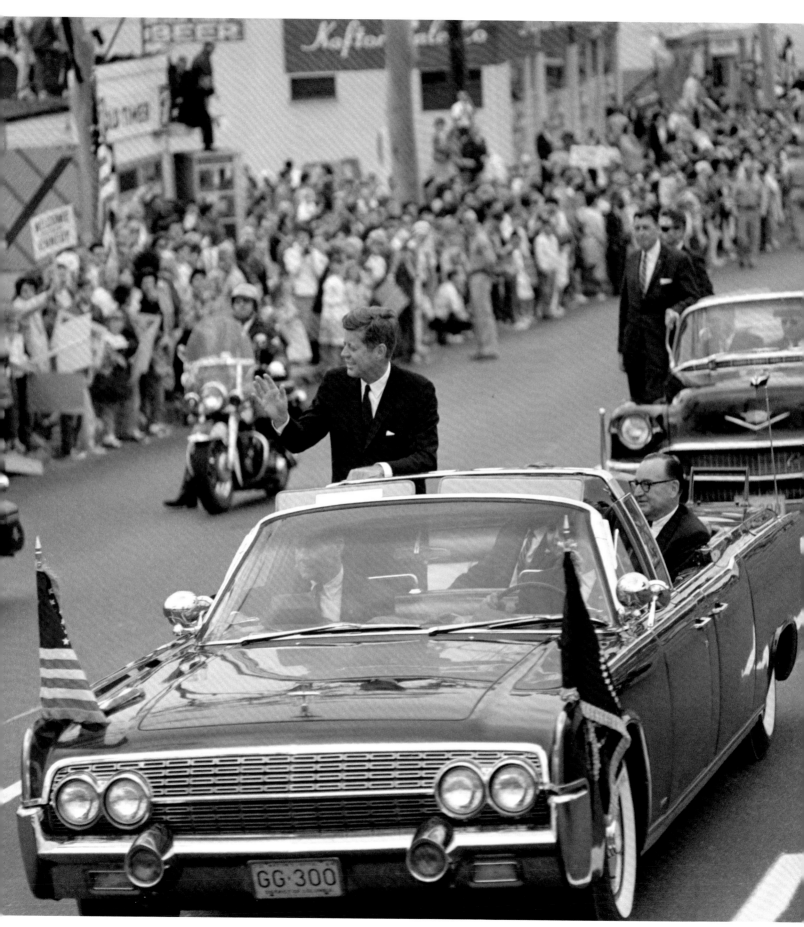

The president signs the Equal Pay Act banning "arbitrary discrimination against women in the payment of wages."

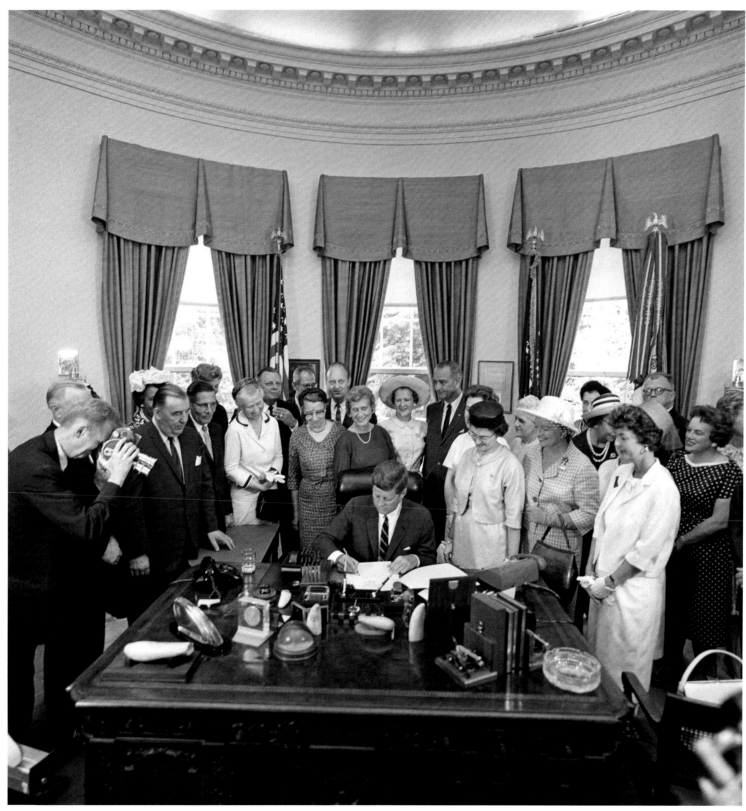

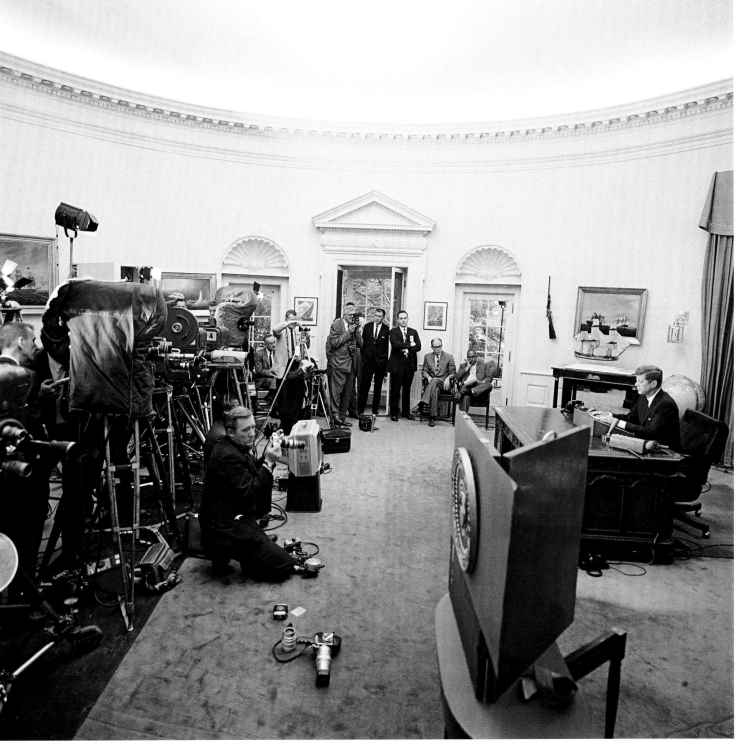

June 11 Robert Kennedy called the president before 8 AM to tell him he should federalize the Alabama National Guard, which was under the command of governor George Wallace. The governor was standing in the doorway of the main auditorium of the University of Alabama to block the entrance of Vivian Malone and James Hood, the first two African Americans admitted to the school. The building was surrounded by state police. Governor Wallace also commanded the Alabama National Guard—unless it was federalized and came under the president's command. (This was the second great civil rights conflict of the Kennedy administration. The first was over the admission of African Americans to the University of Mississippi, where rioting and gunfire lasted for three days in 1962.) By afternoon in

Tuscaloosa, the guardsmen, now under command of the president, and Justice Department officials asked Wallace to step aside and he did. That night, Kennedy went on national television, speaking from an unfinished text, to say: "This is not a sectional issue . . . Nor is this a partisan issue . . . This is not even a legal or legislative issue alone . . . We are confronted primarily with a moral issue. It is as old as the scriptures and it is as clear as the American Constitution. If an American because his skin is dark cannot eat lunch in a restaurant open to the public, if he cannot send his children to the best public school available, if he cannot vote for the public officials who represent him . . . then who among us would be content to have the color of his skin changed? Who among us would then be content with the counsels of patience and delay?"

June 15 Kennedy skeet-shooting at Camp David with David Niven (light shirt), Ben Bradlee, and their wives.

222

June 18 The president meeting with retired Supreme Court Justice Felix Frankfurter (in wheelchair). Among the issues they discussed was civil rights. Racial troubles and violence dominated the front pages of American newspapers—driving Kennedy's "Peace Speech" at American University on June 10 and the self-immolation of a monk in South Vietnam on June 11, in protest of President Diem, to inside pages.

June 20 Kennedy meets with governor William Baron while on the campaign trail in Charleston, West Virginia.

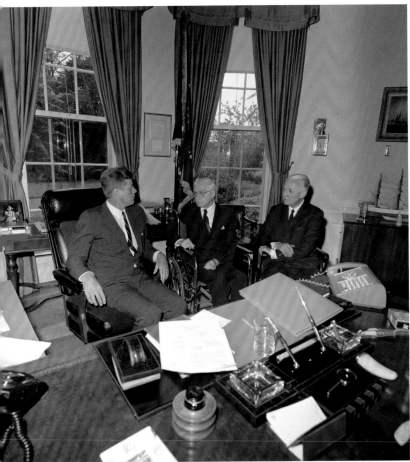

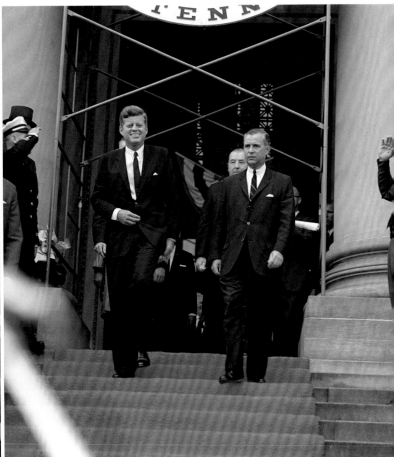

June 21 On the night of June 11 the president gave his civil rights speech, which was broadcast on radio and television. The Mississippi field secretary of the National Association for the Advancement of Colored People, Medgar Evers, was so moved he telephoned his wife, Myrlie, and asked her to keep their children awake until he returned home to Jackson to talk with them about what had happened. As Evers stepped out of his car, he was shot by a white man hidden in honeysuckle bushes across the street. He bled to death in front of his children. Kennedy then invited Mrs. Evers, the children, and Evers's brother, Charles Evers, to the White House for this photograph.

June 22 Kennedy invited African-American and white civil rights leaders
from around the country to the White House for more photos. The president
had chosen sides, standing with the minority—no small thing in a democracy.

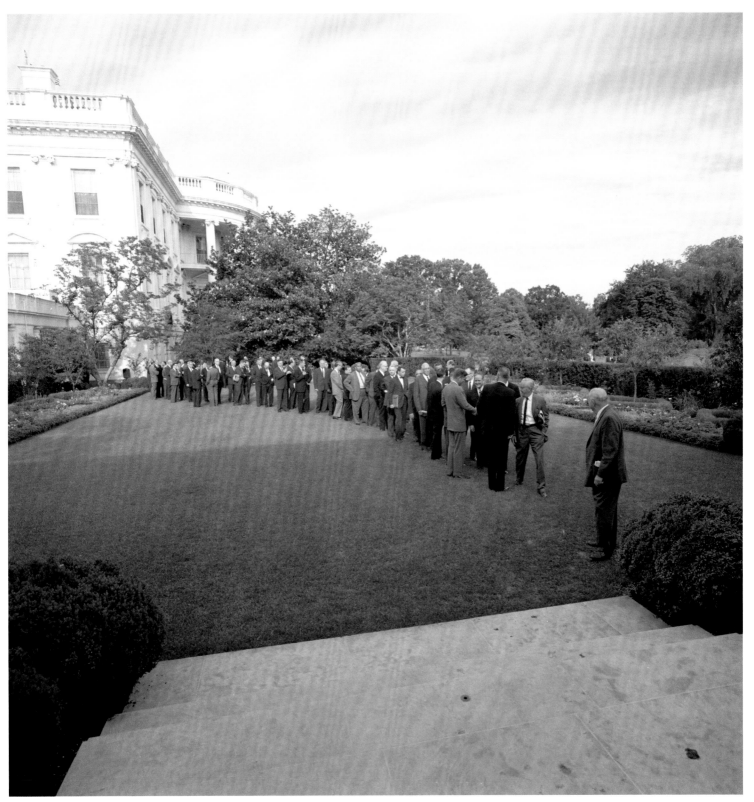

June 23–25 The president was greeted by German chancellor Konrad Adenauer at Bonn, Germany, as he began a ten-day European tour. As part of the four-day leg in Germany, Kennedy visited the U.S. military installation at Hanau, West Germany.

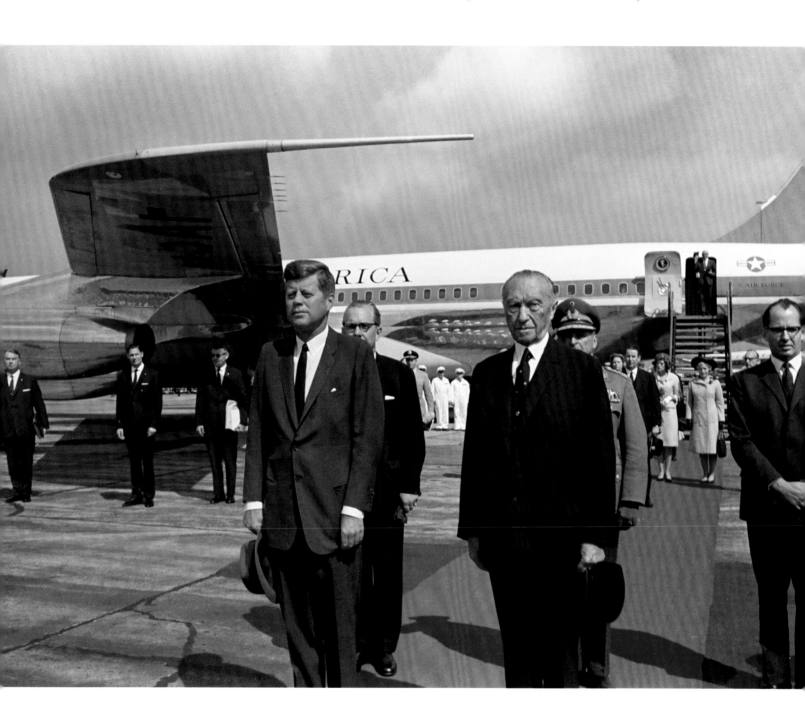

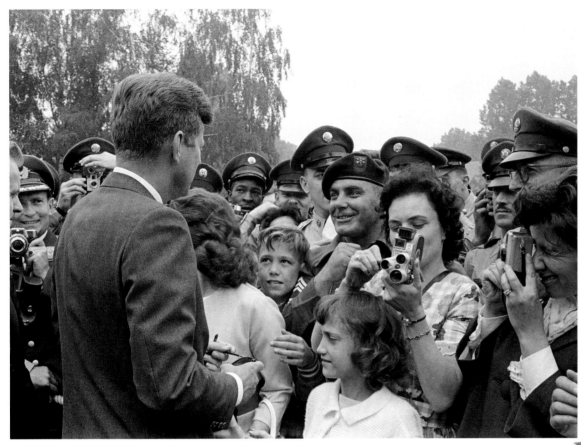

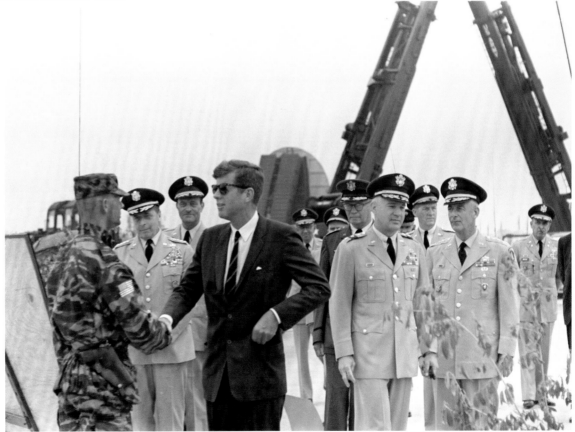

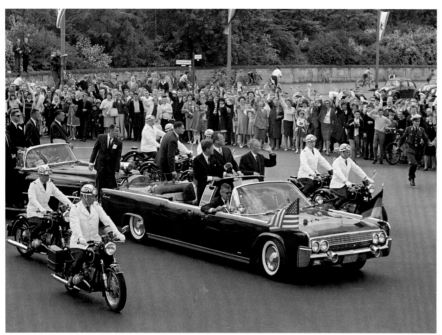

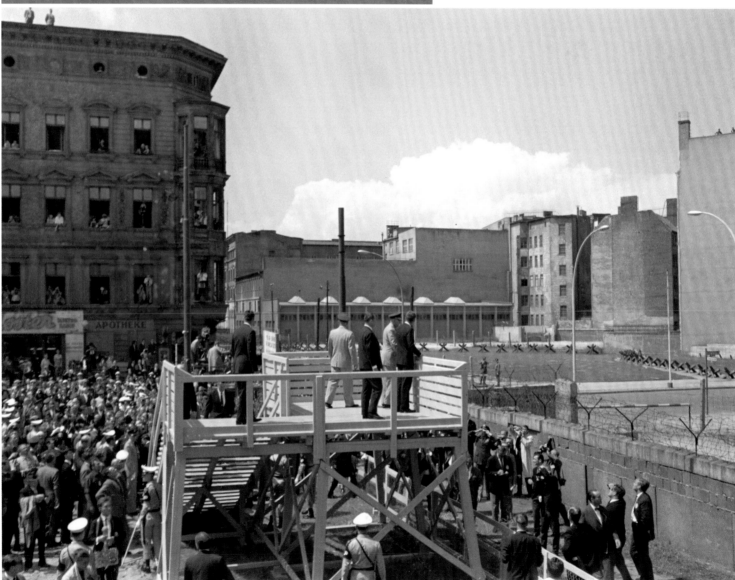

June 26 Kennedy is now long remembered for his visit to Berlin. After greeting American and other North Atlantic Treaty Organization troops in Hannover, the president motorcaded through the old German capital city with Adenauer and West Berlin's mayor, Willy Brandt, to mount a platform and look over the Berlin Wall into East Berlin. (Erected in August 1961, the barrier walled off the western sectors of the city 110 miles inside Soviet-occupied East Germany.)

Otto Bach, Speaker of the Berlin House of Representatives, introduced Kennedy to a huge crowd of one hundred fifty thousand gathered at West Berlin's City Hall and the president famously said, "There are many people in the world who really don't understand, or say they don't, what is the great issue between the free world and the communist world. Let them come to Berlin! . . . All free men, wherever they may live, are citizens of Berlin, and therefore, as a free man, I take pride in the words, *'Ich bin ein Berliner!' "*

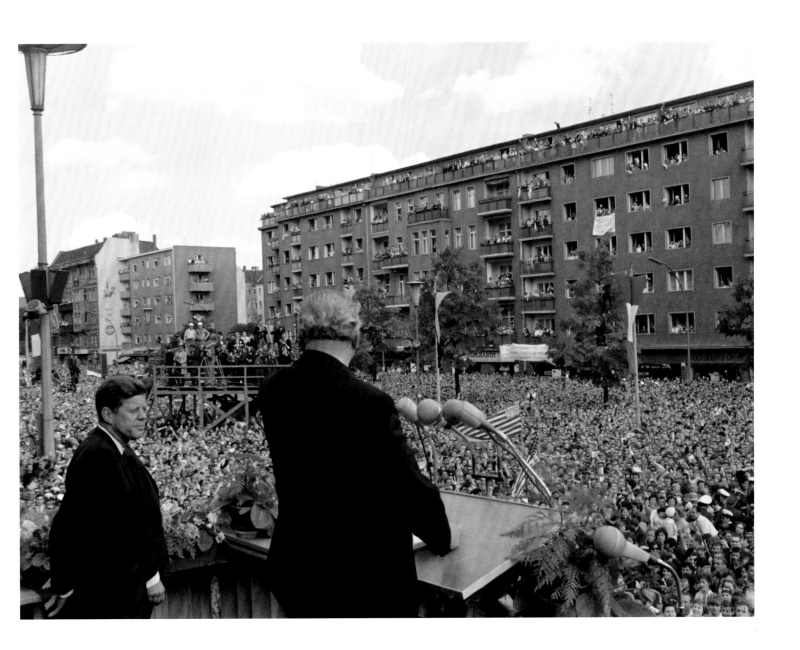

June 27 "He's getting so Irish the next thing you known he'll be speaking with a brogue," said Dave Powers, the president's resident elf, as Kennedy smiled and laughed his way through the largest crowds in Ireland's history. After World War II, Kennedy had gone to the land of his ancestors and remembered it as "magic." Now, he was the most famous Irishman in the world—and he enjoyed it just as much. The president went to Dunganstown, the hometown of his great-grandfather, Patrick Kennedy, the first of the president's family to come to America. Kennedy posed there with his sisters, Eunice Shriver and Jean Smith, and cousins, American and Irish, including Mrs. Mary Kennedy Ryan, to his right. At New Ross, the port where Patrick left the old sod in 1848, Kennedy pointed across the water to the factory of the Albatros Fertilizer Company and said, a little insensitively, "If he had not left New Ross, I would be working today over there."

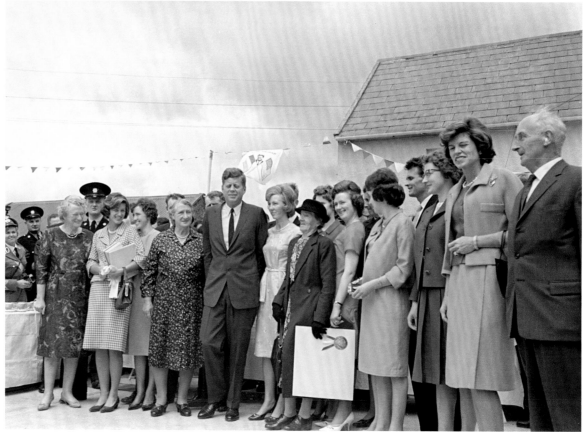

July 1 The first Roman Catholic president of the United States, John Kennedy visited Rome and the Vatican just after the death of Pope John XXIII— "the two Johns" had become worldwide heroes to people who wanted change. The press back home in the United States was burning with questions and speculation about whether the president would kneel and kiss the ring of newly elected Pope Paul VI. He did not.

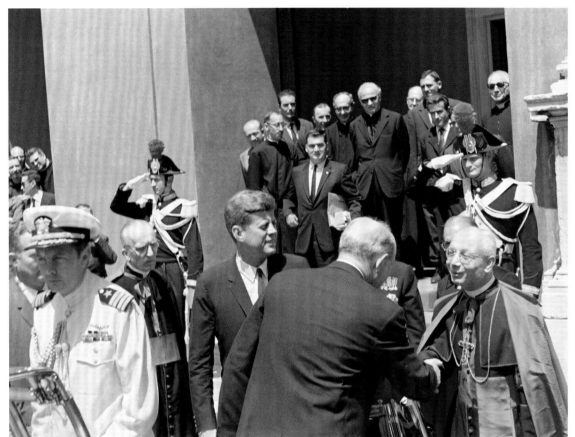

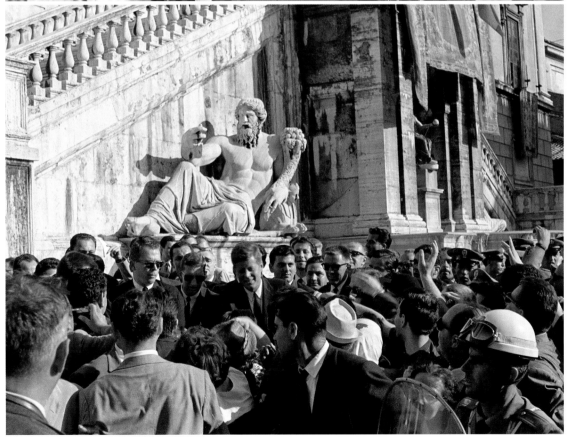

July 5 Home is the sailor. Back from Europe the president spent the July 4 weekend in Hyannis Port. With his brother Teddy and friend LeMoyne Billings, Kennedy watched the launch of a model sailboat given to Caroline by Antonio Segni, the president of Italy. Kennedy also checked out a small catamaran pulled up near his house.

July 27 The day in Hyannis Port was important enough for the president to change into a suit for a short session with reporters and photographers. Kennedy was greeting former U.S. ambassador to the Soviet Union W. Averell Harriman and Secretary of State Rusk to discuss the first Limited Nuclear Test Ban Treaty, negotiated by Harriman and Premier Khrushchev, which began: "Each of the Parties to this Treaty undertakes to prohibit, to prevent, and not to carry out any nuclear weapon test explosion, or any other explosion . . . in the atmosphere; beyond its limits, including outer space; or under water, including territorial waters or high seas . . ."

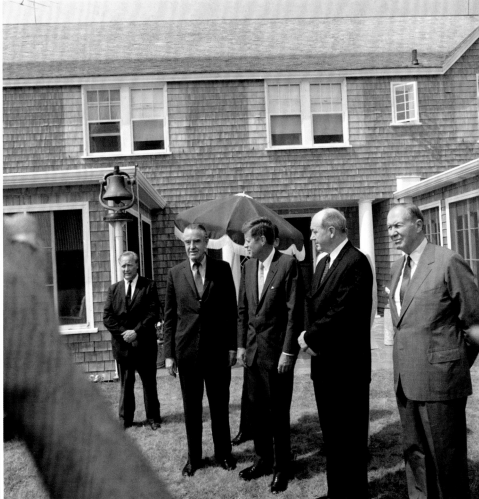

July 27 Back in casual clothes, Kennedy, who was a very good golfer, headed for the golf course with Salinger (not very good) and his old friends, Charles Spaulding, LeMoyne Billings, and the British ambassador to the United States, another old friend, David Ormsby-Gore.

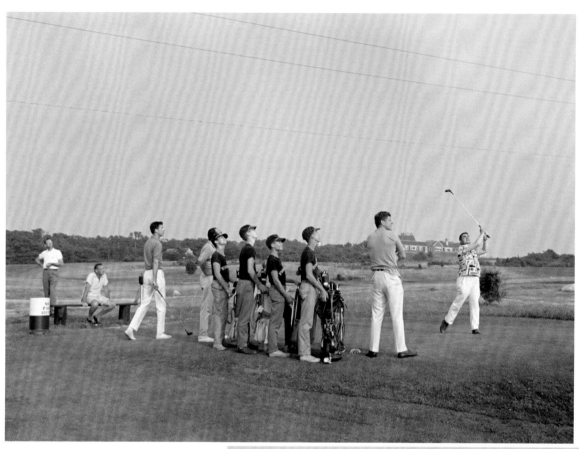

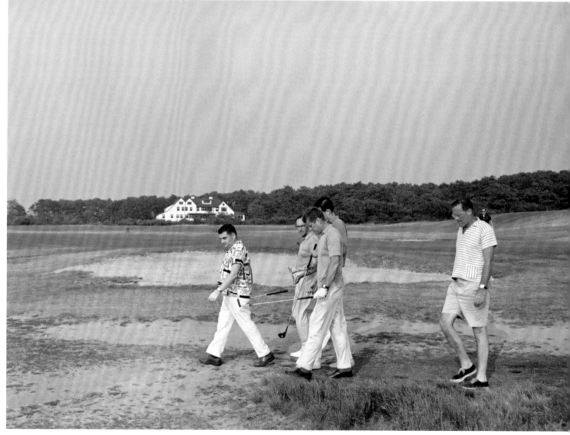

July 28 A long summer day on the presidential yacht, *Honey Fitz*, with Caroline and her cousin, Maria Shriver, and the president's brother-in-law Stephen Smith.

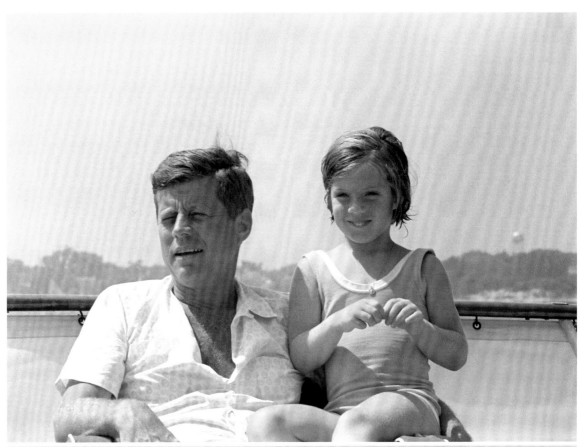

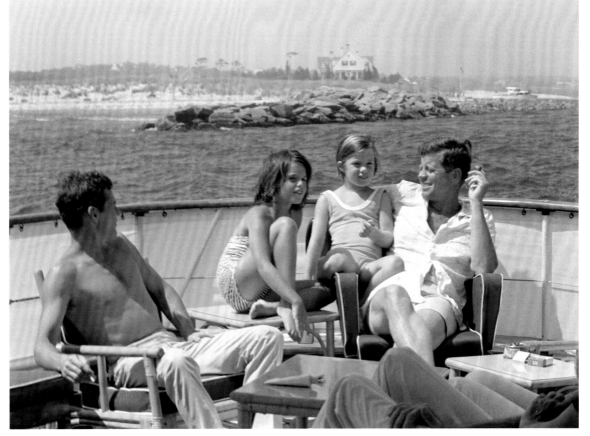

August 3 Back on land, Caroline played with a puppy and then joined her father for a photograph of a new generation of Kennedys.

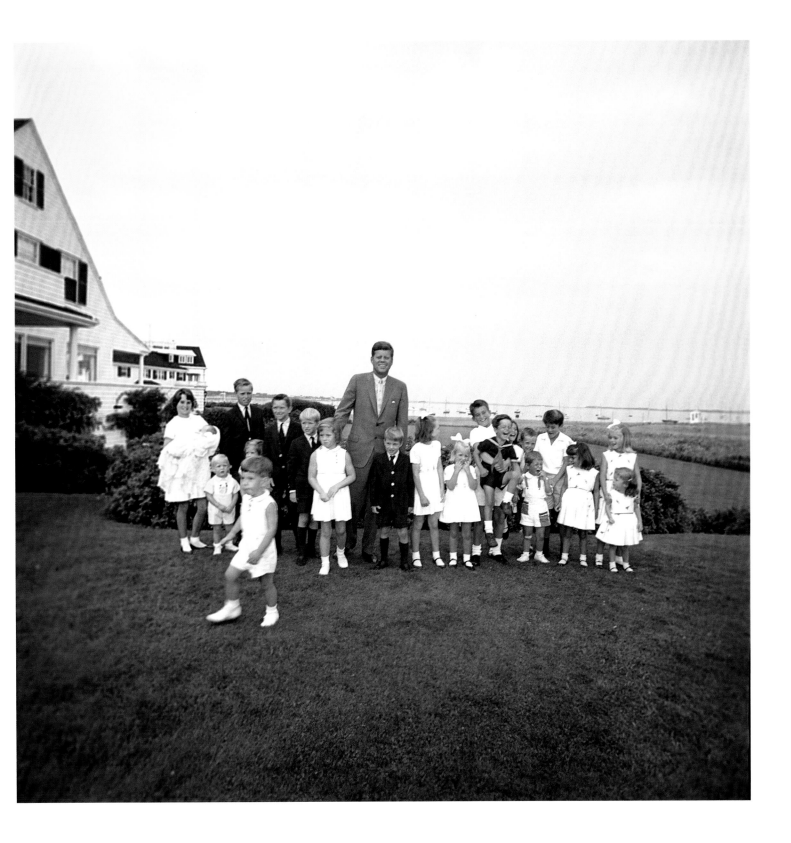

August 4 Back on the yacht, Caroline sleeps as her mother reads. The photograph showing Mrs. Kennedy with a cigarette is a rarity. A heavy smoker, she managed to hide the habit from most of the nation.

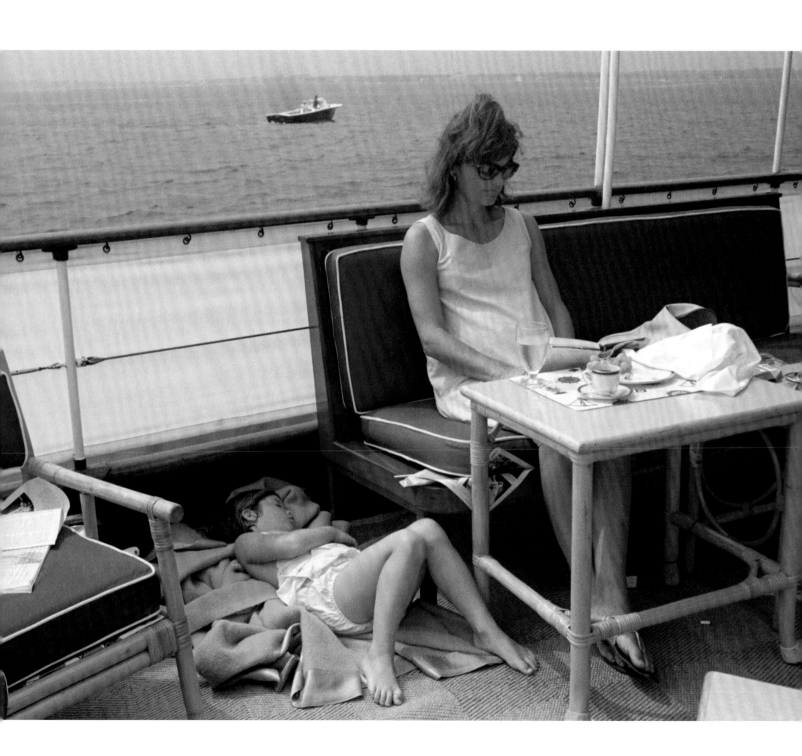

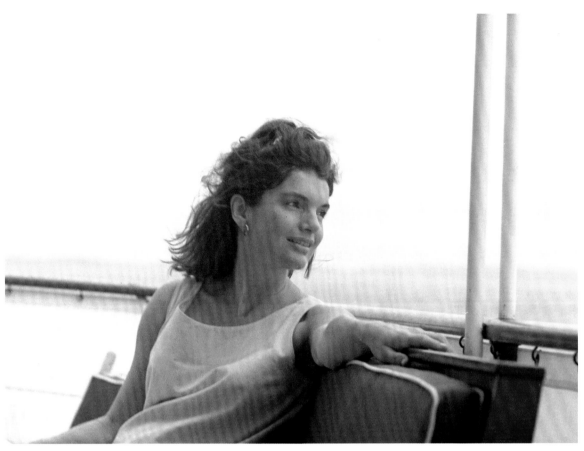

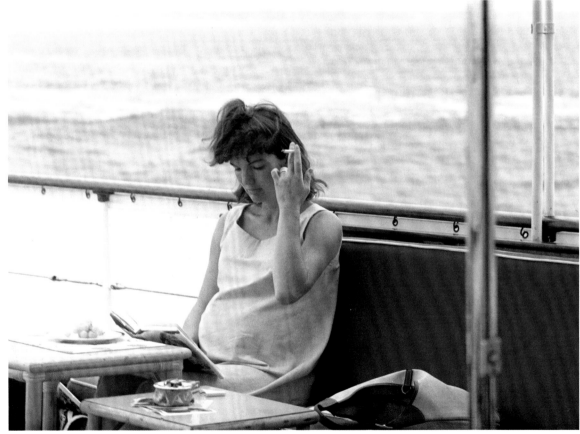

August 4 The couple on board with the Kennedys is Paul "Red" Fay, who was a member of the crew of Lieutenant (junior grade) Kennedy's boat, *PT-109*, in the South Pacific during World War II, and Fay's wife, Anita. Fay was named assistant secretary of the navy, mainly because the president liked having him around. The two men were close enough that Fay watched the president give himself regular shots of cortisone for his Addison's disease. Fay once said, "Jack, the way you take that jab, it looks like it doesn't even hurt." Kennedy lunged over and jabbed the needle into Fay's thigh. As his friend screamed in pain, Kennedy said, "It feels the same way to me."

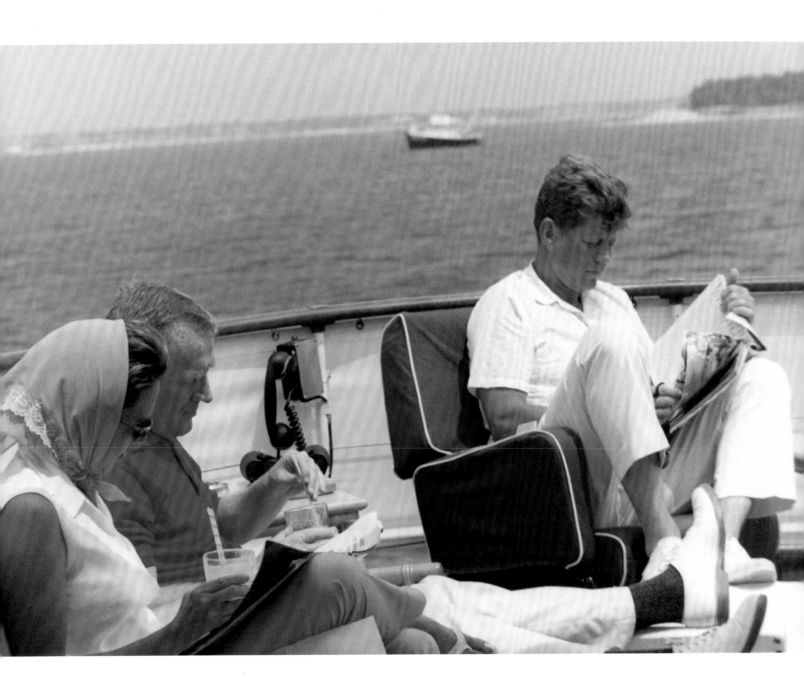

August 6 Kennedy crossing the street with John Jr. in Hyannis Port.

1963

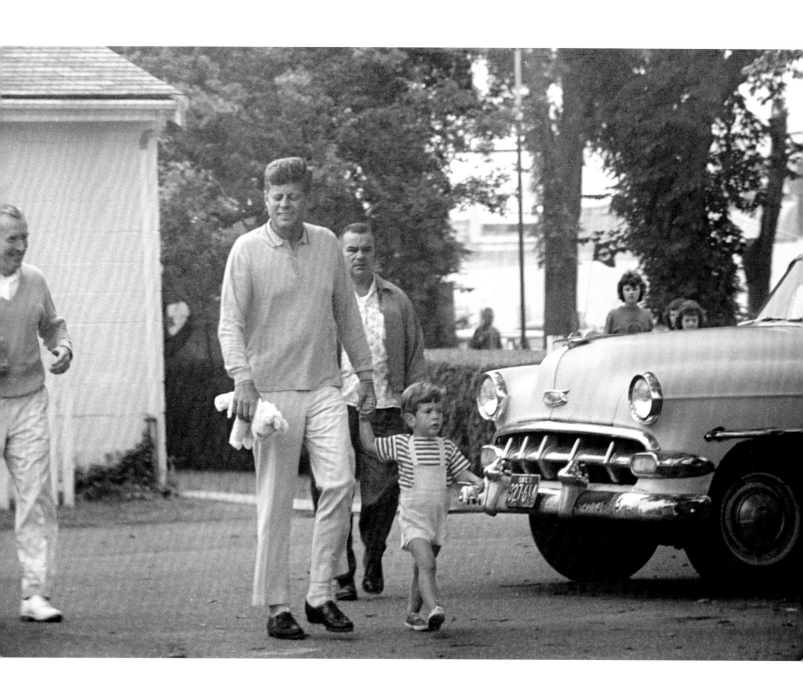

August 6 Caroline riding Macaroni, then John Jr. takes a turn in the saddle.

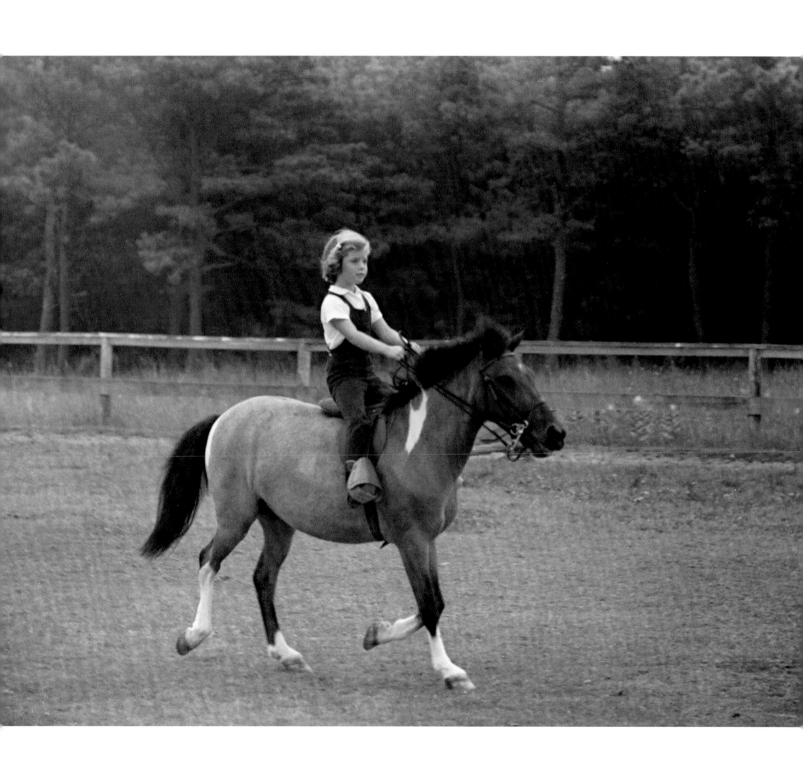

246

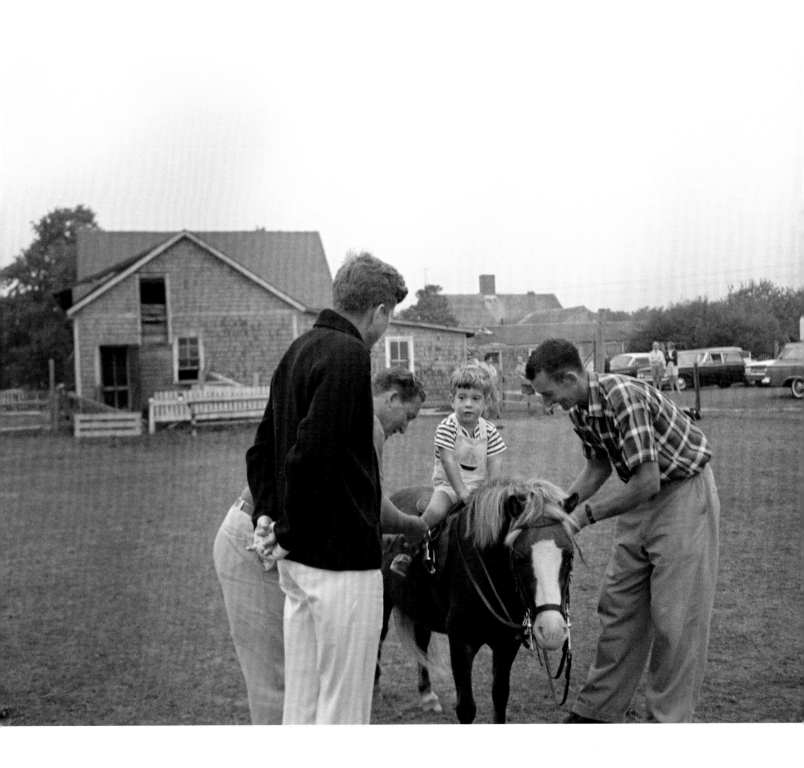

August 6 The son and grandchildren saying good-bye to Joseph P. Kennedy, disabled by a stroke in 1961.

Three brothers, Bobby, Teddy, and Jack, prepare to leave Otis Air Force Base on Cape Cod for Washington; at the same time, Pierre Salinger was briefing reporters on the president's schedule. It was a schedule that changed when Mrs. Kennedy felt labor pains and was rushed to the hospital at Otis, where she gave birth to Patrick Bouvier Kennedy on August 7. The baby lived only two days, dying of a lung ailment called hyaline membrane disease.

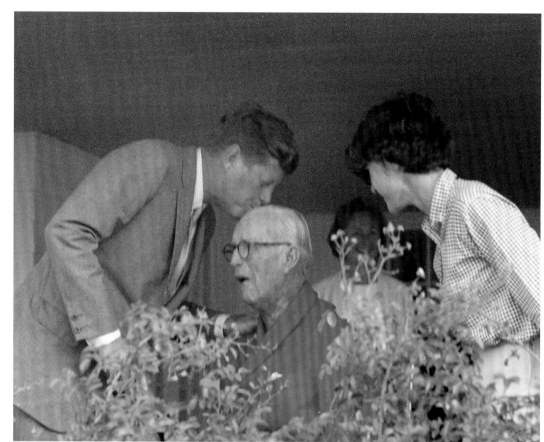

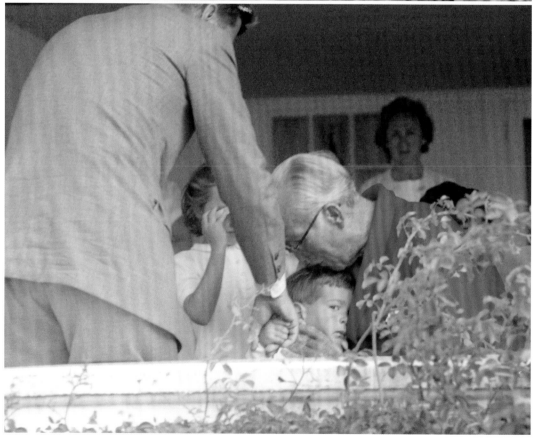

August 13 The president and his children aboard the helicopter *Marine One*,
en route to visit Mrs. Kennedy, who was still in the hospital at Otis.

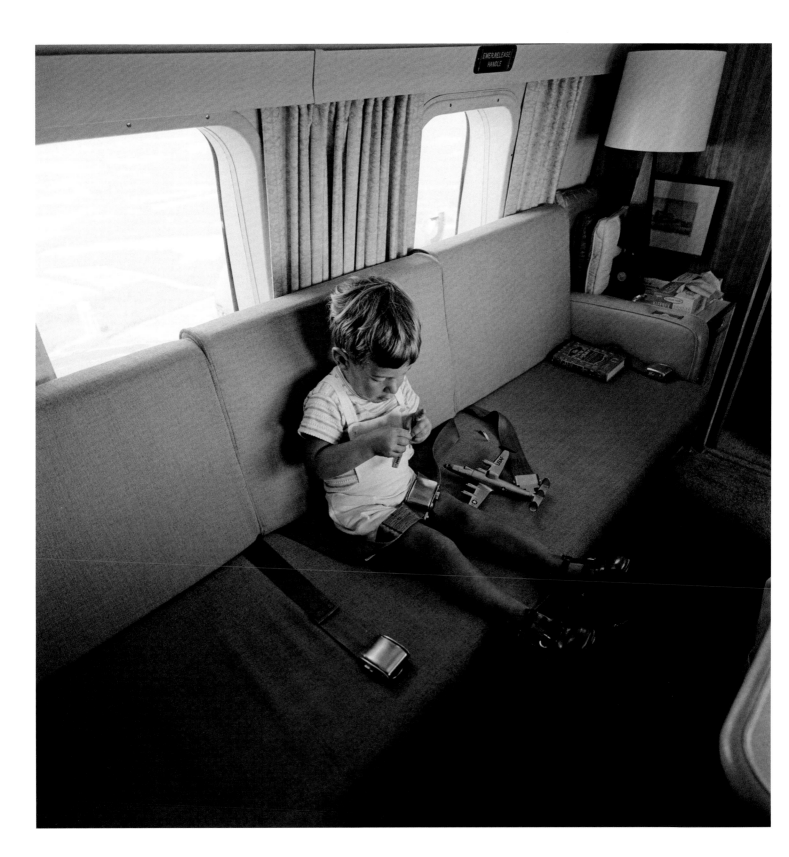

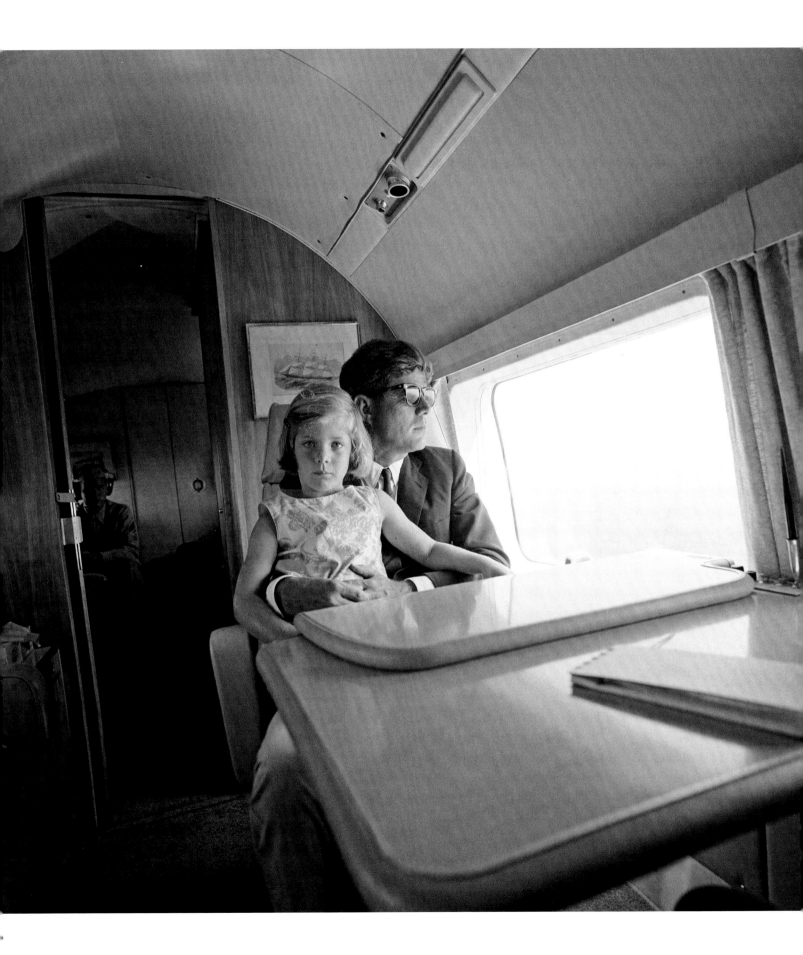

August 14 The Kennedys, wanting more privacy, stayed in a home on Squaw Island, Massachusetts, for the summer, because their Hyannis Port house was filled with more and more government people and equipment. The dogs went along too, including Clipper; the terrier, Charlie; and two new dogs, Wolf and Shannon. Dave Powers was the other man about the house.

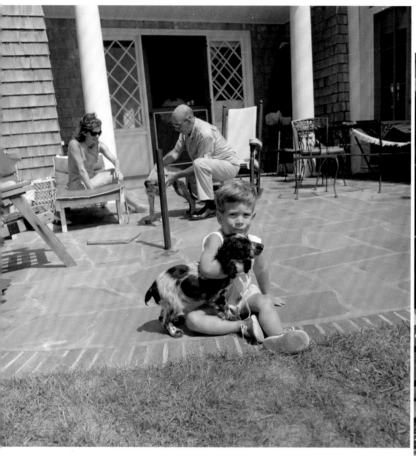

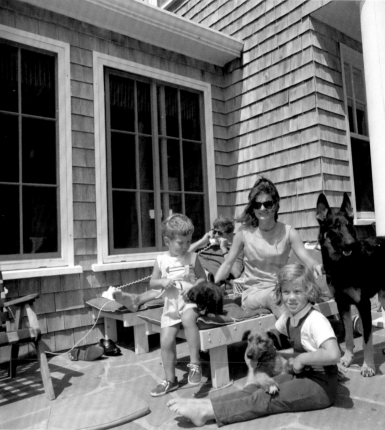

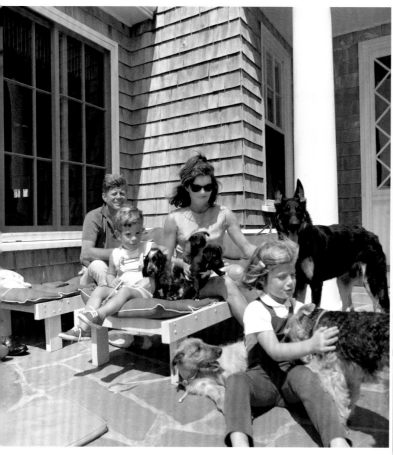

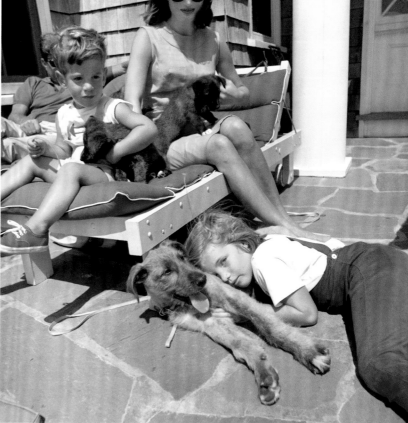

August 20 The president meets with Roger Blough (far left), the chairman of United States Steel Company, and David McDonald, the president of the United Steelworkers Union. Kennedy had humbled Blough in 1962. U.S. Steel and the union had signed a contract with a 2.5 percent pay increase for USW workers; then Blough announced a 3.5 percent average price increase. Kennedy, who had negotiated personally with Blough because he was concerned that higher steel prices would inevitably lead to increased inflation, told Blough, "You double-crossed me, you have made a terrible mistake." So he had.

Kennedy called on congress to pass emergency steel price legislation controlling prices, and he attacked Blough personally and repeatedly on television. Agents of the Federal Bureau of Investigation appeared at the homes of steel executives, asking for notes of meetings and financial records. The Washington offensive lasted eleven days before Blough rescinded the price increases. Now the president was thanking the businessman for organizing the support for civil rights by executives of U.S. Steel subsidiaries in Birmingham during the crisis at the University of Alabama.

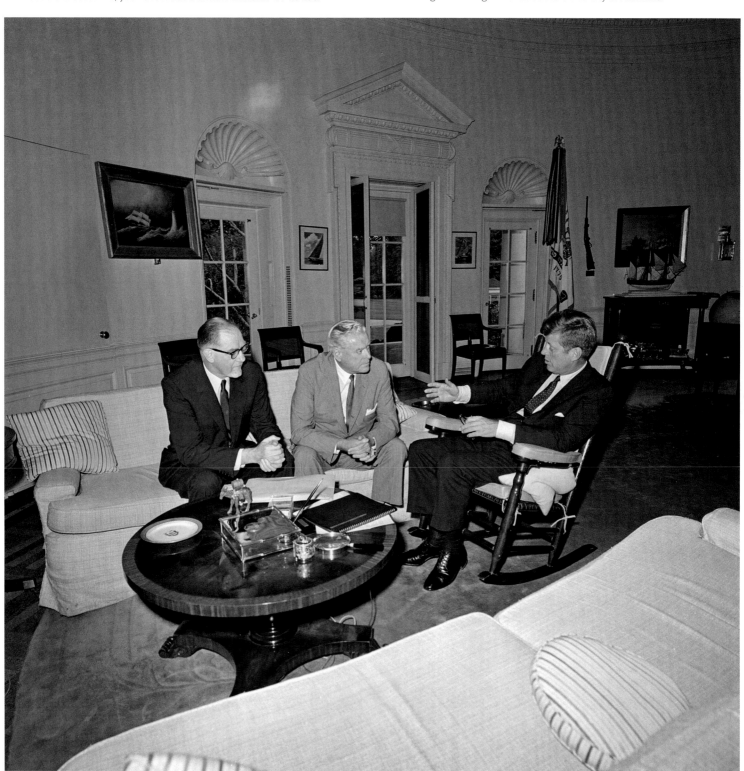

August 23, 25 The president was greeted by his children at Otis Air Force Base as he arrived for a weekend of sailing.

The trip produced some of the most memorable of the Kennedy photographs, particularly Stoughton's shots of the president with his daughter.

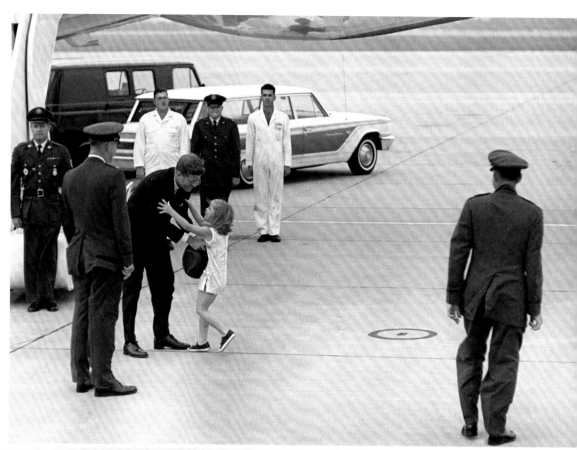

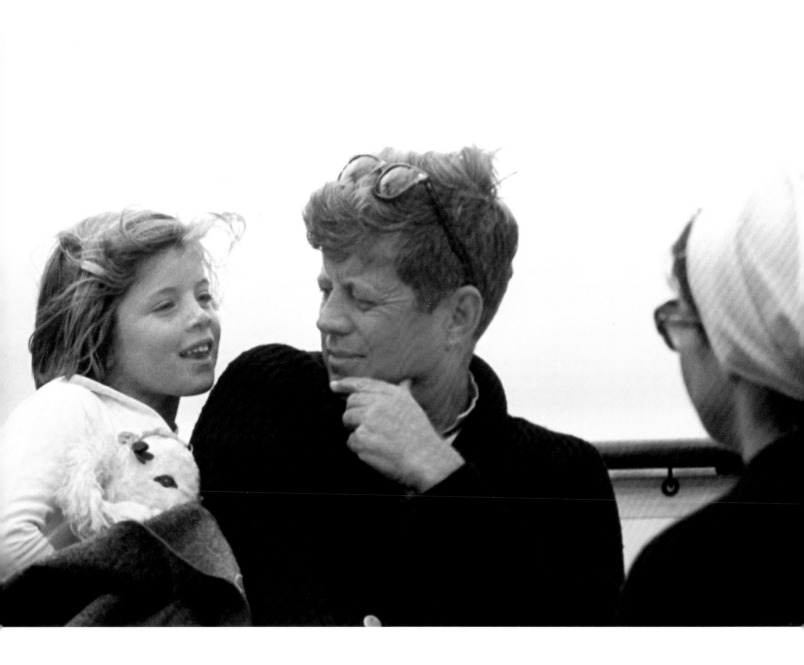

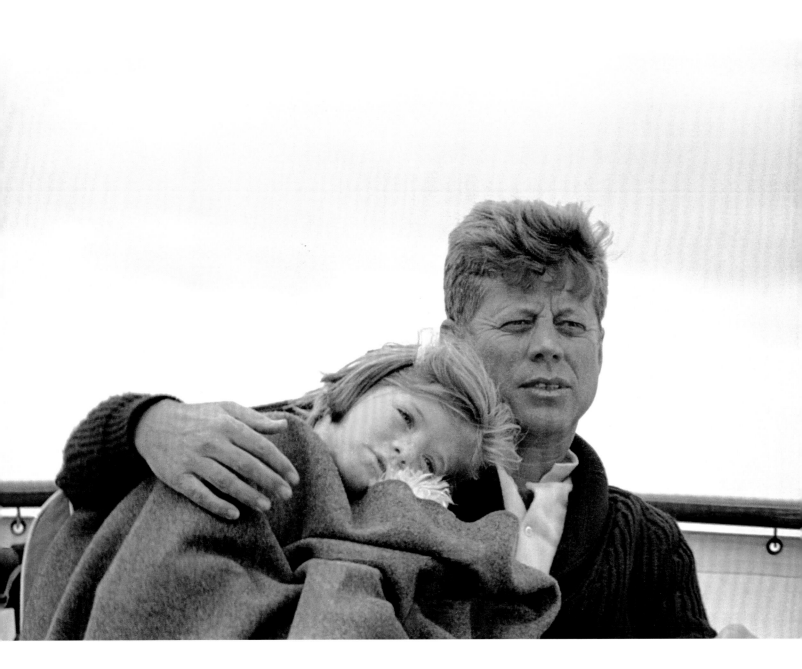

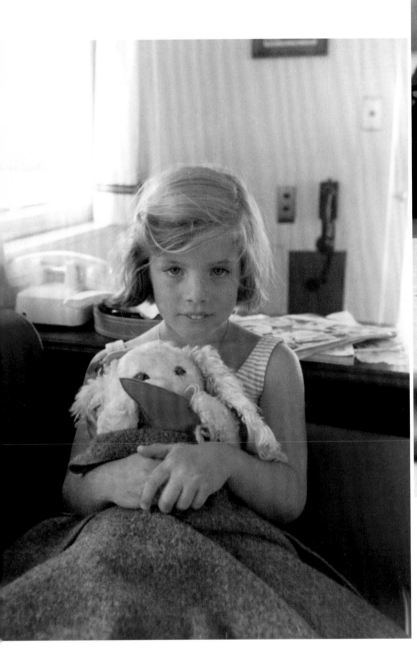

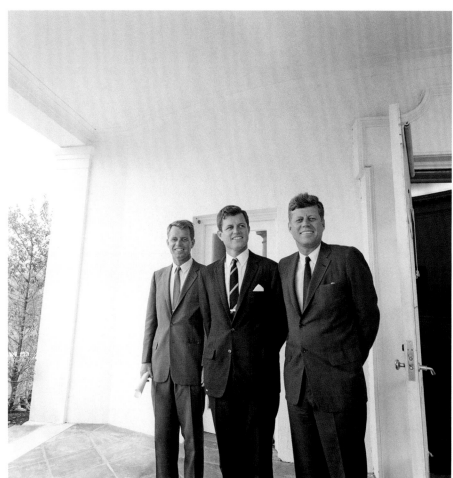

August 28 The attorney general, the senator from Massachusetts, and the president posing (and clowning) at the White House.

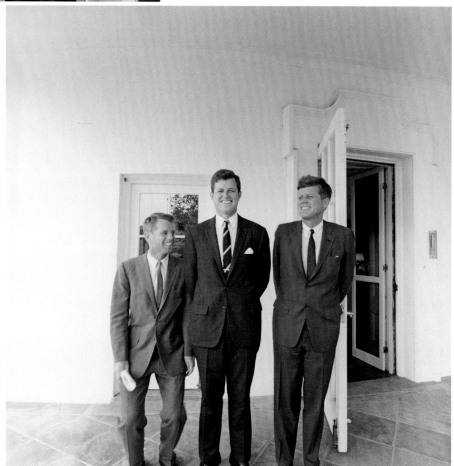

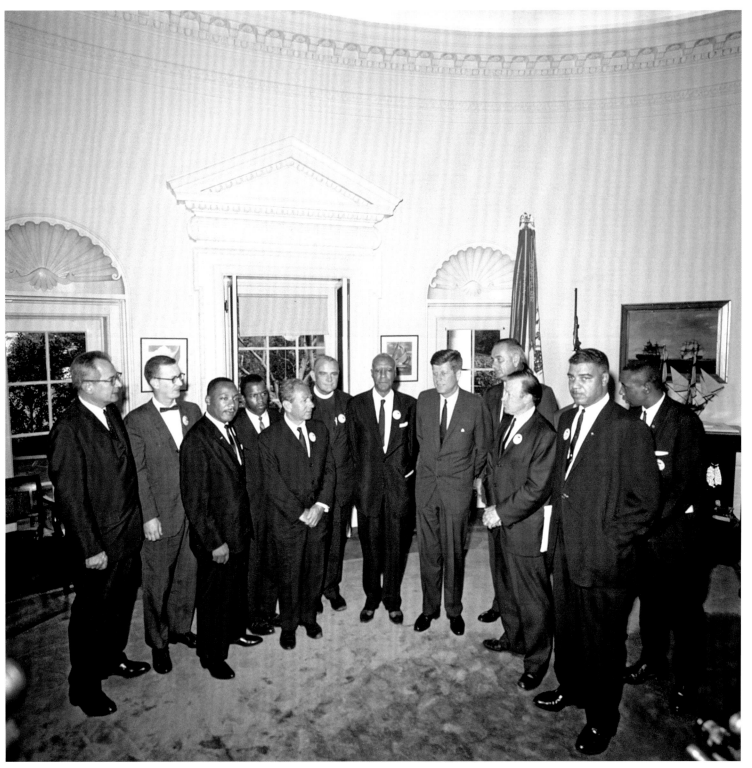

August 28 One of the most eventful days of his presidency: Kennedy was photographed for the first time with Dr. Martin Luther King, Jr., after the Atlanta preacher's "I Have a Dream" speech during the great civil rights March on Washington. Upon seeing a full speech by the preacher for the first time on television, the president said only, "He's damned good! Damned good!" Kennedy told his brother Robert to invite the march leaders to the White House and, for the first time, posed with them all: King (third from the left), John Lewis, A. Phillip Randolph (to the right of the president); next to the vice president is Walter Reuther, president of the United Auto Workers; Whitney Young, president of the Urban League; and Roy Wilkins of the NAACP. Said Randolph, "It's going to be a crusade then. And I think nobody but you can lead this crusade, Mr. President."

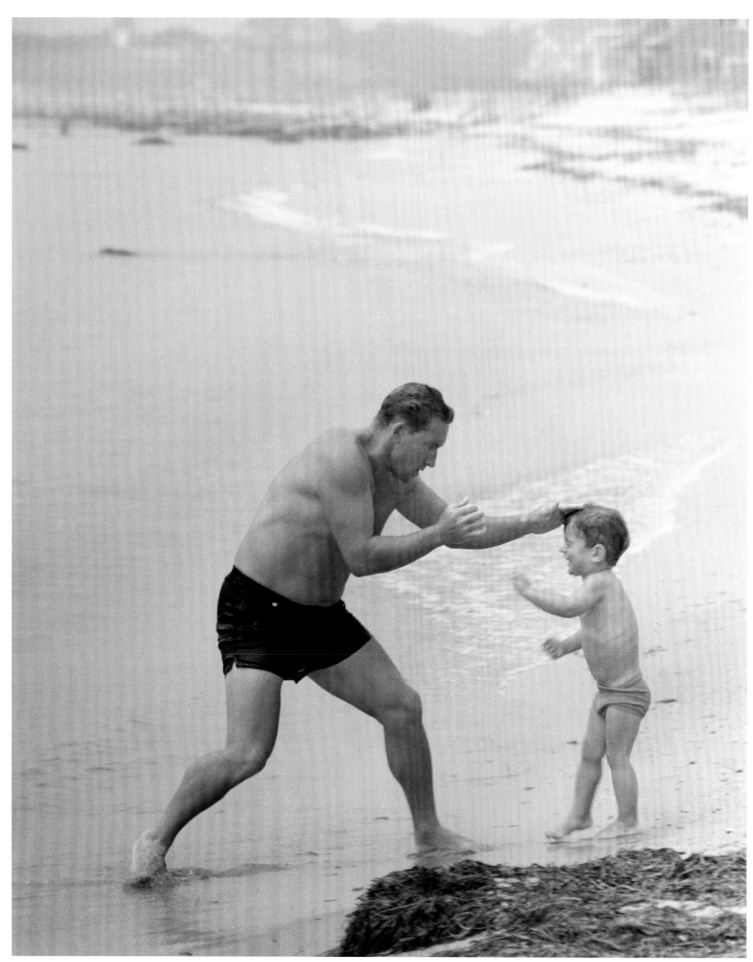

August 31 Back to Hyannis Port for the Labor Day weekend. Sandy Eiler, an athletic coach, playing with John Jr.; the president on board the *Honey Fitz*.

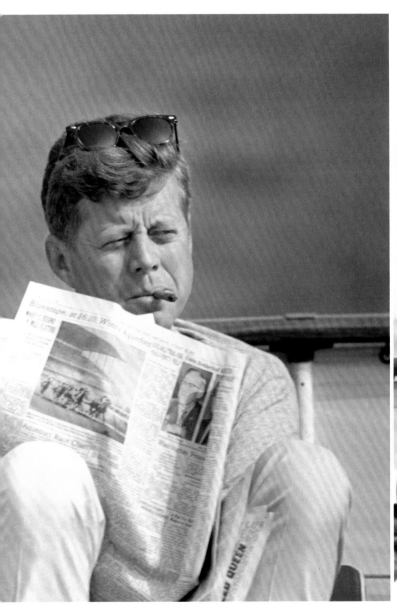

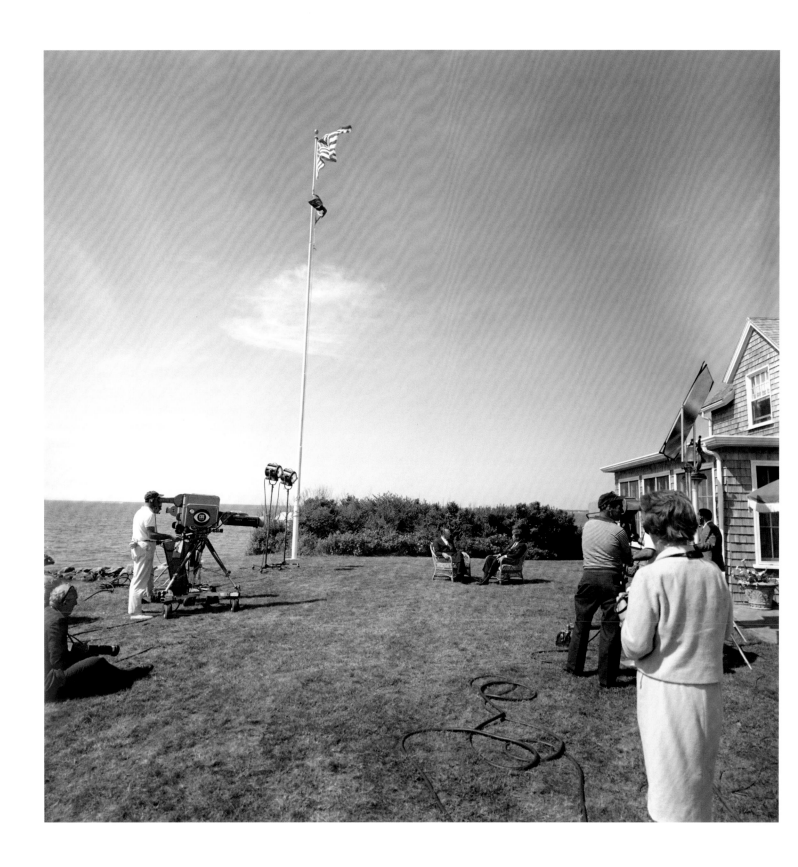

September 2 On Labor Day, when the *CBS Evening News with Walter Cronkite* went from fifteen minutes to a half-hour, the president agreed to an interview in Hyannis Port. "You might want to ask him some questions about Vietnam," Salinger said to Cronkite the day before—which meant, of course, Kennedy wanted to say something about American policy in that faraway place. "You can go to hell, Pierre," said Cronkite. "I'll ask anything I want to ask." But, after questions about racial troubles at home, Cronkite did ask about Saigon.

Kennedy answered, "I don't think that unless a greater effort is made by the government to win popular support that the war can be won out there. In the final analysis, it is their war. They are the ones who have to win it or lose it. We can help them, we can give them equipment, we can send our men there as advisers, but they have to win it, the people of Vietnam, against the Communists . . . and in my opinion in the last two months, the government has gotten out of touch with the people."

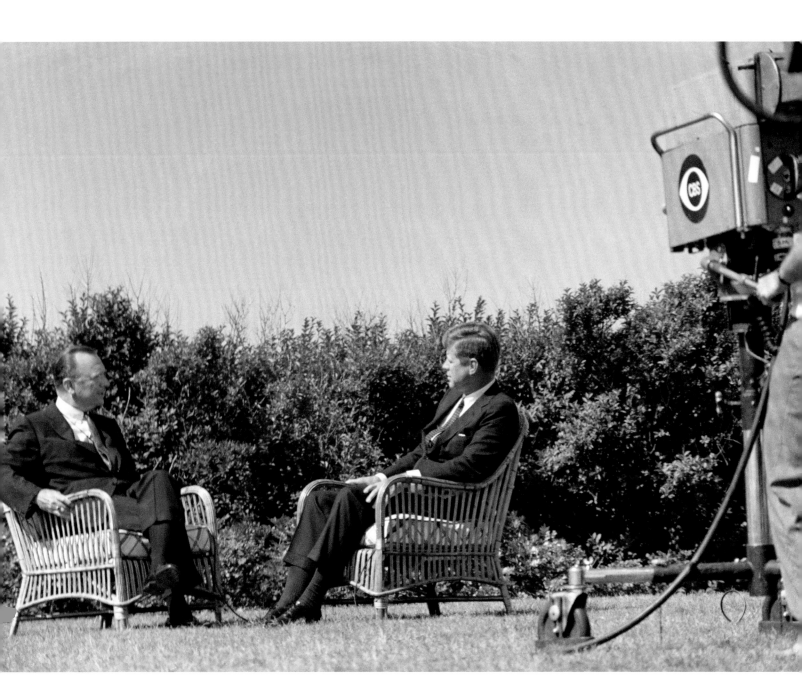

Joseph Kennedy's seventy-fifth birthday. Though he could barely speak, the old man greatly enjoyed a family tradition of disrespectful limericks, toasts, and songs. So, obviously, did the president, here holding a drink, though, in fact, he usually drank milk. With Jackie kneeling next to her father-in-law, others, from the left, include Sargent Shriver, Stephen Smith, Rose Kennedy, Robert Kennedy, Jean Kennedy Smith, Eunice Kennedy Shriver, and Ted and Joan Kennedy.

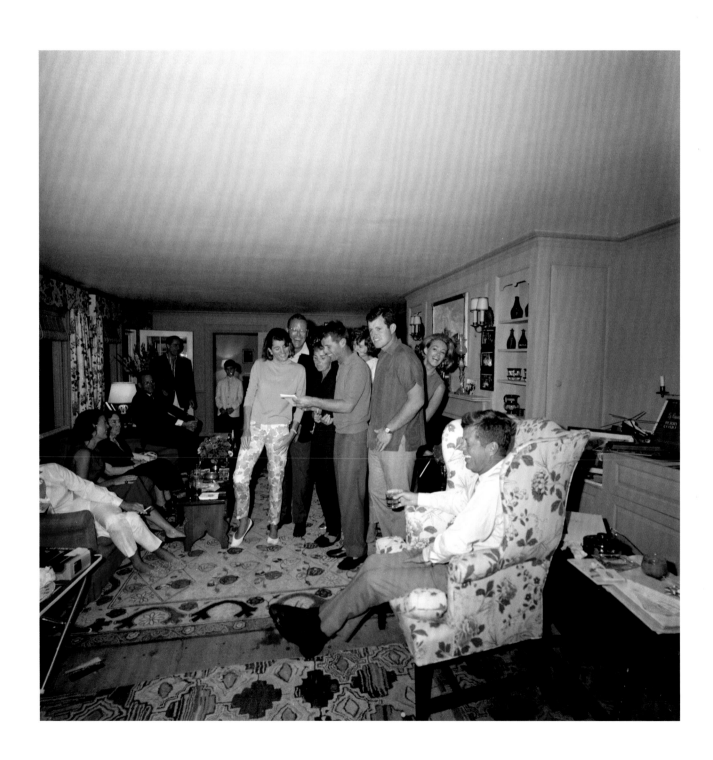

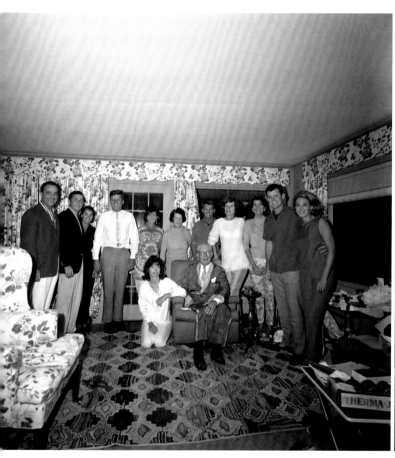

September 11 The president presents the Congressional Gold Medal to comedian Bob Hope in commemoration of his many trips to entertain American troops in several wars. Inside the Oval Office, Kennedy had Hope compare noses with White House policeman Robert S. Suggs, Jr.

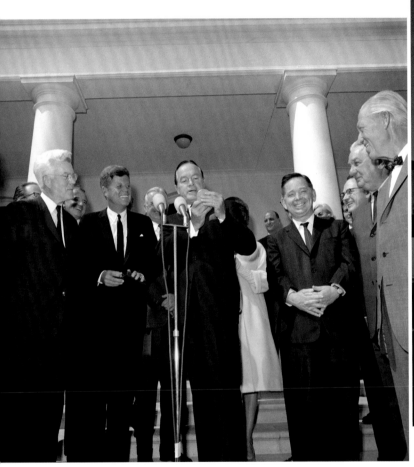

September 11 Later that day, Kennedy talking with comedian Milton Berle.

The president and undersecretary of the navy Paul Fay don hats for a meeting with their navy buddy, "Nice" Al Webb, a vice president of the Hat Corporation of America.

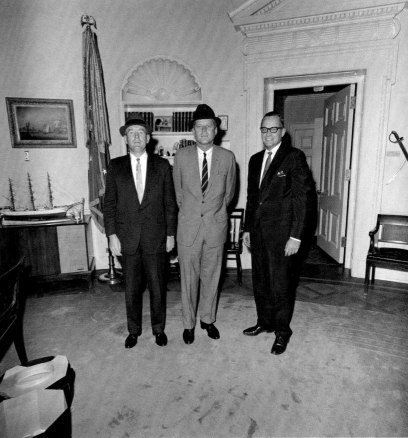

September 18 Kennedy shares a word with Hugh Sidey, the White House correspondent for *Time* and *Life* magazines, before a television appearance.

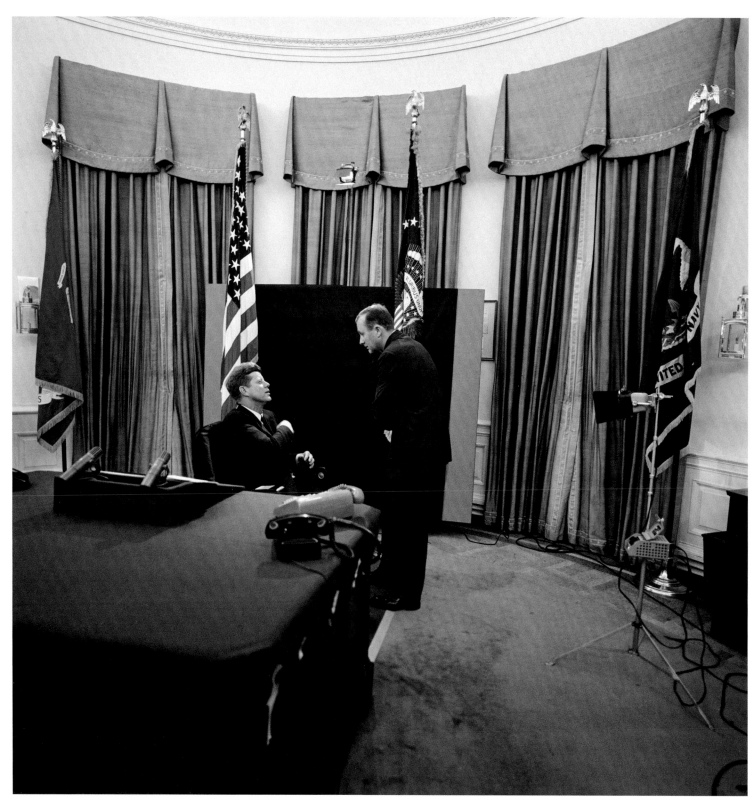

September 23 The president met with Secretary of Defense McNamara and the chairman of the Joint Chiefs of Staff, Maxwell Taylor, as they prepared to leave Washington on a presidential mission to South Vietnam—one of many. The two men, among those most trusted by Kennedy, returned on October 2 and went directly to the White House to report to Kennedy. They told him the war could be won and American troops could begin being withdrawn in 1965. The summary of their written report began: "The military campaign has made great progress and continues to progress . . . The Diem-Nhu government is becoming increasingly unpopular . . . There is no solid evidence of a successful coup, although assassination of Diem and Nhu is always a possibility . . ."

The president sits for a photo opportunity with the prime minister of Laos, Prince Souvanna Phouma, an America ally whose country was slowly being taken over by the procommunist Pathet Lao.

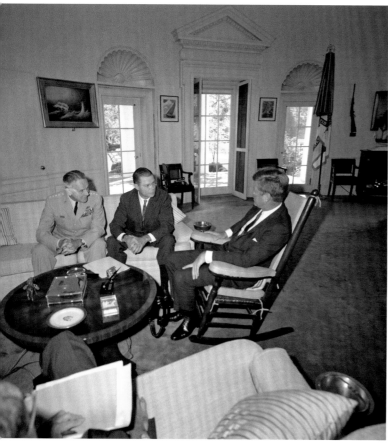

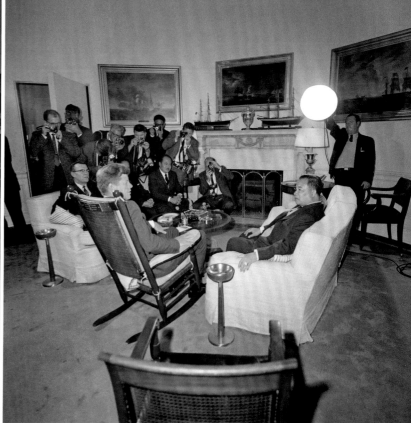

September 24 Kennedy began a five-day "Conservation Tour" in Ashland, Wisconsin, where he joked with local officials at the airport.

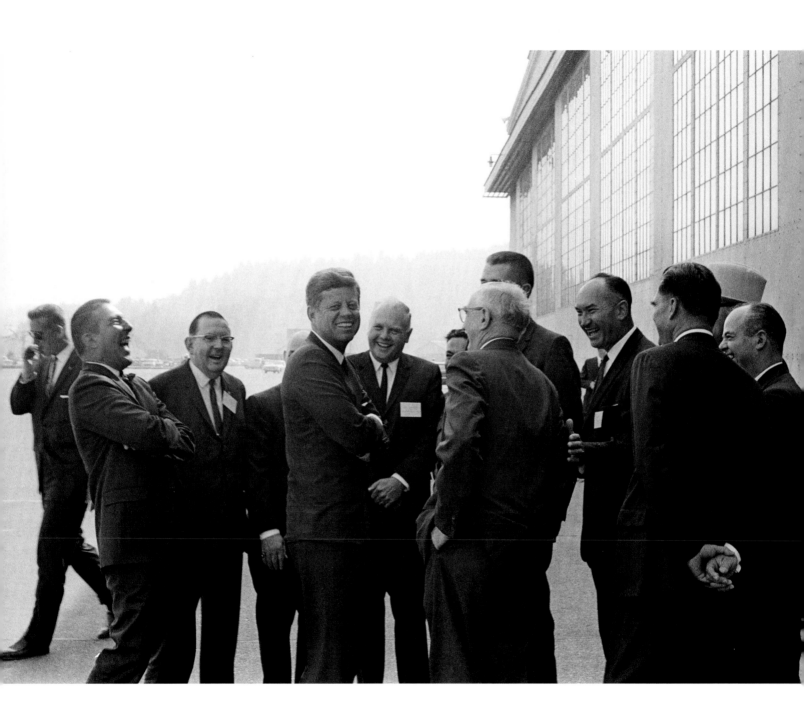

September 25–26

In Billings, Montana, Kennedy quoted Henry Thoreau, saying, "'Eastward I go only by force; Westward I go free. I must walk towards Oregon and not towards Europe.'" Then Kennedy added his own words: "I walk towards Montana."

Kennedy's next stop in Montana was Great Falls, where a young boy named Luke Flaherty gave Kennedy a model he had made of *PT-109*.

September 26 *The president and* Air Force One *in Great Falls, Montana.*

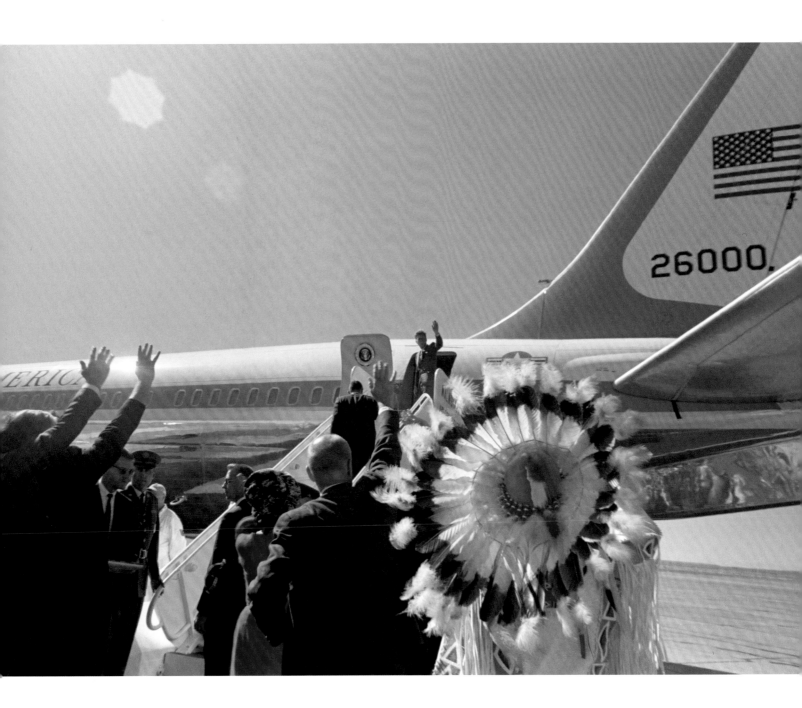

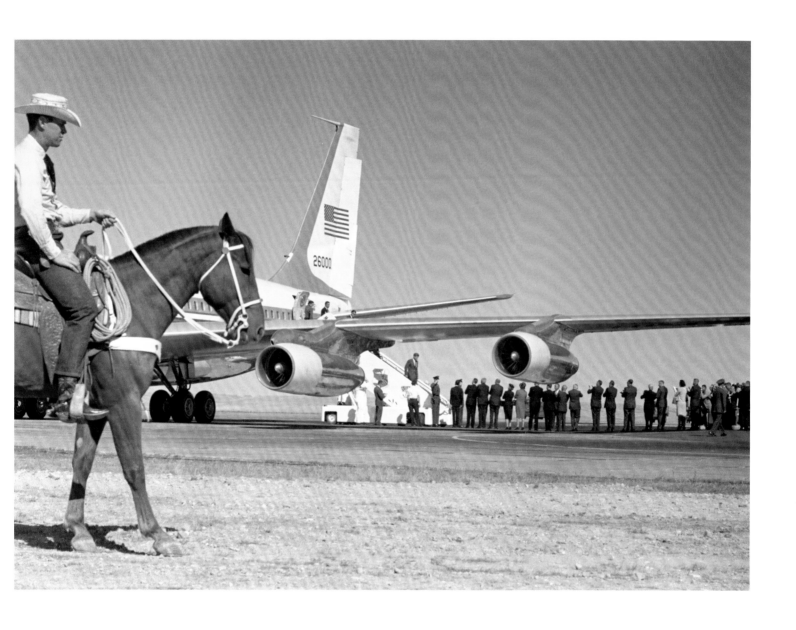

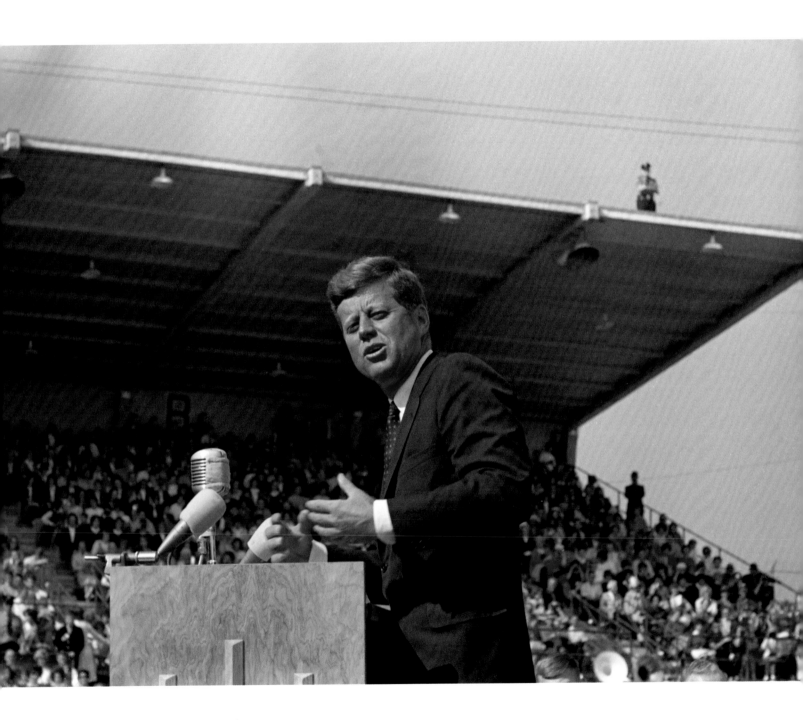

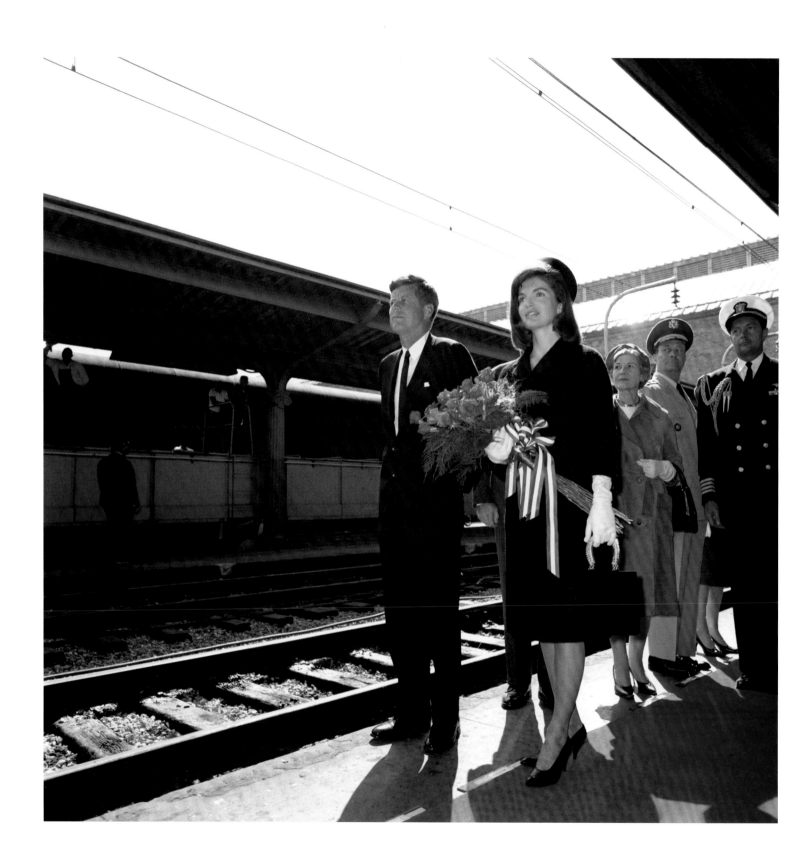

October 1 The Kennedys met Emperor Haile Selassie of Ethiopia at Union Station and then, with Vice President Johnson and his wife, Lady Bird, hosted a reception for the emperor. Rose Kennedy, the president's mother, and Princess Rose Desta, the emperor's granddaughter, joined the reception line. Selassie also met John Jr. at the White House.

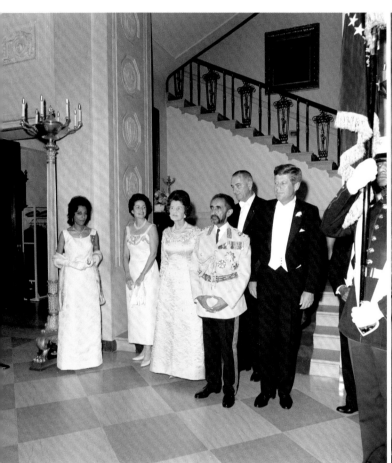

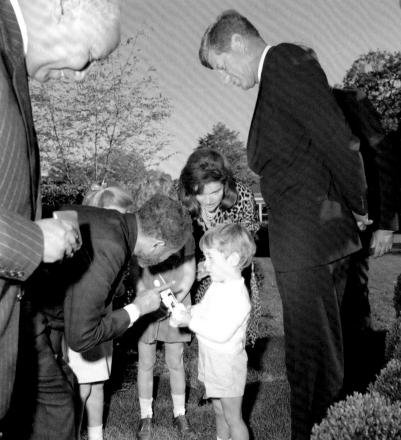

October 3 The president arriving in Little Rock, Arkansas, en route
to dedicating a dam near Heber Springs.

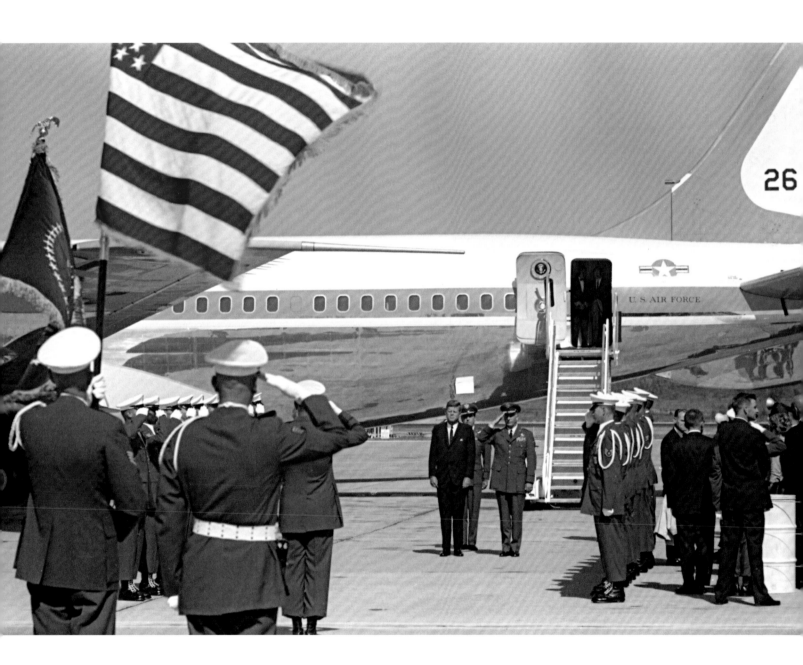

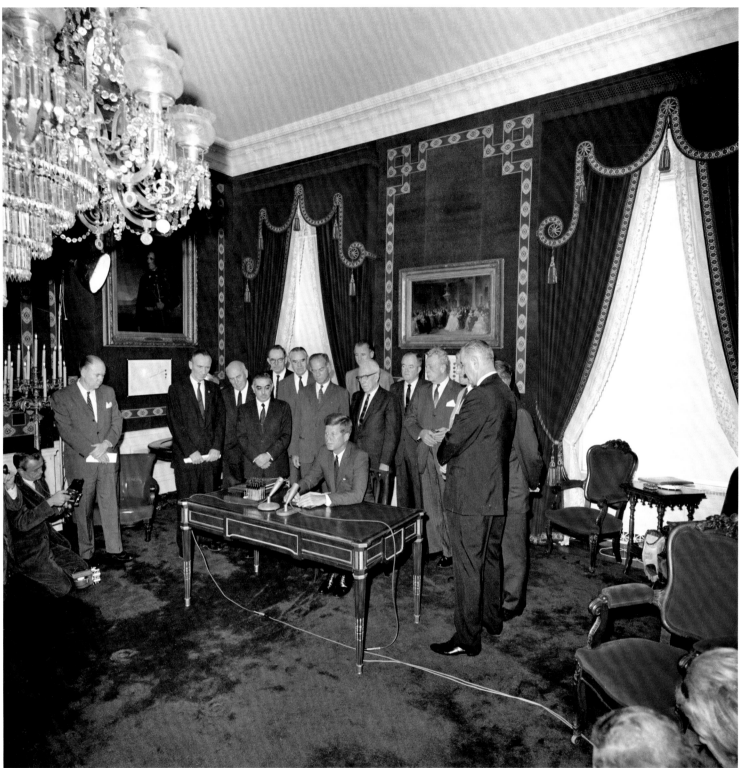

October 7 The signing of the Limited Nuclear Test Ban Treaty after its approval in the
Senate by a vote of 80 to 19. Standing behind the president, from the left, are Senator Mike
Mansfield from Montana, John McCloy, Senator John Pastore from Rhode Island, Ambassador
W. Averell Harriman, Senator J. William Fulbright from Arkansas, Senator George Smathers
from Florida, Senator George Aiken from Vermont, Senator Hubert Humphrey from
Minnesota, Senator Everett Dirksen from Illinois, and Vice President Johnson.

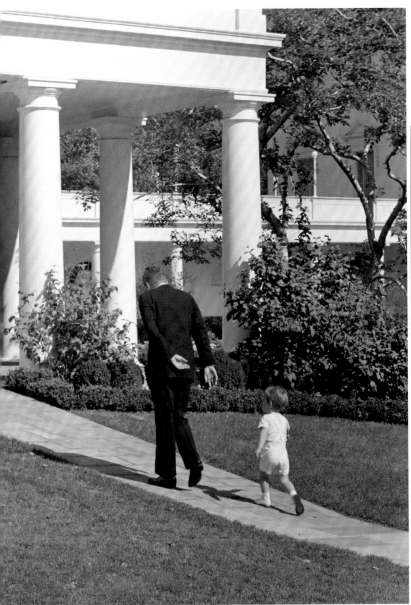

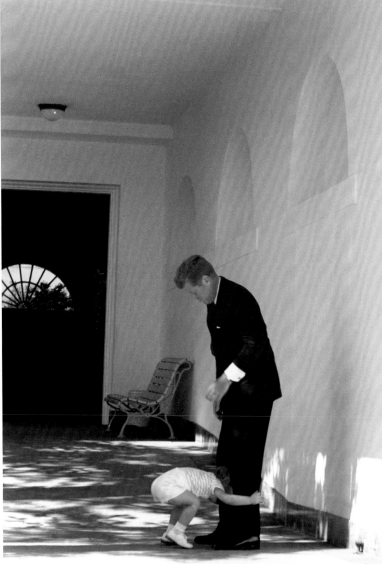

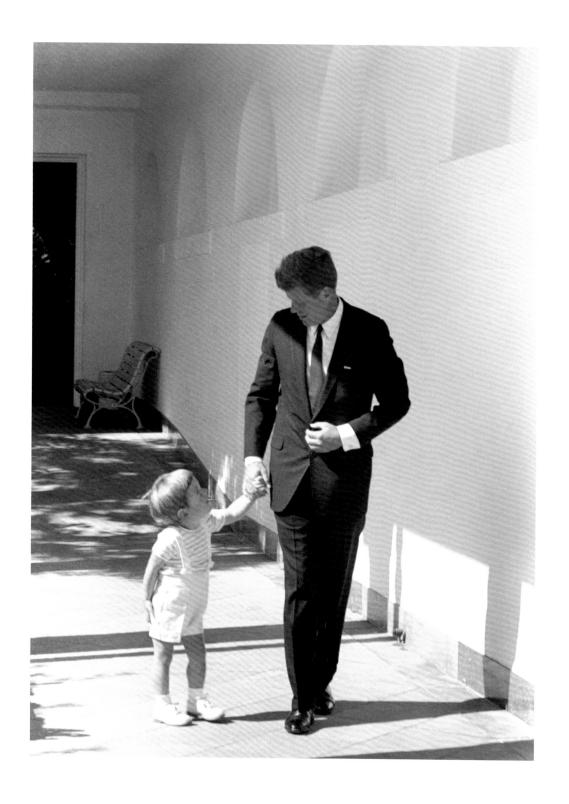

October 10 The presentation of the Robert J. Collier Trophy given annually "for the greatest achievement in aeronautics in America" to the seven Project Mercury astronauts.

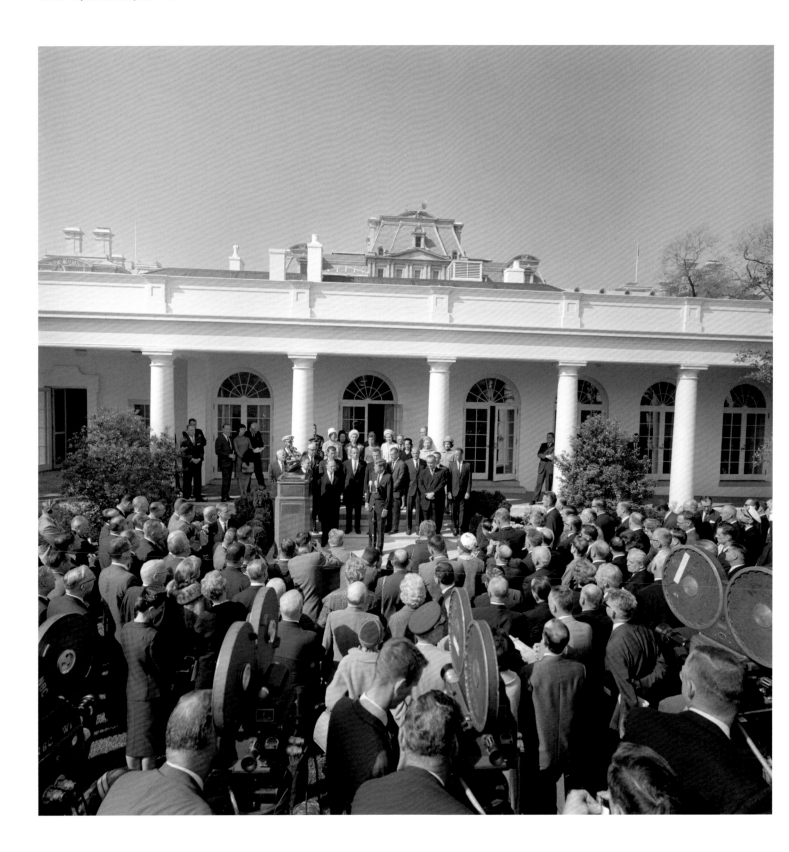

October 15 The president and the prime minister of Ireland, Sean Lemass (in front of the American flag), testing the golf clubs Kennedy gave to Lemass as a gift.

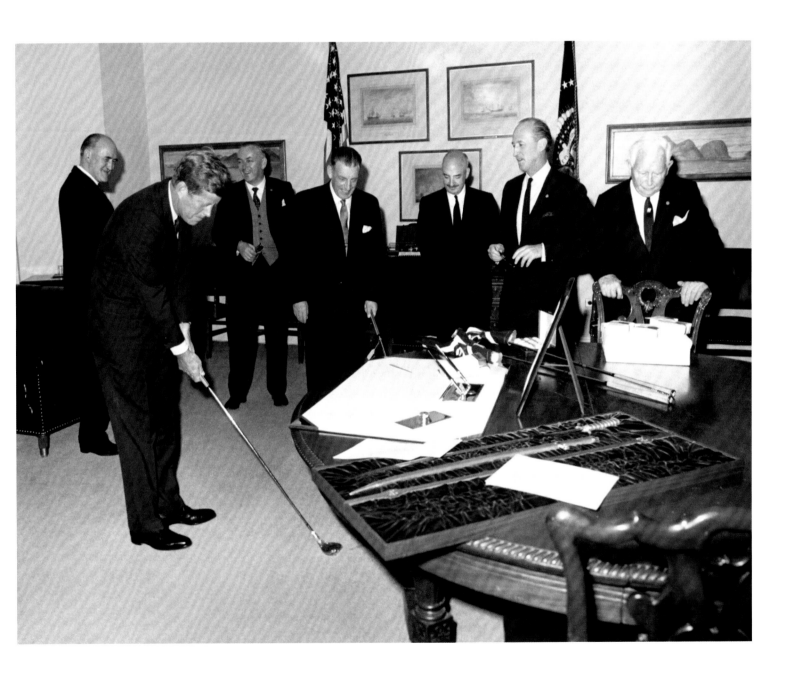

October 17 Kennedy greeting Josip Broz Tito, president of Yugoslavia, on a visit to the White House. The two leaders listening to the national anthems of both countries with the president's sister, Eunice Shriver, and Mrs. Tito on either side. Tito was the first communist leader ever asked to the White House and it was a controversial invitation, even if he was seen as an anti-Soviet communist. There were demonstrations against Tito everywhere; "RED PIG" and "MURDERER" were on signs waved in Washington and New York. Senator Barry Goldwater called it "dining with the enemy." At the Waldorf Astoria Hotel in New York, an alert city policeman stopped two Croatian would-be assassins just as they reached the door of Tito's suite in the early morning hours of October 25. The day before, a woman in Dallas had hit United Nations Ambassador Adlai Stevenson with a sign. Tito's comment: "That could happen against a great man like Adlai Stevenson? What kind of country is this?"

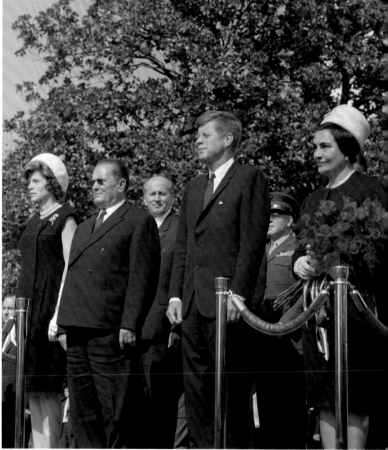

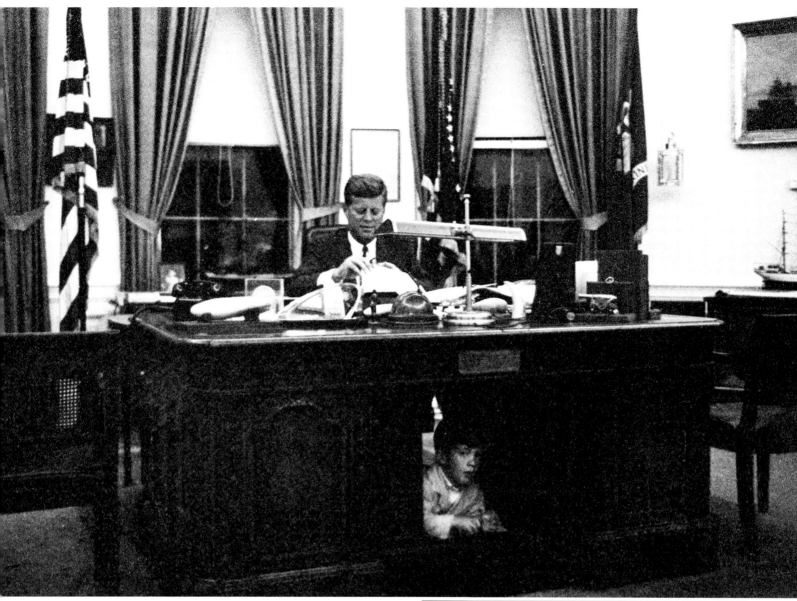

October 17 John Jr. playing under his father's desk.

October 18 Retired general Omar Bradley, one of the great heroes of World War II, presenting a military book for which he'd written the foreword to the president.

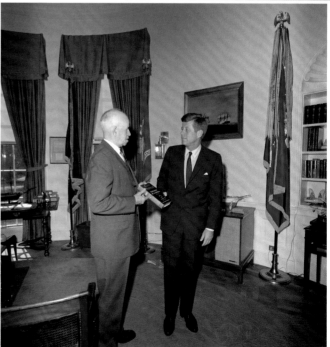

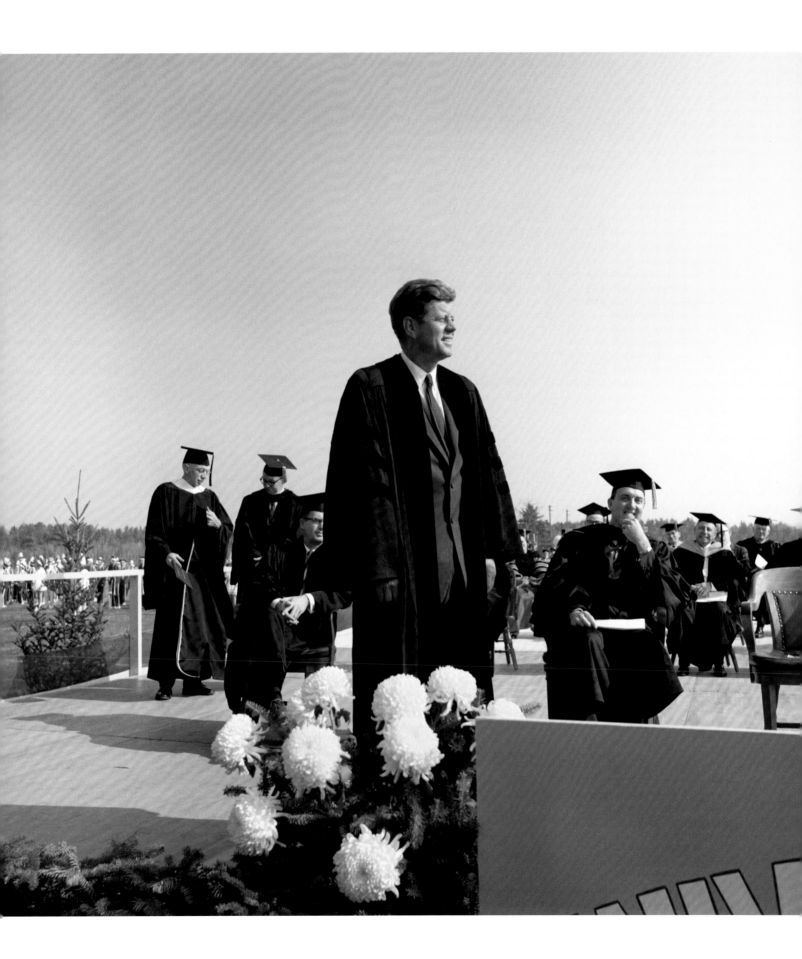

October 19 The president at the University of Maine, where he was presented with an honorary degree. The state's former governor and present senator, Edmund Muskie, is seated behind Kennedy (right). The president spoke at a fundraising dinner that same day in Boston, applauding as the state's junior senator, his brother, Ted, walked up to the microphone.

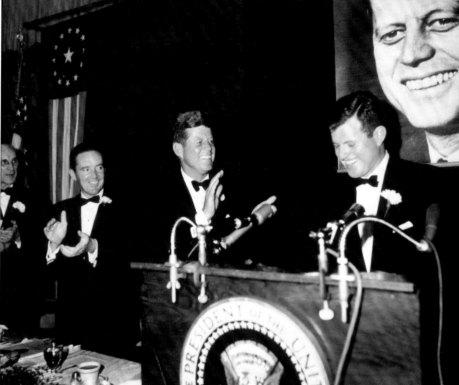

October 19 The president attended the Harvard–Columbia football game, sitting between Muskie and his congressional liaison, Lawrence O'Brien.

October 20 The president leaving Mass at St. Francis Xavier Church in Boston.

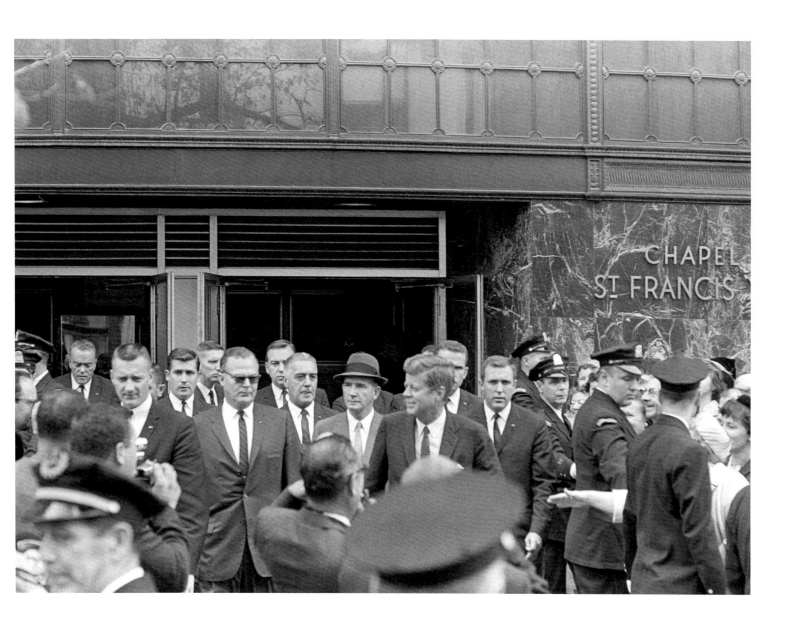

October 24 John Jr., watched by his nanny, Maude Shaw, plays with three of the family's dogs, Wolf, Shannon, and Clipper, and is then joined by the president.

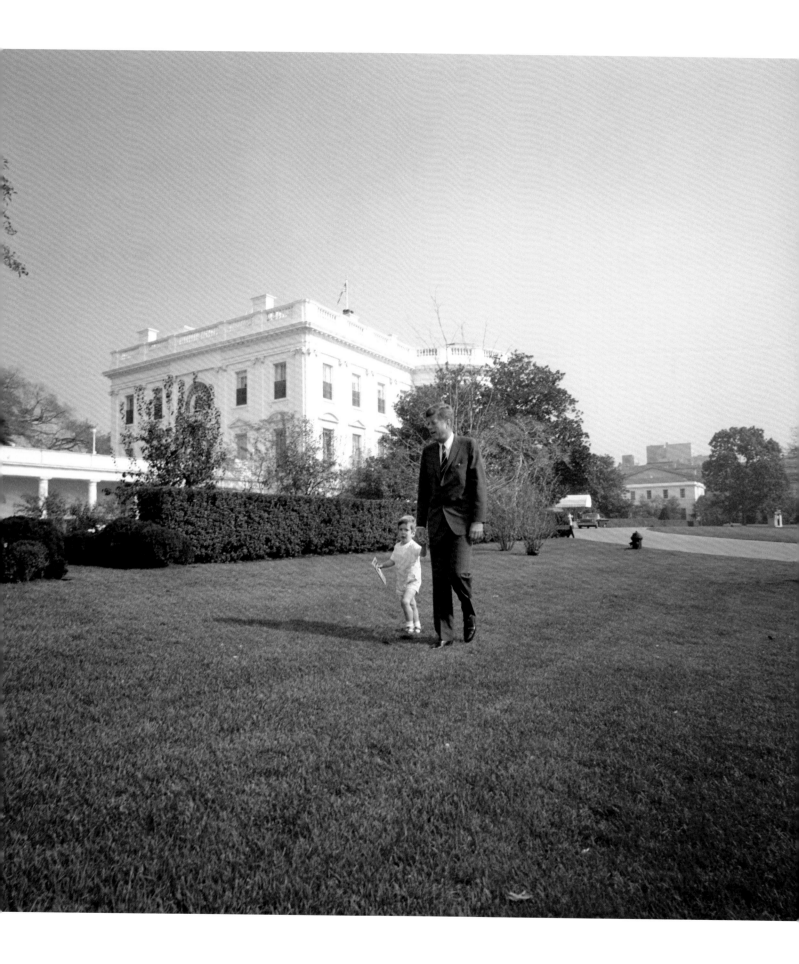

October 24 The president, with his sister, Eunice Shriver, after signing the Maternal and Child Health and Mental Retardation Planning Amendments to provide federal assistance for the mentally challenged, legislation Shriver had promoted.

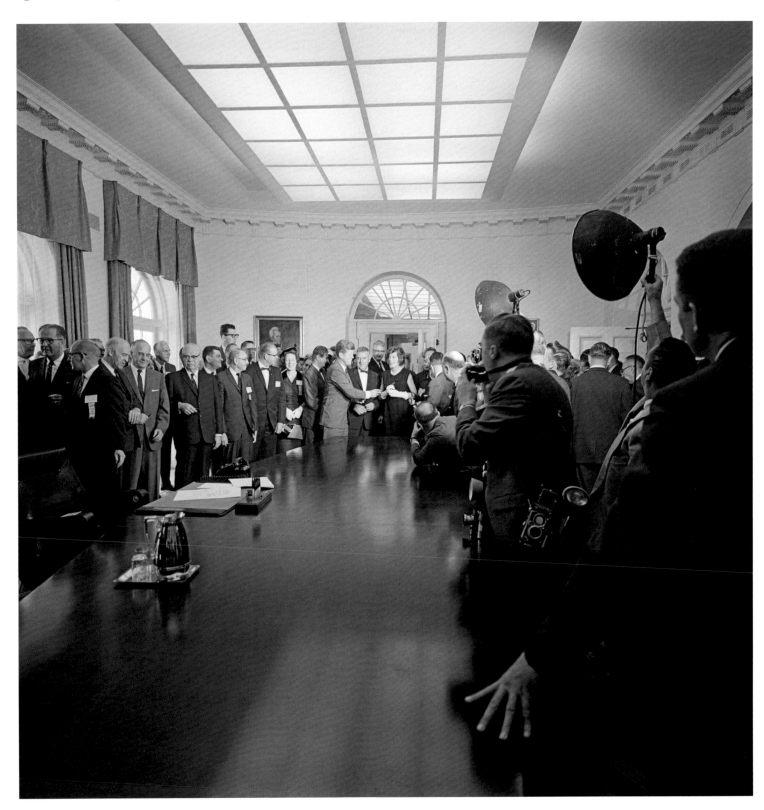

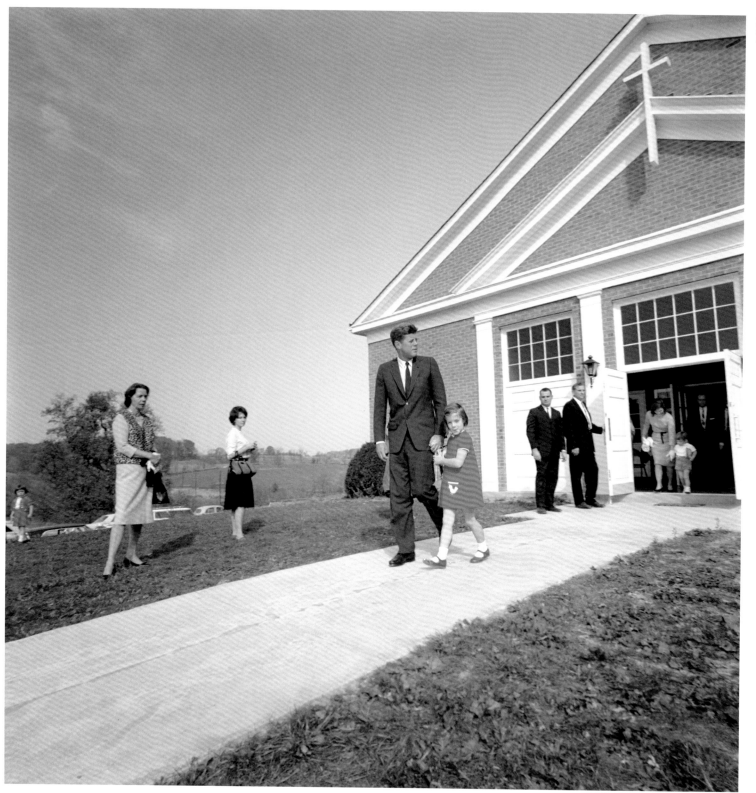

October 27 The president and Caroline leaving the small Catholic church in Middleburg, Virginia, after Mass.

October 27 Caroline on horseback at Atoka, the Kennedy's rented home in the horse country of Middleburg, Virginia.

The Kennedys with their children and LeMoyne Billings at Atoka. The president was receiving cables from Saigon that weekend reporting that a coup to overthrow South Vietnamese president Diem was imminent. The president had wavered about whether he favored a coup or not, but he had essentially ordered that if such a coup began, Americans should not interfere, except to guarantee the safety of Diem and his family—but Kennedy had already lost control of events. The coup began before midnight on October 31, Washington time. It was not until he walked into his office on November 2 that Kennedy was visibly shocked to learn Diem had been killed by his captors, the high command of the country's military. Said General Maxwell Taylor, chairman of the joint chiefs of staff, "What did he expect?"

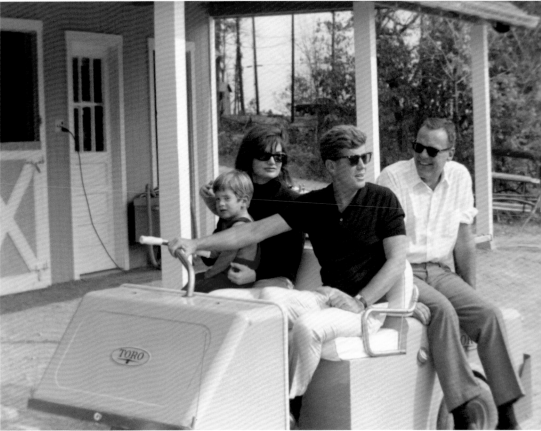

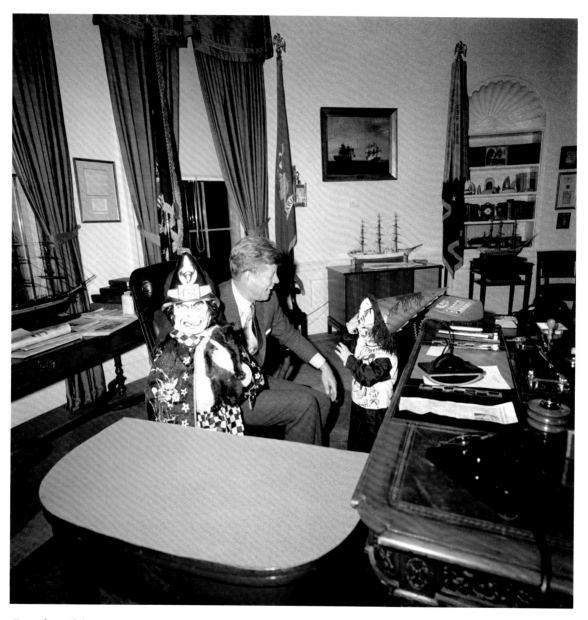

October 31 The president and his children, ready for tricks or treats on Halloween.

November 10 Jacqueline Kennedy on horseback at Atoka. Sitting on the wall with the president are Ben and Tony Bradlee; Caroline, the young equestrian; Mrs. Kennedy with John Jr. and Clipper that same weekend, before the boy went off to play soldier.

November 10 John Jr. talking with Bradlee; the Kennedys and Bradlees. Caroline's horse took an interest in the president, as Tony Bradlee tried to push him away. "Keep shooting, Captain," Kennedy called to Cecil Stoughton. "You are about to see a president being eaten by a horse."

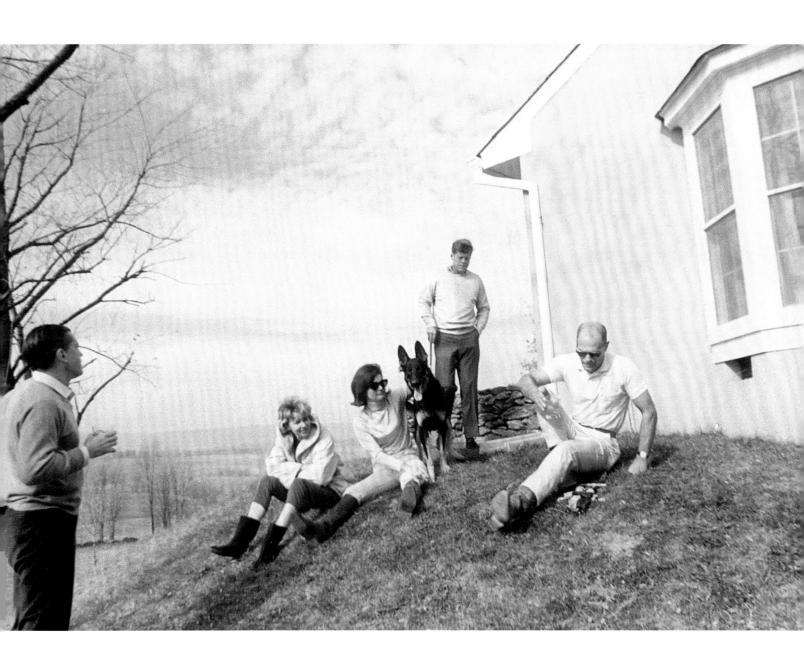

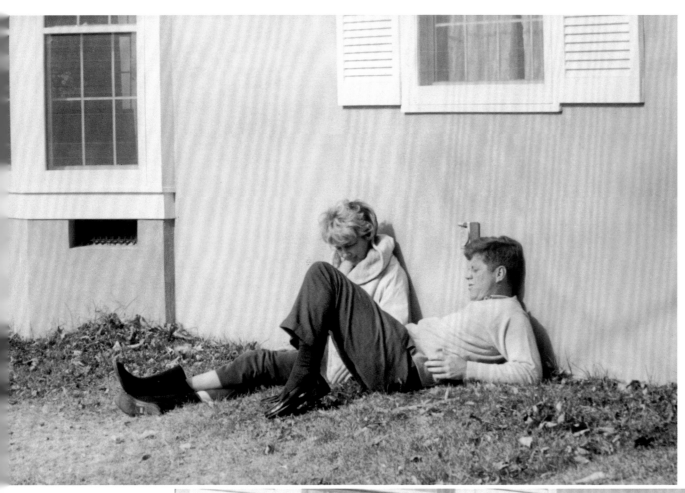

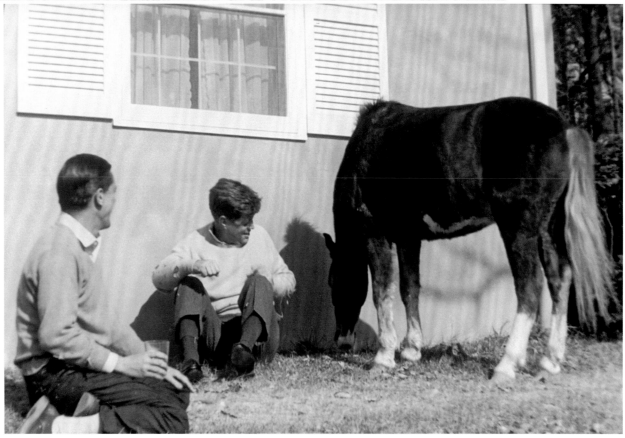

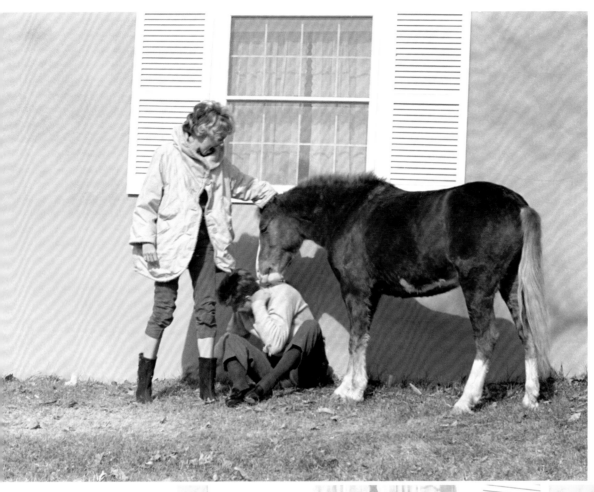

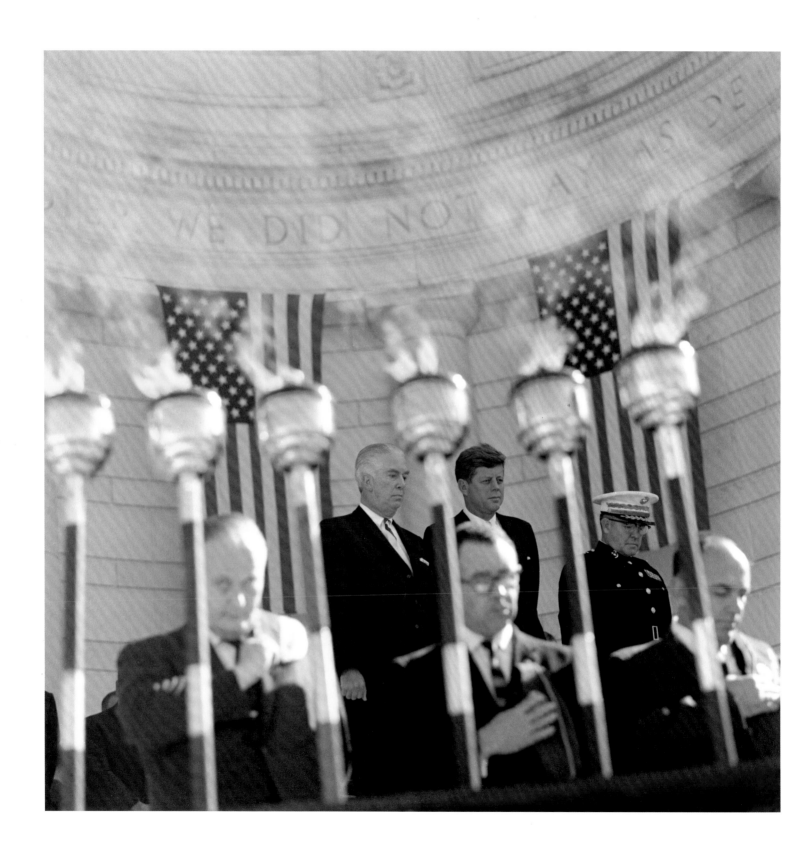

November 11 The president at Arlington National Cemetery on Veterans Day. John Jr., still fascinated with all things military, asked to be there with his father.

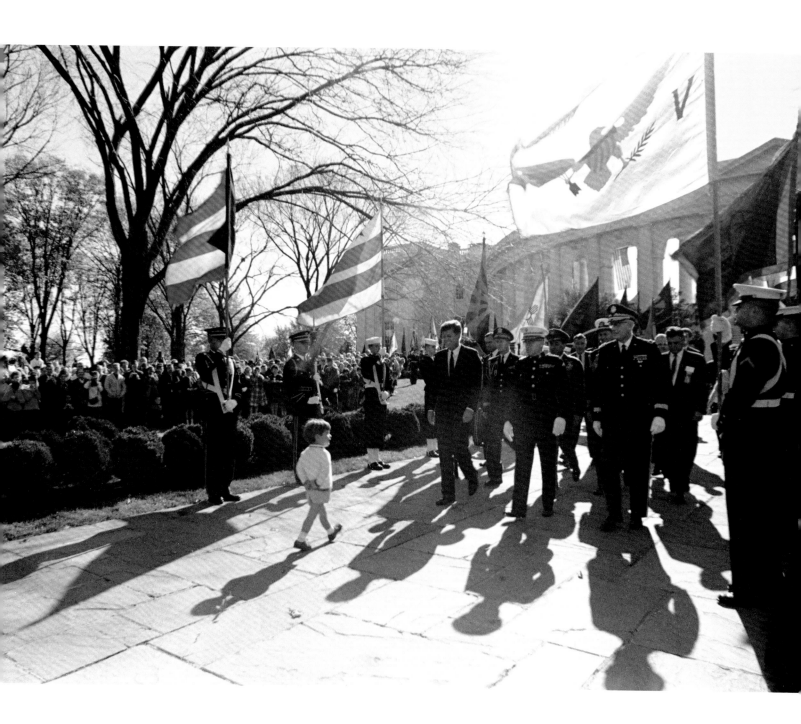

November 13 The Kennedys, with both their children, on the South Balcony of the White House, watching a parade of the Royal Highlands Regiment ("The Black Watch"). This is the last time the first family was photographed together.

The president's first formal reelection campaign meeting was held in the White House that day. His approval rating in Gallup polls had slipped some, but it still stood at 59 percent and he was confident about the campaign and reelection. Kennedy told his political team not to attack Barry Goldwater—"build him up," Kennedy said—because he thought the Arizona conservative would be the easiest Republican to defeat. "Give me Barry," he said with a laugh. Kennedy planned to begin campaigning in Texas, with a trip to San Antonio, Houston, Fort Worth, and Dallas.

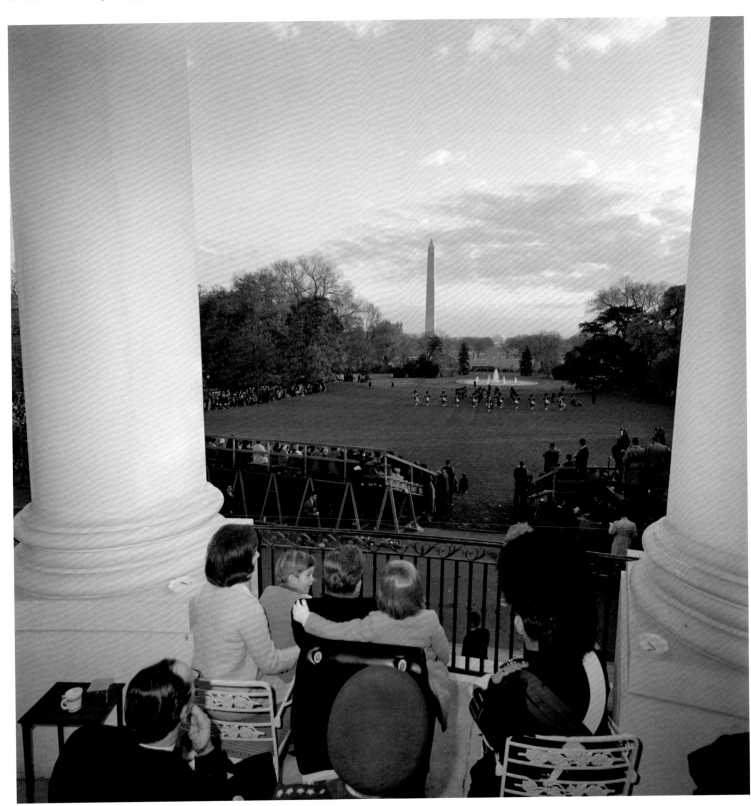

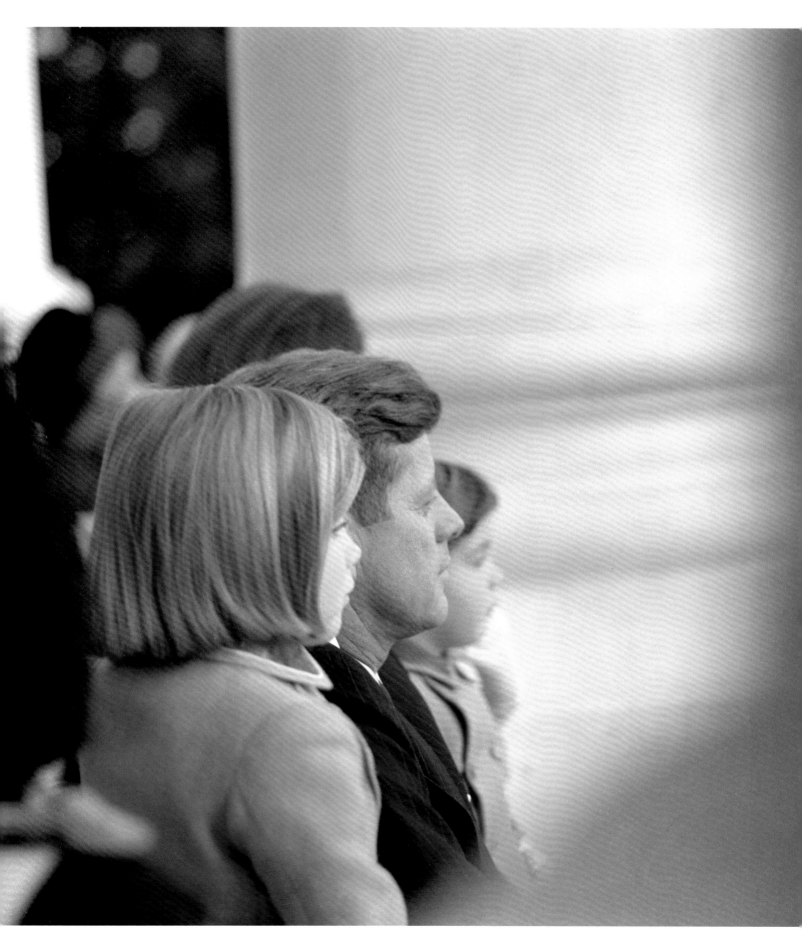

November 16 The president traveled to Cape Canaveral, Florida, to talk with NASA officials, and then he boarded the USS *Observation Island* to watch the launching of a Polaris missile.

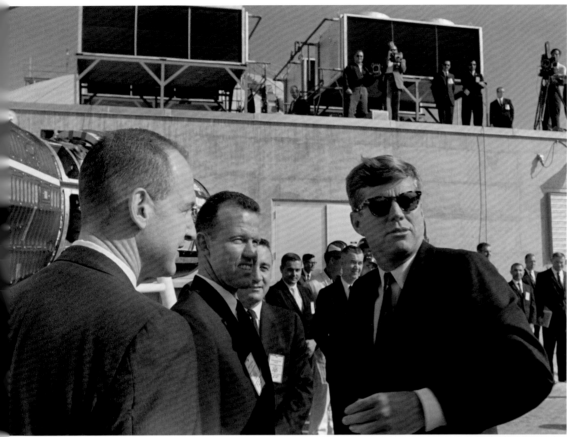

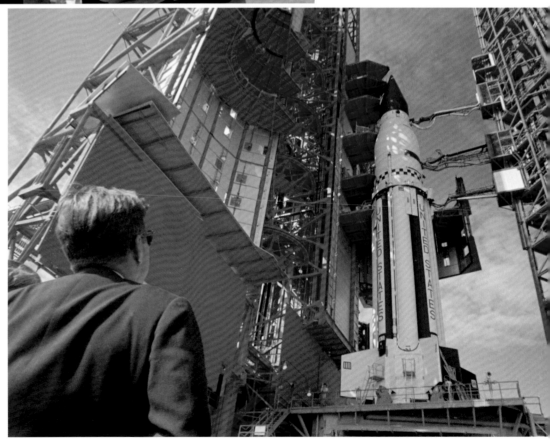

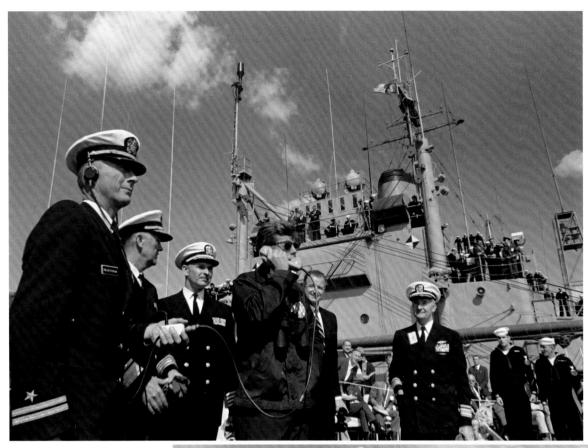

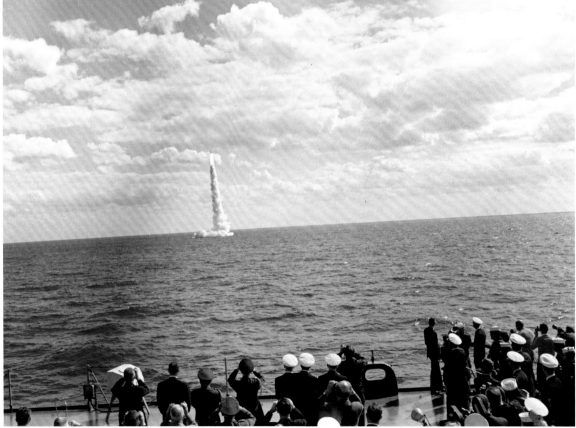

November 18 The president inspecting troops at MacDill Air Force Base near Tampa, Florida, before leaving in a motorcade to speak at the St. Petersburg-Tampa airport.

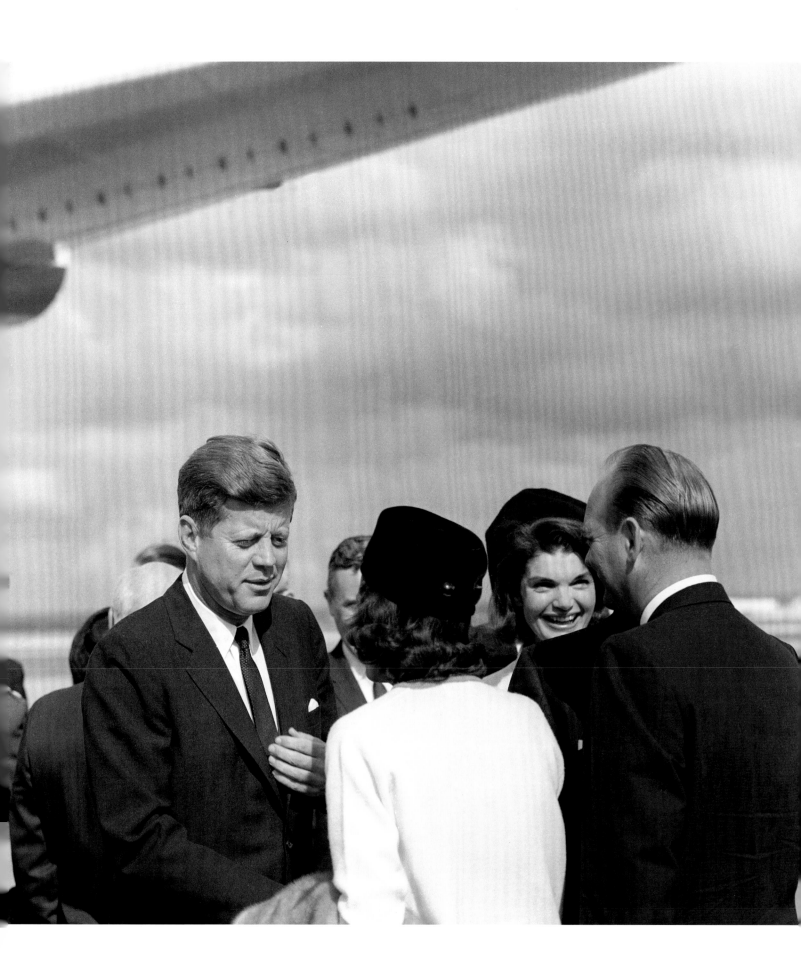

November 21 The president and Mrs. Kennedy arrived in San Antonio and dedicated the Aerospace Medical Center. Kennedy was a happy warrior on the trail, particularly happy because his wife agreed to join him, something she rarely did on political swings. They spent the night in Fort Worth, where Kennedy told her, "We're headed into nut country now . . ."

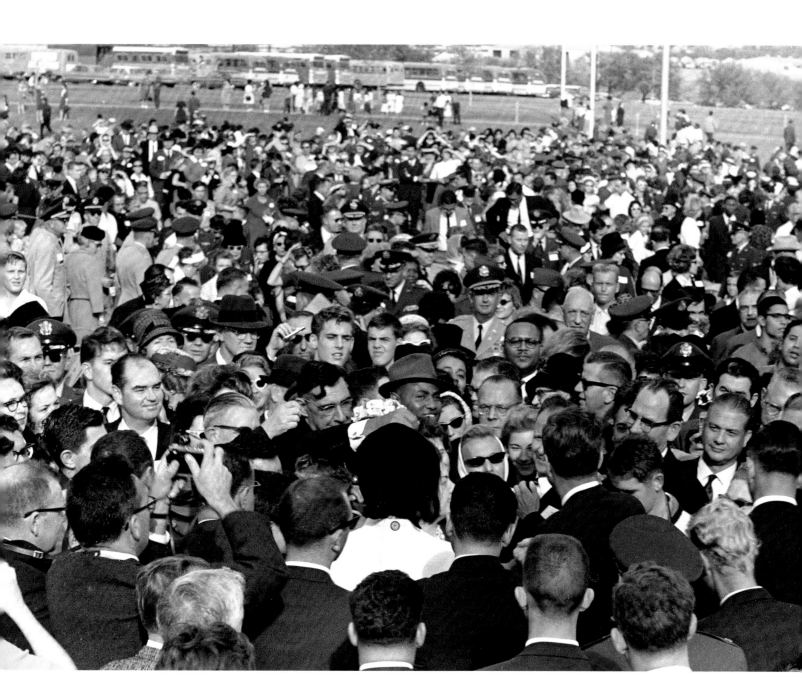

November 21 Kennedy addressed the
League of United Latin American Citizens at the
Rice Hotel in Houston, Texas.

1963

November 22 Suite 850 of the Texas Hotel in Fort Worth was decorated with a Monet, a Van Gogh, and a Picasso—the paintings were from local museums—when the Kennedys stayed over on the night of November 21. In the morning the president looked out the window to see a crowd gathering below to hear him speak in front of the hotel. There were more people than he had expected. "Isn't that terrific?" Kennedy said to his wife. A few minutes later, he looked out again and said to an aide, Kenny O' Donnell, "Look at that platform. With all these buildings around it, the Secret Service couldn't stop someone who wanted to get you." When he got downstairs, the crowd cheered and someone shouted, "Where's Jackie?" The president pointed up toward the eighth floor and said, "Mrs. Kennedy is organizing herself. It takes longer, but of course she looks better than we do when she does it." When the cheering stopped, Kennedy made brief remarks and shook hands with the crowd. The president then went back into the Texas Hotel where he spoke at a Democratic fundraising breakfast.

Kennedy and the first lady came out together and then joined the motorcade to the airport for the short flight to Love Field in Dallas.

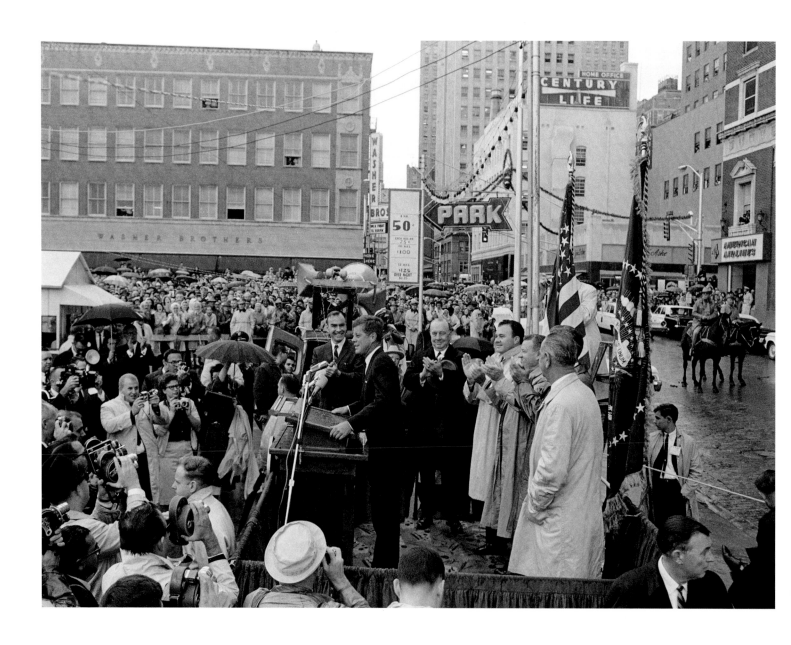

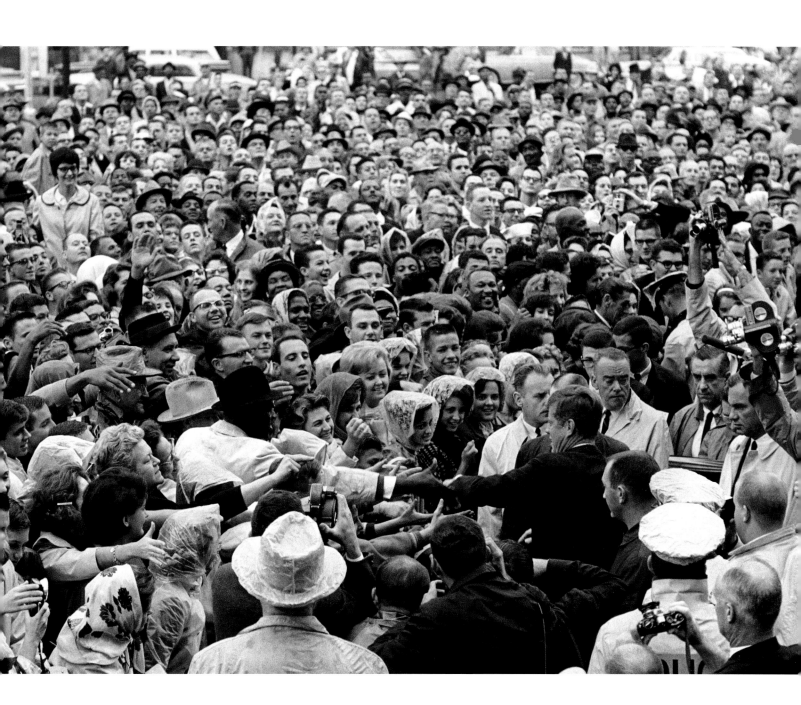

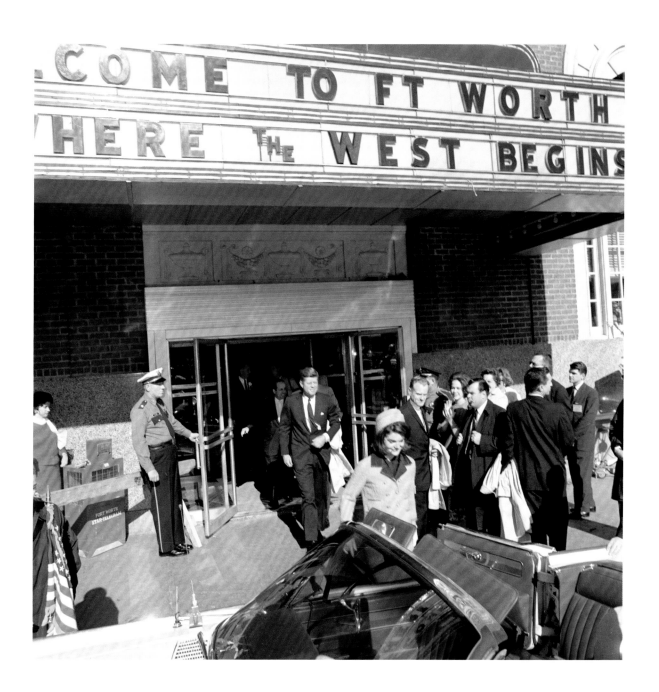

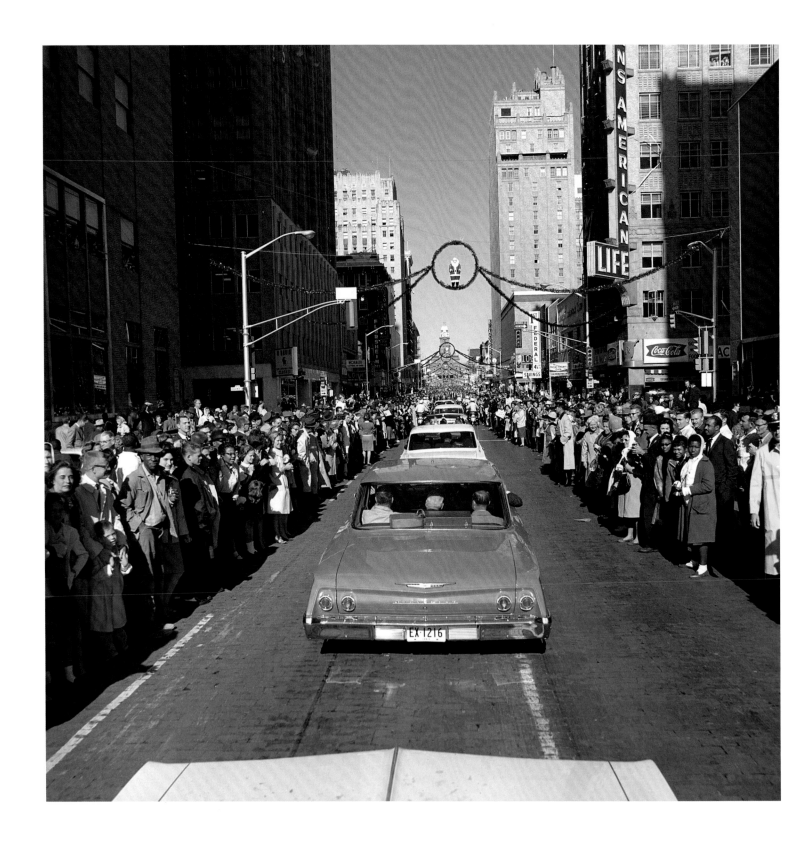

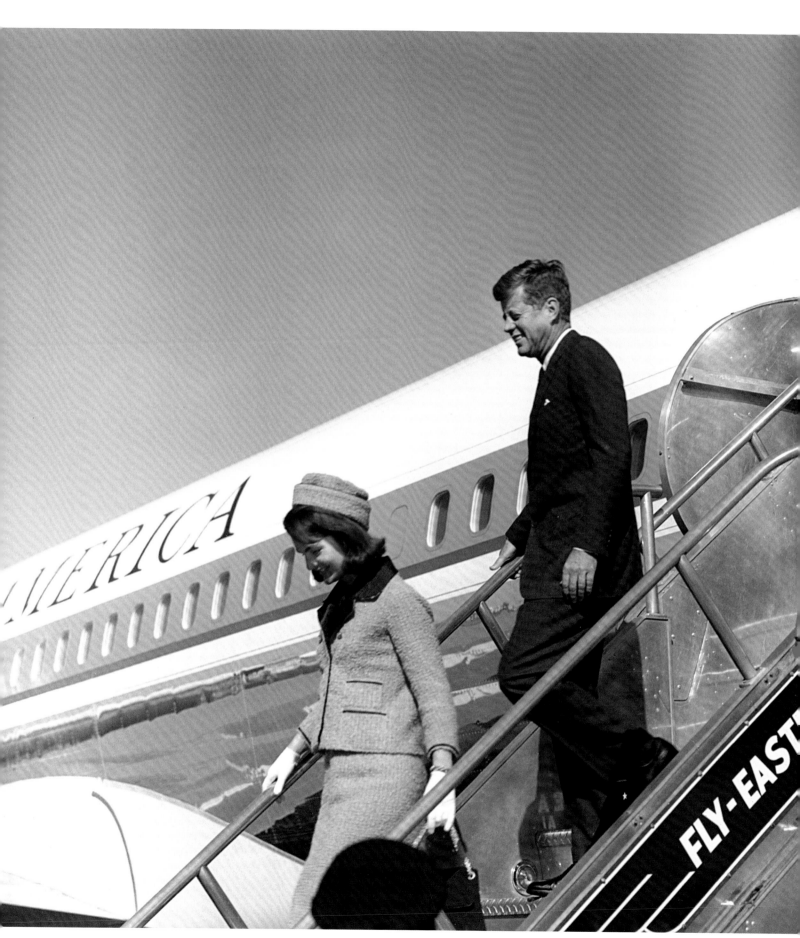

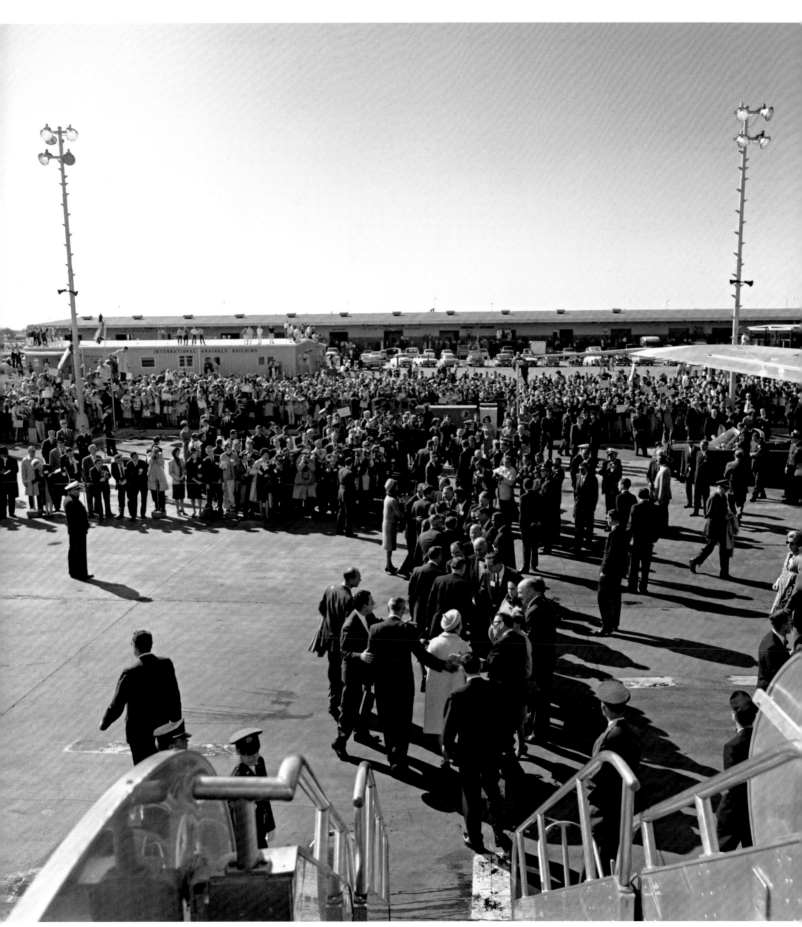

November 22 The Kennedys arriving at Love Field, where a reception line of Texas politicians and a large crowd waited. The next communication from the White House press office, set up at Parkland Hospital in Dallas, was, "After breakfast at the Texas Hotel in Fort Worth, the president flew to Love Field in Dallas. There he acknowledged greeters for a brief period, and then entered an open car. The motorcade traveled down a 10-mile route through downtown Dallas on its way to the Trade Mart, where the president planned to speak at a luncheon. At approximately 12:30 (CST) he was struck by two bullets fired by an assassin. The president was declared dead at 1 PM at the Parkland Hospital in Dallas."

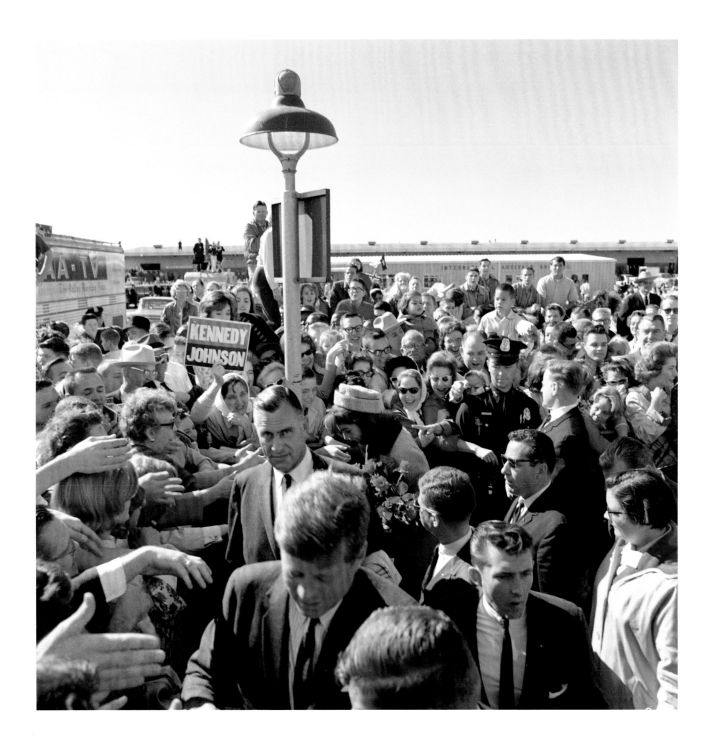

November 22 The president's casket was driven from Parkland Hospital to *Air Force One* at Love Field. Mrs. Kennedy followed the casket into the plane.

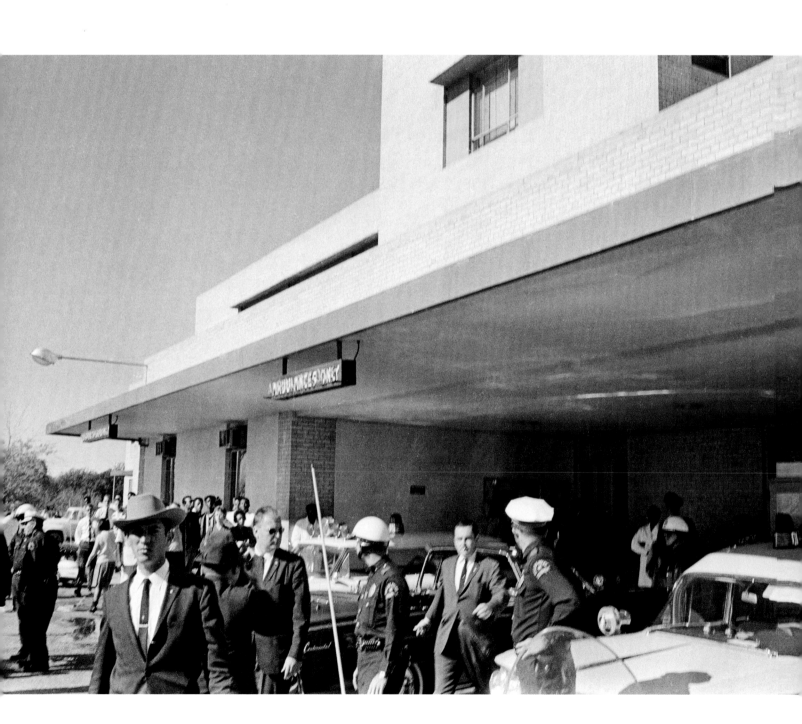

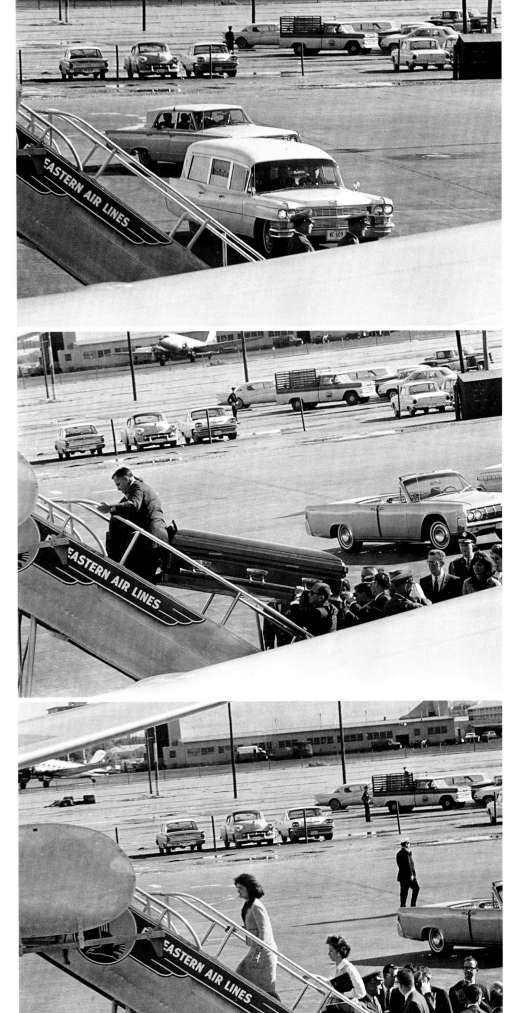

1963

Lyndon Johnson, standing between his wife, Lady Bird, and Mrs. Kennedy, was sworn in as the thirty-sixth president of the United States by U.S. District Court judge Sarah Hughes aboard *Air Force One*. Cecil Stoughton was the only photographer to witness and record the oath-taking.

President Johnson addresses the nation live from Andrews Air Force Base in Maryland, after the return of Kennedy's body from Dallas.

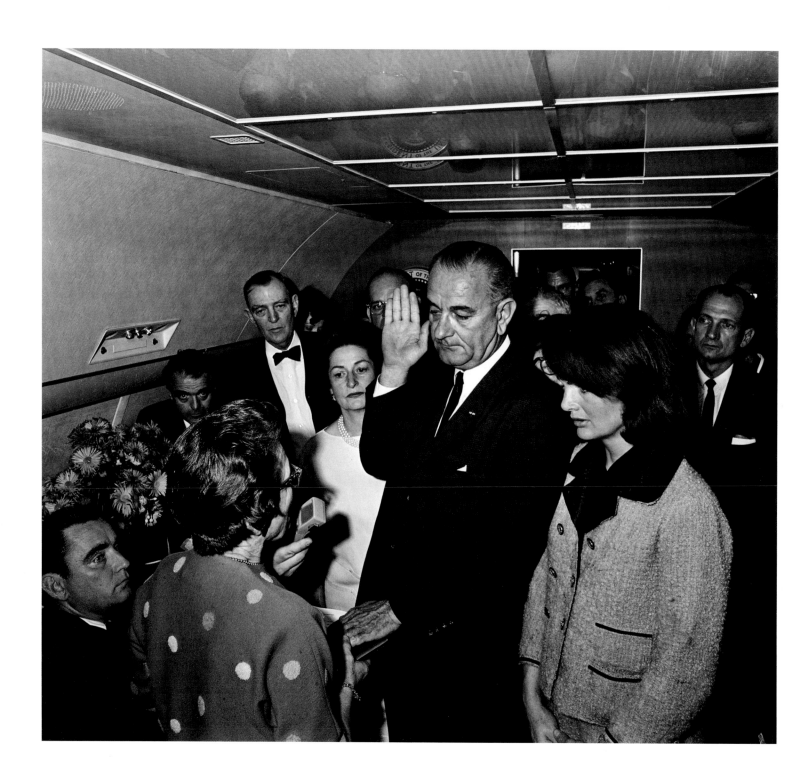

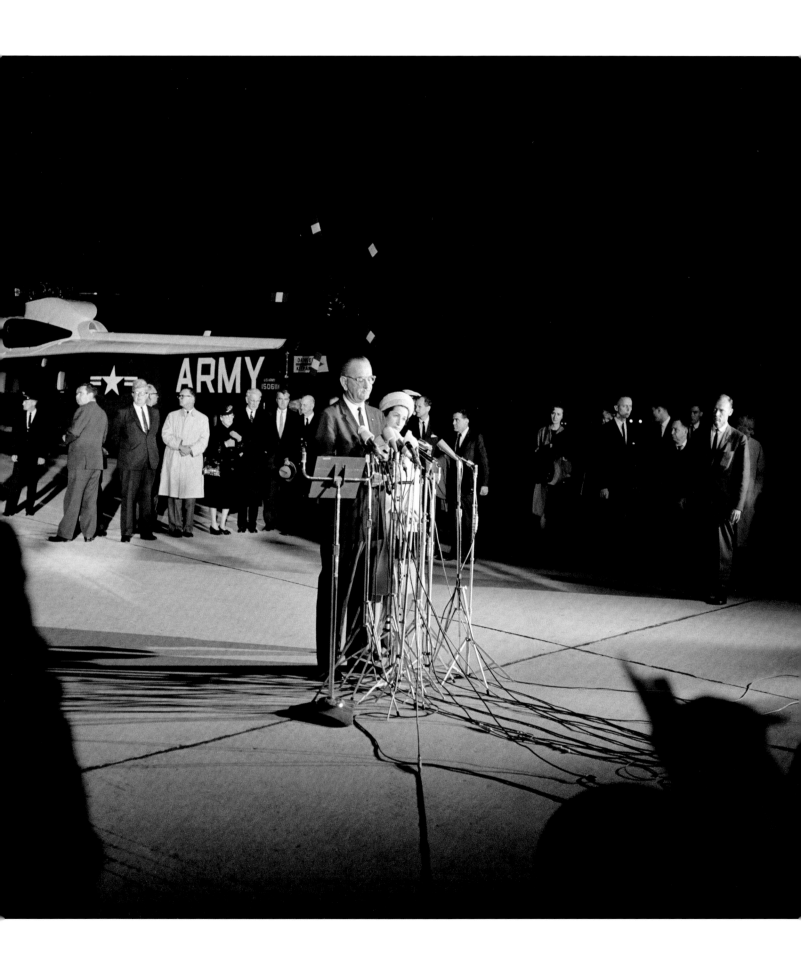

November 23 Kennedy's coffin was carried into the White House by a military honor guard and placed in the East Room, where the president would lie in state.

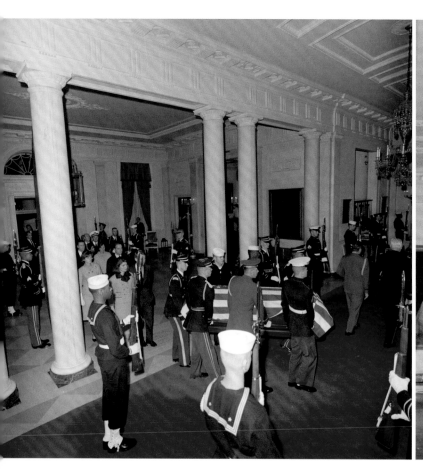

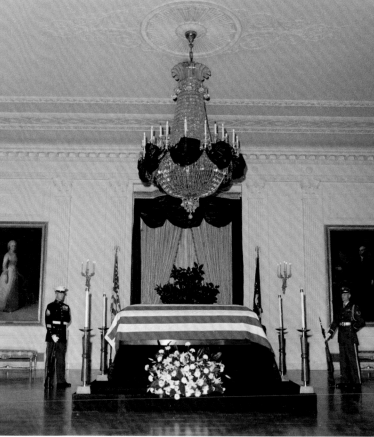

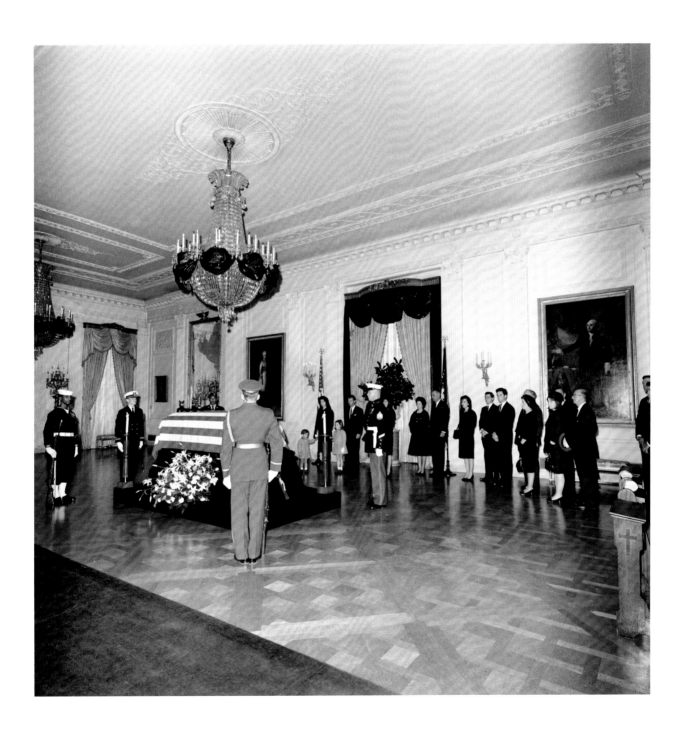

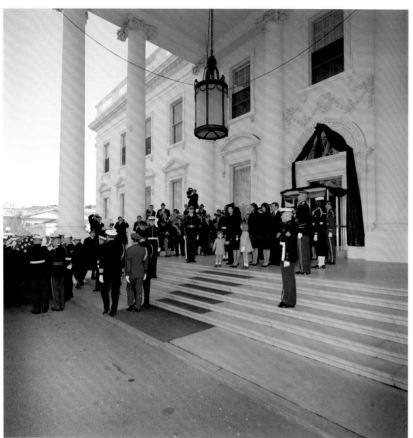

November 24 The first family leaves the White House for the funeral.

The president's casket was placed on an army caisson.

The riderless horse, a gelding named Black Jack, and the horse's walker, Staff Sergeant Travis Nielsen, wait outside the White House to join the funeral parade. The reversed boots in the stirrup are part of this funeral tradition for a fallen leader that dates back to, at least, ancient Rome.

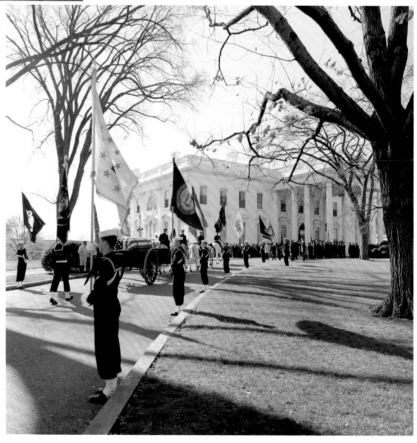

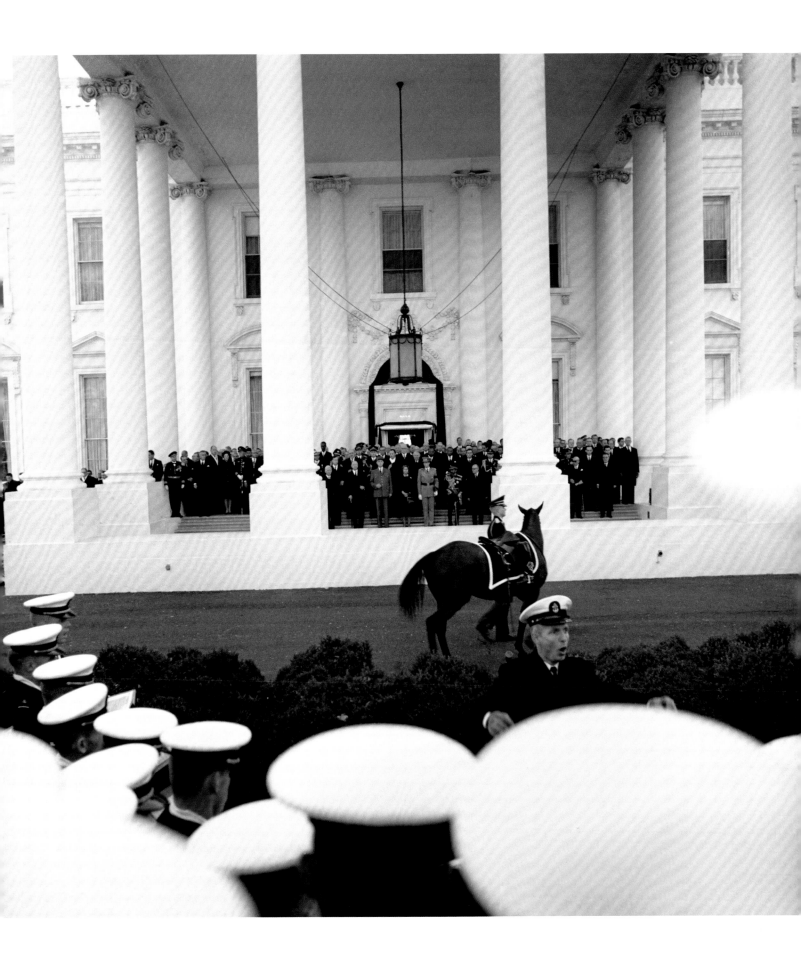

November 25 Foreign leaders, led by Charles de Gaulle, president of France and Haile Selassie of Ethiopia, marching behind the caisson toward St. Matthew's Cathedral. Former presidents Harry S. Truman and Dwight Eisenhower, both more than a generation older than Kennedy, at the president's funeral.

Richard Cardinal Cushing, archbishop of Boston and a friend of the Kennedy family, blessing the casket outside St. Matthew's.

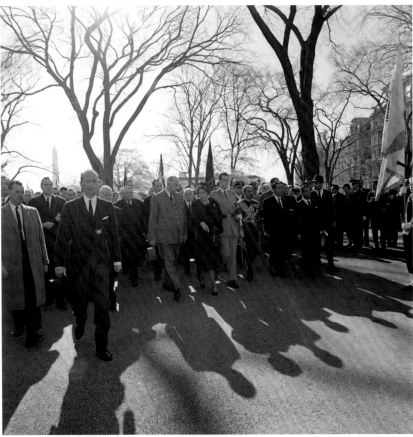

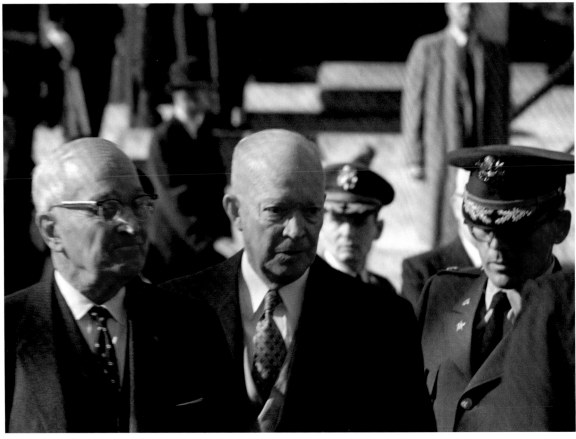

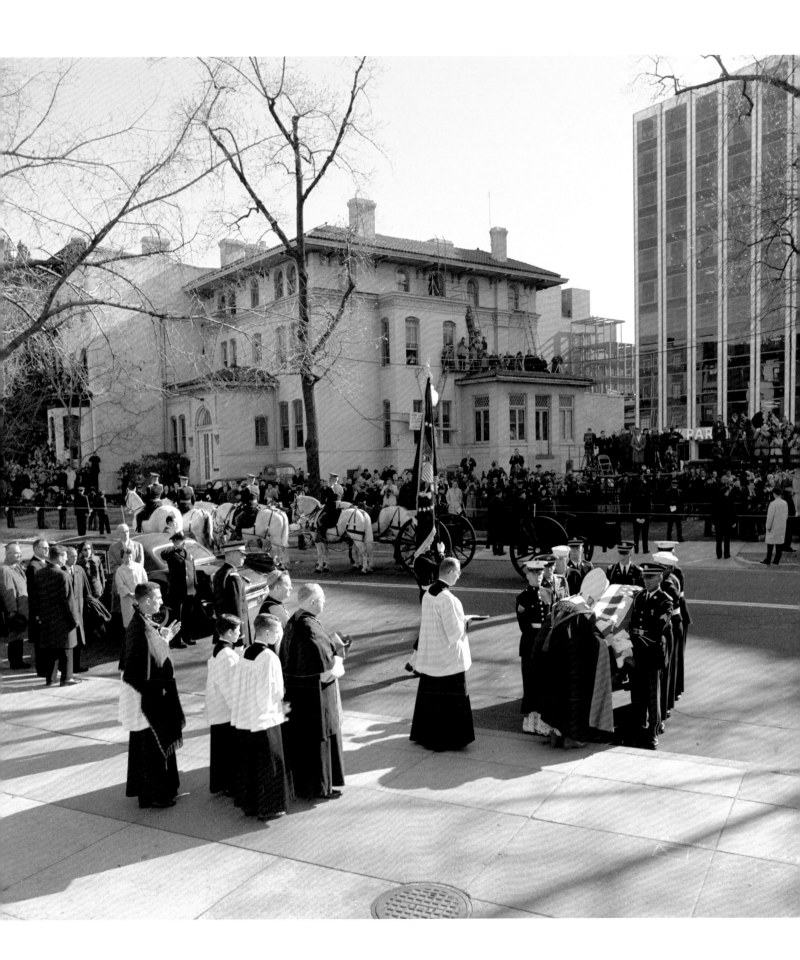

November 25 Twelve air force jets fly over in a "missing man" formation. Military pallbearers folding the flag over the coffin, as de Gaulle, West German chancellor Werner Erhard, Selassie, and King Baudouin of Belgium stand behind the casket.

Mrs. Kennedy, in a mourning veil, holds the folded flag.

The Kennedy family at the burial site on a hill overlooking Arlington National Cemetery. In the front row, left to right: Patricia Lawford, Eunice Shriver, Rose Kennedy, Robert Kennedy, Mrs. Kennedy, Edward Kennedy, Prince Radziwill, Stephen Smith, Joan Kennedy, and Sargent Shriver, far right. In the background are Peter Lawford, Evelyn Lincoln, LeMoyne Billings, and Senator Hubert Humphrey; to the left is the new president, Lyndon Johnson.

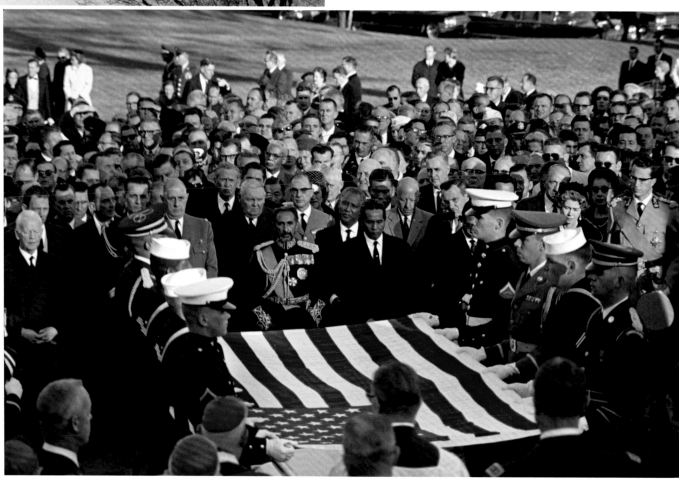

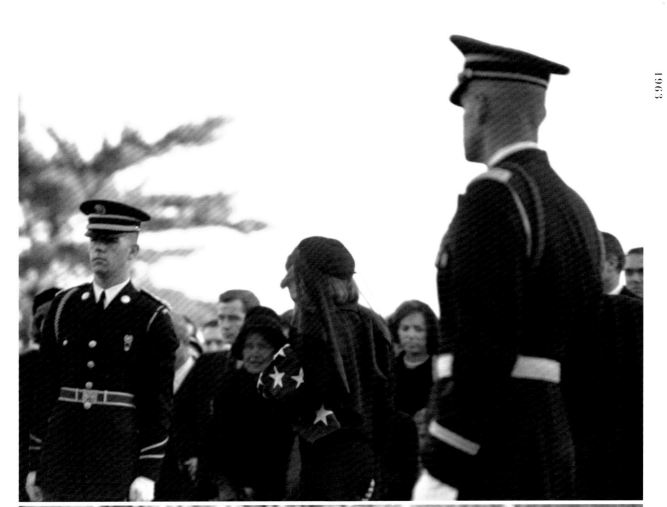

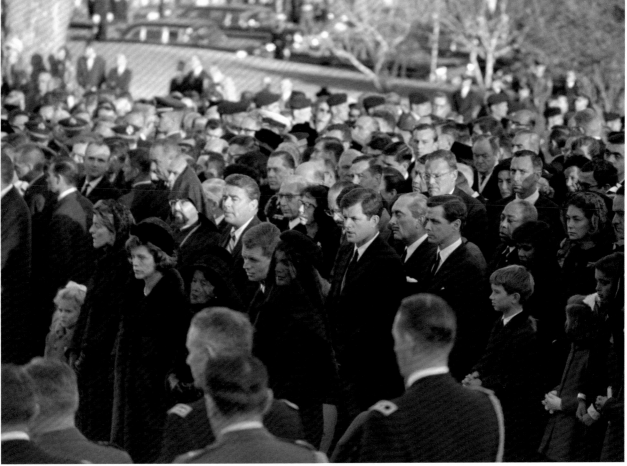

November 25 President de Gaulle and Senator Edward Kennedy returning to the White House. Mrs. Kennedy and Senator Kennedy standing and greeting Golda Meir before a reception line in the Red Room of the White House.

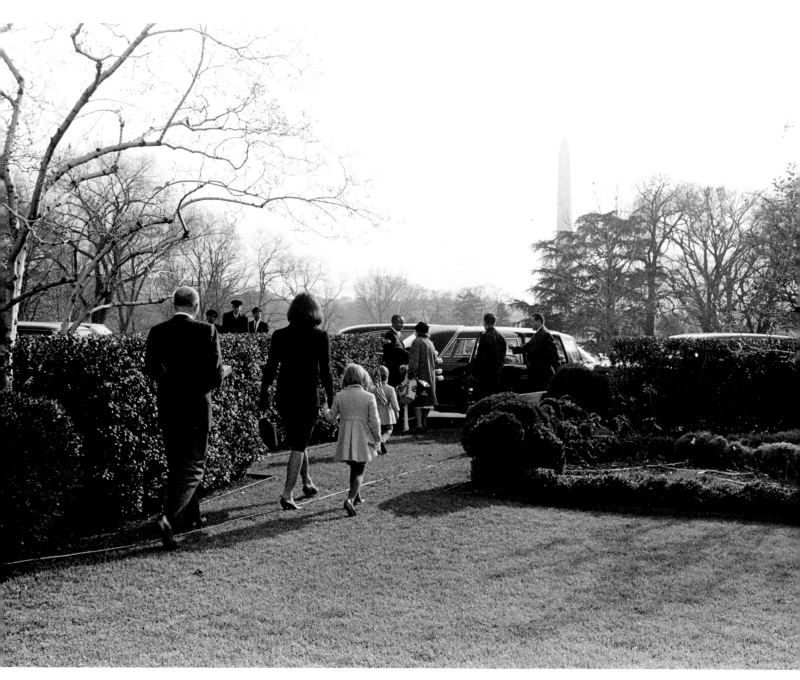

December 6 Mrs. Kennedy and her children leaving the White House for the last time.

Cecil W. Stoughton,
The President's Photographer

HARVEY SAWLER

Americans living at the time were forever transformed by the contrasting stories of January 20, 1961, and November 22, 1963. Cecil Stoughton was among the select few who stood at the epicenter of those stories and the 1,036 days in between John F. Kennedy's inauguration and assassination.

Stoughton played a role unlike any other individual attached to the Kennedy administration. He was the first official White House photographer. Just as remarkable, he also evolved to become the Kennedys' trusted chronicler of their personal lives. Stoughton was ever present, yet undetectable as he photographed and filmed virtually everything the first family did. This unprecedented privilege wasn't just Stoughton's job; it was his life. Daytime, nighttime, and on weekends, he continuously examined the Kennedys through his lens. "This is what I did," Stoughton said in an interview more than four decades after the end of Camelot. "This is what I am." Stoughton's obsession with the Kennedys preoccupied him until his death on November 3, 2008. He loved them in such a deeply personal way that when John Kennedy, Jr. was killed while piloting his Piper Saratoga off Martha's Vineyard in July of 1999, Stoughton was devastated in the manner he'd been over the trauma of Dallas. It was as though one of his own sons had died.

o o o

When Stoughton was a teenager, he and his mother found a crumpled twenty dollar bill on the floor of a Woolworth's five-and-dime store in Oskaloosa, Iowa. They couldn't find the bill's owner, and Mrs. Stoughton used $12.50 of the found money to buy a camera for her son. That 35mm Argus became Stoughton's constant companion. "I documented all of my friends doing everything," he said. "Anything that happened, I was there with my trusty little handheld camera." The same could be said for Stoughton at work in the White House and for his tireless fixation on permissibly shadowing the Kennedys.

Stoughton had an eye for framing people and situations—but his success was really the result of his unrelenting tenacity. When he saw an opportunity for a great photograph, one where the angle and perspective he envisioned could best tell the story at hand, no rule or barricade or Secret Service agent could dissuade him . . . and no wonder.

As a member of the U.S. Army's First Motion Picture Unit, supporting B-24 and B-17 South Pacific bombing missions during World War II, Stoughton learned to work in perilous circumstances: shooting photographs from the open side windows of aircraft, capturing images used for intelligence and for the production of popular movie theater newsreels. He performed similar work in Korea, flying life-threatening missions behind enemy lines aboard MASH unit helicopters used to evacuate dead and wounded American soldiers. Military assignments emboldened the young photographer and taught Stoughton to be adept at both still and motion photojournalism. These experiences also contributed to his fearlessness while photographing the world's most powerful people during his era, as well as countless celebrities, from Sir Winston Churchill to Elvis Presley to Marilyn Monroe.

Stoughton was just another captain in the U.S. Army Signal Corps when he first set his eyes—and lens—upon the young president and his wife at John F. Kennedy's inauguration. But as the other government and free press photographers languished below the presidential dais with their telephoto lenses, Stoughton maneuvered his way up behind the dignitaries; from there he had an exclusive view of the inaugural proceedings, shooting at will with his reliable, regular-lens Hasselblad. Later that day, from atop the Pennsylvania Avenue reviewing stand, he also took pictures of Kennedy happily acknowledging his former navy crew members saluting their commander from the "deck" of a scale model *PT-109* as it passed in the inaugural parade. That night, Stoughton printed large copies of his photos from the inaugural events, put signature borders at the bottom, and took them to his Pentagon boss, newly appointed

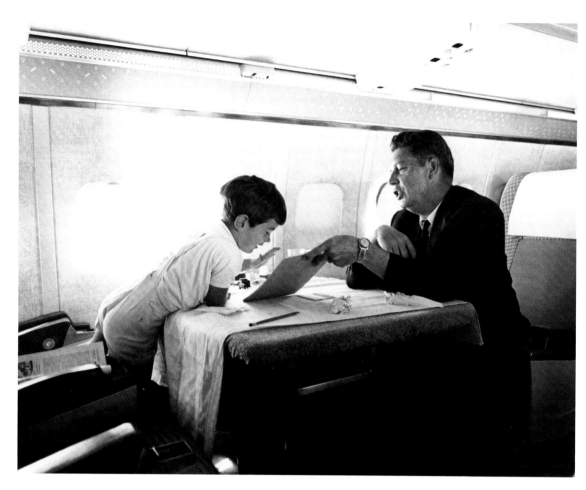

Cecil Stoughton and John Jr.,
May 11, 1965

presidential military aide General Chester "Ted" Clifton. The general took the pictures to Kennedy, and their quality and inventiveness clinched Stoughton's future.

The photographer soon found himself modifying a recording studio located directly beneath the Oval Office into his personal work space. From there, Stoughton could be summoned on a moment's notice to photograph "grip-and-grins" of the president and visiting world leaders, or to chronicle the tense drama of the Cuban Missile Crisis deliberations, or to freeze frame the spontaneity of Caroline and John Jr. dancing across the carpet to their father's obvious delight. Once inside the White House walls, Stoughton began taking the photographs that helped define the Kennedys; the president went along with it all. Jacqueline Kennedy, the true creator, director, and set designer of Camelot, frequently let Stoughton know that she admired his work; he cherished notes the first lady sent on her delicate, personal, powder blue White House stationery, with acknowledgments such as *"For Cecil Stoughton, whose photographs are, to me, as precious as the Mona Lisa."*

From the inauguration photos to the hundreds of others Stoughton shot of the president, his administration, and his family, none was more unpredictable—or famous—than the one Stoughton took without the participation of his main subject.

On November 22, 1963, Stoughton took the most historically important photograph of his career: the swearing in of Lyndon Baines Johnson as the thirty-sixth president of the United States in the bewildering aftermath of the Kennedy assassination. Composed and methodical, in spite of the nightmare he'd just witnessed while riding in the presidential motorcade, Stoughton was the only photographer onboard *Air Force One*, where the oath of office was administered with a shocked, bloodstained Jacqueline Kennedy looking on. Stoughton chose his now-famous photo from a series of more than twenty negatives that were quickly developed in the Associated Press darkroom in downtown Dallas; the black-and-white photograph was shown around the world as grief over the young president's death began to take hold. Forty-five years later, it was the singular picture chosen by editors everywhere to run alongside Stoughton's obituary in November 2008.

Stoughton's hallmark, however, was not tragedy. Rather, his was the photography of joy: the exuberance of the Kennedy children; the dazzle of Mrs. Kennedy, at home and abroad; the eagerness of crowds of Americans, reaching out simply to touch their president; the magnetism of a youthful leader who could send entire foreign cities into a welcoming frenzy. Stoughton framed it all for us; his legacy is our legacy.

Notes on the DVD

Along with still photographs, Cecil Stoughton (or staff members working under his direction and his attribution) shot almost seven-and-a-half hours of film footage of the Kennedy family in 1962 and 1963. This footage, which consists of 34 individual segments, includes formal occasions, state visits, and foreign trips, as well as family outings, weekends, and holidays. In their archived form, the segments are edited and do not adhere to a strict chronology; some have non-synched sound.

The film footage in the DVD that accompanies this book focuses on family events primarily at the Kennedy's homes in Hyannis Port, Massachusetts;

Palm Beach, Florida; and Middleburg, Virginia. The footage has been re-edited to parallel the chronological organization of the book and provide an entertaining visual experience. The soundtrack is not original sound and has, likewise, been added for entertainment.

The film footage on the DVD was dated as accurately as possible using the title cards on the archived footage, visual comparison to still photographs, and corroboration with the White House Diary (www.jfklibrary.org).

CHAPTER 1

1962

Hyannis Port, Massachusetts
July 28, 1962

America's Cup
Newport, Rhode Island
September 15 and 22, 1962

Palm Beach, Florida
Christmas 1962

CHAPTER 2

April 1963

White House Garden
April 1 and 4, 1963

Palm Beach, Florida
Easter 1963

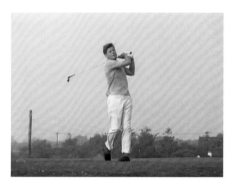

CHAPTER 3

July 1963

Hyannis Port Golf Club
Hyannis Port, Massachusetts
July 27, 1963

Honey Fitz
Hyannis Port, Massachusetts
July 28, 1963

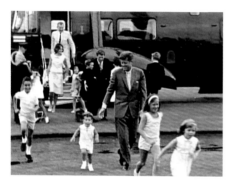

Index

Page numbers in *italics* refer to illustrations.

The authors and publisher would like to thank the following individuals, without whom this book would not have been possible: James Hill and Laurie Austin from the Audiovisual Archives division of the John F. Kennedy Presidential Library and Museum; Cecil Stoughton's wife, Faith Stoughton, his daughter, Sharon Houghton, and his sons, Jamie and Bill Stoughton; Amanda Urban and Alison Schwartz of International Creative Management; Rick Broadhead of Rick Broadhead & Associates; researcher Deborah Paddock; and Charlotte Stewart.

Project Manager and Photo Editor: Deborah Aaronson
Editor: Sheila Keenan
Designer: Sarah Gifford
Production Manager: Anet Sirna-Bruder
Film Editor: Dana Gerolimatos, BlueRock

Library of Congress Cataloging-in-Publication Data
Reeves, Richard, 1936–
Portrait of Camelot : a thousand days in the Kennedy White House /
Richard Reeves ; with Harvey Sawler ; photographs by Cecil W. Stoughton.
 p. cm.
Includes bibliographical references and index.
ISBN 978-0-8109-9585-7 (alk. paper)
1. Kennedy, John F. (John Fitzgerald), 1917-1963—Family—Pictorial works.
2. Kennedy, John F. (John Fitzgerald), 1917-1963—Pictorial works.
3. Presidents—United States—Biography—Pictorial works. I. Sawler, Harvey,
1954- II. Stoughton, Cecil. III. Title.
 E843.R357 2010
 973.922092—dc22
 [B]
 2010017619

Page 2: The Kennedy family, Cape Cod, Massachusetts, August 4, 1962
Page 5: John F. Kennedy and John Jr. in the Oval Office, October 10, 1962
Page 11: President Kennedy and the first lady, Newport, Rhode Island, September 14, 1962

Printed and bound in China
10 9 8 7 6 5 4 3 2 1

Abrams books are available at special discounts when purchased in quantity for premiums and promotions as well as fundraising or educational use. Special editions can also be created to specification. For details, contact specialmarkets@abramsbooks.com or the address below.

THE ART OF BOOKS SINCE 1949
115 West 18th Street
New York, NY 10011
www.abramsbooks.com